INVESTIGATING MODERN ART

INVESTIGATING MODERN ART

EDITED BY

LIZ DAWTREY
TOBY JACKSON
MARY MASTERTON
PAM MEECHAM
PAUL WOOD

YALE UNIVERSITY PRESS IN ASSOCIATION WITH THE OPEN UNIVERSITY
THE ARTS COUNCIL OF ENGLAND AND THE TATE GALLERY

This book is one element in a resource pack for teachers and gallery education officers. The project was initiated by the Arts Council of England to meet the need for a greater critical understanding of twentieth-century visual art and of recent developments in art practice. The project was funded by the Arts Council of England and the Open University in a unique collaboration with support from the Tate Gallery and John Moores University. For further information on the pack, E556 Working with Modern Art, contact, the Learning Materials Service Office, PO Box 188, The Open University, Walton Hall, Milton Keynes MK7 6DH.

Designed by Sally Salvesen
Typeset in Photina
Printed in Italy by Conti Tipocolor SRL,Florence

Library of Congress Catalog in Publication Data
Investigating Modern Art / edited by Liz Dawtrey ... [et al.].
 p.
 Includes bibliographical references and index.
 ISBN 0-300-06796-8 (c.). – ISBN 0-300-06797-6 (p : alk. paper)
 1. Art, Modern–20th century–Themes, motives. I. Dawtrey, Liz.
N6490.I55 1996
709'.04–dc20 95-50877
 CIP

CONTENTS

ACKNOWLEDGEMENTS

The editors wish to express their thanks to the many people who have been involved in working on this volume. This book has been the result of a partnership between the Open University and the Arts Council of England and we are particularly indebted to Marjorie Allthorpe-Guyton, Director of Visual Arts, Arts Council of England for her personal involvement in its creation. Our special thanks also go to Sandy Nairn and Colin Grigg of the Tate Gallery, London for their tremendous support and encouragement during the initial stages of production.

Our thanks go to Dave Allen, Bev Joicey, Laurie Ruscoe and Jane Placca, members of the Steering Group, for their comments on the manuscript, to Rod Taylor for his enthusiastic response to the project and to Tim Benton, Dean of the Arts Faculty at the Open University for his vision which sustained the critical early stages of development.

We are particularly grateful to the Tate Gallery for permission to reproduce works from their collection and for releasing Toby Jackson to work on the book and also to Liverpool John Moores University for enabling Pam Meecham to give of her time both as an author and as an editor. Finally, we would like to express our thanks to the authors for their patience and persistence in working through the drafts, to Julie Sheldon for preparing the Glossary, and special thanks to our secretaries, Karen Codling and Bernadette Emmett whose dedication and resourcefulness has ensured that this book has finally been produced.

INTRODUCTION

This book was devised by a team of educationalists and art historians in response to a widely voiced need for an accessible book about modern art. The book is intended to offer a critical yet enjoyable discussion of what can sometimes appear to be difficult, even incomprehensible, modern works. It is designed to inform the practice of teachers and gallery education officers as well as to help the individual who wishes to develop an understanding of modern art.

Since the 1980s there has developed an approach to the teaching of art in educational institutions that has used the term 'critical studies'. This implies a combination of history, critical analysis and understanding. Though undoubtedly marking an advance over traditional 'art appreciation', there is still debate as to whether 'critical studies' is an adequate term to describe the engagement of a viewer with a work of art, and with the meanings and emotions which a work of art brings into play. At the same time the field of art history was itself transformed by an approach which took its cue from cultural studies and literature, and focused on the political, social and cultural contexts in which art is produced. This was in part a response to developments in the criticism and display of art which had tended to separate works of art themselves from the social and historical circumstances in which they were made. The present book offers a critical discussion of modern artists, art movements and art works from a variety of viewpoints that traditional art history had not found relevant.

It would be impossible for a single volume to discuss all the relevant debates and art movements from the middle of the nineteenth century to the present day. Consequently, our choice of artists is inevitably selective, and our discussion of issues has had to be determined by our individual competences and the space available to us. Within this necessarily restricted compass, the authors have tried to provide an accessible historical progression through the modern period, focusing on particular artists or works of art while attempting to draw out more general issues and implications. We hope that the resulting collection will stimulate a desire both to read further in the literature of modern art and to encounter works of modern and contemporary art at first hand.

Since the end of the last century, Modernism has arguably been the dominant force in the production of western, avant-garde art. It has, however, throughout the period been subject to a variety of conservative and radical challenges. More recently, as so much debate and change has arisen in the wider world — about the relations between men and women, about relations between rich and poor countries, about relations between high art and popular culture, about notions of scientific progress and so on — many of the values assumed by the Modernist avant-garde have come under fundamental scrutiny. The present collection of essays aims to equip its readers with the tools to understand these debates, and the different kinds of artworks to which they have been attached. The Edwardian critic Clive Bell, an early Modernist, when trying to say what was required to appreciate a work of art, said 'nothing'; nothing, that is, except 'a sense of form and colour and a knowledge of three-dimensional space.' The present book seeks to provide a rather

wider range of tools with which to understand modern art: an understanding of relevant techniques and materials, social historical and political information, and the informing terms of contemporary cultural debate.

The first chapter offers an introduction to the development of Modernism, including the relation of changes in the practice of art to critical debates about art, and the role of art in our wider contemporary culture. It raises some of the key issues discussed throughout the book. It is followed by accounts of the decline of the Academy and the development of Modernism in the late nineteenth-century. The essays then chronologically trace key twentieth-century avant-garde artists and movements. The discussion of key figures such as Picasso, Matisse, Pollock and Warhol, and movements such as Cubism, Surrealism, Abstract Expressionism and Minimal Art, is animated by the most relevant concerns of contemporary art-historical scholarship. Questions of gender and ethnicity, criticisms of the accepted canon of modern art, and important social and political influences upon the institution of art are interwoven with the discussion of particular works. The concluding essays address contemporary practices of art and the host of questions surrounding the role of art in contemporary society. These include the issue of Post-Modernism: the question as to whether we in the late twentieth century are witnesses to the end of the modern period as it has historically been understood, and whether the diversity of contemporary art mirrors this situation.

Each author was asked to integrate general analyses with particular historical explanations in their own areas of expertise. Each reader, it is hoped, will both find points to disagree with and much to stimulate further discussion and enquiry. A glossary provides brief explanations of the sometimes specialized terminology and ideas surrounding modern art. There are also suggestions for further reading.

Even in a relatively short and selective book of essays such as this one we have tried to keep our aims and approaches plural and open. We have tried to question some of the myths surrounding modern art, in particular we have attempted to open to discussion some of those myths which have sustained Modernism's dominance over other art practices, examining its claims of universality, as well as its elitism and inaccessibility. We have sought to indicate the ways in which modern art has frequently been a response to the modern world, albeit often a complex response. Yet at the same time as criticizing received ideas and myths we have also acknowledged the importance of many of the key ideas which have been identified with modern art – ideas such as independence and originality, freedom and self-expression. We hope to provide the reader with some of the skills and confidence to talk about and analyse art within the context of the society in which artworks are made, and in which we all live and work.

LIZ DAWTREY

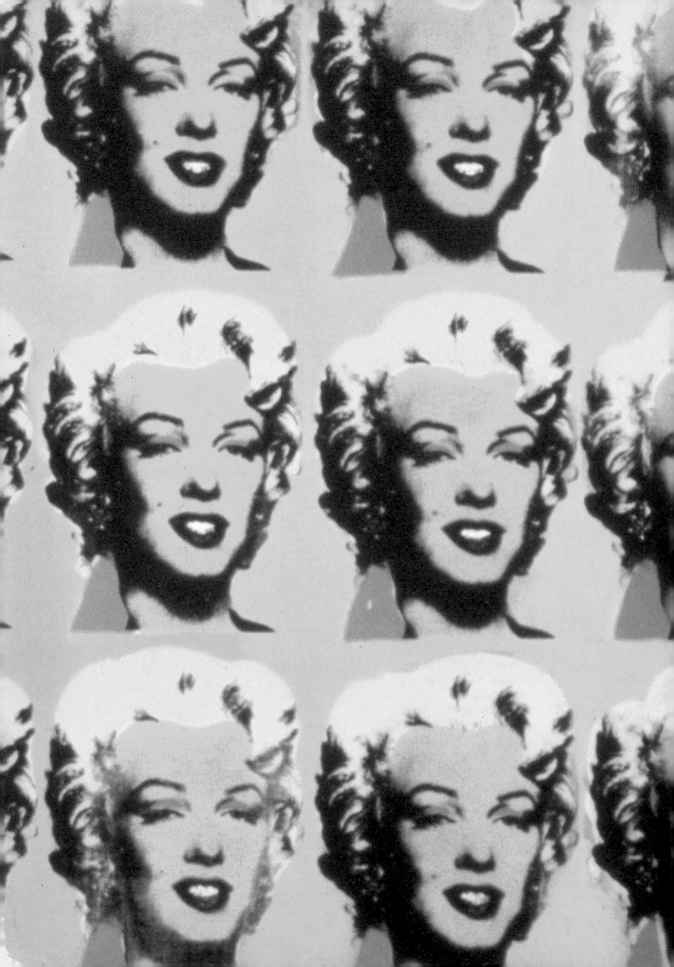

CHAPTER ONE

MODERNISM & MODERNITY
AN INTRODUCTORY SURVEY

PAM MEECHAM AND PAUL WOOD

SOME ISSUES IN MODERN ART

It is a commonplace that works of art in the mod-
ern period often appear strange and difficult. As a
result of this they have frequently been subject to
scepticism and ridicule, for example in the tabloid
press. At the same time the work of a compara-
tively few 'major' modern artists is on display in
museums and has changed hands for enormous
sums in the market place: *Les Demoiselles
d'Avignon* by Picasso (Plate 3) and *Marilyn Diptych*
by Warhol (detail, Plate 1) exemplify this. In west-
ern society, if something costs a lot of money this
is frequently taken to be an indication of its value
in a wider sense. As such these sums of money
seem to imply that the value of confusing and diffi-
cult modern artworks is on a par with the value of
Old Masters (Plate 2), which many people feel they
can understand and appreciate. The connection of
modern art and money, especially when set
against established ideas about art concerning
skill, beauty and value, can become mystifying
and off-putting. This is especially the case for those

who may have no specialist knowledge of art and
its complex histories.

A first step towards an understanding of this
situation involves examining a simple proposition:
that as art itself has fundamentally changed in the
modern period, so have ideas about it. These
changes have involved ideas about the kinds of
function art is believed to have in society, as well
as changes in the very types of thing which can be
considered as works of art. These include paint-
ings and sculptures which do not conform to
traditional expectations about one of the most

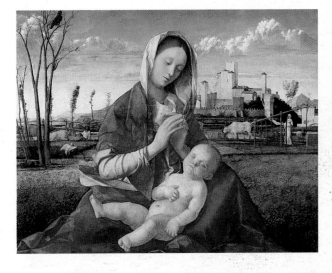

1. Detail from Plate 95, Andy Warhol, *Marilyn Monroe
(diptych)*, 1962, private collection.

2. Giovanni Bellini, *The Madonna of the Meadow*, c.1505,
canvas transferred from panel, 67.3 x 86.4 cm. National
Gallery, London.

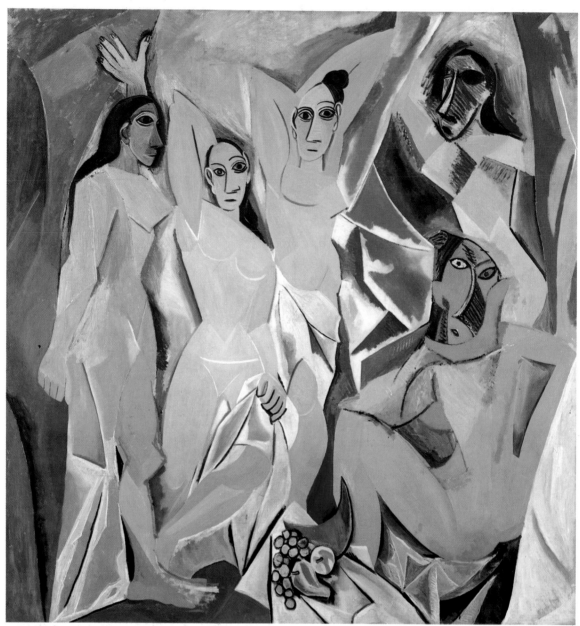

3. Pablo Picasso, *Les Demoiselles d'Avignon*, 1907, oil on canvas, 244 x 234 cm. Museum of Modern Art, New York, acquired through the Lillie P. Bliss Bequest, 1939.

important tasks of works of art – to depict real things in the world – and instead present either distorted images of recognizable things, or completely abstract relations of shapes, colours and forms. Such works first emerged in the early years of the twentieth century, for example in the paintings of Kandinsky and Mondrian (Plates 4, 66). Sometimes the shapes were rectangular, sometimes more organic, and the compositions also tended to involve varying degrees of formal complexity. But in some later works even these formal relations may be reduced to a minimum: a well-known example is Carl Andre's so-called 'Bricks', actually titled *Equivalent VIII* (Plate 101). This work was first made in 1966 and subsequently bought by the Tate Gallery in 1972, though the press scandal did not erupt until 1976. One of the main reasons for the tabloids' outrage was the

absence of traditional compositional skills, as well as the fact that bricks, though often found in the world, are not often used in sculpture. It is perhaps worth pointing out however that though Andre abjured the skills of modelling, carving or welding, he did not offer, as is often claimed, a 'pile of bricks': the one hundred and twenty bricks were arranged in a grid form, two rows deep on the floor; and, as the title implies, they were one of eight such arrangements. (Neither, as it happens, were they conventional building bricks with concave surfaces: they were flatter, thinner firebricks with flat sides. The point being that what mattered for Andre was less that they were bricks than that they were mass produced modular units which could be combined together without orthodox sculptural methods of fixing.)

Both before Andre's generation of the 1960s, and very noticeably since then, the materials out of which modern art has been made have become diverse. In the early twentieth century in movements such as Cubism and Dada, techniques of collage and assemblage were introduced (Plate 5). This process has continued in the second half of the century. In addition to paint and canvas, and metal and wood – and bricks – some works incorporate photographs, or imagery from advertising and the mass media. Other works incorporate real objects from the world of consumer goods, or sometimes from the debris and rubbish of that world (Plates 6, 7, 97, 99). Still other types of artwork consist of activities which result in no permanent object for contemplation at all. Such activities may be filmed, or photographed, or they may be transient and unrecorded except in the memories of their participants or spectators.

Clearly it is very difficult to make sense of this variety of work if the only tools one has were developed to sort out a very different type of art: concepts such as skill, or genius, or beauty, or

4. Wassily Kandinsky, *Sketch for Composition IV* (*Battle*, also known as *Cossacks*), 1910, oil on canvas, 95 x 132 cm . Tate Gallery, London.

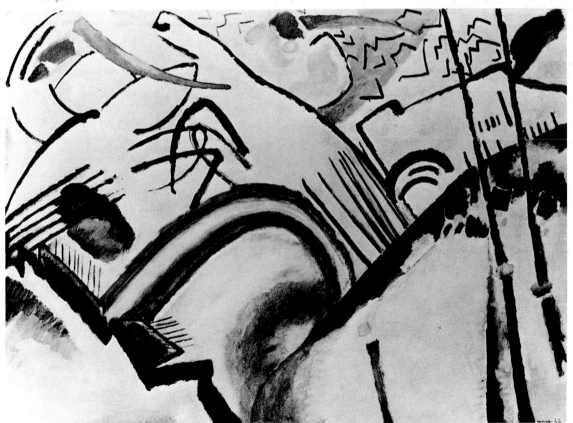

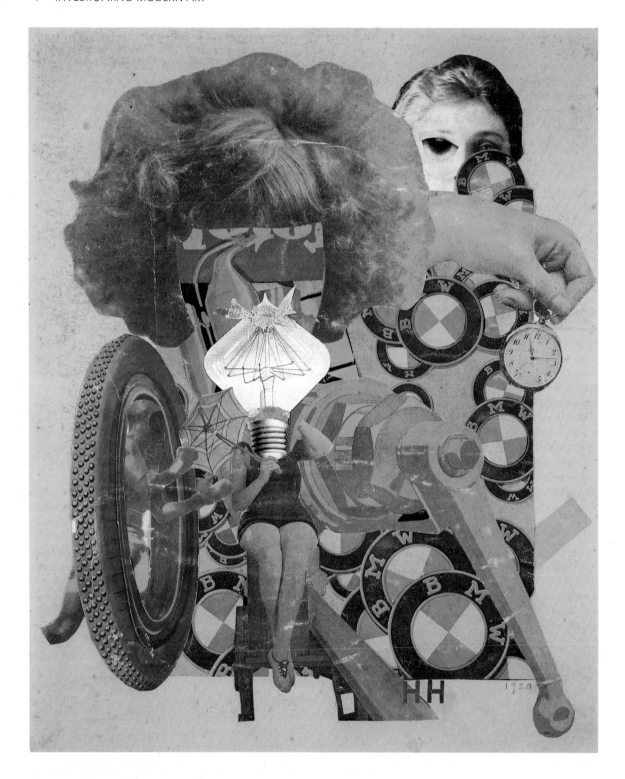

5. Hannah Höch, *Das schöne Mädchen* (*Pretty Woman*),
1920, collage on paper, 35 x 29 cm., Private Collection.

6. Hans Haacke, *A Breed Apart*, 1978, photograph on hardboard, one of seven panels, each 91 x 91 cm., Tate Gallery, London.

7. Barbara Kruger, installation, Mary Boone Gallery, New York, January 1991.

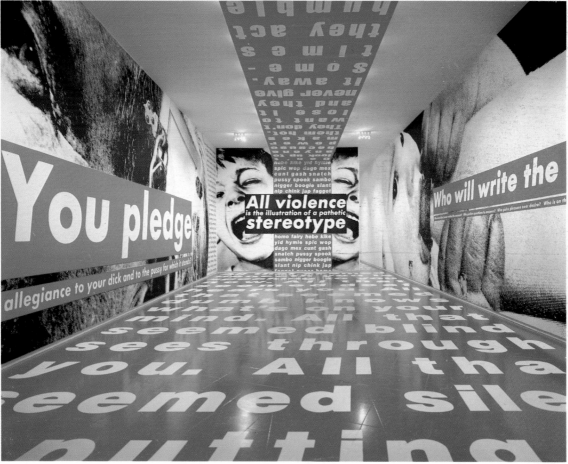

even pleasure. Much of modern art seems to be about very few of these things, or about them only in oblique and negative ways. Writing in the 1930s, the German playwright Bertolt Brecht acknowledged the necessity for change, arguing that 'reality changes; in order to represent it, modes of representation must also change.'[1] A good starting point might be to understand that modern art often involves a variety of challenges. Here we may identify three: some art may represent a challenge to the modern world, for example to the persistence of social inequality, or to the way individuals' lives have been transformed by technology. In addition, modern art may also, as we have seen above, involve a variety of challenges to traditional forms of art itself. It follows from this that such art also involves a challenge to conventional forms of response to art: much modern art, that is to say, represents a deliberate challenge to 'taste'.

As modern art rapidly became its own kind of establishment with specialized places to go and look at it and a specialized language to talk about it, so other practices have grown up in our contemporary period which in turn question even what has been called the 'tradition of the new'. Sometimes this is done from a conservative point of view – getting back to skill, getting back to depicting recognizable objects, getting back to the values enshrined in the national heritage etc. But more often than not it involves still more radical approaches which mix and break codes only recently established. The results of this attitude may be paintings and sculptures, but they may equally well be works involving language, performance, video and other multi-media installations and so on.

Many of these issues fall outside the scope of our present discussion. But the key lesson is that one cannot employ a static set of ideas to look at changing forms of art. Both the ideas out of which art is created, and the ideas in terms of which critics, historians and non-specialist viewers alike interpret it, are in a continual state of development and even conflict. We have to begin by reviewing some of these key ideas; by acknowledging that art can perform different social functions; and perhaps most importantly by acknowledging that our own preconceptions about art need to be treated as provisional. It helps if we can understand that our own positions and beliefs, rather than being our own unique property, or being the natural response that sensible people would always have

had, are often the product of sedimented beliefs and opinions which have come down to us through the wider culture. Beliefs about art, about what is good and bad, about what art should or should not do, change. Our common sense, so to speak, has a history. What seems normal and clear cut may be the product of ideas which were originally formed in circumstances whose relevance to our own is not as straightforward as we may assume.

Art is a specific set of practices within a culture, with an equally specific set of histories. These histories themselves are never wholly objective but are constructed according to changing interests at different times, and while it may seem that there is a common core, or canon of great art, even the work of figures as apparently secure as Rembrandt or Vermeer has been subject to changes in taste and fashion. In trying to come to grips with modern art, we have to recognize the need to understand and question our own history, education and preconceptions when faced by the demands of art. At the same time we also have to acknowledge that there is no one correct position to strive for: the possible meanings of art, while never wholly arbitrary, remain open.

WHY DID ART CHANGE?

The simplest answer to this question is to say that the world changed. Of course this is to say everything and nothing at the same time. But it is important to remember how much the modern world did change. There are obvious factors associated with the development of industrial capitalism such as the growth of cities and new methods of transport and communication. There are also less tangible ones such as increased democracy and the secularization of modern society. Even conceptions of human subjectivity itself have changed, as a result 'for example' of modern ideas about the unconscious (which have had an important influence on art). All this amounts to a context which altered out of all recognition between the beginning of the nineteenth century and the beginning of the twentieth. And it should go without saying that this process has continued. Our contemporary world in the late twentieth century is as different from that of the century's early years, when such significant modern artists as Picasso and Matisse were beginning their careers, as their world in turn differed from that of the Classicists and Romantics inspired by the French

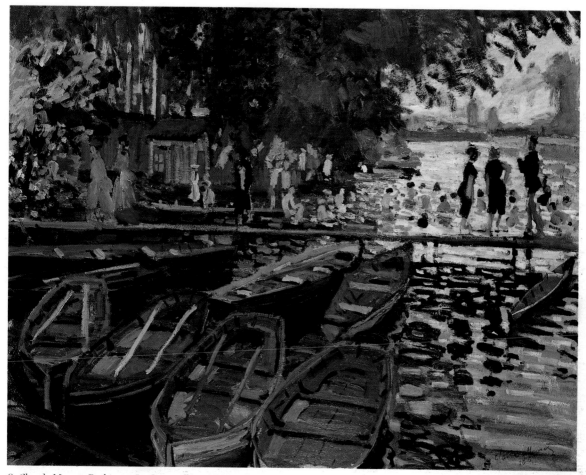

8. Claude Monet, *Bathing at La Grenouillère*, 1869, oil on canvas, 73 x 92 cm. National Gallery, London.

revolution at the turn into the nineteenth century. Dramatic change has been a kind of constant in the modern world.

Viewed in this light, the changes which have marked modern art have been no more profound than those which have marked modern literature or modern music, and certainly no more far reaching than the transformations which have characterized science and technology. No more profound, perhaps. But what they have often been is more noticeable than many of the changes affecting the other arts. Partly this can be attributed to the sheer weight of the Renaissance tradition of picture making, in particular of perspectival representation and the associated predominance of depictions of the human figure. Sight is a particularly powerful sense. People are acutely aware of shifting visual nuances – in fashion for example, as regards the length of a dress,

the style of a jacket or a haircut. The page of a book by Samuel Beckett still looks like the page of a book by Jane Austen: you have to read it to detect the difference. But a glimpse of a Cubist painting in a magazine or a TV programme is all one needs to realize that something different is going on. That is precisely one of the problems. To be able to see that something is going on but not to know what it is, is more likely to result in defensiveness and suspicion than curiosity and enquiry.

Given the changes in the world at large it would have been strange if art had not changed. But the specific changes taking place in art have been rapid and extreme. We need to develop our sense of why this might be: of why, for example, paintings of fields, horses and cows have not merely been replaced by equally recognizable paintings of factories and cars.

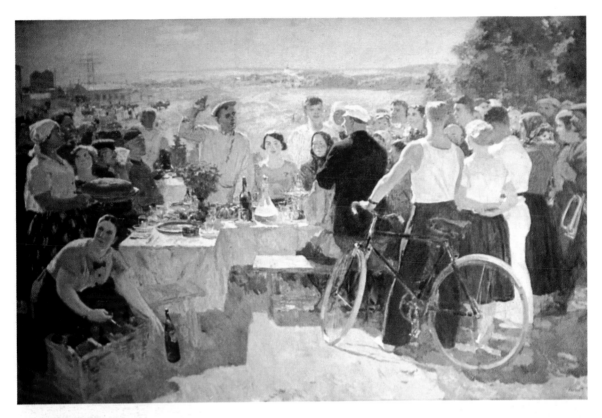

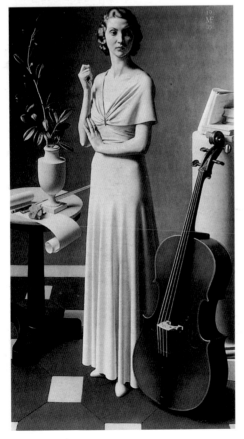

9. Sergei Gerasimov, *A Collective Farm Festival (Kolkhoz Harvest)*, 1936–7, oil on canvas, 234 x 372 cm. State Tretyakov Gallery, Moscow.

10. Meredith Frampton, *Portrait of a Young Woman*, 1935, oil on canvas, 205.7 x 107.9 cm. Tate Gallery, London.

It might seem that this is what we could have expected. Modern art began in the mid-nineteenth century in the urge to paint modern life (Plate 8). There have been situations in the twentieth century when such a programme was indeed demanded. In the Soviet Union, the doctrine of Socialist Realism resulted in technically conventional pictures of work and leisure (Plate 9). But in the West, with a few notable and complex exceptions (such as a type of Surrealism exemplified by Dali and Magritte), demands for recognizable pictures have tended to be artistically conservative (Plate 10). We have to understand how a form of modern art developed which both went in a different direction from making pictures of a changed world and became the dominant form of art in modern western societies. In brief we have to understand something of the development of Modernism, where this term conveys an approach to art distinct from the picturing of modern subjects (Plate 47).

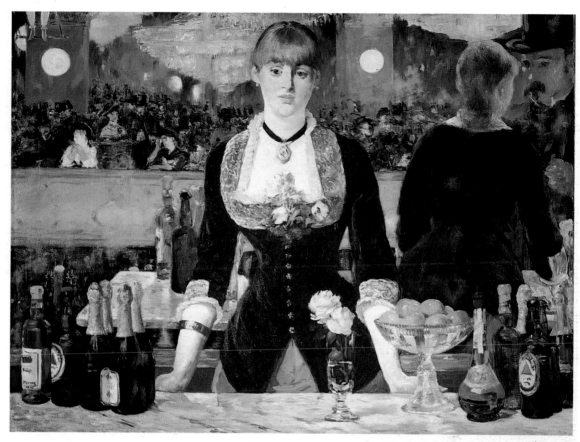

11. Edouard Manet, *Bar at the Folies Bergère*, 1882, oil on canvas, Courtauld Institute Galleries, London.

MODERNITY AND EARLY MODERNISM

Modern subjects were not, however, unimportant – at least in the beginning. In the mid-nineteenth century the French painter Gustave Courbet sought to paint his contemporary world, and called his art Realism (Plate 31).[2] At about the same time the poet Charles Baudelaire formulated the concept of modernity. He spoke of the 'heroism of modern life', indicating a peculiar and double-edged condition. On the one hand he seized on the hitherto largely unnoticed beauty of black frock coats and patent leather boots, the uniform of the newly emergent middle classes; yet he also saw as heroic the flotsam and jetsam of the city, the rag-pickers, prostitutes and other displaced victims of the modernization of Paris.[3] The point is that modernity, for Baudelaire and for like-minded artists such as Edouard Manet, consisted of more than new types of clothes and commodities in the shops. To grasp modernity in its full force requires more of us than that we notice new things around

us. In particular it requires two more abstract competences. One is the ability to recognize the new kinds of social relations in modern capitalist society out of which the new commodities are produced and in which they are consumed: mass production in factories, and mass urban leisure consumption in the music halls, cabarets, bars and shops which grew up at the same time (Plate 11). The second competence involves an ability to grasp the fact that these objective changes in social relations gave rise in their turn to new forms of subjective experience. New forms of self-consciousness, of individualism, were a key aspect of the modern life that began to emerge in western societies in the nineteenth century.

This had an important consequence for art. For the person who would be a modern artist, who would represent modernity in all its complexity, had to be alert to a special form of self-consciousness: namely consciousness of the practice of representation itself. As much as anything, it was this insight which set art on a different track from

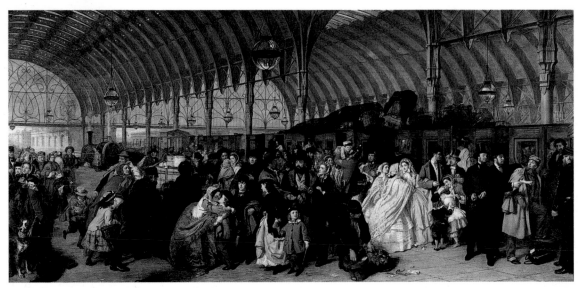

12. William Frith, *Paddington Station*, 1862, oil on canvas,
117 x 257 cm. Royal Holloway and Bedford New College,
Surrey.

13. Claude Monet, *Interior of the Gare Saint-Lazare*, 1877, oil
on canvas, 75 x 104 cm. Musée d'Orsay, Paris.

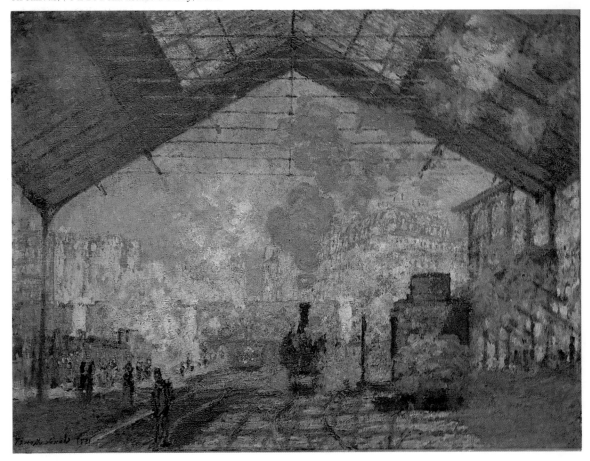

the picturing of modern life. An example may help. Suppose that, impressed by the new ideas of modernity and by what you see as a requirement to tell the truth about modern life as opposed to the old world of saints, heroes and antique gods, you set out to paint a prominent feature of your modern experience and you decide on a railway station.

Conventions exist for painting buildings and for rendering three dimensional objects (such as trains and people) in space. It is quite conceivable that in following those conventions, if you are skilful enough, you will come up with something like the picture of Paddington Station exhibited in 1862 by the Victorian painter William Frith (Plate 12). Doubtless Frith's picture, and others like it of a day at the seaside and of Derby Day at Epsom seemed modern enough and interesting enough to his contemporaries. The crowds which gathered round them when they were exhibited and the number of prints which were subsequently sold, offer some proof of that. But there would be few around today who would not agree, if Frith's painting were placed next to Claude Monet's *Gare St-Lazare* of 1876 (Plate 13), that Monet had somehow captured the experience of modernity in a manner which to us at least is more compelling. Monet's painting still seems to be alive, in the sense of being a vivid part of our world, whereas the Frith seems like a curio of a bygone time. There is of course something odd about this. For the Monet contains far less pictorial information about what a nineteenth-century railway station looked like than does the Frith. What does this tell us about modernity, and about representations of modernity?

It can tell us several things. One is that the terms of seeing itself change. To most of us the Monet will convey a vivid, perhaps a rather charming, impression; though quite what it is an impression of is not so easy to say (the train? the station? the atmosphere of the station?). To the majority of those who actually used such a station for getting to work in Paris in 1876 however, Monet's painting would likely have seemed a vivid demonstration of nothing so much as his incompetence as a painter. What we see as valuable in a painting has been transformed. (And it has been transformed in large part because of the example of paintings like Monet's). That is one thing. Another, perhaps more relevant to our question about modernity is that Monet has succeeded because he has done more (or is it less?) than

depict a train and its passengers. He has somehow represented a modern sensation. Maybe it is the fact that we can still feel such sensations or close approximations to them when confronted by our modernity that makes the painting vivid; whereas its depiction of top hats and crinolines makes the Frith seem remote from our experience.

The key point is that Monet has done whatever it is that he has done through a kind of technical innovation that was largely new to him. It was not at all clear, in 1876, how to render in a painting the impression of modernity that one got through being in a big new railway station. In fact to achieve such a result required a kind of technical experiment, one that involved breaking the rules which at that point specified how to paint the interior of a large building. This in its turn required a new way of seeing, or of 'reading' the painting on the part of its spectators: that is, how not to see it as an unfinished mess, but instead to read its new, relatively messy characteristics as significant of spontaneity. It is worth underlining that spontaneity here does not necessarily indicate the kinds of unproblematic joy and warmth which many twentieth-century viewers have come to associate with Impressionism. Many Impressionist paintings testify to feelings of unease or dislocation occasioned by the spectacle of constant change. But whether positive or negative, the fundamental point is that the technical characteristics of such paintings were intended to register as spontaneous representations of the equally spontaneously and fleetingly felt sensations characteristic of a modern experience.

This may clarify a point left hanging earlier. For it is of course possible that, in response to the comparison just made, some people will continue to find Frith's painting more compelling than Monet's. We can now see that this is because they are still using the traditional way of looking: that is, looking for a picture rather than a painting. The Monet will not give us the details of historical costume as the Frith does. It does not set out to provide that kind of information. What it might seek to do however is to render the subjective impression that the people wearing those dresses or suits had of their world. Of course these distinctions are not clear cut, it is a question of balance. But relatively speaking, whereas Frith's picture offers a narrative of particular events in a railway station, Monet's painting offers a more unified, more undifferentiated, sensation of modernity. As such it requires to be looked at in a different way.

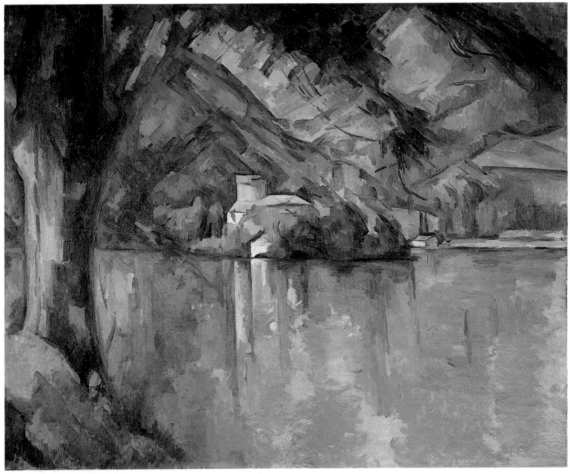

14. Paul Cézanne, *The Lake of Annecy*, 1896, oil on canvas,
65 x 81 cm. Courtauld Institute Galleries, London.

It will fail in face of the criteria of looking appropri-
ate to the Frith, whereas the Frith will now appear
conservative when set against the criteria appro-
priate to the Monet. And there can be little doubt
as to which approach has proved more germane
for the subsequent development of art in our cul-
ture. This is not to say that what has been
important in modern art is not open to challenge,
and has not been reassessed from time to time. Nor
is it to say that modern avant-garde art has no
links with earlier art. But in general the modern
tradition has been more indebted to artists like
Monet than it has to artists like Frith.

We can press this point further. It carries with
it the possibility of seeing how even more radical
technical solutions began to come on the agenda
of art after Impressionism. Note however that

there is nothing predetermined about these solu-
tions. They did not have to arise. They do not
necessarily lead anywhere, as it is often said that
nineteenth-century avant-garde art led to twenti-
eth-century abstraction. Rather, certain painters
(Cézanne, Picasso and others) sought technically
radical solutions to the problems which they
believed faced them as artists in a rapidly chang-
ing modern world. And certain others seem to
have agreed – both that those were the real prob-
lems of art at that point, and that those were
fruitful solutions – to the extent that they adopted
such devices and then changed them according to
their own perceptions both of the new problems
thrown up by their own modernity and the prob-
lems set by the now established technical
innovations.

We are beginning to be in a position to see that the key development in the nineteenth-century attempt to paint the truth of modernity involved a paradox. Representing modernity was not quite the same as picturing modern subjects. Modernity was less a range of physical objects than a condition. Consider for a moment one of the first implications of the desire to tell the truth about modernity: that when a person looks at your painting one of the points they have to be made aware of – as part of the requirement of self consciousness – is that that is just what they are looking at: namely a painting, and not a railway station. Furthermore they will have to be made aware of this by the painting itself. It must, so to speak, recount its own truth. It must both give a plausible representation (an 'impression'?) of the condition of modernity, and give it *as* a painting.

AN INDEPENDENT ART

The consequences of this point are far-reaching. But the rapid technical changes which have marked modern art are likely to remain mysterious if we do not grasp its force. In the late nineteenth century Cézanne, a painter conventionally seen as having played a pivotal role in the development of Modernist art, strove to articulate this insight through his concept of the 'equivalent' (Plate 14). Broadly speaking the idea was that the painting should not be a secondary thing, a kind of shadow of a real thing in the world. But that it itself should be such a thing: as real and particular in the experience of the spectator as the street or the landscape in question. The painting, as an arrangement of shapes and colours and – crucially – of forms in the imaginary pictorial space would have to convey to its viewer an experience as concentrated and as varied as he – Cézanne – had received when he stood before his motif: say, the corner of a rock in a quarry at midday, or a clump of large trees silhouetted against the sky. Such a painting will not be a secondary depiction or illustration of a burst of sunshine, but will seek to offer a potentially equivalent sensation itself, through the balance and contrast of its colours and forms.

This process of development, as remarked above, is paradoxical. The paradox is that a desire to represent the modern world in a modern form of art rapidly led to a preoccupation with the form of art itself, conceived as the bearer of the modern experience. What the implications of this shift were has been and continues to be the subject of much debate. Certainly, the claim that an increased interest in artistic form amounted to for-malism, i.e. that the practice of modern art came solely to be concerned with the manipulation of formal elements, can be questioned. To take only one example: Cubism, an apparently hermetic and almost abstract art can be shown to bear the traces of a continued engagement on the part of Cubist painters with social and even political issues. And furthermore, even an apparently simple still life may be no less meaningful if it is painted in the fractured forms of Cubism than in a more conventional or academic manner. The problem intensifies when there are no depicted subjects, but it is entirely inadequate to assume that pictorial meaning is to be assimilated to depicted subject matter alone. This question is a difficult one, which will be encountered throughout this book. Be that as it may, it seems that a growing acknowledgment of the means of representation affected all the arts in the modern period. Music became acutely self conscious about the production and organization of sounds. Literature and poetry, and even philosophy, became preoccupied with the production of meaning in and through language.

Traditionally paintings told stories, either classical, biblical, or literary, and more recently about contemporary social and political developments. It is as though the pursuit of these last in the nineteenth century, at first in very particular circumstances in Paris but subsequently more generally, bred a self consciousness not merely about modern life but about the nature of representing it – about modern art itself. Stories – in words or pictures – have always been bound up with telling the truth about aspects of human life. But the problem in the visual arts was that the traditional repertoire in terms of which the story was told – such as the achievement of believable and individuated figures interacting in the pictorial space – involved at bottom the production of an illusion. This posed a fundamental problem: how can you tell the truth by making up a lie? That is of course to overstate the case. But in the nineteenth century, to the generation of French artists and intellectuals we have encountered with Courbet, Baudelaire, Manet, and the Impressionist group including Monet, Pissarro, Renoir and others, the illusionistic aspect of story-telling seemed to contradict, rather than to be an unavoidable part of, the requirement to tell the truth about modern life. To this extent the requirement of truth-telling undermined the traditional preoccupation with story-telling. The painter of course still had the same repertoire of tools and devices: paint, canvas

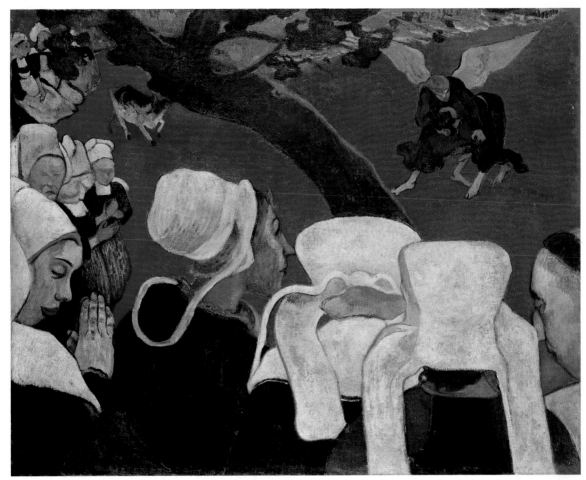

15. Paul Gauguin, *Vision after the Sermon, Jacob Wrestling with the Angel*, 1889, oil on canvas, 73 x 92 cm. National Gallery of Scotland, Edinburgh.

and the organization of the illusory pictorial space. But the manipulation and organization of these devices, the painting of the picture, the production of the plausible illusion, threatened the desire to tell the truth because the more plausible the illusion was the more it threatened to undermine the truth of the painting as itself a made thing, in the last resort a decorated flat surface. More than ever before, by the late nineteenth-century painting as an illusion – as picturing – and painting as paint had come to stand in mutual tension.

THE CONSEQUENCES OF SPECIALIZATION

Something of this was registered in 1890 by the young artist and critic Maurice Denis (who subsequently became an influential figure in the theorization of Modernism), when he pointed out that 'a painting – before being a war horse, a nude woman or some anecdote or other – is essentially a flat surface covered with colours arranged in a certain order.'[4] It is likely that he had in mind certain new paintings which were being produced by artists who had been associated with Impressionism, but had clearly begun to move away from Impressionist fidelity to the experienced sensations of modern life, and to explore further ideas about the relative independence from nature of the colours and forms of the painting itself (Plate 15). Having said that, we have to guard against the idea that truth ceased to be a preoccupation of modern artists, and that they merely saw their task as the decoration of flat surfaces. We might say that what had come to be at issue was the kind of truth that needed to be told, how it could be told, and no less importantly, whose truth it was.

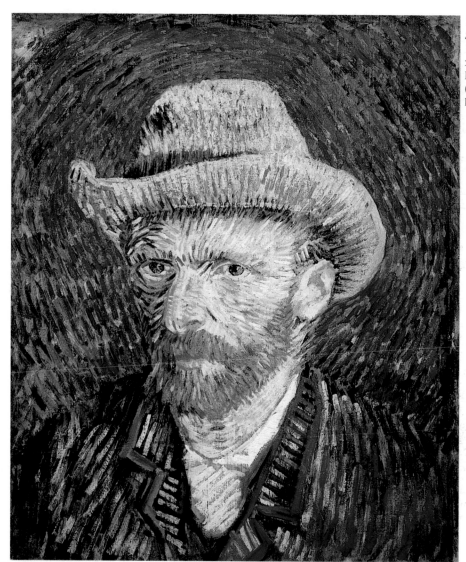

16. Vincent van Gogh, *Self Portrait with Felt Hat*, 1887-8, oil on canvas, 44 x 37.5 cm., Van Gogh Museum, Amsterdam (Vincent van Gogh Foundation).

In the particular history which we have been reviewing here, one of the results of the emergence of these problems in heightened form towards the end of the nineteenth century, a sort of negative consequence, was that their resolution threatened the conventional sense of what a competent painting was. Cézanne, Gauguin, Van Gogh and others of the generation of avant-garde artists at the end of the nineteenth century all suffered from varying degrees of incomprehension on the part of a larger public (Plate 16). They found their first audience in smaller circles of like-minded artists and intellectuals and a few sympathetic members of the cultured middle classes, who had their own complex reasons for dissent from academic convention. This is a crucial shift, and it shows how technical changes can have far reaching social consequences. The difficulty of comprehension and the resulting emergence of a small and committed public can lead to a situation which invites charges of elitism. This has now become a routine charge against modern art. It also however points to an important aspect of avant-garde art: that its characteristic concerns and the values associated with them became detached from, and by implication at least, critical of the concerns and values of the wider society.

This distance can extend both to the concerns and values of the educated, administratively active middle classes and also to the characteristic concerns and struggles of the industrial working class. Although in the case of these latter values, which were themselves opposed to the middle-class norm, a bridge was always open between the artis-

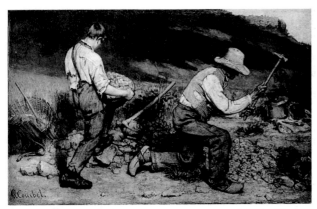

17. Gustave Courbet, *The Stonebreakers*, 1849, oil on canvas, 159 x 259 cm., formerly Gemäldegalerie Neue Meister, Dresden.

18. Camille Pissarro, *The Temple of the Golden Calf*, 1889, from *Les Turpitudes sociales*, lithograph.

tic radicalism of the avant-garde and the political radicalism of the working class movement. Not always, by any means, but sometimes, this bridge was crossed. Those who attempted to combine artistic and political radicalism included, in the late nineteenth century, the Realist Courbet and the anarchist Pissarro; and in the twentieth century the many avant-gardists influenced by the Russian revolution, ranging from the Soviet artists themselves, to Grosz, Heartfield and others in Germany, and the Surrealists in France (Plates 17–20).

ABSTRACTION AND EXPRESSION

This discussion of questions arising from the relative independence of art has carried us into the twentieth century. But we need to pause here to consider two key features of modern art: the linked concepts of 'abstraction' and 'expression'. Resolution of the tension which had emerged in French art between illusory pictorial subject and actual painted surface became important to the development of the avant-garde tradition. There are two main factors to be aware of here. One is that the development of such a self-conscious interest in the power of the artwork itself as the producer of modern effects and sensations was the precondition of the later development of a fully fledged abstract art. There have been many different kinds of abstract art, and the term abstract itself has more than one meaning. Two in particular suggest themselves. The first refers to that kind of art in which motifs are, for one reason or another, 'abstracted' from their natural appearance (Plate 87). Thus a Cubist still life of a clarinet and a bottle of rum on a mantelpiece may not look

much like a musical instrument on a piece of furniture; nonetheless the disposition of those things in the world, and the conventions of the artistic genre of the still life will continue to inform the appearance and effect of the painting at some level.

There is however another kind of abstract art, which is often also referred to as 'nonfigurative' or 'nonobjective' art, in which this is not the case (Plate 88). Such works are made up, or composed, or constructed from elements which are abstract to begin with. These may be regular or irregular, geometric or organic. But the basic point is that they do not originate from anything in the real world of people and things: they are purely pictorial elements. In such works no recognizable or even half-recognizable bits of the world outside the painting are depicted at all. To look at such works in the expectation of being able to detect, say, the shape of a window frame or the colours of a sunset is to look at them wrongly. They are there to be looked at for the formal relations and pictorial effects which they produce. That, of course, is merely to open up another area for discussion: what are the visual, or aesthetic, effects of shapes, colours and forms? And how do they relate to

19. Georg Grosz, *Ecce Homo*, 1921, watercolour, 37 x 26 cm. Akademie der Künste Archiv, Berlin.

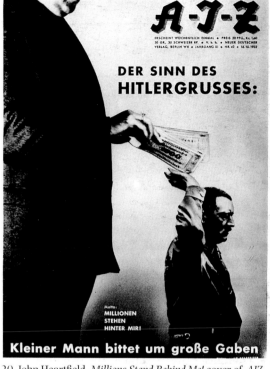

20. John Heartfield, *Millions Stand Behind Me!* cover of *AIZ*, 16 October 1932. Akademie der Künste Archiv, Berlin.

other kinds of effects with which we may be more familiar from our normal life in the world – from notions of red signifying danger, through to apprehensions of harmony, or discord. It is no accident, furthermore, that these last terms are metaphors, drawn from the kind of language we use to speak of music. The relationship between abstract art and verbal language is itself both difficult to specify and varied as across different types of art.

The second factor arising from the matter of pictorial subjects and painted surfaces is also quite difficult to explain, despite its significance for the development of modern forms of art. The point is that the work of painting, the actual practice of applying the paint, is of course being carried out by someone called 'the artist'. We have noticed how the initial aspiration to represent modern life tended to undergo a shift wherein the modernness of the enterprise migrated from what was being depicted to the painting itself: both the painting as a thing, a decorated surface, and painting as a process, what the painter did. The modern world of course continued to cast its shadow over the whole enterprise. But the way in which the modern world bore down on modern art changed significantly. Because of the emer-

gence of the problems we have discussed, a representation of the world tended to become ever more inseparable from the ways and means by which the representation was achieved.

As the need to give an impression of the modern world tended to be absorbed into the practice of modern painting so the world became, so to speak, pushed back a stage. Instead of offering *im*pressions of the modern world, the new painting towards the end of the nineteenth century seemed to be offering *ex*pressions of the modern artist's responses to the world (Plate 42). Modern western art has been deeply marked by the concept of self expression. In a general sense this is clearly dependent on the emergence of a western sense of individualism, as remarked above. More particularly it involves a conception of the artist as a special kind of producer, offering original expressions of what was being felt or emotionally experienced. This sense of self expression, of an authorial self which is being expressed through the act of painting, relates to the shift in emphasis we have noted from depictions of modern subject matter to the articulation of artistically modern surfaces. It is perhaps an unusual thought, but the surfaces of paintings are among the most complex

things we see, excepting the visual experience of nature itself. They are certainly among the most visually complex things produced by human beings. The surface of a typical Impressionist painting, or of a work by Jackson Pollock, is far more highly articulated than, say, the side of a building, or a car, or a piece of furniture. It is an important underpinning of modern art that the visual experience of a work of art matches the density of experience *per se*. The characteristic surface of modern art is an expressive one.

The subject/surface tension, then, in tandem with changing ideas about the sort of individual an artist is, lies at the heart of two of the defining characteristics of much Modernist art, that it has been on the one hand 'abstract' and on the other 'expressive' (detail Plate 22). One difficulty facing those who are not acquainted with the kinds of themes and issues affecting the development of modern art which we have been discussing here is that when it comes to works of 'abstract expressionism', because they are abstract (i.e. because they do not depict anything), it is hard to see them as expressing anything either. That is, it is hard to attach meanings to them at all.

Works of this kind will be discussed in more detail in later chapters. But even with the limited tools provided here it may be possible to see how Pollock has radicalized the means by which he has made his painting. One of the dynamics which fuels this technical radicalization is the aspiration to find more direct – and hence more powerful – ways of expressing responses to the world. (It is of course one of the ironies of modern art that this quest for directness has had the consequence of making much of modern art incomprehensible to those lacking a fairly sophisticated acquaintance with its particular codes and conventions, and their histories.) Be that as it may, we can see that the conventional figure/ground relations have been collapsed so comprehensively that the painting's effect is of an all-over skein of lines rather than an image in which some parts stand out from others. The pictorial space is shallow. If you think of a spatially orthodox painting such as Frith's *Paddington Station*, it is at least theoretically possible to imagine inserting an extra figure into the picture space. Yet if one tried to do this with the Pollock the figure would, as it were, fall off the front of the painting, or fall out of the picture space into your – the viewer's – space. There is no longer any pictorial space even for vestigial figures to inhabit; at most, small flat planes of colour may

articulate the spaces between the skein of lines to set up a kind of rhythm across the painting.

So viewing the painting becomes a matter of reading, or experiencing, its surface; looking for the slowness of this line relative to the quickness of that one, the smoothness of this curve against the abruptness of that slash, the interruption of this stream by that stab crossing it at right angles. This is where the expressive particularity of the painting lies, insofar as it is possible to speculate further about how some curve traces Pollock's sweeping rhythmic gesture, or how a spatter is the residue of the flick of his wrist. The painting, that is, embodies traces of energy out of which it was made by bearing the marks of the process that made it. We may go on to wonder about the experiences that may summon up such gestures and hence such marks – are they controlled or uncontrolled; if controlled, how is such control won; from what is it won; and so on. We may, furthermore, do this in the knowledge that Pollock himself said that it was the business of modern artists to find 'new techniques' in order to express 'the aims of the age' they live in.[5]

Unexpected as it may at first appear from a casual acquaintance with an illustration of the painting itself, these ideas of Pollock's connect his view of art to positions we have already encountered. They share a sense of modern art's need to address modernity, and to find adequately new ways of doing so. Pollock's work presents problems for those unfamiliar with modernist conceptions of expression, and with the kinds of artistic abstraction. Nonetheless, within the avant-garde his work proved enormously influential in the period after the Second World War, and as late as 1970, when the Modernist paradigm appeared to be breaking up into a multiplicity of practices, Pollock was still seen as setting a relevant agenda of problems for a diversity of approaches to art making – many of which had moved far from the practice of painting itself. Much has happened in art since then, but these Abstract Expressionist paintings can still be seen to challenge our normal expectations and habits of looking, both at things in the world and at works of art. At the very least they represent an intensification of one aspect of the Modernist tradition that we have been discussing here.

OPPOSITION TO MODERNISM

The present discussion has focused on the emergence of modern art in the nineteenth century and

21. Isaak Brodsky, *Lenin at the Smolny*, 1930, oil on canvas,
190 x 287 cm. State Tretyakov Gallery, Moscow.

some features of its development in the first half of
the twentieth century. In this development the
subject/surface distinction remained important.
Modernism did not however go uncontested in the
twentieth century, and other approaches to art
making remained wary of the consequences of
addressing that tension: such as the problems of
technical and conceptual difficulty and the result-
ing specialization briefly mentioned here.

On the one hand academic art persisted. It
served an entrenched, largely conservative con-
stituency, and in line with such interests remained
concerned to deploy the artist's traditional skills,
which were needed to articulate traditional the-
matic concerns such as the beauty of the
landscape or the nobility of the national heritage.
On the other hand, politically radical organiza-
tions – which in western society for much of the
twentieth century meant the socialist and com-
munist parties – also found the modern movement
largely uncongenial. Despite the eagerness with
which technically innovative media such as film
were widely consumed, in the field of the tradi-
tional visual arts such as painting the most
common demand from political organizations was

for an art which spoke directly to a 'broad mass of
people', and helped mobilize them for social and
political struggles (Plate 21). As such the unfamil-
iarity, not to mention the apparent introversion, of
the avant-garde led to accusations of elitism and a
consequent preference on the part of socialists for
more conventional, and hence accessible, pictures.
There were exceptions, such as the cartoons of
Georg Grosz and the photomontage of John
Heartfield, but surprisingly even these dynamic
and effective techniques were sometimes viewed
with suspicion by political activists. The central
ground of political art was for long occupied by a
type of picture-making which sought transpar-
ently to depict laudable actions, events and
individuals. The result, ironically, was that an art
which saw itself as socially progressive by and
large reproduced the technical conservatism of
academic art. For both types of art the picturing
effect remained paramount.

It is beyond our scope to unpick the relations of
artistic and political radicalism in the twentieth
century. We are able only briefly to mention that
diverse range of practices which came to challenge
the central ground of early Modernism as a

opposition – traditional
– political
– post modern.

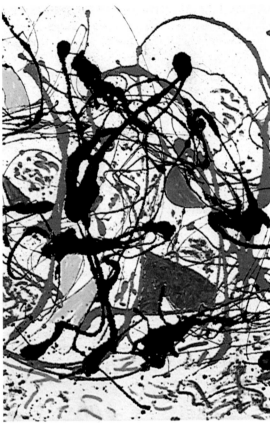

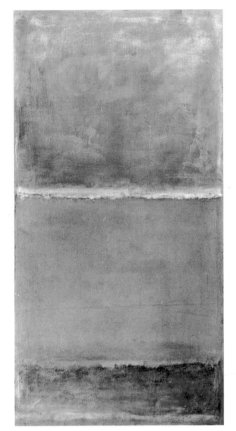

22. Detail from Plate 82, Jackson Pollock, *Summertime no. 9A*, 1948 Tate Gallery, London

23. Mark Rothko, *Untitled*, c.1951–2, oil on canvas, 189 x 100.8 cm. Tate Gallery, London

response to the first global crisis of bourgeois society in the twentieth century: the First World War and the Russian Revolution. Dada and Surrealism and Constructivism all sought to destabilize the normal relations of art in bourgeois society as part of a programme of changing those societies totally – socially, economically and politically, as well as culturally. The fact that modern western societies did not fundamentally change their characteristics in this fashion led in the end to the compromise of such radical practices, and either to their demise or to their incorporation into more conventional cultural roles. It may be said that these radical avant-gardes, somewhat against their own original intentions, came gradually to change and to stimulate the subsequent practice of art rather more than they effected change in society at large.

After the next great shock to the international system – the Second World War and the inception of the nuclear age after 1945, an increasingly institutionalized culture of Modernism came to represent the official art of western societies (while an equally stereotypical Realism remained the official art of the Soviet bloc). This involved a growth in the number of galleries trading in modern art, and a growth in the number of journals discussing modern art. Television programmes about modern art have become ubiquitous. Above all, in terms of establishing the cultural authority of modern art, there has arisen the institution of the museum of modern art. Previously the museum was for the ancient or the classic work, from which Western civilization was seen as having descended. Private galleries began showing Impressionist and Post-Impressionist work in the late nineteenth century. Only since about 1930 however, and in large part only during the second half of the century, has the privilege and status of the museum been accorded to contemporary and recently past art.

The other side of the coin of this power and authority, of course, is the implication that the art which was once a challenge to convention has

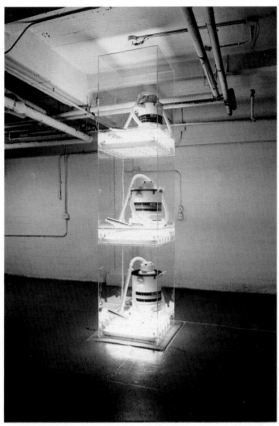

24. Jeff Koons, *New Shelton Wet/Dry Triple Decker*, 1981, acrylic flourescent light, plexiglas, three vacuum cleaners, 316 x 71 x 71 cm. Tate Gallery, London.

now itself become conventional. This extremely problematic area has been the subject of much discussion in recent art history. Paintings by artists such as Pollock, Newman and Rothko (Plates 22, 23) remain aesthetically challenging even as they become the prized artefacts of prestigious museums the world over. Or perhaps this is really a question – do they? Can they remain critically distinct from the curatorial and journalistic strategies which promote them as the valuable products of a liberal, bourgeois culture? Or is their critical and aesthetic significance swamped by such assimilation? Are they reduced to the status of more or less anodyne leisure-time consumption for the gallery-going public, the cultivated, middle-brow, middle classes?

In recent decades the premises of such institutionalized Modernism came under challenge from within western societies, particularly since the 1960s. The question of the relations between the formal and technical means of a work of art and the social (or other) impact it is felt a work of art should have, remains a compelling issue. The terrain however has changed significantly. It is now widely accepted – rightly or wrongly – that Modernism has become historical and that it is an open, supposedly pluralistic Post-Modernism which is definitive of our present condition (Plate 24). But having acknowledged that, it would be a mistake to characterize the fully fledged culture of artistic Modernism as merely the creature of bourgeois society, of the Cold War, of a Western ruling class, or whatever. It would also be a mistake to identify the prevailing culture of art – as exemplified in the blockbuster exhibition, with its accompanying TV programmes or glossy supplements – with either the critical complexity of Modernist theory or indeed with the practice of Modernist art itself. These matters require caution. But equally there can be no doubt that the changing circumstances of our wider culture and society at the end of the twentieth century are among the most significant factors prompting reappraisals in the terms of our understanding of modern art, its origins and its present tasks.

CHANGING WAYS OF LOOKING AT ART

The foregoing discussion has concentrated on the shifts – both visible and hidden – which characterized early modern art: shifts of the kind which led the Modernist critic Clement Greenberg to write, from the vantage point of the 1950s, that by the time of the First World War, the Cubists Picasso and Braque had turned the conventions of painting 'inside out'.[6] All accounts of the development of modern art will however emphasize some factors at the expense of others. All will embody some point or points of view, and will therefore consign other competing viewpoints to the margins – the present account no less than any other. It follows therefore that any account will always be open to challenge from some other perspective, however open that account may strive to be.

Here we offer a brief characterization of some of the major types of explanation of modern art and some of the features they would be likely to emphasize. For purposes of exposition we set them against the account offered above; although that account itself has obviously drawn upon these large-scale canons of interpretation. The point is that our 'balance' may be someone else's 'bias'; so having offered an account of key features in the development of modern art, we now turn to sur-

vey more systematically some of the paradigms of criticism and historical explanation themselves.

MODERNISM

It is likely that an example of full-blown Modernist criticism would have laid greater stress than we have done on formal and technical developments, and offered less by way of an account of early modern art's involvement in a discourse of modernity. Modernist accounts tended to celebrate modern art's distinction from modern life, and its concentration on the production of specifically aesthetic effects. Obviously much will depend on how the term 'aesthetic' is defined here – and no term has been the subject of greater scepticism in recent debate over art. At the level of an entrenched and routinely rehearsed Modernism however, it seems safe to say that the aesthetic was divorced from the social. Rather than aesthetic judgement being seen to equip people to deal with the consequences of social experience it tended to be conceived as something distinct from social experience. What underpins such a belief is that material life in history is a low-grade affair, and that something else is more important. In the Western European tradition, that 'something else' has conventionally been defined as the 'spiritual'. It is hardly surprising therefore to find that one of the key texts of early Modernist Abstract art, by one of its leading practitioners – the Russian artist Wassily Kandinsky – was titled 'Concerning the Spiritual in Art'. For Kandinsky the point of each art – and he seems in particular to have had painting and music in mind – was to awaken, 'through means that are peculiar to each', more refined feelings than those to be found in daily life. This is the realm of what Clive Bell called the 'aesthetic' response, and which Kandinsky explicitly saw as a riposte to the 'nightmare of the materialistic attitude' that had dominated the nineteenth century.[7]

If we are to feel the force with which such early advocates of Modernism advanced their case, we must understand that even though 'the aesthetic' was not about the world of daily life, it was not about nothing: rather it was about something that seemed more important, something that was ineffable, something that transcended history. For Bell the formal features which conveyed aesthetic emotion were to be found in Gothic cathedrals, Chinese carpets, Mexican sculptures and Persian bowls no less than in the Western tradition stretching from Giotto to Cézanne.[8] In the recent past such Modernist argu-

ments have often been represented as elitist and as perpetrating a kind of violence over the cultures which generated such artefacts – precisely by the act of severing them from their social context in the name of an appreciation of their timeless aesthetic forms. There may be some truth in this. But it is also worth recalling that Bell's colleague Roger Fry had taught evening classes for the Workers Educational Association. The argument that all you needed to appreciate art was a sensitivity to its formal values – which is nowadays the prime object of the accusation of elitism – can also be read as an argument that in order to appreciate art you do not have to have attended the right public school, nor do you need to have received a classical education: that all you needed were your eyes, and that everyone had them, not just the well-lettered.

Not all modern art has been imbued with this rhetoric of the spiritual; indeed some practices of modern art consciously opposed it. Nonetheless the sense of art as something distinct, be it spiritual or secular in conception, has been persistent. The drive to independence has been important in the modern world, for 'people' in terms of their individuality and self expression no less than for 'a people' conceived in terms of politics and nationhood. Independence is a powerful correlate of freedom and we should not be surprised to find the idea at work in the field of art. Nor should it be a surprise to find that the manner of its articulation matches the prevailing ideologies of the societies in which modern art has evolved. That is to say that we should not be surprised when we find that a quest for independence in art is linked to ideas of the self, of subjectivity, of style, innovation, originality and so forth. All of these have been powerful influences on the way we have come to think of ourselves in modern societies. The fact that each of them is open to contest and revision from positions critical of the basic assumptions of western societies does not minimize that importance historically. Similarly in the field of art, however much the fundamental assumptions of Modernism may have been opened up to challenge from a variety of points of view, it seems that if we are to understand the art which emerged from such ideas we have to extend a measure of sympathy to them. If we begin from an entrenched position that Cubism is incomprehensible or that a child of five could produce works of Abstract Expressionism then it is unlikely that we will learn much either from or about modern art.

Pure

One of the important ideas in Modernist accounts of the development of modern art was that of art's purity. Its achievement of intensified aesthetic power was widely held to be consequent upon art's being purged of extraneous social concerns. The historian and curator Alfred H. Barr, whose long association with the Museum of Modern Art in New York made him an influential figure in the explanation of modern art, acknowledged in the 1930s that modern art had undoubtedly become impoverished through its exclusion of historical, political, sexual and religious themes. But he simultaneously claimed that the modern artist 'preferred impoverishment to adulteration'.[9] That is, for Barr and others of a similar persuasion, what art lost in terms of complexity and social interest it made up for in terms of the intensity and purity of the experience which could be derived from it by a competent spectator – someone who has learned to view modern art in the way discussed in the previous section. This view was formulated in its main outlines by Barr and other early modern critics such as Maurice Denis, Clive Bell and Roger Fry, and subsequently refined in the period after the Second World War by Clement Greenberg, Michael Fried and other writers. In 1936 Barr mounted an exhibition titled *Cubism and Abstract Art* which exemplified this claim through a chart which was reproduced in the catalogue. The chart implied that the development of modern art culminated in two kinds of abstraction: a geometric tradition evolving through Cubism to the work of Malevich and Mondrian; and a counter-trend of organic, biomorphic forms associated with Kandinsky, and later Miró. To that extent, various types of contemporary figurative art were marginalized: 'modern art' tended to become identified with abstract art. Modern effects, that is the typical visual effects associated with modern art, came to be equated with aesthetic effects produced by the formal organization of the picture space, and grasped by spectators who understood that that was what they were looking at; indeed that that was what they were looking for when they looked at art.

Modernist criticism has had a long history, virtually coincident with that of the historical development of modern art itself. It is conventional now to see Modernism as having been the dominant account of modern art's development and key preoccupation in the century between about the 1860s/70s and the 1960s/70s. The term itself however, capitalized as it is here only

came into currency at the end of this period, notably in the work of Clement Greenberg and in particular his essay 'Modernist Painting' of 1960.[10] Here Greenberg concisely outlined his view that in the modern period each art had become preoccupied with its own intrinsic processes, namely those arising from the manipulation of its own medium. This thesis of the autonomy of each art involved in the case of painting the now notorious concept of *flatness*. This does not mean that Modernist paintings are flat. After all, the *Mona Lisa* is as literally flat as a Mondrian. The point is, rather, that the illusionistic space in modern paintings had become shallower than in earlier art: think, for example, of a sequence of works extending from Courbet, through Picasso to Rothko. Perspectival depth got 'flatter', and it was this shallowness of the pictorial space that informed those features of expressionist distortion and abstraction which typified Modernist painting. For Greenberg, the explanation of this technical feature was that Modernist painting was manifesting that tendency to self definition characteristic of all advanced modern culture. This process of self definition through the self criticism of its own particular medium and procedures was what the work of the avant-garde consisted of, according to the Modernist view. And with Greenberg, as with earlier Modernists before him, the point of this purging was the purification and concentration of the aesthetic experience, the quest for a modern equivalent of what was to be had from the Old Masters. For Greenberg, the work of the avant-garde represented 'the farthest nerve-end of the modern consciousness'.[11]

Yet one of the ironies of Modernism is that its most succinct theorization coincided with the period of its decline as a widely accepted framework for both the making and the interpretation of art. 'Modernist Painting' marked the destination of a critical project which Greenberg had begun, in very different circumstances, at the end of the 1930s, most notably in the essays 'Avant-garde and Kitsch' and 'Towards a Newer Laocoön' of 1939 and 1940 respectively.[12] The *Laocoön*, a classical Greek sculpture, had been the subject of an influential study in the eighteenth century by the German philosopher-critic Lessing. In this work Lessing sought to distinguish the arts, most notably to differentiate the visual arts from literature, in contrast to prevailing Renaissance doctrine which had tended to read the visual arts in terms first established in the theory of poetry and rhetoric. Writing on the eve of the Second

World War, Greenberg sought to continue this dif-
ferentiation in terms of the avant-garde tradition
of the late nineteenth and early twentieth cen-
turies, the process he was later to define as
Modernism.

Critical Modernism, as we have seen, was char-
acterized by a certain amount of exclusivity and –
in a phrase coined by Greenberg himself, initially
to describe the art of Matisse – a sense of 'arrogant
purpose'. The rigorous Modernist critic was not
one to suffer sentimentality. As such, Modernism
always had its opponents – ranging from the
defenders of academic art, to the proponents of a
politically-oriented art, or the wide field of popular
culture. All of these were assimilated by Greenberg
in the derogatory, all-inclusive category of *kitsch*.
But by the 1950s and 1960s new avant-garde
movements such as Pop art and Minimal art had
arisen – and they too were critical of Greenbergian
Modernism. For the, by then, somewhat belea-
guered Greenberg however, such work amounted
only to 'novelty art': yet more kitsch, threatening
the hard-won achievements of the Modernist
avant-garde.

The difference in the late 1960s was that the
main critical tenets of Modernism, such as the
autonomy and purity of art, and the drive to
abstraction, seemed now to be coming under
attack not just from outside, but from within the
avant-garde itself.[13] As we have seen, the avant-
garde, or Modernism in a broad sense, had always
encompassed far more than abstraction, and the
drive to secure art's independence or autonomy
had always been a point at issue in a wider debate
over art's social role. But in the period after the
Second World War, when the centre of gravity of
the world of modern art shifted from Paris to New
York, that strand of avant-garde debate which val-
orized independence and autonomy became
dominant. At least it did so in the critical discourse
surrounding art. It has always been a matter of
controversy how adequately or not Modernist crit-
icism represented the art which it claimed for its
own – in particular that of Pollock, Rothko and
others of the New York school. But in the 1960s it
became clear that the world would not go away.
The campaign for Civil Rights, the Vietnam War
and the demands of the Women's Movement
pushed social concerns to the fore. Art's perceived
purity was found wanting by many artists search-
ing for an adequate language to articulate the
impending sense of crisis. It is as if that intensity
and concentration which, because it had been

wrested from a babel of competing demands on art
in the 1940s had enabled the work of the first gen-
eration of the New York school, had now become
a routine assumption, unable to cope with new
demands. Perhaps it is the case that once such dis-
tinctness is inherited rather than won, it becomes
weakened; rather than offering to the art produced
in its name the space to sort out its own responses
to the world, it instead comes to function as a kind
of insulation from the world. In short, the impro-
vised institutions and protocols mutate into a form
of academicism. Something like that seems to have
happened to Modernism in the decade between the
mid-1950s and the mid-1960s. And as the rela-
tive social quietude of that period gave way to the
social radicalism of the sixties, avant-garde artists
themselves began to chafe against what increas-
ingly came to feel like prescriptions for irrelevance
rather than guarantors of freedom.

In the last twenty-five years, Modernism in the
terms in which we have encountered it here (that
is, in the terms of American critics and curators of
the post-Second World War period, but also what
can retrospectively be deemed the antecedents of
such positions in the spectrum of the earlier
European avant-garde) has come under increas-
ing critical attack. It has both been countered by,
and itself come under critical scrutiny from, a
range of approaches to both the practice and inter-
pretation of art which are frequently referred to
under the general term 'Post-Modernism'.[14]

THE NEW ART HISTORY

Such changes in art practice have been paralleled
by changes in the forms of explanation of art.
Other types of account of modern art have risen to
prominence in the last few decades and have gen-
erated a very different critical agenda. The figure
whose name became synonymous with the pro-
duction of a new 'social history of art' in the
1970s was the English historian T.J. Clark.
Modernism had offered a coherent account of
the development of modern art in terms of its suc-
cessive technical innovations from the
mid-nineteenth century, pre-eminently in the
work of Courbet and Manet, to the 1950s and 60s
in the work of Jackson Pollock and the younger
generation of abstract painters who followed him.
Clark revised the foundations of that account. In
his studies of Courbet and later of Manet he placed
their work in the context of nineteenth century
French social and political debate (the revolution
of 1848; the modernization of the city of Paris; the

Technical innovation
v
Reaction to social changes

social status of women and in particular the symbolism of the prostitute), instead of viewing them as forerunners taking the first steps in the trajectory of an ever more specialized and technically distinct modern art.[15] It was not that Clark ignored technical radicalism, for it has been an inescapable feature of modern art. Rather he interpreted it differently. Discussion in this area tends to be complex and nuanced but the broad outlines of the account are clear. Paintings such as Manet's *A Bar at the Folies Bergère* (Plate 11) embody ambiguous spatial relations. Thus in the *Bar* the reflected figures are apparently askew, the identity of the reflected male figure being especially problematic, and the depicted space of the picture as a whole is rendered unstable by the fact that its furthest plane – which is 'actually' just behind the barmaid – is a mirror, and hence appears to reflect deep space. Modernist critics tended to read these effects as early symptoms of a subsequently more extreme form of technical radicalism to be found for example in Cubism and abstract art. Clark however tended to read such spatial ambiguities as expressive of ambiguities in modern social experience. Thus in his analysis the painting was seen as testifying to the dislocation of modern life, to the elusiveness and mobility of our responses to uncertain circumstance. The upshot is a different kind of understanding from that of the Modernist critic, which tends to view modern art less as a repository of independent aesthetic effects than as a kind of testimony to the themes which animate social life in history.

Of course works of art are not mere documents, and to view them as if they are is to lose something crucial to their nature – something which has to do with the independence of their effects. Such an argument can go round and round, and part of the attraction of the renascent social history of art was perhaps that it seemed to hold together in its explanations this unstable compound of forces without ever quite resolving their priorities.

It may be for this reason that whereas Modernism developed over a relatively long period, incorporating many strands woven around a few basic principles, the new social history of art was rapidly transformed in the 1980s by a range of new intellectual and political resources. In particular these included feminism, psychoanalysis and ideas of otherness.[16] An important source for these ideas was Simone de Beauvoir's pathbreaking study *The Second Sex*, originally published in France in 1949. In it she developed her central

thesis that woman's role has been culturally constructed rather than biologically determined. De Beauvoir argued that man was positioned as the central defining category of humanity, and that women were differentiated with reference to this category: 'He is the Subject, he is the Absolute – she is the Other.' De Beauvoir also pointed out however that gender difference was only the privileged site of a tendency which also affected understandings of both race and class: that 'Otherness is a fundamental category of human thought' which always involves distinguishing something else as different from the position from which the distinguishing is being done.[17] More than that however, because of concentrations of power in terms of class, gender, and race, that which was differentiated tended to be positioned as inferior to the initial position. In addition to the development of feminism, these ideas have had particular influence on the development of new histories of art in the wake of Edward Said's 1978 critique of western assumptions about other cultures, as exemplified particularly in the discourse of 'Orientalism'.[18]

In the field of art practice, the challenge to Modernism stimulated interest in the operation of what has been called a 'politics of representation', as distinct from the cultivation of independent aesthetic effects. This politics of representation takes as its starting point the proposition that our culture, indeed any culture, any society, incorporates a system of values; and furthermore that those values are not eternal or natural but themselves subject to social processes. In particular the argument proposes that the dominant values of a society embody the interests of dominant groups within the society. That much is a commonplace of sociology. But in the field of art, such a proposition has taken on a new force in the period since the Second World War. For one of the key mechanisms by which values are disseminated throughout modern society is the mass media. In the case of two of the most powerful of these – advertising and television – the principal medium is visual. As a consequence, for many artists and critical theorists in the 1960s and after, the main business of a socially relevant practice of art was seen as being to lay bare the workings of such a system, and to bring to the surface many of the contradictions normally hidden by the smooth operation of the mass media. Accordingly, widespread use has been made by such artists of material drawn from the fields of advertising and

the media (Plate 126). Such developments in art paralleled those of the 'new art history'. In short, in the two decades after the high water mark of artistic Modernism in the mid 1960s, the interlinked fields of art practice, art criticism and art history were recast.

Instead of claims for the independence, let alone for the purity of art being widely accepted, profound social disjunctions, such as those generally ascribed to the divisions of class, race and gender, increasingly provided the balance in which modern art was weighed. For many new art historians, no less than for many Post-Modernist artists, Modernism was more often than not found wanting.

It is now possible to see how the account of the development of early modern art offered in the previous section, as well as being open to hypothetical attack from a more full-blooded Modernist position (for engaging with social factors beyond the scope of art itself), would also be susceptible to challenge from the range of new art histories. The way the account of changes in early modern art offered here dwells on the consequences of technical developments, is open to criticism for its relative neglect of certain other preoccupations of contemporary academic debate.

These include, for example, the fact that almost all the early painters of modern life were middle-class men. It has been pointed out by feminist historians that middle-class women could not even enter many of those characteristic sites where an experience of Baudelairean modernity could be had: the bars, night clubs, and, it goes without saying, the brothels. To take another example, this time bearing particularly on avant-garde practice in the early twentieth century, albeit with repercussions extending through the entire tradition: it has been pointed out how, as a concept of 'self expression' increasingly came to the fore in modern art, the Self that was to be expressed was conceived overwhelmingly in terms appropriate to middle-class European men. A third assertion characteristic of the new art history is that the quest for authenticity which was bound up with early ideas of self expression in the arts was itself deeply compromised. Thus artists, in flight from the stultifying norms of bourgeois culture in turn of the century western Europe, tended to seek their authenticity in cultures distinct from the western heritage: that is they tended to model their authentic self expression on the forms of 'primitive' artefacts (Plate 38). They came across

these forms, for the most part, in the new ethnographic collections which had sprung up in major European cities in the second half of the nineteenth century. For many persuaded by the new art history in the second half of the twentieth century, the effect of this was to overturn the traditional judgements of Modernist art history. There, the turn to the 'primitive' had been celebrated as a liberation from the Academic tradition. For many committed new art historians, however, the way in which Expressionist artists adopted the forms and techniques of tribal artefacts without concerning themselves with the social context in terms of which those artefacts actually functioned, amounted to a violation of those cultures. Thus, in certain more extreme formulations of the new art history, far from the Expressionists freeing art from bourgeois convention, the claim now was that these predominantly male, predominantly middle-class European artists were complicit in the colonialism practised by the societies in which they lived.

This area is criss-crossed by concerns ranging from claims about spontaneity and beauty to counter-claims about racism and exploitation. A hypothetical and extreme exponent of the new art history might, as we have seen, argue that by neglecting the cultural specificity of the original artefact – a tribal carving perhaps – and hence of the society in which it had its meaning, the Expressionist artwork is open to being seen as a form of cultural exploitation for western benefit on a par with the imperialist exploitation of other forms of raw material on which European capitalism was then embarked. But against this it can be argued that there is something false in a move which conflates the avant-garde with the dominant culture it strove against. However much artists may have been unconsciously affected by the assumptions of the societies in which they lived, it can be argued that as *art* their work remained a challenge to the conventions of taste and culture of those societies; and furthermore, reached forward from their societies to influence the taste and cultural assumptions of subsequent generations. Once again we can see that the question of art's embeddedness in a set of wider social relations, or its relative independence from them, is at the heart of controversy over modern art's meaning and value.

To oversimplify, then, the new art history characteristically concentrates on a vastly expanded range of the causes of art's being as it is.

"ascribe
= attribute

In addition to technical causes rooted in the previous practice of art there are a range of political and economic causes, which can in turn be ascribed to the operation of capitalism; causes rooted in the imbalances of gender in capitalist society, in turn ascribed to the operation of patriarchy; causes rooted in the oppression of certain ethnic groups by others, in turn ascribed to the operation of imperialism. From such a viewpoint art cannot escape this constellation of social injustice and psychic unfreedom. All of which stands in sharp contrast to the Modernist preoccupation, not with causes, but with art's aesthetic effects. From that point of view, as Clement Greenberg put it, 'all that we ask of a work of art is that it be good', in other words that it can be 'good' as art, which is to say, that it be aesthetically 'good'.

These starkly posed alternatives of Modernism and the New Art History are to some extent simplified. This does not mean however that either is without substance. One thing at least may be clear: that such a clash poses fundamental problems for any enterprise which seeks to offer an introduction to modern art. Neither are such problems diminished by the fact that in our present society the traditional media of art have been overtaken by photographic and electronic media as the dominant forms of visual representation.

The result is a kind of double paradox. Firstly, the practice of art has been a fairly specialized pursuit in our society, yet despite its unfamiliarity people generally feel they have a right to opinions on it far in excess of what one might find in respect of, say, physics or mathematics. Secondly, although it seems there is a widespread desire to know about, say, Picasso, or Pollock, or Abstract art, the most institutionally developed form of contemporary debate in this field itself now professes scepticism about the very ideas, motivations and principles which guided such practices. Or – what is not quite the same – the new art history which dominates contemporary debate is in large part based upon scepticism about the suppositions of freedom, purity, originality etc. which guided the types of (Modernist) critical and historical account which granted prominence to those artists and movements in the first place. To put it simply, perhaps over-simply, many people are both curious and sceptical about modern art. But the types of modern art around which that interest and scepticism alike are focused have been accorded pre-eminence by canons of explanation which are now themselves the objects of profound intellectual challenge. The question is: does the work itself – of Picasso, Pollock etc. – survive the challenge to the terms in which it was originally judged to be of merit? Or does it fall down with those terms? And if so, need anyone be concerned with it at all? The alternatives need not be quite so stark, of course. For canons of judgement do change. A Renaissance altarpiece cannot only be appreciated by a practising Christian. In similar ways there may be a space for diversity of interpretation between the interests of different contemporary sub-cultures.

At the present juncture the resolution of these questions remains open. It simply is not clear for example, whether Picasso's work will in the long run be judged according to exclusively formal and technical criteria; according to a generalized notion of its humanism; or according to its inflection by particular historical discourses of class, race and gender. What perhaps can be said is that if it is not judged positively at all, the society in question will be a very different one from our own. At the close of the twentieth century, which has witnessed the collapse of many certainties, we should not be surprised to find that the field of art – which has seemed so profoundly to embody the tensions and aspirations alike of the modern period – should itself be riven by conflict.

Given that it would be unrealistic to expect to resolve such far-reaching disputes, or even to be able to mediate between them (for that is to presume that there exists a neutral place in which such arbitration can itself be grounded), what one

25. Cave painting, *c.* 15,000 BC, Lascaux, France.

26. Carlo Crivelli, *The Annunciation*, 1486, panel transferred to canvas, 207 x 146.7 cm. National Gallery, London.

27. Buddah, Royal Scottish Museum, Edinburgh.

28. Fancy print cotton textile, Nelson Mandela, for ANC Campaign in the first democratic elections, South Africa, 1994, private collection.

can do is bring the terms of critical debate out into the open. There is no need to be silenced by the crisis of a discipline, by the fact that one cannot please all parties to a dispute. The requirement is to acknowledge the provisional nature of all explanations in the field of art and culture now.

THE FUNCTIONS OF ART

No-one doubts that art, or more particularly what we call 'art', has fulfilled different functions in different societies and in different historical periods. Objects and images have performed a wide range of tasks in a variety of cultures, usually as reinforcements to a range of other practices: religious, political, military and so on (Plate 25). When they were originally made these objects and images were produced expressly to fulfil their ritual, or religious, or propagandistic task; and we may safely assume that a sense of whether they were any good or not depended on how successfully they helped the social task: getting the harvest in, winning the battle, appeasing a god. This remains the case moreover for economically developed societies and not merely for less developed ones: it applies to the Renaissance image of Christian martyrdom as readily as it does to the aboriginal carving.

All cultures then, have used images and objects as adjuncts to a range of purposive social practices. It was however only in the middle of the eighteenth century in western Europe that con-

cepts of art and of the aesthetic as we commonly employ them today began to be developed. That is to say that it was only then that there began to arise an idea of art, the cornerstone of which was that it was valuable in itself. The idea of an independent aesthetic value, distinct from moral, political or pedagogic value seems to have been peculiar to the highly differentiated cultures of modern western bourgeois societies.

As the characteristic assumptions of these societies that they were the undisputed sites of civilization and progress – ideas which held sway for most of the modern period – have come under increasing challenge in our own times, so some of these fundamental ideas about art have been questioned. This is not surprising. What is at issue in concepts of pluralism and multiculturalism is the area of values. And since art, particularly with the relative decline of religion in western societies, has become the secular site of value, assumptions about the independence and objectivity of artistic and aesthetic value have become contested. It does seem to matter whether a Buddhist mask is to be regarded in the same terms as a Christian madonna, or whether the image of a hero of some national liberation movement can be seen on a par with an abstract painting (Plates 26–8).

THE AESTHETIC

Particularly at issue in these debates is the relative specialization of much modern art, the way Modernism has seemed to become remote not only

29. Vladimir Tatlin, *Model for the Monument to the Third International*, 1920, wood, cardboard, wire, metal and oil paper, height *c.* 5m. photograph Moderna Museet, Stockholm.

from broad areas of social life but even from other cultural practices of representation. The mainstream of Modernist art has arguably been informed by the idea of an independent, aesthetic realm for art (as distinct from political or social criteria for artistic value). And even those movements which have been critical of such a role for art – such as Dada, Surrealism, and Constructivism – have not been any closer to traditional ideas of what made for good art; nor any more open to judgement by terms grounded elsewhere in social life. Anyone with a fundamental distrust of abstract painting is unlikely to feel more at ease with a Constructivist machine-sculpture or a Dada nonsense collage (Plate 29).

In the early twentieth century Clive Bell and Roger Fry agreed that knowledge was not required in the encounter with art: quite the reverse. What was required was that one shed all preconceptions and confront the work of art in a state, so to speak, of moral, political and intellectual nakedness. For Fry, one's looking must exhibit disinterest. Such ideas are now regarded by some, though by no means all, new art historians not merely as philosophically impossible, but as a form of camouflage for the cultural interests and social status of their authors. Such scepticism about early Modernist criticism parallels the scepticism about early modern art discussed above. And once again the scepticism can in its turn be disputed, a certain

30 The Tate Gallery, London, shop.

suspension of self-interest and the deliberate cultivation of a capacity for balanced judgement does not of itself have to be reduced to an apologia for social privilege.

Caution is in order. Is it a good thing if art is judged politically, or ethically? At what point does a sense of social responsibility tip over into an impulse to police forms of expression by individuals or groups whose political or moral outlook is not your own? And to what extent is it precisely the notion of a formal, aesthetic value, inherent in objects themselves, and which it is possible to distinguish from their social functions, which has underwritten our modern openness to the artefacts of a world culture? Only under some such rubric can we appreciate the beauty of an Aztec dagger used in rituals of human sacrifice. And in less extreme cases, it would seem that some suspension of immediate self-interest is implicit in the very notion of pluralism itself, of recognizing, and respecting, what someone else's interests might be. The two faculties involved in these types of operation – the bracketing of attributes, and imagining the Other – seem to be requirements of civilized existence at a fairly deep level. And it is at least part of the case for an interest in art in the first place that it is art above all which seems to hold out the possibility of the experience, the questioning, the testing and negotiation of value in a secular society.

LEISURE

This of course sets the stakes fairly high, and art in our culture obviously fulfils a range of other less elevated functions. One of the main ones of these is as a form of leisure. It is one of the ironies of avant-garde art that much of it was made in a spirit of dissent from the core values of western societies and yet it has achieved its widest audience as an object of leisure in those societies. A kind of levelling-out has taken place. Matisse said that he wished his art to function as refreshment for a tired businessman, whereas for André Breton, the leading spokesman of the Surrealists, art was a 'lamentable expedient' in the service of the revolution.[19] Far from overthrowing capitalism, an appreciation of modern art now tends to count as a mark of cultivation within middle-class society. Moreover, such appreciation seems able to embrace the work of Matisse, Surrealism, Soviet Constructivism, of utopian idealists such as Mondrian, successful bourgeois like Monet, misfits like Van Gogh and so on, without any difficulties of historical differentiation. The burgeoning of the museum shop with its prints and postcards of the 'modern masters' is testimony to this (Plate 30).

At one level there is nothing wrong with this. A young person may collect postcards or illustrations out of magazines as part of a developing interest in art which ultimately helps them to a deeper engagement both with art and with the wider culture. Just as someone on a stroll through a gallery may become so fascinated with a painting or sculpture that subsequent imaginative and intellectual work results in a critical understanding very different from that to be got out of wandering through rooms full of culturally sanctified icons. That is perhaps the key distinction: that art's function as a leisure activity is a function which at bottom reproduces a range of institutionally and culturally approved meanings. This may be better than not engaging at all. But it is still a far cry from engaging with the critical power of art. Art as a form of leisure activity represents a mode of consumption in our consumer-oriented culture. It is perhaps less about the consumption of objects than about the consumption of meanings and values; and clearly there is a grey area as to whether some set of values is emancipatory or mystificatory, potentially critical, or part of the general dissuasion from critical thinking which the large scale media agencies of our culture promote.

THE COMMODITY

The function of art in social practices of leisure and tourism is a prominent one in our societies; no less important is the function of art as a commodity. Only rich and powerful individuals may own

major works of modern art. But anyone can purchase lowlier examples of original works, not to mention limited editions of prints. And when one gets to the level of the T-shirts, calendars, mugs and postcards stocked by the shop of any large museum of modern art, the merchandising aspect of art, its status of cultural marker, may safely be said to have eclipsed its other more critical functions. Although having said that, and as if to prove that in the field of art nothing remains static, the Post-Modernist artist Barbara Kruger has attempted to turn the tables on – or at least to ironize – commodification by producing as an artwork a T-shirt bearing the phrase 'I shop, therefore I am'.

The commodity aspect of art is not peripheral to its status in our societies. Art works of all types are continually being bought and sold; indeed almost all of them are made to be bought and sold. In the past works of art were usually commissioned, either by enlightened bourgeois patrons or by institutions such as the church. Before that, one assumes, they were produced organically by skilled members of a community, as a necessary part of that community's cohesive rituals. Since the mid-nineteenth century however, the professional practice of art, as distinct from the amateur who paints in his or her spare time, has been powerfully influenced by the market. Professional artists have contracts with dealers. They produce their work which is either offered to the dealer in exchange for a retainer, or is bought per piece by the dealer, in either case to be sold on at a profit to collectors. These collectors may be private individuals or public bodies such as the boards of Trustees of major museums. If an artist is prolific and successful, if for example his or her work ultimately enters the collection of a major museum of modern art, the asking prices will increase. This dimension of exchange value is fundamental to professional art practice in contemporary society.

It is also arguably the greatest stumbling block in the popular attitude to modern art. A practice which on the one hand continues to be surrounded by a high-flown rhetoric of creativity, insight and value, yet which on the other hand has abandoned most of the criteria by which such value has traditionally been judged (skill, beauty, effective story telling etc.), stands in an exposed position when the resulting products continue to be exchanged for what to most people seem exorbitant sums of money. 'The emperor's new clothes' is one of the most persistent refrains in lay criticism of modern art; and not always without justification.

The relation between the claimed use values of art, be they spiritual or more evidently social, and the exchange values of works of art in the market place, is fraught. Partly this is because the products of other artistic practices of literature and music, for example, are available in the form of books and records to much wider ownership. Partly it is because, in the very myth of modern art itself commerce and commercial values are perceived as a threat to integrity and to spiritual or critical values. Some of this is cant. In our culture everything can be bought and sold, people no less than works of art. Some of it also amounts to a useful way for conservatives to attack innovations they dislike, and even to enlist an ignorant public behind their own different, and often singularly patrician, cultural values. Yet that said, there is some truth in the widespread misgivings. It is very difficult to measure the emancipatory effects of aesthetic value, even if these have a reasonably evident socially critical edge to them, against the claims of a new nursery or health centre. Yet it is very easy, perhaps misleadingly so, to measure the thousands of pounds spent by a museum on an abstract painting against the thousands of pounds which a hospital may be trying to raise for a kidney machine.

QUALITY AND QUANTITY

The qualitative and quantitative dimensions of human experience in our societies are just not so easily reconciled. A culture is a delicate and complex organism: and however much reform and amelioration is pursued it is usually done in the name of producing a better life. That is to say, in the name of producing a qualitatively superior experience of life for a quantitatively larger number of people. It is seldom or never the case in societies as complex as ours that financial outlay on works of art could be seen directly to take from budgets devoted to the provision of social services. The interface between the two is not of that kind. Although that said, the demand that art should perform some emancipatory social function, particularly when public funds are at stake, is hard to resist.

Art's manner of performing its emancipatory task is more complex and more subtle than robustly pragmatic forms of political debate may allow. It might be no small part of art's social benefit that it can free us, even if only in imagina-

tion, from the thrall of the politician's vocabulary. Many considerations collide here. And many questions have to be held in abeyance while a few are answered. But the fact remains that if we want to find out about Picasso, or Abstract Expressionism, if we want to find out how Andy Warhol's silkscreened soup cans or a geometric arrangement of firebricks can be interesting, then certain particular histories and problems have to be reviewed. There are no short cuts. Conversely, if we want solutions to the world's problems at the close of the twentieth century, the history of modern art is not likely to help us. Or rather, it may; but not directly so. We will, it is safe to say, be disappointed if we look to art to solve the problems of culture, let alone of politics. Art is a part of culture. It also arguably always has a political dimension. But art's bearing upon culture and politics is, unless the circumstances are exceptional, highly mediated and indirect. A painting of a bunch of flowers, indeed a painting depicting no recognizable subject matter at all, may be a pathetic object when confronted by the scale of human suffering in a war. This does not however mean to say that a painting of a scene from the war will *ipso facto* be a better painting than a picture of flowers. It does not even mean that either the abstract painting or the still life must necessarily lack or trivialize the human values which do stand opposed to war.

Art can mean in many ways; certainly in more ways than by picturing alone. Yet art is not easy, and at its best it may challenge our sentimentalism, as well as our taste, as well as what the powerful are wont to say is good for us. Insofar as there is a solution to the difficulties art presents (and there is none unless we want there to be one and are prepared to work for it), then it seems to lie in the principles of education, inquiry, and informed understanding. Whether art, which is not after all such a force in the big world of corporations and nation states, has the opportunity to perform any of its claimed social tasks of enlightenment, redemption, or criticism has much to do with the matter of whether those in positions of responsibility in the society, are empowered with an adequate understanding.

NOTES

1. Brecht, B., 'Popularity and Realism' in Adorno, T.W. *et al.*, *Aesthetics and Politics*, London, New Left Books, 1977, pp.79-85 (quotation p.82).

2. See Courbet, G., 'The Realist Manifesto' (1855), reprinted in *Gustave Courbet 1819-1877*, exhibition catalogue, Arts Council of Great Britain, London 1978, p.77.

3. See Baudelaire, C.,'On the Heroism of Modern Life', section xvii of his 'Salon of 1846', reprinted in *Charles Baudelaire. Art in Paris 1845-1862*; and Baudelaire, C.,'The Painter of Modern Life' (1863), reprinted in *Charles Baudelaire. The Painter of Modern Life and other Essays*, both vols translated and edited by J. Mayne, London, Phaidon 1964 and 1965.

4. Denis, M., 'Definition of Neo-Traditionism' (1890, extracts reprinted in Chipp, H.B., *Theories of Modern Art*, Berkeley and Los Angeles, University of California Press, 1968, pp.94-100 (passage quoted p.94).

5. Jackson Pollock, interview with William Wright (1950), reprinted in Harrison, C. and Wood, P. eds, *Art in Theory 1900-1990*, Oxford, Blackwells, 1992, pp.574-8 (quotation p.575).

6. See Greenberg, C., 'The Pasted Paper Revolution' (1958), reprinted in O'Brian, J. ed., *Clement Greenberg. The Collected Essays and Criticism* vol. 4 *Modernism with a Vengeance*, University of Chicago Press, 1993, pp.61-6.

7. Kandinsky, W., *Concerning the Spiritual in Art* 1911/12, extracts reprinted in Harrison and Wood, op.cit., pp.86-94 (quotations pp.87 and 91).

8. See Bell, C., 'The Aesthetic Hypothesis', 1914, extracts reprinted in Harrison and Wood, op.cit. pp.113-16.

9. Barr, A.H., *Cubism and Abstract Art* (1936), exhibition catalogue, Museum of Modern Art, New York, extracts reprinted in Harrison and Wood, op.cit. pp.361-3.

10. Greenberg, C., 'Modernist Painting', 1960/65, reprinted in O'Brian, op.cit., vol.4, pp.85-93.

11. Greenberg, C., 'Review of an Exhibition of School of Paris Painters', 1946, reprinted in O'Brian, op.cit., vol.2, *Arrogant Purpose*, 1986, pp.87-90.

12. Greenberg, C., 'Avant Garde and Kitsch', 1939, and 'Towards a Newer Laocoön', 1940, both reprinted in O'Brian, ed. op.cit., vol.1, *Perceptions and Judgements*, 1986, pp.5-22 and 23-38 respectively.

13. See for example Oldenburg, C., 'I am for an art...', 1961; Judd, D., 'Specific Objects', 1965; Smithson, R., 'Cultural Confinement', 1972, extracts reprinted in Harrison and Wood, op.cit., pp.727-30, 809-13, and 946-8 respectively.

14. The literature of Post-Modernism is voluminous. Key general texts include: Lyotard, J.F., *The Postmodern Condition. A Report on Knowledge*,1979; Jameson, F., *Postmodernism, or the Cultural Logic of Late Capitalism*, 1991. In the field of the visual arts, important treatments include: Owens, C., 'The Allegorical Impulse. Towards and Theory of Post-modernism', 1980; Kelly, M., 'Re-viewing Modernist Criticism', 1981; Burgin, V., 'The Absence of Presence', 1984; Krauss, R., *The Originality of the Avant Garde and Other Modernist Myths*, 1986. Two important anthologies of writings on Post-Modernism and the visual arts are: Foster, H. ed., *Postmodern Culture*, 1983/5; Wallis, B. ed., *Art After Modernism. Rethinking Representation*, 1984. Section viii of Harrison and Wood, op.cit., consists of extracts from thirty texts, including some of the foregoing, under the title 'Ideas of the Postmodern'.

15. See Clark, T.J., *Image of the People. Gustave Courbet and the 1848 Revolution* and *The Absolute Bourgeois. Artists and Politics in France 1848-1851*, both London, Thames and Hudson, 1973; and *The Painting of Modern Life. Paris in the Art of Manet and his Followers*, London, Thames and Hudson, 1984.

16. See in particular Parker, R. and Pollock, G., *Old Mistresses. Women, Art and Ideology*, London, 1988; Duncan, C., *The Aesthetics of Power. Essays in Critical Art History*, Cambridge University Press, 1994.

17. De Beauvoir, S., *The Second Sex* (1949), translated and edited by H.M. Parshley, London, Jonathan Cape, 1953, quotations from p.16.

18. Said, E., *Orientalism*, London, 1978; Kruger, B., and Mariani, P. eds, *Remaking History*, DIA Art Foundation, Discussions in Contemporary Culture no. 4, Seattle, Bay Press, 1989.

19. See Matisse, Henri, 'Notes of a Painter', 1908; Breton, A., *Surrealism and Painting*, 1928. Extracts reprinted in Harrison and Wood, op.cit., pp.72-8, quotation p.76, and pp.440-6, quotation p.444, respectively.

CHAPTER TWO

THE ACADEMY &
THE AVANT-GARDE

JOSIE BLAND

When art is discussed, or when we read about paintings and sculptures, the terms 'academic' and 'avant-garde' crop up. The former is generally used to describe works which are technically conservative, smoothly finished and which have a high degree of resemblance to the visible world. The latter term is often heard when art which is technically innovative and experimental is under scrutiny. Although an over simplification, it can be suggested that in the minds of the public the art of the Academy is associated with respectable gentlemen painting socially acceptable pictures of nudes, landscapes and still lives, while the avant-garde artist is thought of as tormented, starving and struggling in the creation of art.

These two terms will be examined in detail through a study of two nineteenth-century paintings, Gustave Courbet's *After Dinner at Ornans*, 1848–9 (Plate 31), and Thomas Faed's *The Mitherless Bairn*, 1855 (Plate 32) in order to establish what it is that makes one painting avant-garde, the other academic. These works have been deliberately chosen for the similarity of their subject matter, the rural domestic interior, which will demonstrate that the differences between the works in terms of composition and

Detail of Plate 35, Camille Pissarro, *Apple Picking at Eragny-sur Epte*, Museum of Fine Arts, Dallas.

technique are underpinned by the ways in which the two artists perceived their society, one promoting a dominant ideology, the other subverting it. The chapter concludes with a discussion of the development of the avant-garde through the introduction of a third image, Camille Pissarro's *Apple Picking at Eragny-sur- Epte* (1888; Plate 35).

THE ACADEMIES

The term Art Academy refers to those institutions which taught the practice of Fine Art (painting, sculpture and printmaking), displayed this work through annual exhibitions, and which were seen as the places where the authority on what constituted good art was held. Academies superseded the Art Guilds, medieval in origin, which had trained artists through an apprenticeship scheme and determined the rules of artistic training.

During the sixteenth century in Italy, Art Academies were developed along the lines of universities, and later the idea of the Academies was to spread throughout Europe as Italian artists travelled to work at various European courts. In 1648 the Academy of painting and sculpture was set up in Paris, and by 1790 there were more than one hundred Art Academies in Europe. Academic training in the seventeenth and eighteenth centuries encouraged a Classical style of drawing,

31. Gustave Courbet, *After Dinner at Ornans*, 1848–9, oil on canvas, Musée des Beaux Arts, Lille.

painting and sculpture, a way of depicting the figure based on the idealized proportions of Greek art, and a method of creating an illusion of reality based on the system of a single-point perspective. This method was to be used extensively in the large paintings of heroic historical scenes and scenes from the bible and mythology enjoyed by the aristocracy, who supported the Academies and who wished art to be ennobling and uplifting. This way of producing art persisted well into the nineteenth century, as can be seen in Lord Leighton's *Captive Andromache*, 1888 (Plate 33). By the early nineteenth century, while much of the subject matter of academic work still reflected the taste of the aristocracy, the growth of the middle class and their subsequent interest in the art market meant that there was a gradual increase in images of everyday life, known as genre paintings, a category of art which was influenced by earlier Dutch and Flemish images.

Industrialization had enabled the middle class to acquire wealth and privilege. They celebrated the modern, wanting images of it, but also enjoyed scenes of rustic rural life, which reassured them that, although their urban world was rapidly changing under industrialization, there was still a place where traditional and timeless values could be found. Genre scenes of both the urban and rural variety were particularly prevalent in England, where industrialization had been ongoing for at least a century, *The Mitherless Bairn* being a key example.

By the 1840s the Academies were producing a wide variety of art in terms of subject matter. This ranged from large heroic history paintings intended to decorate large châteaux and country houses to small intimate domestic scenes meant to grace the walls of suburban villas. What the majority of these Academic works had in common was that they promoted the dominant views of society. The attitudes expressed in Academic paintings were often those held by a wider section of society, whose views were linked to those exercising economic power.

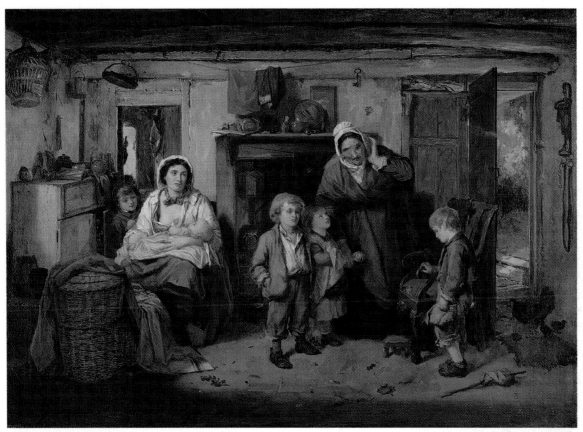

32. Thomas Faed, *The Mitherless Bairn*, 1855, Royal
Pavilion Art Gallery and Museums, Brighton.

33. Lord Leighton, *Captive Andromache*, exhibited 1888, oil
on canvas, 196.8 x 406.5 cm., Manchester City Art
Galleries.

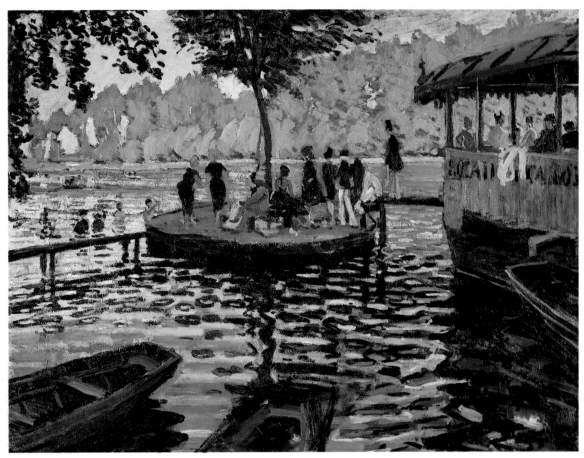

34. Claude Monet, *La Grenouillère*, 1869. Metropolitan
Museum of Art, New York, the H.O. Havemeyer Collection.

A problem for many young artists was the stranglehold the Academies had on the art market. The Academies' annual exhibitions of new work were the places buyers gravitated towards when they wished to purchase a work outright, commission an artist to decorate their town hall or paint their wives and families (Renoir did very well out of the latter). Indeed, before the dealer system of selling art was established, the Academic exhibitions were virtually the only venues in which artists could make their name. However work shown in these exhibitions had first of all to be vetted by a jury consisting of Academicians (those people who had trained at the Academies and gained the Academies' qualifications). It was often difficult for up and coming artists to get their work shown in the Academies' exhibitions; so during the nineteenth century alternative groups developed both to challenge and to circumvent the Academies' domination of the art market. For example in

France when history painting still dominated, the Realists responded by painting genre subjects, the Romanticists painted emotive works in opposition to the Academies' supposedly 'cold' classicism. As well as challenging through subject matter and style many artists set up alternative exhibiting venues away from the Academies' annual shows, a well known example being the group shows of the artists who became known as Impressionists.

Among those offering an alternative to the Academies there were artists who were described as being avant-garde. This was a military term applied to soldiers who went on ahead of the rest of the troops, and it became associated with artists whose practice was ahead of the mainstream. The Utopian Socialist Henri de Saint-Simon used the term in the 1830s to describe the role of the artist as one who, together with scientists and industrialists, would show the way towards an ideal society. Avant-garde artists were those whose work in

some way was a critique of the *status quo*, their ideas linked with radical politics. For example, during the 1848 Revolution in France the new, arguably oppressive political order was criticized by those in opposition to it. Several artists and writers aligned themselves with this critical position, including the poet and critic Charles Baudelaire and Gustave Courbet, both of whom took a critical, often overtly oppositional view of the dominant beliefs of the society within which they produced.

However, a more common usage of the term avant-garde is its reference to technically innovative art. Claude Monet's work is a key example. *La Grenouillière* (Plate 34) represents the boating lake and floating restaurant of the title, located on the Seine in the western suburbs of Paris. This work, a study for a larger painting which was never produced, was aimed at the growing middle-class market. It celebrated Monet's modern world, in a technically radical way, through the use of large slab like brushstrokes to represent the water, a light, bright, colour range and a multi-point perspective, a clear departure from a mere mirroring of the visible world, and from traditional Academic techniques.

However, there is a sense in which this work too is critical. As Meyer Shapiro has argued, the technical radicalism of Monet's work and other early Impressionist images, combined with what was represented – supposedly spontaneous social events such as picnics and boating – enabled the work to act as a critique of both Academic art with its stiff formalism, and, by implication, the stiff and formal lifestyle of those who supported it – the aristocracy and the ever growing middle classes.

It is the nature of avant-garde art always to act critically. Technical radicalism and political radicalism both operate from a position outside the *status quo* and must by their very nature criticize the norms of society.

Asking Questions

After Dinner at Ornans depicts four men and a dog. They have been hunting, and after dinner sit around the table. One with his back to us lights his pipe, another plays the violin, the two characters on the left listen. The four men are recognizable individuals, Courbet with his chin in hand listens to the violin, his father is depicted on the left of the work. The others are family friends, Promayet and Marlet.

In *The Mitherless Bairn* an orphaned child has entered a humble abode. A family, consisting of two women, mother and grandmother and a group of children look at him in consternation.

Questions need to be asked when looking at these works. But what sort of questions? When faced with an unfamiliar piece of art from the past one needs a method of questioning which will yield fruitful answers.

Look at the illustrations of *After Dinner at Ornans* and *The Mitherless Bairn*. Initially you can find out something about the works simply by examining them. Ask yourself what are the significant differences in the paintings in terms of imagery, composition, size and the way in which the materials have been used. (You will probably have difficulty seeing the quality of the paint surface from a reproduction.) Having done this, ask yourself what else you need to know about the works in order to gain a greater understanding of them.

You might have concluded that questions external to the images in front of you should be raised. There are several different approaches to interpreting art: under the blanket term of the new art history, some historians use a social historical approach. They locate the works within a social, economic and political context, and investigate how this context might have informed both the production of the paintings and their reception at the time. Here this approach will be used to contextualize the works and to try and find some answers to the questions raised. This is a means of gaining awareness of the ways in which visual images are both informed by and in turn inform the ideas and beliefs of the society within which they were produced.

'The Mitherless Bairn'

Thomas Faed produced two versions of this picture, the one examined here is painted in oil on canvas, measures 35.1 x 61.7 cm and is located in the Royal Pavilion Art Gallery in Brighton. Its relatively small scale was deemed suitable for genre paintings. These did not have the 'importance' of history paintings, and were aimed at middle-class purchasers who owned suburban villas rather than huge country houses. The size of the work was just right for hanging on a drawing room wall. It was exhibited at the Royal Academy in 1855 establishing Faed's reputation as a painter of genre scenes. So what is it about this painting that

makes it Academic? Faed was trained at a Scottish Academy, the Trustees Academy in Edinburgh, eventually gaining membership of the Royal Academy, which entitled him to use the letters R.A. after his name. Part of his training would have required that he draw figures from plaster casts, casts of classical Greek and Roman statuary. This training explains the stiffness of many figures within Academic paintings (for example *Captive Andromache*). Although in Faed's painting the figures are not rigidly posed, closer examination reveals the composition to be somewhat theatrical. The nursing mother gazes tenderly at the orphan, the grandmother raises her hand in perplexity, the orphan hangs his head. These figures carry the hallmarks of a tableau, the composition's theatricality suggesting the residue of Faed's training in front of classically derived plaster casts. The highly finished surface of the Academic style is less evident here, a livelier brushstroke being acceptable in genre subjects, but the work is illusionistic, inviting the viewer to enter a believable pictorial space. So, in subject matter, composition and technique the painting is conservative. Is this what makes it Academic? Perhaps we need to look further. As we shall see, the Courbet was also shown in an Academic exhibition and praised by the establishment, yet it is unquestionably avant-garde. So being exhibited at the Academy does not necessarily make a work Academic.

Much Academic work promoted a dominant ideology, a way of looking at the world employed by those in power, politically and economically. The picture's 'message' can be examined by asking what kind of ideological statement Faed was making, and what was the social, political and economic context which informed that statement? Faed was noted for his scenes of poverty, of the Scottish rural poor. Vincent van Gogh, himself a painter of the rural poor, approved of Faed's work. Seeing it while intermittently living and working in London between 1873 and 1876, Van Gogh praised Faed for showing the reality of poverty in such works as *Home and the Homeless*, *Worn Out* and *The Poor*. Does this then suggest that Faed was critical of his society, that his work was thus more in line with an avant-gardist enterprise and not part of a socially acceptable mainstream Academicism? Probably not. Having a social conscience does not in itself make for a critical practice, it is possible to feel sorry for the poor without wishing to criticize the social structures which create their poverty. Rather than challeng-

ing the establishment in *The Mitherless Bairn* Faed has made poverty acceptable by sanitizing it. To find out how he did this we need to look at that period in history when the painting was produced and try and reconstruct the way in which the painting would have 'spoken to' its audience.

Faed's starting point for the picture was, like much Victorian painting, a literary text, a poem written by a Scottish weaver, William Thom.

> Her spirit that pass'd in yon hour of his birth,
> Still watches his wearisome wand'rings on earth,
> Recording in heaven the blessings they earn,
> Wha' couthilie deal wi' the mitherless bairn!
>
> Oh! Speak him nae harshly – he trembles the while –
> He bends to your bidding and blesses your smile!
> In their dark hour o' anguish the heartless shall learn
> That God deals the blow for the mitherless bairn!

Clearly Thom was addressing a social problem – that of the child whose mother has died, the whereabouts of the father unknown. The problem of waifs and strays was ongoing during the Victorian period and exercised the minds of the middle classes, Dickens was to use it as a theme in *Oliver Twist*. For Dickens, the solution was for Oliver to be 'discovered' by a relative, a kindly and significantly wealthy great-uncle. Thus the problem of the orphaned child was firmly placed on the shoulders of the individual. In Thom's poem and Faed's painting, the solution lay in putting the fear of God into the population. To deal 'couthilie', or kindly, with the orphan, as the peasant family in *The Mitherless Bairn* are about to, was to please God, to treat the child harshly was to incur his wrath and thus the poor were encouraged to look after their own. Why was this way of representing poverty to prove such a success for Faed? (The work was popular, establishing Faed's reputation as a painter.) To answer this we need to look at attitudes towards poverty in the 1850s when the work was produced and we shall see that the popularity of the work must be linked to the way it represented the dominant attitudes of the middle classes towards the poor.

In 1851, three years before Faed began work on *The Mitherless Bairn*, Henry Mayhew, a proto-sociologist published the first volume of his epic survey of the condition of the poor in Victorian London, *London Labour and the London Poor*. Mayhew divided the population into four categories – Those who will work, Those who will not work, Those who cannot work and Those who need not work. The first and last categories

referred to the workers and the rich, the middle two categories – those who cannot work and those who will not work, led to two further definitions – the deserving and the undeserving poor. 'Those who cannot work' included those who wished to work but were unable to gain employment, and the sick. 'Those who will not work' were to be described in Mayhew's fourth volume *The London Underworld* and included prostitutes, thieves, swindlers, beggars and other lawless characters who made a living by illicit means. The deserving poor were deemed such by their willingness to try and help themselves, adopting what in our modern times is a self-help philosophy. This was fostered through religion, the Christian notion that one's reward was to be found in the afterlife, a useful tool to those in power.

Attitudes towards the poor in the 1850s can be traced back to the New Poor Law of 1834. This law reformed the existing Poor Law which was seen as placing an unacceptable financial burden on the middle classes. In 1834 stricter controls were implemented for the relief of poverty. Outdoor relief was abolished (that is the subsidy given to bring very low wages up to subsistence levels) and was replaced by a new punitive system. Large centralized workhouses were built and, in order to obtain relief, applicants had to enter them after becoming totally destitute. Conditions within them were supposedly more miserable than those experienced by even the most destitute on the outside, thus the poor were supposedly encouraged to do all they could to gain employment and avoid the workhouse. While many Victorians were indignant at this new regime for dealing with poverty – Dickens for one as we see in the pages of *Oliver Twist* – many approved of the doctrine of punishing poverty and encouraging self help.

Faed's painting is located in an indeterminate Scottish setting. The specificities of the Poor Law as implemented in Scotland at that time are largely irrelevant here, as the painting had a London audience. A message of the poor helping each other and not depending on the state, overlaid with a religious moral, would have been more than acceptable to those espousing the then dominant ideology of self-help. J. F. C. Harrison has argued that unemployment was commonplace and expected among the labouring poor in the early Victorian period: he states

the concept of continuous employment was probably quite alien to most early Victorians,

indigency ... was an acceptable (and inevitable) part of the lot of the lower orders.

(*Early Victorian Britain: 1832-51*, p.57)

Harrison offers the example of Leeds, where in the trade depression of 1848, 15,000 people were receiving relief from public soup kitchens. That same year revolutions swept Europe, and a great fear of a working-class uprising gripped the British middle class. Faed's picture, produced some six years later must have been reassuring – a vision of the poor being 'deserving' by helping one less fortunate than themselves in order to please God. Also there is not a man in sight to plot and incite riots! Thus *The Mitherless Bairn* can be categorized as Academic. Through what was represented and how that representing was done, it promoted the dominant ideology of mid-Victorian Britain, a key factor of which was the notion of self help. It promoted it to an audience – the mainly middle-class viewers who frequented the Academy's exhibitions – who, by their enthusiasm for Faed's painting, we might assume subscribed to that ideology.

'AFTER DINNER AT ORNANS'

This is a large painting, measuring 195 x 217 cm. It is owned by the Musée des Beaux Arts in Lille, and was painted by the French Realist painter Gustave Courbet. Courbet's picture, like the Faed, was exhibited at the Academy. It was shown at the Salon, the name given to the annual exhibition of the Ecole des Beaux Arts, the French equivalent of the Royal Academy. Not only was it shown at a mainstream venue but Courbet won a medal for it and it was bought by the Government for the museum at Lille. Given this information you might be puzzled as to why the Courbet was described as avant-garde. What made it so?

Courbet came from Ornans in eastern France, from a fairly well-off rural family. He lived and worked in Paris from 1840 to 1849 adopting a bohemian lifestyle, and associating with intellectuals including Baudelaire and the anarchist writer and theorist Pierre-Joseph Proudhon. Courbet was largely self taught, his Realism taking the form of a rejection of both Classicism and Romanticism, both of which he felt were over literary (remember Faed's painting had a literary source). Instead his Realism resided in his wish to show things as they were, which meant both looking life-like and revealing the truth beneath the surface. It is this latter notion which makes Courbet's work produced around 1848 avant-

gardist, although it was after 1848 that Courbet produced his most overtly critical work, his politics focused by the events of the 1848 revolution and the repressive regime of the Second Empire which followed it. Courbet stated that 'Realism is democracy in art' and his wish to represent his own epoch truthfully led him to develop a means of representation which was at odds with Academic techniques.

Before going on it is important to clarify the term Realism in relation to another term – Naturalism. The French artists described as Realist (with a capital R as they were a recognized group) were noted for their depiction of genre subjects, i.e. scenes of everyday life. Courbet's work indeed fits into this category, but if we understand naturalism to describe work which simply mirrors the visible world then his work of this period arguably does more than this.

Realism when used with a small 'r' has come to be used to describe work which attempts to show the real, i.e. the artist's understanding of his or her reality, and this is a better description of Courbet's practice. In order to show this reality, artists developed a range of differing techniques, which changed as societies changed. As the nineteenth century moved into the twentieth century and as this century progressed, art which was produced from a critical realist stance moved gradually and inexorably away from naturalistic representations. *After Dinner at Ornans* may appear technically orthodox in comparison to Monet's *La Grenouillière*, and is a far cry indeed from Picasso's *Three Dancers* or Carl Andre's *Equivalent VIII* (Plates 34, 47, 101). However it was recognized at the time as being technically unorthodox.

With *After Dinner at Ornans* Courbet does not appear to depart significantly from similar Academic representations of domestic rural life. Yet, although the work received acclaim from the establishment, it was not without its critics, and their dissent might alert us to the way in which the painting operates as a critical piece of art. In his book about Courbet, T. J. Clark has drawn our attention to one critic, Lagenvais, who argued that Courbet 'should show them [the characters] to us in the Flemish manner, through the wrong end of a telescope, so that they become poetic as they recede into the distance' (*Image of the People*, p.70). Clearly this critic wanted these people to be represented as one step away from reality as they became picturesque and sanitized. This is surely the same view of how the peasant should be repre-

sented that Faed subscribes to in *The Mitherless Bairn*. In finding out how Courbet's work subverts this view we can begin to understand what makes it avant-garde. We need, I think, to look at three aspects of the painting – its size, its technique and its composition.

After Dinner at Ornans, which depicts four men relaxing after their evening meal, is clearly a genre painting. The size of the work is puzzling. The figures are virtually life-size. This gives them the importance usually reserved for history painting. In accordance with Courbet's beliefs, his wish to portray his own epoch, the present and the everyday is deemed as worthy and as important as the great (but idealized and often fictitious) events of history. The painting therefore works against similar representations by changing an accepted convention. The small size of Faed's characters renders them 'safe'; we see them, as Lagenvais would have it, 'through the wrong end of a telescope'. Courbet's characters, because of their size, have a material presence, a corporeality which is difficult to avoid. Next we need to be aware of the brushwork and paint application. Although the thickly applied paint and evidence of brushstroke was, as we have seen in the Faed, acceptable in genre painting, which had as its predecessor Flemish rather than Italianate work, Courbet almost exaggerates the roughness of his paint surface, making the viewer clearly aware that the painting was a material object. This is underpinned by Courbet's assertion that painting was a material practice. In this he challenged the illusionism of Academic work, which through its mimetic techniques created a false sense of reality, the kind of illusion which appears in Faed's representation of the rural poor.

Faed produced an image which satisfied his viewers that all was well in the countryside, the poor were simple but happy and looked after their own. Courbet's representation is surely more complex than this. In the Faed we know exactly what is going on, what everyone depicted is thinking. This reinforced the middle-class sense of power and dominance over the poor; the poor are shown as having nothing to hide. Courbet's characters are far less easy to read. Their gestures and poses are more natural than those encountered in Faed's work. They are also recognizable individuals, Courbet, his father and two friends, rather than Faed's stereotypical characters – the tender mother, the fussy grandma, the poor orphan. But what is important in distinguishing the Courbet

from typical academic genre work of that time is that the viewer is not privy to any information about the figures. While the viewer might imagine stepping into Faed's painting and being warmly received by the people within it, Courbet precludes this. The composition is arranged so as to make the viewer feel excluded. This is achieved in two ways. Firstly by the postures of the four men, depicted as lost in private thoughts, thoughts the viewer could not know. Secondly by the actual grouping of the four men, particularly the one with his back to the viewer. They form a self-contained, private and excluding circle.

Courbet wished to represent his society truthfully, from the point of view of one whose politics were of the left. The Faed type of representation just would not do for Courbet, and this led him to make the technical changes just described. In order to find out why, we need to look at the economic and political situation in France in 1848–9, using a social historian's approach.

Around the time of the 1848 Revolution the countryside was undergoing a process of change moving from a feudal to a capitalist economy. Many small farms were amalgamated into large concerns, in other areas farms were subdividing, their owners unable to run them. For others, finding the countryside no longer able to sustain them, the solution lay in moving to the city. Rural work patterns were thus changing rapidly and with this change came changes in traditional patterns of country life. Parts of the countryside were becoming politicized, voting for the left, particularly after the 1848 Revolution. There was a genuine fear that if another revolution were to occur it would originate in the countryside. At the same time middle-class city dwellers in both France and England wanted comforting representations of a countryside which showed a myth of stability, of timeless traditional values, a place where they could imagine they could go to escape the rapidly changing experience of the city, transforming as it was under capitalism. They did not want representations which reminded them of the changing nature of the countryside as Courbet's image did.

After Dinner at Ornans refused the sanitized view of the countryside offered by Faed's painting and endless similar works, offering instead a transformed vision. Courbet, in wishing to show the reality of the countryside rather than an anodyne image of it, showed his own family. They were peasants in the sense that in France the term described all those who worked on the land. However Courbet's father owned two homes, the family were partly bourgeois, and clearly do not fit into the stereotypes of peasants common in genre painting. Instead Courbet offers us a view of the inhabitants of the countryside as absorbed in their own affairs, people, it might be argued, capable of making political decisions. He does not represent his country folk as opposite to townspeople – as simple, honest and so forth – but rather shows them as complex individuals, who were also affected by modernization and change as were the inhabitants of the city. Their 'difference' is negated. (Courbet is of his time representing these individuals as men – in 1848 women were not deemed capable of intellectual activity.) Thus as the countryside transformed, so Courbet who himself had lived as part of a rural community, transformed genre painting and in so doing challenged and changed viewers' beliefs about the timeless and traditional thing they believed the countryside to be. Changes in society thus inform and work on the artist, who has to find ways of representing those effects pictorially. In turn the artist's work, in the way it affects the viewer's thinking, is a part of those events and processes which effect change. Art and life are inextricably entwined.

It is thus Courbet's transforming artistic practice which made this work avant-garde. It was a critical response because by altering the genre category it showed the misrepresentative nature of works such as Faed's. The two pictures demonstrate the way in which the early avant-garde operated in opposition to the Academy. We can see this opposition in practice within the paintings' structures. The Courbet is large, giving importance to the characters he paints; the Faed is small, his depicted characters are thus diminished. Faed's colour scheme is light, bright with a preponderance of warm tones which form an open and accessible group of women and children, which viewers felt they knew everything about. Courbet went for sombre tones in his depiction of a closed inaccessible group of men.

THE DEVELOPMENT OF THE AVANT-GARDE

The unorthodox nature of Courbet's techniques may be difficult for a modern viewer to perceive. However, by the late 1860s – for example Monet's *La Grenouillère* of 1869 (Plate 34) – technical innovation was obvious in works which were pro-

35. Camille Pissarro, *Apple Picking at Eragny-sur-Epte*,
1888, oil on canvas, 60 x 73 cm. Museum of Fine Arts,
Dallas.

duced outside the Academic mainstream, and as the century progressed the work of the avant-garde took on increasingly unfamiliar forms. Another rural scene, *Apple picking at Eragny-sur-Epte* (1888; Plate 35), by Camille Pissarro, demonstrates this development. Pissarro's political radicalism was bound up with his technical radicalism which in the 1880s took the form of the newly developed Neo-Impressionist technique, so he clearly has the credentials of an avant-gardist.

Pissarro exhibited regularly with the Impressionist group who had their first exhibition in 1874. He shared their concern to represent a fresh way of seeing. Many (but by no means all) Impressionist landscapes were produced from direct, on-the-spot observation, as opposed to the Academic convention of working in the studio from studies. This process enabled the Impressionists to observe at first hand the effects of light on landscape, for example to study how local colour (the colour inherent in an object) is changed by the colour of the object next to it, and the effect of light on it.

Pissarro, like Courbet before him, had read the anarchist literature of Pierre-Jean Proudhon. In the 1880s and 1890s as the Anarchist movement gained momentum, Pissarro's Anarchist sympathies become overt, as is evident in his letters. Anarchism is a belief in the freedom of the individual without the institutions of government and it is this belief which underpins Pissarro's painting both in subject matter and technique. In his book *On the Principles of Art and its Social Uses* of 1865 Proudhon stated that art must serve a moral and a social purpose. It must make visible the realities of everyday life, people must be painted at home or work without idealization, a process clearly visible in Courbet's *After Dinner at Ornans*.

Proudhon's Utopian society would be one where agriculture was paramount, with groupings of land-owning peasants working collectively on smallholdings, offering mutual aid to each other. The life of the peasant, in harmony with nature, was thus the Anarchists' ideal. It was the antithesis of the life of the city workers seen by the Anarchists as wage slaves, employed in repetitive, tedious alienating labour. The alienation of urban work was supposedly the result of the worker having little or no satisfaction in the product he or she made, which was sold for a profit rather than made for the workers' own needs.

Apple Picking at Eragny-sur-Epte depicts the apple harvest in Pissarro's orchard at his home in the town of Pontoise. It shows a group of peasants working harmoniously together – the harmony made visible in the means of representation. The rhythmic quality of the individual figures, their relationship one to another and the use of colour all emphasize that harmony. The painting then is of both an actual scene and a projected one – a statement of how life could be if Capitalism was replaced by Anarchism. The peasants work co-operatively. This is in their best interests, and it is the way Anarchists believed people would operate if left to their own devices without the interference of government. Pissarro in a letter to his son Lucien on 26 April 1900 stated 'Salvation lies in Nature'. Conversely he believed that the greatest iniquities of the Capitalist system were to be found in the city, and the antithesis of his rural scenes such as *Apple Picking* can be found in a series of pen drawings he produced in the 1890s called *Turpitudes Sociales* (Plate 36) where he represents the injustices of the capitalist system in an urban setting, by contrasting the rich with the poor.

Apple Picking is obviously technically different from the Courbet and the Faed. In the 1880s Pissarro was closely connected with Seurat and Signac, both Anarchist supporters. With others, including Pissarro's son Lucien, they formed a group known as the Neo-Impressionists. Building on Impressionism, which relied on empirical observation, they developed a scientific theory of colour based on the various studies of light and colour made by such scientists and theoreticians as Charles Henry, Ogden Rood and David Sutter. Science taught the Neo-Impressionists that light is made from the colours of the spectrum, so in their paintings they rejected earth colours and black, using only the colours of light. They applied paint to their canvas in dots of pure colour. Viewed from

36. Camille Pissarro, *Enterrement d'un Cardinal qui avait fut voeu de pauvreté*, from *Les Turpitudes Sociales*, lithograph.

a certain distance the dots would appear to blend into recognizable colours (rather like a colour television). This technique, known as Pointillism, was meant to create the equivalent in pigment on canvas of the effect of light on landscapes, figures, and objects. The innovative nature of this technique is evident when we realise that the shadows around the figures consist largely of complementary colours placed together – red and green, yellow and violet, a juxtaposition which lends a vibrancy and intensity to the colour (page 34). For Pissarro, this new means of representing the visible world was more than just an exciting new technique. It represented a new way of seeing, at odds with Academic representation and its illusionism. While the viewer of Academic art could fantasize about being part of, owning, or exercising power over the places, people and objects depicted, Pissarro's art and the art of the other Neo-Impressionists refuses that fantasy by making the means of representation visible. As in Anarchy, Pissarro's represented figures cannot be owned.

On 13 April 1891, Pissarro wrote to his son Lucien 'I firmly believe that something of our ideas, born as they are of our anarchist philosophies, find their way into our work.' Just by

looking at Pissarro's painting it is difficult, indeed impossible to extract his Anarchist beliefs from what you see in front of you – a group of apple pickers painted in dots of colour. It is equally difficult by just looking at the Courbet to see why one critic complained after viewing *After Dinner at Ornans* that 'no one [but Courbet] could drag art into the gutter with greater technical virtuosity.' In order to circumvent this difficulty the terms Academy and avant-garde have been examined through close analysis of paintings using the approach of the social historian of art. This demonstrates the importance of placing a work of art within its specific historical context.

The concerns of artists, which are in turn part of the wider concerns of the society within which they operate, find their way into their art – through choice of subject and importantly how that subject is represented. It is that 'how' which, through line, form and colour, made Faed's painting Academic, and Courbet's and Pissarro's work avant-garde.

REFERENCES

BEST, G., *Mid Victorian Britain: 1851–75*. London, Fontana, 1971

BRETTELL, R., *Camille Pissarro; A Revision*. London, Arts Council, 1980

CLARK, T. J., *Image of the People: Gustave Courbet and the 1848 Revolution*, London, Thames and Hudson, 1973

HARRISON, J.F.C., *Early Victorian Britain: 1832–51*, London, Fontana (1971) 1988

SELIGMAN, P., *History and Techniques of the Great Masters. Pissarro*. London, Quarto, 1989

SHAPIRO, M., 'The Nature of Abstract Art', *Marxist Quarterly*, Jan–March 1937.

TREUHERZ, J., *Hard Times: Social Realism in Victorian Art*, London, Lund Humphries and Manchester Art Galleries, 1987

MATISSE & THE PROBLEM OF EXPRESSION IN EARLY TWENTIETH-CENTURY ART

JULIE SHELDON

'Expression' is arguably one of the most used and yet least understood terms in commonplace notions of modern art. Over-used, because the capacity for expression is, after all, a distinctly human one enabling, for example, individuals to speak to one another. And misused because in the case of modern art the dialogue between artist and viewer may be conducted in conflicting visual languages. For instance, it seems reasonable to assume that Matisse's *Snail* (1953; Plate 37) must 'mean' something but the expressive language of the work may be at odds with that of the viewer. We should be aware that at best, expression in art has a long and complicated provenance touching on aesthetics and the psychology of art and, at worst, expression has come to qualify motives and methods of the artist, bypassing alternative tools for thinking.

EXPRESSION THEORY

It is not irrelevant (although beyond the scope of this particular chapter) that there are trends in twentieth-century art which have been labelled (albeit *post-hoc*) Expressionist with a capital E. As an adjunct to German-, Abstract-, or Neo-, or as a description of a tendency to distort style or exaggerate emotions in art or film, expression remains part of the currency of modern concepts of art and the individual. It suggests that the artist is a producer of sensations and the primary value of artistic production resides in the artist's ability to experience and convey feeling. Now, although the claim that art reproduces inner states and feelings seems to be a distinctly modern phenomenon, there is, in fact, ample precedence in writings on art from Plato to Gauguin. What is significant for our purposes is that the connections between art and feeling should become the subject of a systematic investigation (Expression Theory) in the first half of the twentieth century.

Taken at its simplest, Expression Theory runs something like this: first the artist experiences a unique intuition, then the artist organizes and articulates it inwardly, and finally endows his or her intuition with an external form – say a painting, a poem or a piece of music. According to this model, art begins within the artist and then finds outward form, thus closely following the etymological origins of the word expression (which means to press or squeeze out). However, since the 1950s, newer theoretical stances have dis-

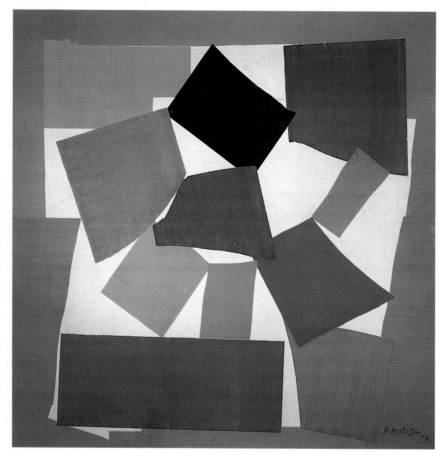

37. Henri Matisse, *The Snail*, 1953, gouache on paper, 287 x 28 cm., Tate Gallery, London.

38. Ernst Ludwig Kirchner, *Bathers at Moritzburg*, 1909–26, Tate Gallery, London.

credited many of the ideas upon which Expression Theory was based. In particular, Structuralist, Marxist and Feminist histories of art find Expression Theory implausible. Just as formalism has been criticized for placing the work of art at the centre of critical inquiry then so theories of expression have been denigrated for pivoting art history around the 'artist'. What Structuralist, Marxist and Feminist art history recognize is that, as a construct of the viewer, the artist embodies a set of cultural ideas many of which change according to conditions of time and place. One of the chief problems of expression today is, therefore, that there is no simple or stable theoretical model which continues to validate its ideas and, furthermore, there is no universally acknowledged authority which underwrites Expression Theory in the twentieth century.

EXPRESSIONISM

When the term Expressionism was first coined it was ostensibly to differentiate between Impressionist and Post-Impressionist art. When,

for example, Herwarth Walden, a German publisher, produced *Expressionism: the Turning Point in Art* in 1918, he included work by Cubists and Fauves as well as work by members of Der Blaue Reiter and Die Brücke. As the subtitle suggests, Walden's central effort was to explain a significant shift or 'turning point' in art. Clearly there was some need in the art community to distinguish between what had gone before (Impressionism) and what was new (Expressionism). Not least in order to make provisions for ways of writing about art which used anti-naturalistic devices – such as illogical perspective, irrational colour and inconsistencies of scale. The previous chapter discusses the avant-garde break with the Academy and how modern art undermined both traditional notions of skill and the academic notion of standard art practice. Correspondingly, Expressionism marked another break with convention – this time the convention that the artist was someone who primarily took his or her cue from the object world. The deliberate abandonment of naturalism evidenced, for example, by Ernst Ludwig Kirchner's *Bathers at Moritzburg* (1909–26; Plate 38) was a

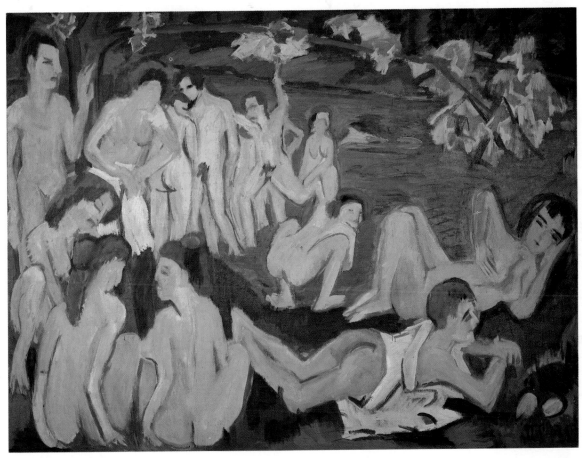

statement of the new confidence of the artist as someone who was a producer and communicator of thoughts and feelings and not just a recorder of visual appearances. What Walden, among others, perceived was that this type of modern art emphasized the subjective and personal vision of the artist to a degree hitherto unknown.

EXPRESSION AND THE ARTIST

According to R.G. Collingwood, a leading philosopher and Expression Theorist of the 1930s, the artist is the agent who is best able to experience emotion and represent that emotion in visual terms. Although more recent theoretical debates within the history of art have tended to decentre such auteurism (the privileging of the artist/author as a self-contained unit in the production of art), the belief that art is about personal expression is still widely held. Then as now, we not only attach a material value to works of art but seem to hold in special regard those who possess the impulse to create. Undoubtedly there has

been an upturn in the fortunes and status of the artist in general in the twentieth century. Henri Matisse, for example, found wealthy patrons forthcoming and, more significantly, indulgent in their purchase of his art works. His *Portrait of Madame Matisse* (Plate 39), exhibited at the first Salon d'Automne in 1905, was bought by the collector Leo Stein who reportedly described it as the 'nastiest smear of paint' he had ever seen and admitted that he would need time to get used to it. On the one hand this anecdote may signal that the successful modern artist had licence to pursue a policy of self expression that not only defied accepted canons of taste but redefined them for the bourgeois market. Alternatively it may imply that self expression was a marketable commodity. More to the point, Leo Stein's anecdotal remarks are reported because they beg the broader question: what historical conditions or combination of circumstances permitted such an unprecedented degree of individual artistic expression in the first place?

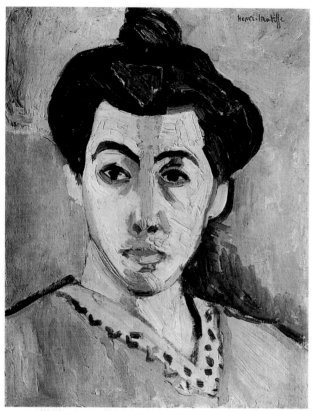

39. Henri Matisse, *Portrait of Madame Matisse*, 1905, Statens Museum for Kunst, Copenhagen.

SELF EXPRESSION

This image of the artist (usually male) working at an easel to create a painting that nobody asked for in the first place gathered momentum in the modern period and was valorized by Matisse. Foremost in his view of art, first outlined in *Notes of a Painter* in 1908, was his insistence on the sanctity of the artist's experience of the object world:

> What I am after, above all, is expression. Sometimes it has been conceded that I have a certain technical ability but that all the same my ambition is limited, and does not go beyond the purely visual satisfaction such as can be obtained from looking at a picture. But the thought of a painter must not be considered as separate from his pictorial means for the thought is worth no more than its expression by the means, which must be more complete (and by complete I do not mean complicated) the deeper is his thought. I am unable to distinguish between the feeling I have about life and my way of translating it.

(Flam, p.35)

Visual perception used to be a branch of the science of optics which assumed that we all perceived the same things in the same way. But by the nineteenth century visual perception was less a question of universal truth and more a way of describing the object world which varied from one individual to the next. As Matisse's statement boasts, seeing and representing an experience on canvas is fundamentally subjective so the artist has creative agency to paint in any way he or she pleases. Moreover, as the remarks of Leo Stein above indicate, for the first time there was an art market – dealers, buyers and galleries willing to pay artists for their unique and subjective vision.

The highly personal nature of artistic expression has a tendency to be compounded by artists talking about their art. Take, for example, this radio interview with Matisse in 1942; he was asked the question, 'to express yourself, how do you go about it?' His reply attempts a crude deconstruction of the relation between mind and matter in his creative practice:

> A study in depth permits my mind to take possession of the subject of my contemplation and to identify myself with it in the ultimate execution of the canvas. The most elementary means suffice: some colours employed without mixing, other than white or black, in order not to disturb their purity and their brilliance. It is only through their relationship that I express myself. As for drawing, I follow my inner feelings as closely as possible. Thus all the intellectual (savante) part of my work is secondary and very little evident.

(Flam, p.92)

This statement makes explicit two key notions of expression – namely that the creative process is largely intuitive and that art is the visual reproduction of feeling. We shall consider the notion of feeling below but first we should give thought to the idea of intuition. We have already encountered the emphasis that Expression Theory places upon the relation between art and emotion. For example, one of its chief exponents, writing in the opening years of the twentieth century, was Benedetto Croce, an aesthetician for whom the artistic personality was utmost in any consideration of art. Croce proposed that art is first and foremost the expression of feeling, believing that the visualization of an artistic image (intuition) was inextricable from the physical realization of it (expression). Moreover, Croce insisted, the posses-

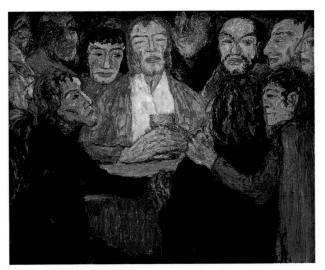

40. Emil Nolde, *The Last Supper*, 1909, Statens Museum für Kunst, Copenhagen.

41. Käthe Kollwitz, *Mourning Parents*, 1931, Vladsloo-Praebosch, Belgium.

sion of intuition and expression were one and the same thing – which he reduced to a formula: intuition = expression – and art is the most highly developed form of intuition-expression (Croce, 1902). To return to Matisse's statement by way of illustration, it emerges that product and process are inseparable parts of the creative impulse. To put it another way, the formation of an idea and the realization of that idea on a two-dimensional support are one and the same thing. This is not to say that Matisse was directly influenced by Croce's aesthetics. On the contrary, Croce's attempt to make expression a science capable of systematic investigation is at best circumstantial, but it demonstrates its topicality nonetheless.

Statements by Croce and other Expression Theorists are frequently (albeit innocently) endorsed by artists. For example, many a maxim issued from the proverbial horse's mouth echoes Expression Theory. Emil Nolde, painter and a member of Die Brücke, paraphrased Croce much more succinctly when he said that, 'instinct is ten times greater than knowledge'. To this end creativity is not simply unconscious and intuitive, it is instinctive. 'The painter doesn't need to know much; it is fine if, led by instinct, he can paint as confident of his goal as when he breathes or walks' (Nolde, 1934). Now while it may seem that for Nolde the artist is led by an elemental impulse to create, we should not undermine his fundamental belief in the authority and validity of this instinct – what amounts to the painter's very sense of self. For instance in works such as *The Last Supper*

(1909; Plate 40) Nolde personalizes his account of the New Testament story which reflects his own feelings towards the subject:

> I doubt that I could have painted with so much power the Last Supper ... so deeply fraught with feeling, had I been bound by a rigid dogma and the letter of the Bible. I had to be artistically free ... The Last Supper ... marked the change from optical external stimuli to values of inner conviction.
>
> (Chipp, p.149)

The role of the self as a filter for 'external stimuli' is equally important to Matisse when he writes on art. Like Nolde his first-person narrative stresses his personal and individual response to the subject. If we look at his paintings, sculptures, drawings, cut-outs and prints then we find that, in general, they do not deal with a great variety of human situations or emotions; usually depicting dancing or seated nudes, figures in interiors or views from an open window. This is interesting when we consider that Matisse's career as an artist was parallelled by two World Wars and a depression. Some art historians have regarded the work of art as an expression of the society in which it was produced. For instance, Arnold Hauser, an exponent of the sociological approach to art, frequently made such claims on behalf of the work of art; seeing the work of art as expressive of some cultural value or crisis. So Käthe Kollwitz's sculpture *Mourning Parents* (1931; Plate 41), by this token, serves to connect art, society

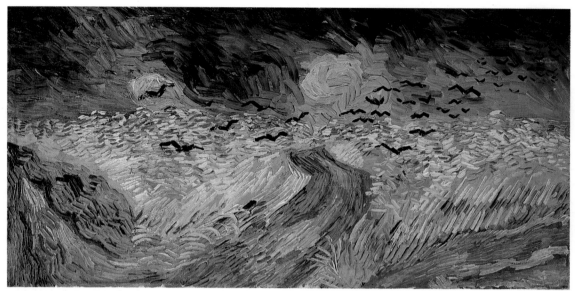

42. Vincent van Gogh, *Wheatfield under Threatening Skies with Crows*, 1890, oil on canvas, 51 x 101 cm., Rijksmuseum Vincent van Gogh, Amsterdam (Vincent van Gogh Foundation).

and the self. As a memorial to the artist's dead son and all soldiers killed in the first World War, it seems reasonable to regard the work as expressive of both an individual's feelings and a nation's emotions. But to what extent is it possible to profitably extend the notion of self expression to collective expression? T.J. Clark, for example, has refuted such connections in *Image of the People* (1973) and dismisses the notion that art in general reflects or epitomizes social values. This implies, according to Clark, that 'all artists experience, answer and give form to their environment in roughly the same way'. (Clark, p.12) Perhaps there are no firm conclusions to be drawn from Hauser or Clark in our analysis of expression. However, their inclusion serves to illustrate that the terms 'self' and 'collective expression' are contended.

FEELING

To return to self expression and to Matisse for a moment, it is true that his art makes no claims to represent any collective political views and that, according to his statements at least, self expression is an end in itself. But it would be misleading to negate the cultural and indeed social significance of Matisse's enterprise. Implicit in Matisse's writings, and particularly in transcripts of his conversations about art, is the belief that the artist in one way or another contributes to human intellectual efforts to understand – to know – the self and to civilize that self.

Leo Tolstoy, the Russian author, also saw art as a civilizing process but drew a distinction between intellect and emotion, 'words communicate thought; art communicates feeling'. It was, he argued, the special nature of visual art that permitted the exchange of feeling, 'it is on this property of men to be infected by the feelings of other men that the activity of art is based'. (Tolstoy, 1896) But how can feeling be infectious? How can the emotions of the artist be transferred to the viewer? We have to be clear that what we really mean by 'the artist' is, in fact, a construct of the spectator. To take an example: Van Gogh is often presented by his biographers or in films as a tortured genius, misunderstood, and working in the face of adversity. By extension, his paintings have been viewed as material expressions of Van Gogh's mournful and lonely life. This is not to say that Van Gogh was not a misunderstood outsider. He may very well have been. The point is that Van Gogh's reputation rests largely upon an anecdotal interpretation of his life which emphasizes the artist's unhappiness in order to account for his use of colour, impasto and selection of motifs. So *Wheatfield under Threatening Skies with Crows* (1890; Plate 42) has a special resonance because we know that it was the last painting he ever did and consequently the formal aspects of the image

socio/econ/politic creations/acts culture

may also be read as the physical manifestations of feeling.

But how useful is it to regard the instinct for and transfer of a feeling as a central tenet of modern art practice? Some theorists have seen this emphasis on 'feeling' in writings about art as a way of depoliticizing modern art practice. Bertolt Brecht, for example, believed that 'art should make you think not feel'. Feeling, according to his agenda, is a crude way of displacing the ability (and perhaps the duty?) of the artist to convey any serious political message. We could contrast Brecht and Kurt Weill (musical collaborators in late 1920s and early 1930s Germany) whose work directly addressed issues of the day with Matisse in the same period running the repertoire of still-lives and women in interiors. We saw above how Matisse appears indifferent to political stimuli but more than this he retreats into personal feelings about himself in order to create art:

> Feeling is self-contained. You don't say to yourself: Look, today I am going to manufacture some feeling. No, it is a matter of something more authentic, more profound. Feeling is an enemy only when one doesn't know how to express it. And it is necessary to express it entirely. If you don't want to go to the limit, you only get approximations. An artist is an explorer. He should begin by seeking himself, seeing himself act; then, not restraining himself, and above all, not being easily satisfied.
>
> (Flam, p.104)

The point to notice here is that, in Matisse's view, what constitutes the most significant feature of his art practice is feeling. To recap, using Matisse's metaphor of exploration, the artist has to chart the territory within (the self) in order to fashion anything on the outside. So if we are to accept this notion that art can express – in the sense of externalize – what is internal, then to what extent is the art work capable of relaying the artist's feelings?

what was internalized.

EXPRESSION AND THE WORK OF ART

In *Art and its Objects*, first published in 1968, Richard Wollheim discusses the 'problem of expression' (one incidentally that has been revised since) and the main dilemma for him comes down to, 'how can anything purely physical be expressive?' (Wollheim, p.38) He goes on to detail some

of the ways in which artists and writers have overcome the materiality of the art work, including discussions about 'state of mind' and 'correspondence'. But for our purposes the problem of expression in modern art may be reduced to: why in the modern period have works of art been invested with an expressive significance that they have not (consciously at least) possessed in the past? The question to ask at this point, is not how artists became the producers of sensation, but how those corporeal masses – art works – became the carriers of sensation.

limited possible in past imposed by audience

FORM

To understand how art works can be expressive we first have to accept this proposition – that art conveys in physical form what is abstract (the artist's mood, temperament, beliefs and ideas). An example we could use is the so-called 'expressive surface' whereby mood and materiality may be one and the same thing. That is, the way in which paint is laid on canvas may recall the emotions felt by the artist or the emotion suggested by the subject of the art work. We have seen how the swirling impasto of Van Gogh's *Wheatfield with Crows* (1890) may be read as a portent of the artist's agitated emotional state just days before his suicide. Another example might be the shattered and claustrophobic perspective and acid colours of Georg Grosz's *Suicide* (1916; Plate 43) which reinforce the dark subject matter (prostitution, drink and death) of the painting. In both cases the images are not simply representations of the outside world, they are entities – capable of expression in their own right. Their very arrangement of paint on canvas expresses meaning to the viewer.

We have established that, on the face of it, modern art seems to embody individual expression to a degree hitherto unknown and how the artist has apparent freedom to choose the subject of art and the means of artistic expression. Two general attitudes toward expression have emerged from this apparent freedom: one favoured expression through partial or total abstraction; the other figurative. Both approaches however, have tended to flag the expressive surface as an important feature of modern art. The signature style of the artist – those distinctive marks which distinguish the hand of one artist from another – has become a significant feature of our commerce with modern art. For example, Wassily Kandinsky's

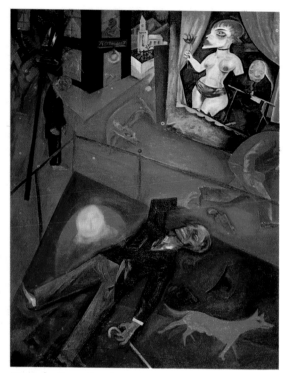

43. Georg Grosz, *Suicide*, 1916, oil on canvas 100 x 78 cm.,Tate Gallery, London.

Cossacks (1910–11; Plate 4) is an 'abstracted' image where the viewer is denied detailed references to the object world (beyond the suggestion of its title) and is left to regard the expressive meaning of colour and form – which is probably the most profitable way into the painting since he claimed that form is 'the external expression of inner content'. Accordingly, the expressive mark is a trace of the artist left behind in paint. To extend this logic, colour, line, and form are capable of expression in their own right because they are the material consequences of the artist's feelings towards his or her subject. Matisse certainly supported Kandinsky in this:

> Expression, for me, does not reside in passions glowing in a human face or manifested by violent movement. The entire arrangement of my picture is expressive: the place occupied by the figures, the empty spaces around them, the proportions, everything has its share. Composition is the art of arranging in a decorative manner the diverse elements at the painter's command to express his feelings.
>
> (Flam, p.36)

But what happens when the 'painter' expresses him or herself without recourse to 'painting' in the conventional sense of the word? *The Snail* (1953; Plate 37) is one such work by Matisse. Using large squares of paper coloured with gouache and assembled on a square support, the work reportedly recalls the spiralling shape of a snail's shell. It is possible to analyse *The Snail* purely as an expression of the artist's belief or emotion but this would only go part way to explaining the art work. It is useful, for example, to know that owing to ill health Matisse was bedridden in the last years of his life and that 'cut-outs' were a means of overcoming his inability to paint. So is it entirely accurate to account for the form of *The Snail* solely in terms of the artist's free choice without some attention to the circumstances that produced it?

THE PRIMITIVE

Although detailed discussions of primitivism exist elsewhere in this book, it is worth reiterating some of those themes here because European artists learned – or at the very least validated – many of their ideas about new formal and expressive means of depiction on the basis of an (admittedly) incomplete knowledge of non-European art. There are several definitions of 'the primitive' and the term is still subject to revision. In this section primitivism is used as it was understood by Matisse and his contemporaries; that is to label art produced outside a European tradition – specifically, African, Oceanic and South American art. This art was admired and its effects were imitated by avant-garde artists such as the Fauves, the Cubists and the German Expressionists. The Fauve painter Maurice Vlaminck first began collecting African masks and carvings in 1904 and Matisse and Picasso followed soon after. Each assimilated something of the stylistic impact of African work into their own art – in particular, its simplification of form – and, as a result, 'primitive' also came to describe the style of these imitations.

The whole issue of cultural appropriation raises some interesting questions – nearly all of which are beyond the remit of the present chapter. More productive to our purpose is to question (rather than ascertain) the motives of Matisse and his contemporaries. What did they hope to achieve by appropriating non-European artefacts? Conventional histories of art tell us how 'tribal' carvings taught avant-garde artists that their ideas could attain physical form without recourse to traditional pictorial refinements. For instance,

the adopted practice of so-called 'direct carving' in the early twentieth century dispensed with some of the traditional tools of the sculptor's trade so that artists such as Hans Arp, Ossip Zadkine and later Henry Moore carved pieces without the use of detailed preparatory drawings, models or measurements. This was because these artists regarded the creative process that fashioned an African mask or a totemistic carving as more intuitive and direct than that which produced, say, a classical bronze equestrian statue. And why would an artist be interested in directness? Probably because by liberating the work of art from academic discipline they might enhance its power of expression. The belief that 'the primitive' entailed pure, unmediated expression was, in fact, something of a misconception since 'tribal' art usually follows strict codes and traditions. Nevertheless, the fact remains that, under the influence of 'the primitive', there was a significant rejection of European pictorial conventions after 1906 and expression plays an important part in the language of this secession.

Matisse himself began collecting African art in 1906 and Islamic art soon after. His reasons for doing so at that particular time are suggested here:

> When the means of expression have become so refined, so attenuated that their power of expression wears thin, it is necessary to return to the essential principles which made human language. They are, after all, the principles which 'go back to the source', which relive, which give us life. Pictures which have become refinements, subtle gradation, dissolutions without energy, call for beautiful blues, reds, yellows – matter to stir the sensual depths in men. This is the starting point of Fauvism: the courage to return to the purity of the means.

> (Flam, p.74)

The key phrase for our purposes here is 'go back to the source'. Not only is it central to Matisse's thinking at that time, it is also characteristic of Expressionism as a whole. For these artists the primitive was the flip-side of culture, denoting 'under-developed' or 'un-tutored'. Going back to the source was a quest for the origins of expression in European folk-art or non-European 'tribal' art in the belief that this exercise would recover something that had been lost in the modern world.

Matisse's *Portrait of André Derain* (Plate 44) painted at Collioure in the South of France in the

44. Henri Matisse, *Portrait of André Derain*, 1905, Tate Gallery, London.

summer of 1905 abandons certain conventions of portraiture. In many ways the picture sums up the outlook of Fauvism. It is a painting of one Fauve by another and recalls the informal grouping of artists under the nominal leadership of Matisse. But more than this it is a statement of the painter's faith in the rendering of sensation. Matisse's writings often suggest that his choice of palette arises from an instinctive and largely inarticulated personal sense of appropriateness. This was not an entirely novel proposition. For instance Gauguin's doctrines on expressive colour had also described the use of anti-naturalistic colour – imaginative and non-literal – as matters of personal choice for the artist. Moreover, Gauguin had expounded a theory of the 'noble savage', a state to which he actively aspired through his own return to 'source' (this time in the islands of the South Seas). Similarly, the bold colour scheme, crude contours and brisk brushwork of Matisse's portrait seemed so aggressively modern to its critics, that they coined the term 'wild beasts' (Fauves) to describe him and the artists who worked alongside him. The choice of

45. Henri Matisse, *Bonheur de Vivre*, 1905–6, oil on canvas, 174 x 238 cm., The Barnes Foundation, Merion Station, Pennsylvania.

wild beasts is significant because it recalls contemporary notions of the primitive as savage or untamed and anticipates the conscious adoption of the label 'savages' by the artists of Die Brücke.

EXPRESSION AND THE VIEWER

Apparently Matisse used to say to his students: 'You want to be a painter? First of all you must cut out your tongue because your decision has taken away from you the right to express yourself with anything but your brush.' (Flam, p.92) The implication of this rather extreme piece of wisdom for the viewer of modern art is that the expressive meaning of art is firmly located in the work of art itself. We have seen how art works are capable of expressive meaning and how the artist acquired creative agency to express feelings using a variety of pictorial means. But the equation between expression and expressed is incomplete without a viewer to receive the signal. After all, what use is a work of art if its expressive content is not communicated – if there is no match between what the artist expresses and the viewer feels? Is the viewer really able to reconstitute the psychic state of the artist from a work of art? Or are art works independent of their creator and capable of individual expression?

INTENTIONALITY

At this point it is useful to distinguish between the emotions represented in the work of art and the emotional response felt by the spectator. For example, Matisse's *Bonheur de Vivre* (1906; Plate 45) is an emotion of joy represented within the painting. The formal properties of the work – lighting, colour, texture – may combine to underscore the emotion represented by the painting. But

the viewer may experience an altogether different emotion when looking at the work. Therefore it is not only important to separate the viewer's notion of what a work expresses from that of the artist's, but also to recognize the difference between speaking of a work of art expressing something or speaking of the artist expressing something. Often, the position of the spectator in relation to modern art is problematic. Take for instance, Kandinsky, who berated the viewer for missing the point of modern art in 1911:

> The spectator is too ready to look for a meaning in a picture – i.e., some outward connection between its various parts. Our materialistic age has produced a type of spectator or 'connoisseur', who is not content to put himself opposite a picture and let it say its own message. Instead of allowing the inner value of a picture to work, he worries himself in looking for 'closeness to nature', or 'temperament', or 'handling', or 'tonality', or 'perspective', or what not. His eye does not probe the outer expression to arrive at the inner meaning.
>
> (Kandinsky, p.49)

This statement is significant insofar as Kandinsky insists that the viewer need only regard expressive qualities of the work in order to understand it. But more relevant for our purposes, is the implication that the dialogue between artist and viewer defies articulation. The psychology of Gestalt was highly topical around the time Kandinsky was writing in Germany. Gestalt is the German word for pattern and insists that the organized whole of a painting or a piece of music has qualities different from those of its component parts considered separately. Kandinsky seems to be asking his viewer to regard the entire configuration of his paintings in order to understand the sum of its parts. While not exactly an overt endorsement of Gestalt theory, this description given by Matisse of his drawing appears to share Kandinsky's broad philosophical beliefs:

> I have never considered drawing as an exercise of particular dexterity, rather as principally a means of expressing intimate feelings and describing states of mind, but a means deliberately simplified so as to give simplicity and spontaneity to the expression which should speak without clumsiness, directly to the mind of the spectator.
>
> (Flam, p.81)

This begs the question what exactly is the mind of the spectator? We have seen how the artist can be a construct of the viewer. By the same token there is no such thing as a neutral spectator; each viewer approaches modern art under a specific set of conditions. Conditions of class, race and gender may impinge on the way in which the viewer looks at a work of art – more so perhaps than the mood of a viewer at a particular time. So we are not really free to read a painting – on the contrary the meaning of an art work (expressive or otherwise) is often fixed for us – for example by the ways in which we have been socialized. We are left with a problem, nonetheless. How can the artist address the 'mind of the spectator' with any degree of confidence that his or her message will be understood by the viewer? If we accept Matisse's view that art is principally a form of self expression then are the consumers of art active or passive in the production of expressive meaning?

EMPATHY

Faced, nonetheless, with this apparent belief by artists such as Matisse that communication in art bypasses all the phases of human cognition and addresses itself directly to the mind, then it is perhaps not surprising that the viewer has called upon the services of a medium – the art critic – to explain modern art. The role of the critic as interpreter is beyond the scope of this present chapter but it is always worth asking just how far our own 'readings' of art have been negotiated by a body of experts who have cordoned off a specific area of knowledge – the history of art. More to the point of this chapter, however, is the question of projection and identification between art work and viewer. Like Gestalt theory, Empathy theory was also topical in the early years of the twentieth century. Used in a pseudo-psychological sense to describe the projection of the self into the feelings of others, it also came to denote the projection and identification of the self with inanimate objects – such as paintings. To begin with, we have seen the problems inherent in regarding art works as the embodiments of expression. Finally we should note that the relationship between artist and viewer is seldom uncomplicated.

In the case of Matisse then the empathetic projection from audience to artist was not always realized. At the International Exhibition of Modern Art (now better known as the Armory Show) which opened in New York in 1913, Matisse was the leading target of vitriolic attacks

46. Henri Matisse, *Blue Nude (Souvenir of Biskra)*, 1907,
oil on cavas, 92 x 140 cm. Baltimore Museum of Art,
Maryland, the Cone Collection.

by American art critics. His erratic use of colour
and distortion of form in paintings such as *Nude
(Souvenir of Biskra)* (1907; Plate 46) confounded
the general public and critics alike. Far from iden-
tifying the artist's expressive message, they poured
scorn on this new way of painting, suggesting the
artist's vision was a fraudulent one. It is possible
to cite numerous other occasions when modern
artists have been ridiculed by their public. The
exhibition of Degenerate Art (*Entartete Kunst*) in
Germany in 1937 was staged with the specific
intention of undermining the art of the German
Expressionists among others. But as modern art
became an increasingly collectable commodity in
the United States then so Matisse found consider-
able success there. Similarly the exhibition of
Degenerate Art was reconstructed in 1992 in
Berlin to redress historical wrongdoing. So can we
conclude that successful expression merely implies
a correspondence between artist and audience?
Must the viewer always acquiesce with the artist?

And why does the artist's expressive message often
seem to lie in wait for future, sympathetic audi-
ences?

Expression Theory has some answers.
Tolstoy's belief that art communicates feeling, out-
lined above, further insisted on the match between
artist and audience. 'The moment the spectators,
the hearers, are infected by the same feeling which
the composer experienced, we have art.'
Collingwood expanded upon this dialogue
between artist and audience in *Principles of Art*.
Using the analogy of the poet, Collingwood
describes the artist as someone,

> who can solve for himself the problem of
> expressing it (emotion), whereas the audience
> can express it only when the poet has shown
> them how. The poet is not singular either in
> his having that emotion or in his power of
> expressing it; he is singular in his ability to take
> the initiative in expressing what all feel, and all
> can express.

So while Expression Theory may place the artist at the centre of art history and critical inquiry, it also satellites the audience. To pursue this image: Expression is not the exclusive preserve of the artist; each one of us, presumably, has some capacity for expression and some outlet in which to vent it. Nor is expression restricted to the visual arts – many activities can claim to be expressive outlets of one form or another for groups or individuals. What Expression Theory does insist on is that the artist's physical realization of experience or feeling is a unique one.

Conclusion

These observations on the uses of expression, if they are correct, raise more questions than they answer and so have implications for the present time. As we have seen, all too often the language of expression evades useful definition. But herein lies its appeal. It dissuades the viewer from scrutinizing the function of art and its images too closely. How often do students of art avoid answering any probing questions about the nature and function of modern art by using the old standby that the artist was merely 'trying to express him/herself'? Used in this way, expression saves us the task of qualifying the motives and intentions of the artist, studying the period or area in which it was produced or considering the art work in relation to issues such as class, race or gender. It is undoubtedly reasonable to consider the art work as an 'expression', but only insofar as it is mediated by a consideration of a particular set of historical circumstances, which have combined to privilege the artist.

REFERENCES

BARTHES, R., 'The Death of the Author', *Image–Music–Text*, London, Fontana, 1977, pp.142–8

BARTHES, R., 'The Third Meaning', *Image–Music–Text*, London, Fontana, 1977, pp.52–68

CHIPP, H.B. ed., *Theories of Modern Art: A Source Book by Artists and Critics*, Berkeley, Los Angeles and London, University of California Press, 1968

CLARK, T. J., *Image of the People: Gustave Courbet and the 1848 Revolution*, London, Thames and Hudson, 1973

COLLINGWOOD, R.G., *The Principles of Art*, Oxford University Press, (1938) 1974

CROCE, B., *Aesthetic as Science of Expression and General Linguistics*, 1902

FLAM, J.D., *Matisse on Art*, Oxford, Phaidon, 1973

FOSTER, H., 'The Expressive Fallacy', *Recodings: Art, Spectacle, Cultural Politics*, Seattle, Bay Press, 1985, pp.59–77.

HAUSER, A., *The Social History of Art*, 4 vols, London, Routledge, 1962

JAMESON, F., 'The Deconstruction of Expression', *Post-Modernism: or the Cultural Logic of Late Capitalism*, London, Verso, 1991

KANDINSKY, W., *Concerning the spiritual in Art*, New York, Dover (1911), 1977

NOLDE, E. 'Jahre der Kampfe', 1934, trans. Chipp, op.cit., 1968

POLLOCK, G., 'Art, Artschool, Culture: Individualism After the Death of the Author', *Block*, 1985

TOLSTOY, L., 'What is Art?' (1896), *Miscellaneous Letters Count Leo N. Tolstoy*, trans. L. Weiner, London, Dent, 1902

WOLFF, J., 'The Death of the Author', *The Social Production of Art*, London, Macmillan, 1990

WOLLHEIM, R., *Art and its Objects*, London, Penguin, (1968) 1978

47. Pablo Picasso, *The Three Dancers*, 1925,
oil on canvas, 215 x 142 cm. Tate Gallery, London.

PICASSO & THE THREE DANCERS

PAM MEECHAM

Few artists have been subject to such persistent mythologising and valedictions as Picasso, his face, life and loves no less than his stylistically diverse, eclectic body of work. So important does Picasso become that his personality and biography threaten to swamp some accounts of his work. Picasso, continually experimental, leader of the avant-garde, appears and reappears in the narrative of twentieth-century art. In a range of guises the artist, who died in 1973, seemed to be simultaneously innovator, genius and magician; a protean versatile creator described by his contemporary, André Salmon as 'alone between earth and heaven' (Alley, 1986). He presided over an avant-garde within an avant-garde and became the bench mark by which all artists who would be 'modern artists' would judge themselves. However, despite the widespread institutional, critical and popular acclaim, Picasso's position and the significance of his work is and has been the source of much controversy. If our curiosity about him and his work shows no sign of diminishing (witness his appearance in this book), it is at least in part because his work remains unresolved in terms of its precise meaning, presenting challenges in interpretation. It is still the subject of debate, the nature of the debate itself changing as new ideas emerge about how works gain currency in critical practice. An example, *The Three Dancers* (1925; Plate 47), provides a case study for the fought over arena that Picasso's work and life currently occupy, serving to demonstrate the complexity of reading a work of art. Recognition is the first step in decoding an image, but beyond recognition there is the possibility of interpretations.

Even a cursory glance at *The Three Dancers* will reveal a large painting showing uneven thickness of paint, cracks, and angular distorted figures in unsubtle colours. There is little sense of Matisse's dream of an art 'of balance, of purity and serenity, devoid of troubling subject matter, an art which could be for every mental worker ... which provides a relaxation from physical fatigue' (Matisse, 1908). When *The Three Dancers* was first shown in Picasso's studio, even his most enthusiastic followers reacted with a mixture of awe, dismay and incomprehension. The painting's apparent unwillingness to act as a form of relaxation and contemplation might encourage reference to other Picasso works from that period. There are however no studies or preliminary drawings of *The Three Dancers* to work with. It is often useful to refer to paintings of the same period to see if the work can be contextualized within a broader framework. However in this case it only helps obliquely by establishing what the painting is not.

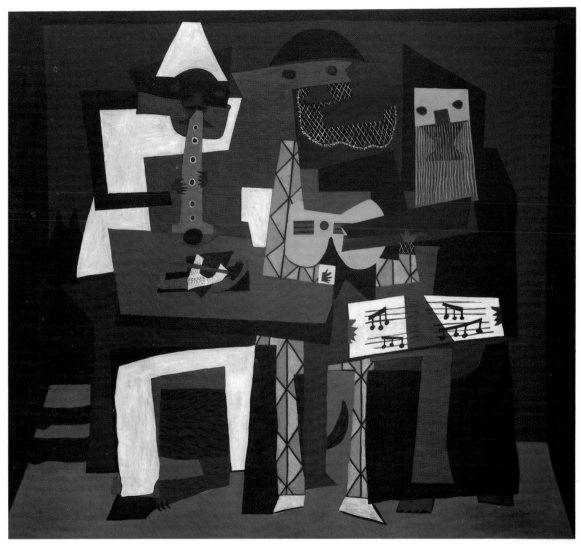

48. Pablo Picasso, *The Three Musicians*, 1921, oil on canvas,
201 x 223 cm. Museum of Modern Art, New York,
Mrs Simon Guggenheim fund.

Since 1914 Picasso had begun to paint in a more naturalistic way even as he continued to develop Cubism. By 1924, after the predominance of a series of neo-classical paintings in Picasso's work, *The Three Dancers* almost looked like a resumption of earlier concerns. The last major work in this late Cubist manner had been *The Three Musicians* of 1921 (Plate 48) but even that lacked the overt aggression and violence connoted by the distortions apparent in the later work. Picasso's turn to a neo-classical style during and after the first world war has been the subject of much debate.[1] Some have claimed that the works aligned him with conservative forces in French society, others have suggested that Picasso's innovative status remained intact as the works do not conform to an orderly version of the classical: that their oddities and distortions made them instead an ironic commentary on the contemporary fashion for classicism. After 1918 France, disrupted by war, became subject to a 'call to order' and artists were no less implicated in this than anyone else. For many painters this meant a re-working of an older more stable, more orderly art associated with the French classical tradition stretching back to Poussin's example and a rejection of many of the technical and critical innovations of the previous twenty years most notably those of Cubism. Picasso's work of the post war years does use classical iconography, but he frequently and subtly subverts the classical reper-

49. Lee Miller, *Picasso and The Three Dancers*, photograph, 1965.

toire. It is this aspect of even his neo-classicism that allows him to be seen as continuing rather than retreating from the pre-war avant-garde which he had done so much to establish.

What then can *The Three Dancers* tell us? The photograph (Plate 49) taken by Lee Miller in January 1965 shows Picasso standing in front of his work. This gives it scale showing the three figures as life size with the canvas as a whole measuring about seven feet high by five feet wide. At its most rudimentary level the image shows three dancers in front of a half open French window with a balcony. The walls of the room in which they stand are covered with an inconsistently coloured patterned wallpaper that in its motif can be seen to echo the shape of the dancers. The perspective is uncertain – the picture space is shallow and it is impossible to tell whether the window opens out onto the balcony or into the room in which the dancers – and presumably ourselves – are standing.

A closer look at the three figures reveals ambiguities that need to be accounted for. They are outlined in black, a technique Picasso used at this period, but they bear little resemblance to each other stylistically and have heads that can be read in at least two ways. The most distorted figure on the left can be seen to have two faces. One of these faces, which reads as a crescent moon looking inwards from the left edge of the painting, is almost gentle in countenance. The second face, closely attached to the crescent which helps to form its three spaces (eyes and nose) is turned on

its side. It is arguably aggressive and mask-like with sharp gaping teeth and red lips. Another eye-like form appears schematically to double as a left breast in this figure.

The central figure has a similar duality of features. It can be read with the head upright or with the head on the side. Read vertically the eye doubles as a mouth, becoming huge, grinning widely and wildly, contrasting with the neat, tight slit of the horizontal head, which together with the triangular nose and rigid schematic eye looks almost aloof and prissy.

The third head on the right is no less ambiguous. It has a small neat flat profile in brown surrounded by a second darker, more naturalistic silhouetted profile. What are we to make of such a complicated set of heads? The nudity of the central figure, the suit-like planes of the right figure and the dishevelled nature of the figure on the left's clothes, further compound the complexity of interpretation. Here, a thickly painted white broken line across the right shoulder suggests, with the 'pleating', some kind of classical shift or robe. In fact, Picasso was working on other paintings at this period where the classical shift or chemise is utilized. There is also the possibility that the folds refer to the Charleston, this being Paris of the 20s. The curious zigzags and the black slit against the blue background have been interpreted as sexual references. Ronald Alley delicately suggests, 'the patch of sky and a railing lower down, glimpsed through the skirt, alludes in an even more intimate way to the femaleness of the sex.' (Alley, 1986) The black slit can indeed be read as a schematic rendering of female genitalia or simply as a vent in the garment revealing the balcony beyond. The lack of implied depth in the picture helps create the ambiguity. In a more speculative interpretation the zigzags have been seen as saw-like and an allusion to male fear of castration, thus demonstrating Picasso's conscious or unconscious fear of women.

How could such readings have arisen; how much credibility might they be given? Are these interpretations read into the work from outside – for example from critics' preoccupations – or can they be seen as generated from the work? We know Picasso enjoyed punning and obscure joke telling. In his personal correspondence and painting he often left a word to be completed by the reader or viewer. These jokes often involved sexual, musical and journalistic word play. It is not unusual therefore to find some difficulty in interpretation in Picasso's paintings. However

50. Pablo Picasso, *Portrait of Olga in an Armchair*, 1917, Musée Picasso, Paris.

acknowledging a liking on Picasso's part for playing games, often with an intimate group of friends, does not get us far in the interpretation of some works.

Biographic details might shed some light on *The Three Dancers*. During World War One Picasso who had continued working in Paris, became very interested in the ballet, specifically working with the impresario Serge Diaghilev's Ballets Russes for whom he designed sets. He worked with Jean Cocteau on the ballet *Parade* with music by Erik Satie, demonstrating his ability to mix styles and media – some characters were dressed in Cubist costumes but the stage sets incorporated both cubist and baroque elements. The designs for *Parade* were very successful, much more like circus and carnival than traditional ballet. It was incidentally in the programme for *Parade* that Apollinaire linked Picasso and Surrealism (see Chapter 6 and Glossary), an association to which we will return. Picasso subsequently married Olga Kokhlova (Plate 50), a dancer with the Ballets Russes, in 1918, consolidating his links with the ballet and high society. He spent some of 1925

(the year of *The Three Dancers*) drawing in rehearsals in Monte Carlo, but the drawings have only the subject matter in common with *The Three Dancers*. Stylistically it bears no resemblance to them. However, by 1925 Picasso's marriage was already in difficulties, as was his collaboration with Diaghilev and in late Spring he returned to Paris. By July the painting was reproduced by André Breton in the publication *La Révolution surréaliste*. We must assume therefore that it was painted within three months, sometime between April and June 1925. It is unlikely that Picasso began the work earlier in Monte Carlo and transported it back to Paris. We now have to take into account a factor which has come to colour subsequent interpretations of the painting's meaning and content. Forty years later Picasso remarked to Sir Roland Penrose (who negotiated the sale of the picture to the Tate Gallery, London, in 1965) that 'while I was painting this picture an old friend of mine, Ramon Pichot, died and I have always felt that it should be called *The Death of Pichot* rather than *The Three Dancers*. The tall black figure behind the dancer on the right is the presence of Pichot.' (Alley, 1986)

X-rays show that Picasso did alter the work from more rounded forms to the angular work we now see. The biographic details may help us to understand why Picasso altered his painting to include, say, the dark Pichot presence. They do not however account for the particular way in which the form of the painting changed. Too often explanations of art rooted in biography do not attempt any formal analysis. How can we account for the changes from rounded, naturalistic forms to what have been described as more expressive forms, forms which have been interpreted as marking 'the beginning of a new period of emotional violence and expressionist distortion' in Picasso's art? It was largely due to the character that the painting had, which in turn is traceable to its technique of flattened angular forms and compressed pictorial space, that Alfred H. Barr (curator of the Museum of Modern Art, New York) claimed 'The metamorphic *Three Dancers* is in fact a turning point in Picasso's art almost as radical as was the proto-cubist *Les Demoiselles d'Avignon*.' (1907; Plate 3; Barr, 1946). *Les Demoiselles d'Avignon* claims a major space in Picasso's innovative production. It is commonly seen as altering the grounds on which paintings were made.

Barr is making a very great claim indeed for the significance of *The Three Dancers* in Picasso's output. The question we need to ask, perhaps, is

not so much what does it mean, because for what it's worth Picasso has already told us. The more fruitful line of enquiry to pursue is 'why is it as it is?' or 'how does it mean?' How does the significance Barr gives it accrue to this work, and what does that significance consist of?

First then some more context. The death in 1925 of Ramon Pichot, a Spanish painter friend of Picasso, appears to have resurrected the grief felt at the death of another Catalan friend – the suicide in 1901 of Carlos Casagemas. Casagemas had been the model for Picasso's *La Vie* (1903; Plate 51), one of the major works of the so-called Blue Period. He was apparently sexually impotent and his unsuccessful affair with Germaine Florentine, who was also an artist's model involved with Picasso, resulted in the attempted murder of Germaine and his own fatal shooting. Germaine subsequently married Ramon Pichot, which is presumably why Pichot's death a quarter of a century later, summoned up in Picasso's mind memories of the complicated *ménage*, perhaps compounded by the complications of his own marriage in the spring of 1925. Picasso had been close to Casagemas, although he was not in Paris at the time of the suicide. He subsequently worked through a series of memorial drawings and paintings after his friend's death. Following this line of enquiry, it has been suggested of *The Three Dancers* that Germaine becomes, at re-painting, the figure on the left. Casagemas becomes the crucified figure in the centre and Pichot the dancer with the ghostly presence on the right. Various technical features of the painting have been invoked to support this reading with various degrees of plausibility. For example the black 'fingers' can be read as large nails. Also the wallpaper motif can be interpreted as a cyrillic character from the Russian alphabet that sounds the same as the beginning of the name Germaine and of course Olga was Russian. Furthermore Picasso was a Spanish Catholic so the crucifixion reference is not of itself impossible either consciously or unconsciously.

Picasso's relationship with women was problematic, not least to those who would see the women in his works. Women close to Picasso were often destroyed by the nature of the relationship. The charge of misogyny is often laid at his door. Picasso's biographer Richardson, however, claims not only that Picasso put his misogyny to good use in his art, but also that some works have greater power because of the misogyny that went into them. Needless to say this assertion has not gone unchallenged. So closely is Picasso's art associated

51. Pablo Picasso, *La Vie*, 1903, oil on canvas, 196.5 x 129.2 cm. The Cleveland Museum of Art, gift of the Hanna Fund.

with the women in his life that some historians have identified periods of his work as the years of Olga Kokhlova, Marie-Thérèse, Dora Maar or Jacqueline Roche etc. Is it possible therefore to read *The Three Dancers* as some sort of cathartic experience – a working out of anger against Olga perhaps, transferred to Germaine who is in turn blamed in some way for Casagemas's death? The left hand figure is wild, almost Bacchanalian, in exaggerated abandon, while the central figure is almost prim in its vulnerability and the third figure on the right could be read as a looming deathly presence. But then do we need to exercise care here, even a degree of scepticism? Do these types of readings border on the fanciful? Do they invite tragic analysis as an easy option? Do they depend on notions of expression that are difficult to verify? These are all important questions. The point, perhaps, is not to agree or disagree, but to be aware on

the one hand that serious problems accrue if we read works as experience of incident in the artist's biography with insufficient regard to questions of technique, avant-garde culture etc., yet on the other hand to be no less aware of the dangers of an empty formalism if we evacuate all reference to a life outside art from our consideration of the painting as a painting. That is to say, a reliance on a reading that only deals with the appreciation of line, tone, colour and mass, but without analysing the significance of subject matter or historical context may lead to fundamental misunderstandings about the function of an artwork.

There is of course a sense in which all art is autobiographic but to read art works as merely a reflection of an artist's life or inner state may be simplistic and reductive. Roland Barthes has argued that 'a desire, a passion, a frustration, may very well produce exactly contrary representations; a real motive may be inverted into an alibi which contradicts it: a work may be the very phantasm which compensates for the negative life....' The work of art will never be anything else, if it is continually shackled to artists' intentions and biography. All works are mediated in some way. Paintings are complex products with, so to speak, a life of their own, just as a play or a novel though produced by an author with a life will represent more than that biography alone. Rooted in biographical experience, works of art generalize. To the extent that they represent relations and states of mind, these are not the sole property of the author. Nonetheless the process of what Rosalind Krauss characterizes as 'positive identification' (Krauss, 1981) has become something of an industry where Picasso is concerned, and we have to remain alert to the problems such biographical readings carry with them. Krauss charts the changes in recent scholarship in the reading of *La Vie* (1903; Plate 51) since its identification with Casagemas, stating,

> But once a real person could be placed as the model for the standing male figure – moreover a person whose life involved the lurid details of impotence and failed homicide but achieved suicide – the earlier interpretations of *La Vie* as an allegory of maturation and development could be put aside for a more local and specific reading.'
> (Krauss, 1981)

The reading of the middle figure as the impotent Casagemas when the figure is clearly identifiable as female raises questions about the viewer's association of male impotence with the female. Since Picasso had already reworked the picture but left the central figure as female are we to assume that, he too felt that a less than sexually virile male should be represented by a female? Is the Casagemas reading untenable or just unpalatable? Is Woman forced to play 'other' to Man's 'absolute'? Even the biographical reading coming from the horse's mouth itself is not as secure as it may seem. Picasso laid the seeds of autobiography as a way of reading his works by relating the Casagemas story in 1965. But he then apparently contradicted himself by saying of *The Three Dancers* that it was a better painting than *Guernica* (Plate 90), the large and overtly political mural he painted during the Spanish Civil War, which is perhaps his most renowned single work, since 'It's more a real painting – a painting in itself without any outside considerations.' We might want to question what Picasso means by 'a real painting' and we might be sceptical about the possibility of a painting 'without any outside considerations' but there is no doubt that Picasso's different remarks do compound the issues at stake.

If perhaps what Picasso meant was that *The Three Dancers* was a work that he closely identified with himself as opposed to *Guernica*, a work that is somehow outside because it was 'political', other issues are raised. Perhaps to Picasso a 'real' painting was about him, i.e. of him, or his subjectivity, of his own experience. The separation of the personal from the political is highly problematic but given the context of the day Picasso's words do find some echoes in the developing world of psychoanalysis, to which many artists were increasingly drawn.

Carl Jung argued the case for an understanding of the importance of the 'unconscious' in interpreting art works as did Freud in his study of Leonardo. In an article about Picasso written in November 1932, in *Neue Zuricher Zeitung*, Jung suggests that non-objective art draws its contents essentially from 'inside'. He argues that Picasso's work, as it becomes less concerned with the external appearance of things in an empirical sense – recording accurately – becomes more about the unconscious, so he maintains that pictorial elements which do not correspond to any 'outside' must originate from 'inside'. This is a complex area and can be frustratingly elliptical in argument since psychoanalytic theories of art cannot be tested. The existence of an inner or essential self has also become a contested area – as the unconscious

has been since Freud's attempts to understand its presumed functioning. It could also be argued that pictorial elements always, no matter how obliquely, refer to something outside. It is also more than a pedantic quibble over terminology to suggest that 'non-objective art' is not a satisfactory description of Picasso's work. If used, however, it does fit more exactly with Jung's theories of the internal corresponding to some notion of non-representational painting. Jung argues that Picasso's work reveals 'alienation from feeling':

> At any rate they (paintings) communicate no unified harmonious feeling-tone but, rather, contradictory feelings or even a complete lack of feeling. From a purely formal point of view, the main characteristic is one of fragmentation, which expresses itself in the so-called 'lines of fracture' – that is a series of psychic 'faults' (in the geological sense) which run right through the picture. The picture leaves one cold, or disturbs one by its paradoxical unfeeling, and grotesque unconcern for the beholder.
>
> (Jung, 1932)

Jung was not talking specifically of *The Three Dancers*, however there is a sense in which he mirrors the reception the work received even from Picasso's most ardent devotees. Jung continues to relate Picasso's work to a symbolic content, a sense of the primitive and associations with Faust, metamorphosis and the pagan, a decidedly darker side. Psychoanalytic theories when related to art works, focus on readings that interpret paintings and sculptures in the context of the psychic life of the individual artist. In these theories society in art production plays a less significant role. The major difficulty with psychoanalytic theories, while they can be very useful in uncovering sublimated motivation or even unconscious attitudes on the part of both artist and viewer, is that motivation and its visible outcome are very difficult to articulate and substantiate. There are however sound enough reasons for using them as a 'tool' to gain some understanding while acknowledging the limitation of the process.

Picasso was not an official member of the Surrealist Group, but he was frequently co-opted by others to give weight to their claims for avant-garde status. *The Three Dancers* does however fit entirely within a general conception of what might constitute a surrealist art practice. Women, as artist and muse, subject and object were fundamental to the Surrealist project. In 1929 André Breton could write 'The problem of women is the most marvellous and disturbing problem in all the world.' Few art movements since Romanticism have treated women as so central to their art, orbiting both as creative and created around the machismo of a perceived notion of the artist. This mythology around women and male genius is a challenging area of debate. Michel Leiris, the Surrealist poet, quotes Picasso as saying 'What is a painter? A man who works with brushes, a dauber, an unrecognized genius, or a demiurge, a creator who mistakes himself for God?' (A demiurge is a creator of the world within Platonic and Christian philosophies.) Certainly popular mythology suggested that being a child prodigy (unusual in artists but not musicians) and supplanting his father's skills as a painter at a very early age may have had a profound effect on Picasso and has promoted Oedipal readings of some of his earlier works suggesting his flight to Paris was an escape from dominant maternal influences and a failed father.

Picasso's massive, innovative output, longevity and sensuality have been linked to notions of genius that have been bound up with a series of creative, talented and beautiful women who did not survive the encounter unscathed. Breton, in another context felt able to claim 'Picasso himself is absolved by his genius from all primary moral obligations.' (Breton, *La Révolution surréaliste*) A romantic fallacy no doubt but an enduring one rooted in a concept of the artist stemming from eighteenth- and nineteenth-century philosophy. A belief in Picasso's creativity and individualism coupled with an understanding of Picasso's neuroses and sexual preferences, has been a popular way of reading recalcitrant works that do not yield meanings easily. Freudian psychoanalytic theories applied to art practice suggest that creativity itself may be the sublimation of desire at the level of the socially acceptable. Whatever the merits of psychoanalytic readings of art works the work of Sigmund Freud had a profound effect on the Surrealist Movement. Picasso's involvement with Surrealism may have been at the point of desire and dreams – supplying a possibility for reading *The Three Dancers*.

Let us return to the painting and the partly clothed figure on the left. The problem of the heads can be partially explained by the enthusiasm for the crescent moon shaped which is a recurring preoccupation in Surrealist work. The division of the head is also partly explained by Freudian interest in the unconscious, the supposed site of 'truth'

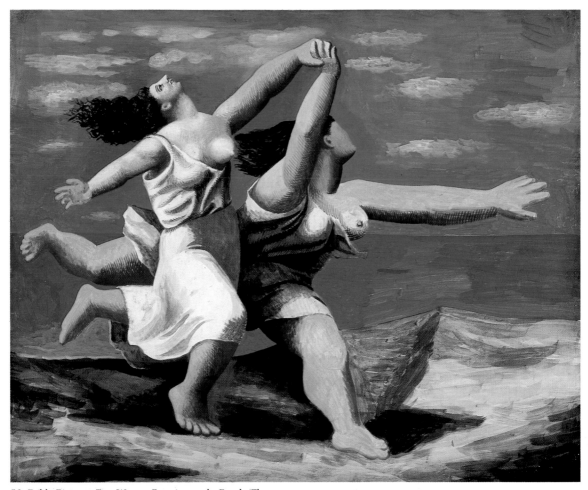

52. Pablo Picasso, *Two Women Running on the Beach (The Race)*, 1922, gouache on plywood, 33 x 41 cm. Musée Picasso, Paris.

as opposed to the 'cultural conscious'. Popular mythology encouraged by early Freud maintained women were closer to the unconscious, in some way more natural and authentic than man's nurtured self. Women came to stand for what men are not. The moon shaped head could therefore have a significance beyond the specific, i.e. Germaine. The second part of the head is equally problematic. It has been suggested that the wide grinning mouth is based on African sculpture, in this case specifically a tribal mask from the Ekoi tribe of Southern Nigeria. Picasso's interest in what was perceived historically as the 'primitive' is well documented. Photographs of his studio in the early years of the century show his collection of African masks. Modernists like Picasso held a view of the African, collapsing many peoples into one, that romanticized a concept of authenticity. Bourgeois culture in Europe was seen as deeply compromised and unauthentic, even morally bankrupt. The formal qualities of African carvings by contrast were seen as more real, less artificial compared with the sophistications of the western, classically dominated tradition. Such readings have of course proved problematic in post colonial discourse, as their main tenets – for example the African as primitive idol worshipper – were used to underwrite colonial expansion. Patricia Leighten maintains

> Modernists did not extend their social criticism to a radical critique of the reductive view of Africans that was promoted for colonial justification... considering, Africa the embodiment of human kind in a precivilized state, preferring to mystify rather than to examine its presumed idol worship and violent rituals. The 'modernist' method was to critique civilization by

embracing an imagined 'primitiveness' of Africans whose 'authenticity' they opposed to a 'decadent' west.

(Leighten, 1990)

The left head then can be read in relation to a search for the authentic, unconscious and primitive in women, even if the premise for that quest was rooted in historical and biological inexactitude. This is not to dismiss Picasso's work but to contextualize it in the beliefs and understandings of the period. It can however be argued that Picasso's representation of women in *The Three Dancers* takes the classic shape of women as dreamy, irrational and uncontrollable, sustained by association with the 'primitive'. Picasso's use of African art was based on a profound admiration for its formal qualities albeit at the expense of a deeper cultural understanding. Whatever the outcome of the debate around Picasso's 'plundering' of African cultures and its association with the female, the effect on the formal devices that he incorporated into his work was immense. In *Orientalism* Edward Said argues that 'European culture gained in strength and identity by setting itself off against the Orient as a sort of surrogate and even underground self.' (Said, 1978)

There is a further interpretation that might be worth considering – a return to the earlier 'call to order' issue, Picasso's neo-classical works from the period 1914 and Barr's insistence on *The Three Dancers* place as pivotal in Picasso's output. Look closely at *Two Women Running on the Beach (The Race)* (1922; Plate 52) and compare it with *The Three Dancers*. *The Race* was also re-used by Picasso as the curtain for the ballet *The Blue Train*. The two running women, classical in dress, timeless in an unspecific landscape, bear a certain resemblance to the central and left figures of the 1925 work. The right classical figure's breasts, shape of head, and upright arm are echoed in the schematic rendering of the flattened central figure in *The Three Dancers*. The figure on the left in both paintings has her head thrown back and a sense of abandon – the pose in both, sustaining Bacchanalian mythologies of wild women opposed to alternative conceptions of restraint and serenity derived from the classical emphasis on order and reason. Both elements had been present in Greek culture. In the post-war call to order which sought to expunge Dionysian tendencies in favour of restraint, Picasso worked on several neo-classical works that emphasized what routine classicism rejected. It was the emphasis on Greek order and restraint

that were seen as virtues after World War One, chaos, any sense of disorder, needed to be purged.

It is not of course new for a woman's body to become the embodiment of ideals and values, from Greek caryatids, the architectural support that was a literal reminder of bondage and slavery in Greek culture, to Marianne, the figure of the French Republic, symbolically giving form to an abstract notion – the idea of the state. Is it possible to see a broader context for Picasso's work as an allegory? At this level the painting may be said to represent a rejection of rationalism and the call to order. The radical technical innovations noted by Barr could be a solution to the problem of how to represent a rejection or at least an ambiguous response to the tendencies then dominating French artistic and cultural life. It could be, through its rejection of the harmonious within the classical ballet tradition and even through the subversion of a *Three Graces* conception of beauty, it forms part of a rupture, an intervention – a radical critique of French society through the metaphor of dance.

An interpretation of *The Three Dancers* poses some challenges to those interested in visual culture. This chapter has attempted to introduce some of the principal interests and difficulties in reading this work. Ultimately it may be that an interpretation of an art work is constructed by us from our particular subject position which is informed by our race, class and gender. It may be that there is no correct singular reading of a work of art. To rely on Picasso's intentions becomes problematic with *The Three Dancers*. As we have already seen Picasso's remembered intention in 1965 of a work back in the 20s remembering a death over twenty years earlier creates inevitable inconsistencies. It is this difficulty of recoverable meanings in terms of artists' intentions that has led to a reliance on the re-creation of an art work as an act of interpretation. It is perhaps simpler to begin with the self and to accept the position from which we work. We are a product of history to date not just an empty value-free vessel, but one that arrives at works of art with prejudices. These prejudices are not necessarily negative however. It is important to remember that ideas and in the broadest sense meanings are not transparent but have their roots in historical conditions. To interpret is one act, to come to an explanatory understanding of the interpretation is another. It becomes necessary to uncover the layers of the mythologies that are often presented to us as natural, in order to see the subject position that we

work from. It may be necessary therefore in order to understand any art work to look beyond what we deem to be value free to where sociological, ideological and aesthetic considerations combine to produce meanings.

There is another consideration that is important in any discussion of an interpretation of art works; the issue of unsubstantiated readings. It must be possible to look for meanings beyond the artist's intentions and biography but be guided by the art work and attendant histories in the construction of those interpretations. If the art work can be anything we want it to be because the artist's intention is irretrievable the possibility of a crude visual anarchy will replace informed debate. The range of possible readings should not be infinite but must be sustainable. It is possible to get it wrong.

The Three Dancers poses many issues for the viewer. Its lack of naturalistic technical accuracy and rejection of conventional standards of beauty, a problem at the outset, is quickly replaced by an engagement with the meaning of the work. Ultimately a reading of it, whether reliant on biography, the status of the avant-garde, an understanding of psychoanalysis, Surrealism or the state of post-war French culture and its relationship to classicism, or any combination of these, will depend on a whole host of supplementary issues, not least our own positions in late twentieth-century culture.

NOTES

1. Neo-classical work was characterized by a conscious imitation of classical work of Greek and Roman origin. The imitation took the form of style and subject matter. It presented an art of austerity and restraint after what was seen as the excesses of Baroque and Rococo art.

2. This painting was also reworked as a critique of white male power and black women by Lubaina Himid in *Freedom and Change*, 1984.

REFERENCES

ALLEY, R., *Picasso: The Three Dancers*, London, Tate Gallery, 1986

BARTHES, R., *Essais Critiques*, Paris, 1964; English translation, *Critical Essays*, Evanston, Ill., 1972

BARR, A.H. JR, *Picasso: Fifty years of his Art*, New York, 1946

BERGER, J., *The Success and Failure of Picasso*, London, Penguin, 1965

COWLING, E. and MUNDY, J., *On Classic Ground: Picasso, Léger, de Chirico and the New Classicism 1910-1930*, London, Tate Gallery, 1990

FER, B., BATCHELOR, D., WOOD, P., *Realism, Rationalism, Surrealism: Art Between the Wars*, New Haven and London, Yale University Press, 1993

FRASCINA, F. and HARRIS, J. eds, *Art in Modern Culture, an Anthology of Critical Texts*, Oxford, Phaidon, 1992

FREEMAN, J., *Weeping Woman: The Years of Marie-Therese Walter and Dora Maar*, Los Angeles County Museum of Art, 1994

JUNG, C.G., 'Picasso', *Neue Zuricher Zeitung*, Zurich, 13 Nov. 1932, reprinted McCully, op.cit. 1981.

KRAUSS, R., 'In the Name of Picasso', reprinted in Frascina and Harris, op.cit., 1981, pp.5–22

LEIGHTEN, P., 'The White Peril and *L'art nègre*: Picasso, Primitivism, and Anti-Colonialism', in *The Art Bulletin*, Dec. 1990, pp.609–30.

MCCULLY, M., *A Picasso Anthology. Documents, Criticism, Reminiscences*. London, Thames and Hudson, 1981

MATISSE, H., 'Notes of a Painter', *La Grande Revue*, 1908, notes of Sir Roland Penrose reproduced in Alley, op.cit., 1986; first published *The Tate Gallery Report*, 1965–6

RAPHAEL, M., *Proudhon, Marx and Picasso, Three Essays in Marxist Aesthetics*, London, Lawrence and Wishart, 1980

SAID, E., *Orientalism*, London, Routledge and Kegan Paul, 1978

CHAPTER FIVE

DESIGNING FOR THE MODERN WORLD – DE STIJL

THE RED BLUE CHAIR AND THE SCHRÖDER HOUSE

PAUL OVERY

Issues of 'design' and 'modernity' are addressed in this chapter by focusing on two works by the Dutch furniture designer and architect Gerrit Rietveld, 1888–1964, the Red Blue Chair, (c.1918–23; Plate 53), and the Schröder House (1923–5; Plate 59), designed in collaboration with his client, Truus Schröder.

THE RED BLUE CHAIR

The Red Blue chair has often been represented as an icon of modern design, and is constantly reproduced today in slides and illustrations in books, in three-dimensional scale models, and as full-size modern versions. The chair is often employed as a signifier of modernity, not only of a notion of modernity now historically past, contemporaneous with its own design and production (1918–23), but also of modernity today, for example to advertise a contemporary 'modern' kitchen (Plate 54). How is it that a chair can so powerfully signify modernity? What is special about this particular chair that it has been – and continues to be – so frequently reproduced and exhibited?

Chairs have been given special prominence in the history of twentieth-century design because it is possible to consider them as abstractions of, or from, the human body. They are not merely supports for the body at work and at rest. Chairs are also representations of the body and were used fre-

53. The Red Blue chair. Victoria and Albert Museum, London. The unpainted prototype was designed around 1918. The chair was probably painted in the primary colours plus black in 1923.

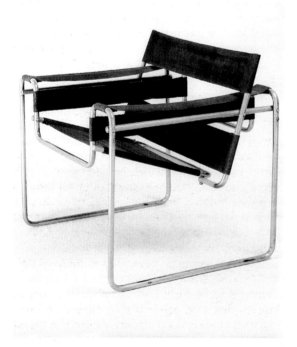

54. A recent advertisement in which Rietveld's furniture (designed over seventy years ago) is used to advertise an 'up-to-the-minute' contemporary kitchen.

55. Marcel Breuer, Wassily Chair, 1925. This chair, which Breuer designed at the Bauhaus, was known as the Club Armchair in the 1920s.

quently as a sign for the absent body in the art of the second half of the nineteenth century. A chair was often used to represent a person who had just died, as in Luke Fildes's famous engraving *The Empty Chair, Gad's Hill – Ninth of June 1870*, which depicts Charles Dickens's study at Gad's Hill on the day after his death. Here the empty chair in front of the desk where Dickens wrote his novels signifies his presence by his absence.

Chairs were also sometimes used to suggest an absent but living person – nearly always in nineteenth-century art to suggest an absent male presence. In two well-known paintings by Van Gogh, *Van Gogh's Chair* and *Gauguin's Chair*, chairs are employed as symbolic evocations of absent male sitters. (Van Gogh was a great admirer of illustrative works by nineteenth-century English artists like Fildes and had been deeply impressed by *The Empty Chair*.) Van Gogh's work was just beginning to be accorded canonical status in The Netherlands in the second decade of the twentieth century when Rietveld was starting his career as a designer and architect. His last and most prestigious architectural commission (completed posthumously) was the Van Gogh Museum in Amsterdam.

In the twentieth century chairs have frequently been used by architects as stand-ins – or rather sit-ins – for the human beings who are so often absent in architectural photographs and drawings of the interiors of Modernist buildings. It is possible that the fascination with the chair constitutes an attempt to recuperate the body, or at least an image of it, against the depersonalization of modern life and the buildings designed for it – perhaps to produce through the image of the modern chair the notion of a specifically modern body. The often stated and frequently exaggerated uncomfortableness of the Red Blue chair may reveal this need for an awareness of the body within Modernism: to incorporate the immediacy of tactile experience in an increasingly optical world. Rietveld used often to say that to sit (*zitten* in Dutch) is an active verb.

Another 'early modern' chair, the so-called Wassily Chair (Plate 55) designed at the Bauhaus

in 1925 by Marcel Breuer, is perhaps employed even more frequently than the Red Blue chair to signify modernity today. This chair can be found in every high street hairdressers, in clothes shops and in quite ordinary homes, as well as in offices. There are some fairly straightforward reasons for this particular chair's current popularity. It is relatively cheap. It is light and strong and can easily be moved around on its tubular sleds. The chromed steel tubes and leather seat, back and arms are quite easy to clean. The Wassily Chair is visually skeletal and appears to take up even less space than it does, making a room look uncluttered. But there are, I think, also important reasons why this chair functions powerfully at a symbolic level. It resembles a line sketch of a conventional armchair drawn out in space with thin metal tubes. The chromed tubing is reminiscent of the steel frame of the ever popular (but timeless) bicycle, a cheap and classless artefact. It combines the animal and mineral into a skeletal form which seems close to the human body, while at the same time rich in associations with machinery and mass-production (as also is the bicycle).

The Red Blue chair shares some of these characteristics, but has a number of important differences. It is made of wood, the traditional material for making chairs. It is – at least in its definitive and best-known form – painted in bright, primary colours. It is expensive to buy in the perfectly finished modern version (the price includes hefty reproduction fees), but can be constructed by do-it-yourself enthusiasts relatively easily and cheaply from deal and plywood. (Reproduction rights are waived for construction of individual chairs for private use.) The design is rationalized and reduced to a number of lengths of wood of standard section which can be pre-sawn and assembled in batches, and could thus be produced by mass-, or at least batch-production methods. However, its peg-and-hole (dowel) joint is a very old technique and the method of extending the individual wooden elements from which the chair is constructed an inch or so beyond the point of juncture dates from the middle ages or even earlier.

Paradoxically, the Red Blue chair combines elements of modernity ('rationalization' and 'standardization' of parts) with a rather crude and ancient ('primitive') method of jointing that requires relatively little technical knowledge ('deskilling'), and which manifestly reveals each individual element from which the whole artefact is constructed. In its clear, apparently self-evident

structure and bright primary colours the Red Blue chair resembles constructional toys such as Lego, or older systems such as Meccano and Froebel wooden blocks. Although the painting of the chair in pure primary colours plus black for the frame probably dates from only 1923 (and the chair seems often to have been bought or exhibited unpainted for long after that), this is how it is almost invariably reproduced, or produced today. Its painting in the primary colours makes it, superficially at least, look like a three-dimensional Mondrian painting. This and the chair's alleged uncomfortableness gives it the air of an art work or piece of sculpture, which at the same time is not entirely useless. It seems to have a function, even though most people who buy or make the chair themselves probably do not sit on it very frequently. Even when first produced the chair was probably perceived not so much as a functional piece of furniture but as a sign – an emblem of their belief in their own modernizing role for the young progressive Dutch professionals who purchased it immediately after the First World War.

Quite soon after it was first made the prototype (unpainted version) of the chair was published in September 1919 in the *De Stijl* magazine. Founded in 1917 to promote the work of a group of artists, architects and designers working (initially) in The Netherlands, the magazine was edited by the artist and designer Theo van Doesburg and was to become one of the most influential Modernist art magazines of the early twentieth century. Artists associated with *De Stijl* included Piet Mondrian and Bart van der Leck. Among the architects and designers were Rietveld and J.J.P. Oud, famous for his municipal housing in Rotterdam. They shared similar social and artistic ideals and their work had many elements in common.

It is sometimes said that in making the chair, and other pieces of furniture like it, Rietveld was subjecting to analysis the process of construction involved in making a chair or other piece of furniture – a process with which he was familiar with since childhood. (He went to work in his father's furniture-making and shop-fitting workshop at the age of twelve.) This was a typical Modernist procedure, whereby the form and making process of the work are rigorously put to the test.

Rietveld might well have adapted such a procedure from his knowledge of modern art. He almost certainly visited exhibitions of modern art in Amsterdam and other Dutch cities, and frequented professional circles where the latest artistic and intellectual ideas would have been dis-

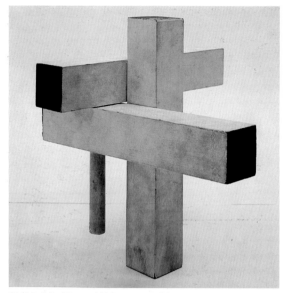

56. Model of Rietveld Joint. Rietveld made this demonstration model of the joint he used in the construction of the Red Blue chair and some of his other early experimental furniture in the 1950s. This was probably made for a retrospective exhibition at the Centraal Museum in his home town of Utrecht organized on the occasion of his seventieth birthday.

57. Detail from Giovanni Bellini, *St Francis in Ecstasy*, Frick Collection, New York, *c.*1400. St Francis's lectern (bottom right) is constructed using a similar jointing system to the Red Blue chair or Rietveld's other experimental furniture of the period.

cussed. After studying Cubist works in the original or in reproduction and reading some of the critical analyses written about them he might well have devised such a reflexive strategy of analysing the medium of his trade on similar lines to the methods employed by Cubist artists. He may have begun to use the so-called 'Rietveld joint' (Plate 56) in his experimental furniture because it enabled him to make the elements of his furniture look as though collaged or montaged together, an assemblage of simple, standardized wooden elements.

This or similar joints are also found in medieval or vernacular furniture and wooden artefacts (Plate 57). Rietveld's use of this may have been a kind of 'primitivizing', comparable to the borrowing of elements from other cultures in the works of Picasso, Braque, Brancusi and other modernist artists. Or, on the other hand (or as well), it may represent an attempt to link Modernist ideas to tradition, as was beginning to happen elsewhere in Europe at the end of the First World War.

By using the Rietveld joint the wooden rails which form the chair's supporting structure are made to extend one or two inches beyond the point of juncture, appearing to probe the space around the chair and giving the impression that

the elements from which it is constructed are merely glued, or held together by magnetism. The rails are actually joined by dowels, or peg-and-hole joints. In this method of construction holes are drilled in the pieces of wood to be joined together and a round peg is glued and hammered into the holes to form the joint. The pegs are not visible once they are driven home. Rietveld also employed the Rietveld joint in a number of other experimental pieces which he designed at about the same time.

By extending the ends of the rails beyond the point of juncture he not only made them function like spatial probes, the rails are also perceived as visually independent: separate elements of a construction forming a whole, yet keeping their own distinct forms. They do not merge with the other wooden rails and rectangles of plywood employed for the back and the seat to create what appears to be a unitary visual whole, as do the individual pieces of wood used in traditional furniture constructed with dovetail or mortice-and-tenon joints, where the pieces of wood fit together almost seamlessly. This gives the chair a clear, clean outline, almost skeletal or diagrammatic in form.

The joint, however, does not function purely for formal or visual effect – merely to convey

visual pleasure. For the chair's first Dutch pur-
chasers and admirers, the visual separation of the
individual elements would also almost certainly
have been seen as representing ideas about indi-
viduality and collectivity current in early
twentieth-century social-democratic Holland. The
architect, writer, social critic and socialist H.P.
Berlage (who occupied a place in Dutch culture
similar to that of William Morris in Britain) wrote
of the notion of unity in diversity in Dutch society.
This can be related to the utopian, left-wing ideals
held by most of the artists and designers associated
with De Stijl.

Although Van Doesburg reproduced the
unpainted Red Blue Chair in an early issue of *De
Stijl*, he also illustrated and wrote about a number
of other examples of Rietveld's early experimental
furniture. The painted version was never repro-
duced in the magazine, even in a black-and-white
photograph. The production of the Red Blue Chair
as an icon of the modern movement and as the
central artefact of De Stijl really dates from some
decades later, long after *De Stijl* had ceased to be
published, and Rietveld was designing rather dif-
ferent kinds of furniture. This was when early
Modernism was beginning to be institutionalized
in the 1930s through retrospective exhibitions
and museum displays, catalogues and books of art
and design history. The chair was published and
exhibited with other examples of early twentieth-
century furniture design in several books and
exhibitions during the late 1920s (mainly in
Holland and Germany). But it does not seem to
have been given its key position in international
modernist design until shown in 1936 in *Cubism
and Abstract Art*, organized by Alfred H. Barr Jnr at
the Museum of Modern Art in New York. This is
generally regarded as the seminal exhibition in the
construction of a Modernist canon and the institu-
tionalization of Modernism. The chair, lent by the
American sculptor Alexander Calder, was the only
example of Rietveld's furniture included, and was
also illustrated in the often reprinted publication
which accompanied the exhibition (Barr, 1974,
p.148, pl.150, cat.no.321).

After the Second World War the Red Blue
Chair was represented in art historical discourses
as Rietveld's major contribution to the history of
design and as the key three-dimensional artifact of
De Stijl. During this period, the Schröder House
was similarly positioned within the emergent and
increasingly dominant discourses of Modernist
architectural history.

58. Cover of P. Drijver and J. Niemeijer, *How to Construct
Rietveld Furniture*, 1986.

In 1972 the Italian company Cassina, which
specializes in the reproduction of classic Modernist
furniture designs as costly highly-finished luxury
artifacts, began to produce the Red Blue Chair, the
Zigzag Chair and the End Table as part of the col-
lection *Cassina I Maestri* (Cassina Masters). In
1986 Peter Drijver and Johannes Niemeijer pub-
lished drawings and plans for a number of
well-known pieces in a book entitled *How to
Construct Rietveld Furniture* (Plate 58), further
reinforcing a canon – a limited selection of
accepted designs (Drijver and Niemeijer, 1986). A
small number of Rietveld's early experimental
designs have been constantly reworked and recy-
cled through production and reproduction over
the last three decades. However, he designed over
350 pieces of furniture and over a hundred build-
ings during the fifty or so years of his working life
(Vöge, 1993; Küper and Van Zijl, 1992).

THE SCHRÖDER HOUSE

Rietveld and Schröder began to discuss the siting
and design of the Schröder House at the end of
1923, shortly after the death of Schröder's hus-
band, a prosperous Utrecht lawyer. (She and her
children had to move out of the apartment above
her late husband's legal practice in the centre of
the city.) After leaving his father's workshop,
Rietveld had worked for a time as an assistant to
an established Utrecht architect, P.J.C.
Klaarhamer, and studied drawing and architec-
ture at night school. He also took classes in
painting, anatomy, and clay modelling.
Previously, apart from furniture he had only
designed a few interiors and shop conversions.

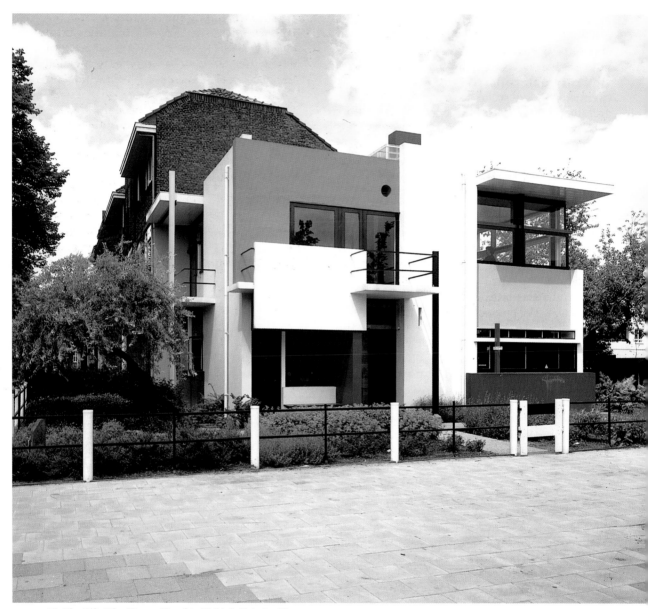

59. The Schröder House, Utrecht. 1924-5. Exterior View.

Among these was a room he had remodelled for Truus Schröder in her earlier apartment above a cinema in the centre of the town.

The design of the Schröder House was undertaken in close collaboration with Schröder who was probably responsible for key features of the house such as the sliding partitions (Plate 60). Rietveld had produced a plan for a completely open-plan living/dining/sleeping space on the first floor without walls or partitions. This was the type of living space he personally favoured. Some years later he rented the second floor above a cinema which he had designed in the main square of Utrecht as an apartment for himself and his family. Rietveld organized the whole floor as a single large living area, with curtained bunks for his six children against one wall and only the lavatory, kitchen, bathroom and a small bedroom for his wife and himself separate. This might be considered an early prototype for the currently fashionable loft living in converted warehouse, commercial or industrial spaces of today, although at the time it was far from fashionable and considered highly eccentric.

In her house, however, Schröder insisted on a transformable space which could be altered, by means of sliding and folding partitions, from a completely open area for living/eating functions, to a variety of completely divided or partially divided spaces (seven different possibilities in all) for sleeping, or when members of the family wished to be alone or different people wanted to do different things. These included a bedroom area for Schröder's son Binnert, and another for her two daughters, Marian and Han. The lavatory, bathroom, and the tiny bedroom used by Schröder herself were the only parts of the upper floor of the house which could not be completely opened out to form a single large space.

The ground floor of the house was arranged more conventionally with a number of enclosed rooms. However, these were linked visually to each other and to the hall by means of a narrow strip of glass at the top of the doors and some of the inner walls (including the lavatory!). Thus the ceiling extends visibly beyond the individual rooms so that they remain private but are not completely isolated from one another, combining privacy and sociality. This may have been another of Schröder's contributions to the design.

The downstairs rooms included a kitchen – with a service lift, or dumb waiter, to the dining area above – a study used mainly by Schröder's son (Plate 62), a workroom for a home help who came in on a daily basis, and a space which was originally intended as a garage. As Schröder seems to have decided that she did not need a car, the garage was used by Rietveld himself as an atelier for his architectural practice, which began to develop after the completion of the Schröder House, until he moved to an office in the centre of Utrecht in 1932. During this period Rietveld and Schröder collaborated on a number of designs and speculative ventures, including two blocks of

60. Interior of Schröder House, restored 1985–7, photographed in 1987, showing the folding and sliding partitions drawn back.

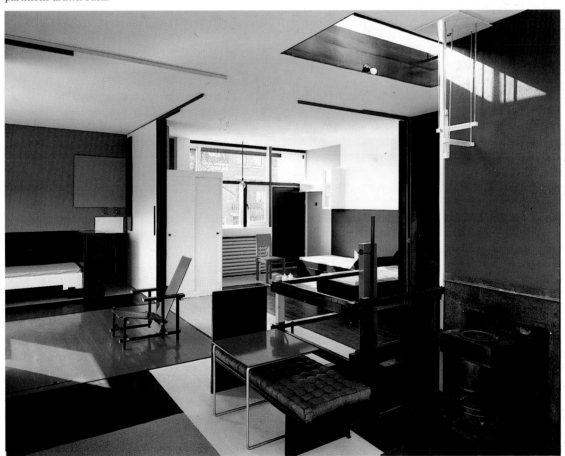

61. A photograph of 1925 showing the first floor interior of the Schröder House.

62. Schröder House, ground floor study, photographed in 1987. This room remained virtually unchanged and needed hardly any restoration.

houses and flats opposite the Schröder House, and they continued to work together on other designs, including some pieces of furniture, until the 1950s. In 1924 Rietveld handed over his furniture-making workshop in Adriaan van Ostadelaan to his assitant Gerard van de Groenekan in order to concentrate on his architectural practice. However, he continued to design furniture until his death in 1964.

Although Schröder had been left comfortably off after her husband's death she wanted to be in more direct contact with her children. (Previously they had been looked after by nannies.) The internal design of the house was intended to produce this greater closeness within the family. But by being flexible it also permitted individual privacy. This perhaps fulfilled Berlage's notion of unity in diversity at the level of a single family unit. Like the Red Blue chair the house – which is formed from elements (walls, girder, balconies, windows) that appear to remain visually separate while at the same time producing a unified totality – seems to incorporate this notion into its formal structure. The transformable space(s) of the house could also be adapted to new situations and combinations of inhabitants, as happened after Schröder's children grew up and eventually left home. At one time she let rooms off to lodgers. Schröder herself continued to live in the house almost uninterruptedly until her death there in 1985 at the age of ninety-five.

There are many labour-saving devices and built-in features which were almost certainly among Schröder's contribution to the design. At her insistence each separate room or area which could be partitioned off was provided with a bed, a washbasin and an electric point for a cooking ring, so that they could be occupied in as private and self-contained a way as possible if necessary. Inevitably, however, some alterations were made to the house over the years. Most of these were undertaken by Rietveld in collaboration with Schröder, until his death in 1964.

The house was thus both a series of discrete private spaces and a continuous, flowing collective (family) space (Plate 61). It was built at what was then the very edge of the city of Utrecht, looking across what was still at that time open countryside. It was designed to be a house which took advantage both of its connections to the city and its proximity to the country. Here again there is a double aspect to the house, as in the design of private and collective spaces which can be transformed from one into the other.

Other double aspects included ingenious built-in furniture, probably devised by Rietveld and Schröder together and executed by Van de Groenekan. Like the early experimental furniture the built-in pieces had a ludic quality as if designed with a play element – as perhaps they were in a house intended for a family of three young children. These included a Constructivist series of storage boxes painted bright yellow which opened or slid out and contained a wind-up gramophone and a 16mm film projector. This was the 1920s equivalent of today's media centre or stacking hi-fi units. Between this and the family dining table

63. Le Corbusier, Villa La Roche, Auteuil, Paris, 1923–5.

64. The lavatory in the Schröder House as it was in the late 1920s.

was an adjustable ledge forming a desk space for the children to do their homework, if they wished, at the centre of family life. Alternatively they could use the quiet, private study downstairs (Plate 68), a calm enclosed space looking on to the small garden and – originally – the countryside beyond. The built-in furniture seems to have been deliberately made with cheap materials, often finished quite crudely, as if Schröder and Rietveld wanted to avoid any hint of luxury and high-quality finish which generally marked the furnishings and domestic artefacts of the social class to which she and her late husband had belonged. Several pieces of the early experimental furniture like the Red Blue chair and the High Back Chair were used in the house, along with the two later experimental pieces, the End Table and the Berlin Chair (a left- and right-hand version), the Military Chair and Stool, and a number of new pieces, some specially made for the house.

With its mixture of open and closed, private and collective spaces, the house remains domestic in feeling, unlike the villas of Le Corbusier which resemble the public spaces of museums, garages or art galleries with their ramps and double-height interiors (Plate 63). The chimney breast forms a fixed and solid element in the centre of the upper floor beside the stairwell, suggesting the stable core and symbolism of the traditional open fire and hearth. Originally the mantlepiece and fireplace brought from the Schröders' earlier apartment stood here, perhaps as a reminder to Truus Schröder and her children of their former

home and the very different life-style they had left behind. This was replaced by a closed iron stove when Schröder and Rietveld renovated the house in 1936. This remains after the restoration of the house following Schröder's death in 1985 – almost the only original element it was not possible to reconstruct. Another was the bath and upstairs lavatory which had also been renewed in 1936. In an early photograph by the Dutch artist and photographer Paul Citroen the original lavatory can be seen with the bowl placed sideways to the seat, perhaps to make it more comfortable or practical for small children or to fit into a confined space (Plate 64). This very simple but significant displacement of a traditional use-function was typical of Rietveld's way of designing, particularly when working in collaboration with Schröder.

Today the house is a museum and can be visited in small groups. It has been restored as faithfully as possible to a semblance of what it must have looked like shortly after it was completed and occupied by the Schröder family in 1924-5. But this is clearly a semblance only. It is presented to the visitor as a spectacle of early twentieth-century Modernism, as well as an example of national heritage. (The Dutch call such restored and preserved examples of early twentieth-century buildings 'young monuments'). The house now no longer looks across fields but over an urban motorway to the suburbs of an expanded and rapidly expanding modern city. It is now surrounded by brash realisations of that modernity it was once intended to evoke.

65. Mondrian's studio, rue du Départ, Paris, photographed in 1926.

THE SCHRÖDER HOUSE AND MODERNISM

Very shortly after it was completed the Schröder House began to be published and reproduced in magazines and books. It was represented as one of the key buildings of a then newly-constituted Modern Movement and has continued to be characterized as one of the icons of Modernist architecture. We perhaps need to ask why certain designs or buildings have been promoted in this way and accorded special status. Although the notion of the design classic operates both as a commercial and institutional validation of furniture designs such as the Red Blue chair and Marcel Breuer's Wassily Chair, the possibility of commercial exploitation is less apparent in the production of the icons of Modernist architecture. Here iconic status is employed to produce master narratives which reinforce the linear, developmental and historicist nature of Modernist discourses and the histories produced within and through these.

We may ask why has this small family house been considered so important a signifier of Modernism or as an exemplary design for the modern world. Those elements which have been represented as constituting the house's innovatory features are: the open but flexible living/sleeping space, the self-conscious asymmetry and avoidance of a main façade, the close relationship of the house to its garden and the countryside beyond, the connections between the form of the house and that of examples of modernist furniture (such as the Red Blue chair) and of its formal relations with modernist paintings such as those of

Mondrian, and with other spaces conceived by artists and designers associated with De Stijl like Mondrian's Paris (Plate 65) and New York studios.

We may also ask whether there is not a tension or conflict between the two roles customarily produced for the Schröder House: as icon and prototype (or model). Often buildings represented as icons of modern design are luxurious or designed to a high specification for wealthy clients, such as Adolf Loos's Viennese houses, Le Corbusier's Parisian villas of the 1920s, Mies van der Rohe's Tugendhat House in Brno in the Czech Republic, or his Farnsworth House in the USA. They are quite inappropriate as models or prototypes for working class, or even for lower middle-class housing. The Schröder House, however, was small and cheaply built. Although Schröder was quite well-off, the house seems deliberately to have been designed not to appear luxurious or expensive-seeming. Its cost was approximately the same as an ordinary lower middle-class semi-detached or terrace house of the period in The Netherlands. The Dutch have always tended to be cautious about openly displaying wealth or power and Schröder and Rietveld's attempt to make the Schröder House appear transparent and ordinary in its materials – if extraordinary in the way in which these were put together, and in its total effect - can be related to the process of *verzeiling* (equalization) in Holland in the early decades of the century, where endeavours were made to diminish class differences, or at least to make them seem less apparent.

Undoubtedly Schröder wanted her house and the new life she planned to live in it with her children to represent a model not only for well-off women of her own class but also for lower middle-class women who were making careers for themselves and becoming more independent. The magazine which her sister An Harrenstein edited, *De Werkende Vrouw* (The Working Woman), was intended to promote such ideas. Both Rietveld and Schröder wrote for it about furniture, architecture and interior design.

The Schröder House was designed in response to the change in the life-style of a particular middle-class woman and her family as the result of particular personal circumstances. However, similar changes were to become general among many families of this class throughout Europe between the wars and increasingly so after the Second World War. For example, Schröder did not employ a maid in the Schröder House, although she had a woman who came in by the day to help her. She claimed that this was because she wanted to be closer to her children after her husband's death. Almost certainly she could have afforded a living-in maid if she had wanted one.

Many European middle-class women between the wars (particularly after the Wall Street Crash of 1929) had to get used to the idea of no longer being able to employ servants and to adapt to smaller and easier-to-run houses in which they did the housework themselves with the help of electrical machines and other so-called labour-saving devices. In continental Europe, where people tended to have less floor space per inhabitant than in Britain – particularly in cities which were often built up much more densely – living and sleeping functions were frequently doubled-up, even in middle-class apartments or flats. Thus the Schröder House was often projected as a prototype or model for new ways of living, or as a design for the modern world.

In the late 1920s and early 1930s Rietveld himself was to design a number of prototypes for core houses intended for mass- or multiple-production based on a prefabricated central unit containing the services, stairs, kitchen, lavatory and bathroom, to which could be attached different combinations of living rooms and bedrooms according to the needs of the occupants. Although these designs were never built they remained influential, and other ideas developed in the Schröder House, such as the use of sliding and folding partitions to double up spaces, were incor-

66. Piet Mondrian, *Composition No. 1: Composition with Red and Black*, 1929, oil on canvas, 52.5 x 52.5 cm. Oeffetliche Kunstsammlung, Basel, gift Marguerite Arp-Hagenbach 1968.

porated into designs for social housing by a number of Dutch architects in the early 1930s. However, some critics pointed out that what might be practical for the middle-class Truus Schröder and her children might be highly inconvenient for a Rotterdam port worker on shift work who wished to sleep during the day while his children wanted to play.

Undoubtedly the fact that the house in many ways resembles a three dimensional Mondrian painting has helped to ensure its iconic place in Modernist histories. Although Mondrian himself did not produce any executed designs for buildings or interiors, he organized his studios in Paris and New York in a very individual way like a three-dimensional version of one of his paintings.

Schröder never owned any paintings by Mondrian, but she did buy a picture by Van der Leck, *Composition 18–21*. This hung in the Schröder House until her death and is now in the Centraal Museum, Utrecht. However, Schröder's sister and brother-in-law An and Rein Harrenstein purchased one of Mondrian's paintings *Composition No. 1: Composition with Red and Black*, (1929; Plate 66), from an exhibition of abstract art organized by Nelly van Doesburg (Theo van Doesburg's wife) at the Stedelijk Museum in 1929. This hung in the Harrensteins' apartment in

Amsterdam which had been redesigned by Rietveld and Schröder in 1926.

Perhaps the first time that the Red Blue chair was shown with paintings by Mondrian was in the exhibition *Der Stuhl (The Chair)* at the Kunstgewerbemuseum (Applied Arts Museum) in Frankfurt in March 1929, where the Red Blue chair and several other designs by Rietveld were exhibited. The addition of nineteen unsold works by Mondrian already in Germany for the Frankfurt showing of this exhibition was organized by the Dutch architect and furniture designer Mart Stam who was working for the city architects' department in Frankfurt which, under its director Ernst May, pioneered low-cost modernist municipal housing in Germany in the late 1920s. This was to be the first of many later exhibitions in which Mondrian paintings and Rietveld's chair were juxtaposed.

Designers and Clients: Professional Identities

Shortly after the Red Blue chair and the Schröder house were completed and published particular kinds of representations began to circulate about Rietveld's practice as an artist and designer. As a cabinet-maker who had turned to furniture design and architecture he was often portrayed as an artisan designer who worked with his hands, using models rather than drawings in the design process. This notion dates from the late 1920s after the Russian writer and designer El Lissitzky visited the Schröder House and wrote about it as the work of a proletarian designer in a Soviet architectural magazine. Like most myths this serves a particular interest or set of interests and should be seen in relation to other representations of Rietveld as an architect and designer and to debates about the role of the architect/designer as a middle class professional designing for other social groups, particularly in the context of social housing.

Lissitzky was trying to promote for his Soviet audience the idea of Rietveld as a 'new man', a designer and architect from a different background to that from which such professionals had traditionally been drawn. However, this involved him in a certain amount of distortion or special pleading. He wrote that Rietveld was unable to draw out a plan. But it is clear from early drawings in the Rietveld Schröder Archive, now in the Centraal Museum in Utrecht, that Rietveld could

67. Rietveld with his assistants photographed outside his workshop in Adriaan van Ostadelaan in Utrecht, *c*.1918.

draw perfectly well. It is true that having had a craft training he often worked with models at various stages in the design process until the end of his life, and as Peter Smithson has written, often displayed a 'manual intuition' (Smithson and Smithson, 1981, p.18) in his work. There are certain characteristics of Rietveld's design that reveal influences from his early artisanal training and practice, particularly in his early experimental furniture and first architectural works, especially the Schröder House. These early works, although they suggest the possibilities of mass-production by their simplification and standardization, also retain important elements of craft or artisanal production that is apparent in their design. In this sense they suggest a transition, and often a tension, between one way of working and another: thus the extent to which they suggest the 'new' and 'modernity' are often quite problematic.

Sometime around 1918 Rietveld had himself photographed sitting in the chair outside his workshop at Adriaan van Ostadelaan in Utrecht surrounded by his grinning young apprentices and assistants (Plate 67). He looks relaxed and confident and the informal poses of the young men suggest that he was an easy-going master. As far as we know, the photograph was never published. Perhaps it was taken by a friend or relative – its informality suggests this. Or Rietveld might have commissioned it to demonstrate the chair to potential clients or in order to put in his workshop window. In the photograph Rietveld is the only one sitting. His young assistants and apprentices stand or slouch. Although he still has on his arti-

san's smock, Rietveld wears soft slip-on shoes rather than the heavy boots worn by his assistants. That he had himself photographed sitting perhaps suggests that Rietveld already sees himself as half way from being a maker to being a designer. The maker stands – as in the logo of a carpenter planing a piece of wood that can just be seen above his workshop window in the photograph, and which he also used for his professional notepaper at the time. The designer, on the other hand, sits. But the designer's sitting is an activity. The Red Blue chair is a chair which keeps the sitter mentally on his or her toes. It is a chair designed for the alert professional, not for the exhausted worker, nor for Matisse's tired businessman.

Although he himself was in the process of moving from being a maker to being a designer, Rietveld was concerned that his furniture should remain satisfying for his workmen and assistants to produce. He probably regarded its appearance of being machine-made – or at least constructed from rationalized and standardized components – as a deliberate rejection of the craftsmanly ethos of his father who disliked machine methods of production. He was concerned that the furniture he designed should not be a drudgery to produce, whether through repetitive machine work, or through repetitive handwork, which could both be equally soul destroying. As Theodore Brown has argued:

> From a social point of view he wanted, by the use of machines, to relieve the tedium of the man who produced furniture. As a craftsman, Rietveld knew that satisfaction was derived from the production of one or two hand-built pieces. The compulsion of modern life had forced the craftsman, in Holland at any rate, to produce mulititudes of items by hand; and this was drudgery for him.
>
> (Brown, 1958, p.21)

Van Doesburg had come to similar conclusions, writing in an influential essay entitled *The Will to Style* in 1922 that handicraft reduced man to the function of a machine, while the correct use of the machine was the only way to achieve social liberation (Baljeu, 1974, p.122). Rietveld stressed the visual pleasure and satisfaction in making the joints for his early furniture. He designed this at a transitional time when machine methods of woodworking were being employed in The Netherlands (and elsewhere in Europe) alongside traditional

hand methods of assembly. This is perhaps one reason for the ambiguity and strangeness of these works. They were designed so that the individual elements could be cut by machine and assembled by hand, singly or in quantity if desired. Although clearly constructed from standardized and rationalized components, they obstinately retain something of the look of the handmade, refusing to become anonymous machine products.

SCHRÖDER'S ROLE AS A DESIGNER

Rietveld and Schröder worked closely together on the design of the house for herself and her three young children. When first published in the mid 1920s the house was attributed to Schröder and Rietveld as joint architects. Later, when Rietveld came to be promoted as one of the pioneers or heroic figures of modern design and architecture, Schröder's role was written out of Modernist architectural histories and her contribution to the design largely forgotten. Only after Rietveld's death in 1964 was her part in the conception of the house attended to again. But it was not until after Schröder herself died in 1985 – having lived almost uninterruptedly in the house for sixty years – that her contribution to its design began to be properly reclaimed and reassessed. This was presented not so much in terms of the production of the house as a modernist classic but in its role as a prototype for a new kind of family living which addressed the changing roles of European middle-class women.

Schröder had continued to collaborate with Rietveld on architectural and interior designs until the 1950s. It is sometimes difficult to assess the extent of her contribution. When research was being done for a recent Rietveld retrospective exhibition (Utrecht, Paris, Antwerp, 1992–3), some clients remembered Rietveld visiting them more frequently than Schröder at the time when a commission was being discussed, designed and executed (Küper and Van Zijl, 1992). However, such evidence should be regarded circumspectly. It is natural that clients would *want* to remember the famous, male pioneer of modern design as having played the major role in the design of their house, interior or furniture. Also, given their respective class positions, it is not surprising that Rietveld, the former artisan, should have been the one who was most frequently in evidence in preliminary discussions, or on site during the execution of a project.

68. Schröder House, Interior, *c.*1925 (photograph). In this photograph Truus Schröder and her youngest daughter Han can be seen sitting at the dining table on the first floor.

Problems of this kind are frequently encountered in analysing the contribution and role of women as patrons and collaborators in early twentieth-century Modernism. Another example is the collaboration of the designer Charlotte Perriand in the furniture of the late 1920s often ascribed solely to Le Corbusier. Traditionally women have been assigned particular roles within design: colour co-ordination, the organization of the kitchen and the bathroom spaces, and so on. In many ways Schröder's contribution to the collaboration with Rietveld can be seen to both challenge and conform to such stereotypes. Further investigation of her role is still needed.

Examination of early photographs and Schröder's own recorded reminiscences make it clear that the collaboration was not merely a matter of the original design but also the process of living in the house and demonstrating its virtues as a design for the modern world (Overy *et al.*,1988). She clearly conceived of this as a didactic role which she took very seriously. A series of high quality professional photographs of the house in its first year were found in Schröder's archives after her death. They provided precise data for the restoration of the house sixty years later. These were almost certainly commissioned by Schröder herself. They were intended to be historical records of how the house looked, worked, and was lived in shortly after its completion. Most of the photographs do not show anyone in the house although they record the presence of the inhabitants by their traces (no doubt somewhat tidied up for the occasion). One well-known photograph, however, shows Schröder and her younger daughter Han sitting at the dining table in front of the wide first floor windows which then looked across the garden to the open fields (Plate 68). Both Schröder and her daughter stare at the camera with an almost defiant intensity. The force of their gaze conveys something of Schröder's determination to live the new life in this house intended not only to be tailor-made for a particular family but to be a message for the future. The Schröder house was a house designed for a family. But this was a family without a father; its flexibility and lack of strict and hierarchical separate functions perhaps signify this absence of patriarchal authority. However, in many ways the architect himself became a substitute figure for the father. Rietveld and Schröder remained close until his death. When his wife died in 1957, Rietveld moved into the house for the last years of his life. Both he and Schröder died in the house.

It may seem self-evident to say that the Schröder House was designed for a family. However, many classic modernist houses seem to lack this quality. Le Corbusier was inspired in

much of his work by monks' cells in monasteries and by the late nineteenth- and early twentieth-century Parisian artists' studios. Neither of these are models which incorporate the presence of children, let alone attending to their needs. The Schröder House was a unique experiment, depending on a very close relationship between architect and client, a client with remarkable demands (and also tolerances). It was an experiment that could not be repeated, which could not be used as a norm, but only as an experimental prototype. Nevertheless, the Schröder House might be considered the first truly flexible dwelling which took into account the increased informality and freedom of social and living arrangements in the twentieth century. Although Rietveld and Schröder collaborated on a number of subsequent projects, the collaboration was never so complete, because Schröder was never again client as well as collaborator, except for the terrace houses and apartments in Erasmuslaan, built across the road from the Schröder House in the 1930s. However, she did not have the intention of living in these as with the Schröder House, although she did occupy one of the apartments for a short time in 1936 while the Schröder House was undergoing its first renovation and modernization.

CONCLUSION

In the 1960s, the decade of Rietveld's death, the process of canonization of the Red Blue chair and the Schröder House reached its zenith, a process which, as we have seen, began in the 1930s. In this process Rietveld's early works have usually been emphasized at the expense of his later works, or his overall achievement. This is only a more extreme case of how Modernist histories of Modernist art, architecture and design have habitually been constructed and produced. The emphasis is all on the innovatory breakthrough, the Eureka moment when the old form is discarded and the New attained, rather than the slow, sustained development which follows. To some extent accounts of Mondrian's career have also followed this pattern, as have accounts of the careers of other Modernist artists such as Kandinsky. We need to be suspicious of such accounts and be aware of the interests which they serve.

We need to ask ourselves whether the continuing focus upon such early twentieth-century designs indulges a nostalgia for the utopian aspects of early Modernism, or whether this still serves an important role in sustaining such aspirations in a quite different historical period. Do they continue to function as prototypes or models for ways of living in the modern world, or do they constitute a yearning for a period when it was possible to believe in the New? Is their classic, iconic or canonical status used to sell us a fantasy of the New, drained of its original power and hope?

In the photographs of Rietveld in the Red Blue chair and Schröder and her daughter in the Schröder House the protagonists stare at the camera as if challenging the spectator to ridicule the artefacts whose use they defiantly demonstrate – their equipment for the New Life. Today the Red Blue chair is most commonly seen as something to be gazed at rather than sat in; the Schröder House is now a small museum, beautifully restored, but unoccupied – a young monument which has outlived its inhabitants and become a spectacle for groups of visitors shepherded through its once intimate spaces by professional guides.

REFERENCES

BALJEU, J., *Theo van Doesburg*, London, Studio Vista, 1974

BARR, A.H. jr., *Cubism and Abstract Art*, exh. cat., New York, Museum of Modern Art, 1936, reprinted 1974

BROWN, T., *The Work of G. Rietveld*, Utrecht, Bruna & Zoon, 1958

DRIJVER, P. and NIEMEIJER, P., *How to Construct Rietveld Furniture*, Delft, Academia, 1986

KÜPER, M. and VAN ZIJL, I. *Gerrit Th. Rietveld 1888-1964, The Complete Works*, exh. cat., Utrecht, Centraal Museum, 1992

OVERY, P., BÜLLER, L., DEN OUDSTEN, F, MULDER, B., *The Rietveld Schröder House*, Cambridge, Massachusetts, MIT Press, London, Butterworth, 1988

SMITHSON, P., 'Gerrit Rietveld, Obituary', *Architectural Design*, September 1964, reprinted in Smithson, A., and Smithson P., *The Heroic Period of Modern Architecture*, London, Thames and Hudson, 1981

VÖGE, P., *The Complete Rietveld Furniture*, Rotterdam, Uitgeverij 010, 1993

DADA & SURREALISM IN PARIS 1919–1947

MARK GISBOURNE

Any discussion that presents Dada and Surrealism in Paris as an homogenous or continuous history has missed the point of their meaning as movements. For even the term 'movement' suggests a shape to that which was at times polymorphous and disparate – the coming together, political expulsions, the breaking away were all evident at specific periods of revolt. For Dada and Surrealism were marked throughout more than a quarter century of artistic and literary dominance in Paris by any number of ruptures. A sense of the discontinuous, which at the same time valorized above all the free flow of imagination and the unconscious, may at the end be the singular telling fact that holds their ideas together as movements at all. There were no shared formal identities, unlike the visual issues of image-making in the style-based pre-war movements of Cubism and Futurism, or in post-war Purism and Constructivism. There was no style that could be called precursory to Surrealism (a reason later used as justification for writing the pre-history of the movement), any more than there were any clear set of adaptable or re-workable iconographies called Dada.

The motivations of Dada and Surrealism were closer to a series of psychological and artistic themes, ideas that, following the post-First World War period, were forged into several different forms of collective action and group identity. For being 'dada' or 'surreal' was the touchstone by which member artists and writers revealed their own Dada/Surrealist credentials. At a general level they shared with literary movements of the past (like Romanticism and Symbolism) a certain condition of being as the main criterion for membership of the group – rather than a visual or literary practice or style. With the foundation of Surrealism proper (following the first issue of the journal *La Révolution surréaliste*, December 1924) their actions became a far more coherent strategy, opposed to the post-war artists of the School of Paris. Braque, Derain, Severini, and, in the early 1920s, Picasso himself wanted to return to a traditional visual order (*rappel d'ordre*), renewing forms that could be related back to history and French naturalism.[1] If the formalism of Purism in Paris (Léger, Ozenfant, and Jeanneret) and the post-First World War new spirit in art (known commonly as *l'esprit nouveau*) stood apart from the more overt forms of Naturalism, it did so in order to generate its own formal vocabulary, while within Dada and Surrealism the numerous formal innovations were seen as a by-product of a larger aim – namely to reveal new means of unearthing hidden levels of 'revolutionary' imagination and consciousness. It was an emphasis on the revolutionary goal, as opposed to creating a general historical hiatus or

nihilism for its own sake, that separated Surrealism from Dada. However, on other levels or ideas they shared certain affinities.

The themes and ideas I have referred to were those of the role played by chance, word and image, and anti-art strategies. A concern with chance (identifiable in different ways within both Dada and Surrealism) involved bringing together distant realities, and searching out the incongruities and dissonances of both the imagined and the lived. In word and image there was an attempted renegotiation of the relationship between language and art, which was visually distinct from the formal and sometimes anecdotal use of textual sources found in Cubist *papiers collés* or collages after 1911. Anti-art was that part of Paris Dada which furthered a certain sense of nihilism and disgust, a desire for rupture in the face of nineteenth-century positivism which sought to order and classify the world, held responsible particularly by André Breton (1896-1966) and the writers and poets of the French *Littérature* group for the great historical disaster of the First World War. They blamed it for a type of rationalist and positivist thinking that was emblematic of the system-building ideas of the nineteenth century. André Breton, as both the man who defined Surrealism and was its leader, remained the significant thread that ran through the history of both Dada and Surrealism, while many other important figures left the groupings, he stayed at the helm right through to the final major International Surrealist Exhibition on the theme of *Eros* at the Daniel Cordier Gallery, Paris, in 1959–60.

Today the anti-art legacy is seen largely in Marcel Duchamp's 'readymades' – mass-produced objects that Duchamp simply designated as works of art, such as his bottle dryer of 1914 (Plate 69). The enormous consequences of these anti-art strategies of Duchamp problematized not only general aims and ends but the very principles behind art-making itself. Art was what the artist stated it to be and was further reinforced by the 'art site' in which it was placed. A mass-produced wine-bottle dryer became, when exhibited in a gallery or museum, a work of art by the simple act of designation by the artist – no craft or process of making was necessary. The designation of 'given' material objects in the world opened the door to various forms of conceptual and later twentieth-century 'concept' art. The *objet trouvé* or found object (often subjected to degrees of manipulated intervention), which displaced the conventions of

69. Marcel Duchamp, *Bottle Dryer*, 1914, galvanized iron. Replica made by Ulf Linde, 1963, signed by Duchamp, 1964. Modern Museet, Stockholm.

traditional sculpture, was also an idea carried through to Surrealism.

PARIS DADA 1919–21
A MISMATCH OF MEANS

The word 'dada' was problematic from the beginning, claimed both by the Berlin 'dada' writer Richard Huelsenbeck and also Tristan Tzara, the Rumanian poet. Whether it does in fact derive from the French or Rumanian word for a 'hobby-horse' matters less than one might think. Tzara's 1918 *Dada Manifesto* was an anti-manifesto, for 'In order to launch a manifesto it is necessary to want ABC' that is say 'to crush (overwhelm, destroy, ruin, confound) against 1,2,3, etc.', whereas in short 'DADA NE SIGNIFIE RIEN' (dada signifies nothing). The nonsensical component of Dada was always part of a deliberate strategy of performance, confusion, a fissure in art history that led to an anarchic rupture (Gordon 1987).

Dada before it was named began at the Cabaret Voltaire in Zurich on 5 February 1916 (in 1921, Hans Arp tells us that the word Dada was discov-

ered by Tzara at 6 o'clock, on the evening of 8 February 1916, at the Café Terrasse – evidence no doubt of further dissimulation), where Hugo Ball, Tristan Tzara, Marcel Janco, Richard Huelsenbeck, Hans Arp, Sophie Tauber-Arp, and Emmy Hennings initiated the manifestations which were to be the main feature of Dada itself. The ephemerality of these actions, interventions, and performances, allied to their documentation through a series of small journals, single issue tracts and pamphlets, was a specific aspect of Zurich Dada that was later passed on to Paris by Tzara. In the looser group of artists who met together occasionally under the auspices of the wealthy patron Walter Arensburg in New York from late 1915 onwards, most notably Francis Picabia and Marcel Duchamp, there was no such clear agenda of performance related actions and group manifestations. Duchamp was ambiguous from the beginning in his relations to the role to be played by Dada, and it was left largely to the wealthy itinerant Picabia and his witty journal *391* to cement relations between New York (via Barcelona) and Zurich – the first issue of *391* was published in Barcelona in 1917 (its name was a typical Picabia-like pun on the address and journal called *291*, edited by and published by Alfred Steiglitz in New York). The American photographer-artist Man Ray, later a participant in Paris Dada, manifested something of the Zurich Dada spirit by publishing a series of short lived journals: *The Ridgefield Gazook; Wrong, Wrong;* and *The Blind Man*, between 1915 and 1918 – the last of which ceased publication after a game of cards that decided whether *The Blind Man* or *391* should be the single journal to survive.

At the end of the First World War in 1918/19, the Zurich group started to break up, and Dada spread to the main centres of artistic production in France and Germany. In 1918 in Berlin, to where Huelsenbeck had returned from Zurich in 1917, it took a more overtly political turn. Richard Huelsenbeck had joined with Raoul Hausmann and Johannes Baader, the last calling himself the *President of the Society of Oberdadaist Intergalactic Nations*. The *Club Dada* was founded in March 1918, and in the months that followed Huelsenbeck worked on his own Dada Manifesto. Set against the background of the violence of left-wing and communist 'Spartacist' uprisings, the general post-war chaos, and Germany's humiliation, Berlin Dada took on aspects distinct from its manifestations in other cities.[2] This was evident in the Berlin Dada attitudes towards the Hanover *Merzbild* works of Kurt Schwitters, who used estranged materials or found detritus from the streets, which he incorporated into assemblage-collage-type works. These ideas were rejected by the Berlin Dada group which thought they formalized a type of aestheticism and therefore possessed a bourgeois pedigree of an art rooted in poetic and formal values. In retrospect Hanover *Merzbild* can be seen as the Dada-like production that was most connected to Constructivism emerging in a post-revolutionary Soviet Union.[3]

Of all the centres of post-First World War Dada, the most important influence on Paris was Cologne. Between 1918 and 1920, Max Ernst and Johannes Baargeld developed anti-art strategies while using the context of a conventional exhibition format – the Bauhaus Winter exhibition at Cologne of 1920 required you to enter the installation space through the men's lavatory. Members of the public smashed many of the works which were simply replaced. It was to be Max Ernst (who later moved to Paris in 1922 and joined the Surrealists) and his Dada Cologne cliché prints and collages that were to have such a visual impact on André Breton and Louis Aragon in Paris when they were shown at the Au Sans Pareil bookshop exhibition in 1921 (Quinn, 1984). In a cliché print like *Little Machine Constructed by Minimax Dadamax* (1919/20; Plate 70), we find aspects of the fantastic mechanomorphic images and analogous machine drawings based on principles of rubbing – in this instance the artist has used printers' letters – ideas that were to be developed later by Max Ernst into his *frottage* (paper rubbing) and *grattage* (in which several layers of ground were applied to a canvas or other support and objects then placed underneath – an overall effect is created by scraping through the surface of the ground) techniques.

From 1920 Paris became the dominant centre. When Tristan Tzara arrived in January 1920 to take charge of the Dada manifestations, it was with a mixture of expectation and disappointment that André Breton greeted him. To Breton the Dada spirit was informed by anarchic gestures such as the suicide of Jacques Vaché, who had taken his own life by an overdose of opium the previous January (along with two others) 'his death was admirable in that it could have passed for accidental ... on the contrary it is very possible that his unfortunate companions were ignorant of the drug's use and that he wanted, in dying, to

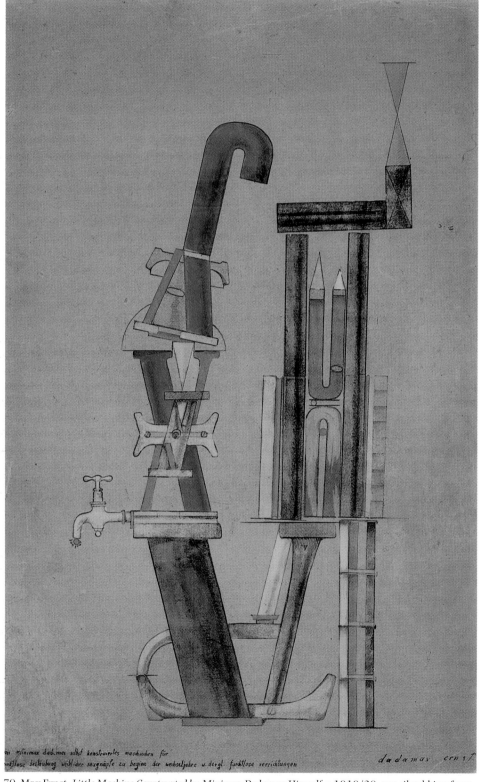

70. Max Ernst, *Little Machine Constructed by Minimax Dadamax Himself, c.*1919/20, pencil rubbing from pencil blocks, with pen, india ink, watercolour, and gouache on paper, 46.7 x 30.8 cm. Peggy Guggenheim collection, Venice.

commit at their expense one last deceitful joke.'[4] Breton's romantic account of the incident informed by what he considered *umour* – translatable as a form of dark ironic humour – typifies what the Frenchman understood to be Dada as a form of intervention or gesture. This somewhat Romantic gesture as described by Breton would seem to be a far cry from Tzara's Dada that 'signifies nothing'.

The contrary position, which related to the Zurich manifestations, was embodied not just by Tzara but by Picabia and Georges Ribemont-Dessaignes. This group of artists and writers were critical of the *Littérature* organized event that took place at the Palais des Fêtes on 23 January 1920, which they considered dull and literary. When two weeks later Tzara organized a Dada movement matinée held at Salon des Indépendants in the Grand Palais on 5 February (four years to the day after the Cabaret Voltaire opening in Zurich), it possessed the nonsensical characteristics that were familiar to Dada. A four-page *Bulletin-Dada* proclaimed that 'the dada was anti-dada' (this formed the basis of the sixth issue of the review *Dada*), a new *Manifesto of Mr Antipyrine* was published in issue no. 12 of *Littérature*, and announcements were made that Charlie Chaplin would appear, added to further lunacies, like the claim that the French philosopher Henri Bergson, and the Italian proto-fascist poet Gabriele D'Annunzio had joined Dada. Naturally this manifestation caused the violent response intended by the Dadaists and the audience threw coins and eggs at the participants on stage.

An account of the many twists and turns that Paris Dada took in the years 1920/21 is beyond our present scope of discussion.[5] Breton and the rest of the *Littérature* group participated fully in the events, but they did so in a manner that revealed their broader literary-poetical and psychical concerns at the expense of Dada's tendency towards nihilism – concerns which re-emerged in the Surrealist movement in 1923/4.

The art works produced by Paris Dada were for the most part ephemeral, since they were based on manifestations, actions, and on performances. They are found in literary and poetry journals, as well as illustrations to publications directly related to the manifestations. This was not a minor consideration, for it revolutionized, extended and problematized the boundaries of art as document, as a record, as an event, and was totally contrary to the old nineteenth-century transcendental ideas about creativity and art production. While it was no doubt founded on a small coterie of elite participants (later criticized in the 1950s and 1960s as a major weakness of the movement) the legacy of Paris Dada created an open-ended aesthetic of art and life, and conventional notions of what constituted a painting, sculpture, literature or poetry became destabilized. From a purely historically determined viewpoint today, it might also be claimed that Dada manifestations were not more than an inevitable product of the disaster and dislocation of the First World War, conditions that in themselves brought to an end the certainties of the nineteenth century and its desire for a static world of classification and order.

In 1921, André Breton and Philippe Soupault published their joint automatic text called *Les Champs magnetiques* (The Magnetic Fields). Debate continues as to who produced what, but it points unerringly to important, unconscious, psychological concerns found among the *Littérature* group led by Breton, Aragon, Soupault, Eluard and others. André Breton had first met Louis Aragon (his friend and co-founder of Surrealism) when both were working as medical attendants. During the First World War Breton and Aragon had seen first-hand the terrible distresses and mental traumas of the shell-shock victims of the trenches – psychological illnesses that could not be located or cured by the simple disease categories of nineteenth-century psychiatry. Patients revealed a vivid experience of the hidden consequences and imaginings at work in the unconscious mind. Breton's interest in what society called mad and disordered imaginings, and in the unconscious, was in place from the early period of his development, and it returned again in his *First Surrealist Manifesto* where it was significant enough to be expressed in the opening paragraphs.[6]

Surrealist pseudo-scientific interest in a disordered imagination for its own sake differed from the more anarchic tendencies behind the strategies of Paris Dada. If we consider Picabia's painting *The Cacodylic Eye* (*L'Oeil cacodylate*, 1921), we find it possesses the subjective and nonsensical self-absorption typical of that Dada artist (Plate 71). The work has received many readings in the past, but the eye is undoubtedly that of Picabia himself who suffered with a serious eye infection from March 1921. The idea came from the use of a medicament that Picabia was taking for his infection: *cacodyl* was a colourless, foul-smelling liquid made up of parts of arsenic, carbon

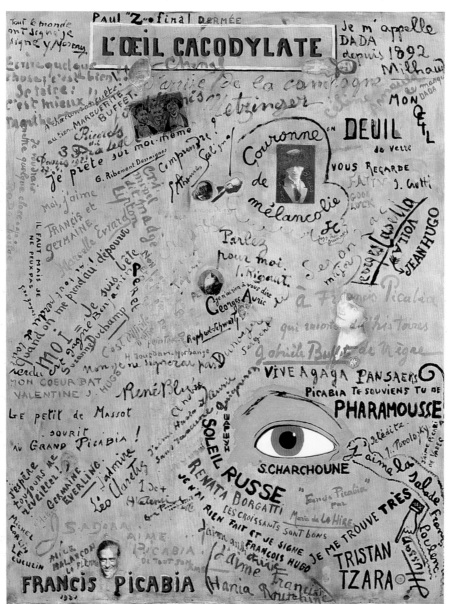

71. Francis Picabia, *The Cacodylic Eye*, 1921, oil and paper on canvas, 146 x 114 cm., Musée National d'Art Moderne, Centre Georges Pompidou, Paris.

and hydrogen. *L'Oeil cacodylate* might be literally translated as the 'stinking eye'. The painting was exhibited at the Salon d'Automne with another work that he called *Hot Eyes* in 1921. The some-times extremely complex personal iconographies found in Picabia's art distinguish his own sense of what was a Dada paradox, and his work never has a feeling of collective endeavour (even where there are the signatures of all his friends on the work it reads like a get well card), unlike those produced by Breton and his *Littérature* group of friends who constituted the collective identity of the proto-Surrealists.

DREAM AND 'THE PERIOD OF SLEEPS AND TRANCES' 1922–4

'It shall not be said that Dadaism served any other purpose than to keep us in that state of perfect availability in which we are and from which we shall now set out with lucidity toward what claims us for its own.'[7]

The *Littérature* group's break with Dada was foreshadowed by the mock trial *in absentia* of the conservative writer and thinker Maurice Barrès (a wooden manikin was used to represent Barrès and placed in the defendant's box), which took place on the evening of 13 May 1921, at the Salle des

sociétés savantes in Paris. Tristan Tzara in his typical Dada fashion turned the event into a farce, and in the process conflicted with Breton who wanted to use the symbolic trial for serious purposes. Breton had arranged for there to be a judge, prosecutor, advocate, witnesses, and a jury made up of young poets and writers of the *Littérature* group. Barrès's right-wing opinions were the subject of the charge – that his thoughts and writings were a crime against the safety of the mind. The result was the beginning of a decisive rupture that eventually split Breton, Aragon, Eluard, Soupault and other *Littérature* poets from Tzara, Picabia, and the older Dada artists and writers – though the variable Picabia himself was also gravitating away from Tzara's Dada at the same time. In February 1922, in the journal *Comoedia*, Breton went so far as to call Tzara 'an impostor always wanting attention' citing him as an outsider who had come to Paris in 1920, as he put it pejoratively, 'from Zurich'.

The separation and fragmentation were completed, and Paris Dada was consigned to the status of a transient movement appropriate for the immediate post-First World War period. Breton, Aragon, Eluard and their followers from this point on tended to develop those ideas of imagination, consciousness, and automatism that were of fundamental interest to them. While still proto-Surrealists they rejected the notion that they were actual poets – today we would understand that they meant they were not conventional wordsmiths – and it followed that they began their pseudo-scientific enquiries into the workings of imagination and the unconscious mind. A frequent stress placed on the term 'pseudo' is intended to emphasize that they did not pursue any rigorous scientific method, but that their experiments were focused on the subjective poetic tools of imagination, intuition, and insight.

The world of the unconscious was under greater scrutiny in the 1920s with the emergence of the writings of Sigmund Freud and the practice of psychoanalysis. In France there was a steady increase in translations of Freud's written works. In 1921, Breton had met Freud while he was in Vienna, his exaggerated account of the meeting revealed no particular insight into the theoretical or practical aspects of psychoanalysis. The main thrust in 1922/3 for the *Littérature* poets was that of the narration and transcription of dreams (Freud's *Interpretation of Dreams* (1900) was an important impulse), transcriptions that were considered by the proto-Surrealists as unfettered avenues, giving access to the workings of the unconscious mind.

What began with practices in automatic writing (writing and drawing without conscious control intended to express unconscious intentions and desires), chance doodling, and drawing (*Les Champs magnétiques* was a precedent), was to be extended in several directions during the two years before the formal founding of Surrealism. There was a love of games as experiments, exemplified by the nineteenth-century social parlour game *Exquisite Corpses* (*Cadavre exquis*). This was a game in which several people drew by turn on pieces of paper which were then folded over before being passed to the next person. As a result an unpredictable or chance image appeared through a process which was a variation on blind drawing. They also began at this time, at the suggestion of René Crevel, forms of spiritualism, entering hypnotic trances under the influence of which drawings were made and texts were written. An increased fascination with altered mental states of consciousness like hallucination and delirium followed. The poet Robert Desnos was seemingly able to fall asleep at will, summoning up supposed images from the unconscious. These were extended into detailed transcriptions of dream experiences intended to reveal the workings of the unconscious mind. The results were then published as if they were scientific experiments, practices that the Surrealists considered as discoveries on the royal road to the unconscious. These experiments were to be a means to the ultimate goal of Surrealist investigations in pursuit of what they called the 'marvellous' (*merveilleux*). This aesthetic theory of the 'marvellous' was developed further over the years that followed, as Breton put it 'the marvellous is always beautiful; anything marvellous is beautiful; only the marvellous is beautiful', and may be read as a fusion of wish (or desire) and reality. The closest and best account of these experimental years (1922/3) appeared in 1924 and '26, written by Louis Aragon under the titles *Une Vague des rêves* and *Paysan de Paris*. He described the daydreams and wanderings through the avenues of Paris, with all the poetic and chance juxtapositions, the strange found objects (*objets trouvés*) of the street markets, which were all potential visual material in the search for the emotive snapshots of the marvellous (Aragon, 1926). At this time Aragon coined the expression that the Surrealists were nothing other than

'hunters of images' (*chasseurs des images*). These strange images, distant realities, objects and finds, are often misunderstood for they were not the products of Surrealism so much as art and life (the condition of 'surreality' conveyed the meaning to the objects), and in fact all surviving material manifestations of Surrealist art, as Breton originally argued, were no more than a record of a confrontation between imagination and life as expressed by the marvellous.

Although not directly involved with the Surrealists at that stage, there was another group of artists who were to be active within Surrealism through the 1920s. They have been called the rue Blomet artists, and included Joan Miró and André Masson. It was not until 1926 in *La Révolution surréaliste*, that Breton securely incorporated the visual arts into the Surrealist project. Masson's paintings in the early 1920s were concerned with alchemy and the magical, with transmutation and the 'primitive', whereas Miró's drew upon Native North American art, and on prehistoric cave painting, the world of ideograms and pictograms, and sundry other Oceanic inspirations – these ideas were often derived experiences from the Trocadero Museum in Paris (Musée de l'Homme), or from the increasing number of articles on 'tribal' art appearing in the popular journal, *Cahiers d'art*. Both these artists codified in visual terms Surrealist ideas on the problematic notion of 'the primitive'. The words 'primitive art' (today seen as racist and pejorative) had in the early 1920s, only recently been transposed from their nineteenth-century categorizations into describing 'tribal' forms of production. Yet the interest in 'primitive art' shown by the Surrealists was very different to the Cubists' appropriation of the formal properties of African 'tribal' art. The Surrealists' interest in 'tribal' art materials was in those that carried a particular propensity for the magical and fetishistic (a connection again with Freud's *Totem and Taboo* (1913) may be considered), and hence they were drawn specifically to those objects and forms represented by Native North America, Oceania, and in some instances African tribal art. There were always in the Surrealist mind ritualistic or magical-transmutational properties attached to the works. These imagined fetishistic objects were also read to fuse desire and reality in the marvellous. What is a fetish if it is not a fusion of wish and reality? By standards of modern anthropology, any Surrealist understanding of so-called 'primitive art' was cursory or simplistic to

72. Max Ernst, *Saint Cecilia (the Invisible Piano)*, 1923, oil on canvas, 101 x 82 cm., Staatsgalerie, Stuttgart.

say the least. Yet, in the longer run, they did play an important role in raising the status and esteem of these sometimes extraordinary 'tribal' objects, and it should not be forgotten either that important French anthropological figures such as Michel Leiris and Claude Lévi-Strauss, founder of Structural Anthropology, came out of a Surrealist background.

By locating oneirology (literally the study of dreams) and dream transcription, the automatic, the 'primitive', and the pursuit of the *merveilleux* prior to the actual First Manifesto of Surrealism, it becomes clear the actual moment of founding of Surrealism was a summation of already exposed tendencies. Max Ernst, who had arrived in Paris in 1922, where he lived with Paul and Gala Eluard (later Gala Dali), perhaps showed most readily the new feeling for imagination and consciousness in art at the time. Human reason and rational thought were reviled as if blind – 'they have eyes but they cannot see', as Aragon put it, became a dominant metaphor of the condition of the unseeing old order in the 1920s. The fascination with blindness or blinding was still evident in 1929,

when in the Dali/Buñuel film *Un Chien andalou*, a woman's eye is slashed with a cut-throat razor. Max Ernst (who took part in *Un Chien andalou*) expressed blindness in a collage-painting *Saint Cecilia (the Invisible Piano)*, (1923; Plate 72). By this time Ernst was re-transposing his collages into painted images of the cut-out components he formerly used. This new visual problematization changed the notions of source from the original collage materials, and thus inverting the status of Cubist *papiers collés*, where the use of collaged material stood in for the real in a painting. In Ernst's work the painted illusion of former collage elements stood in for the unreal – or, as he might have wanted to argue, the 'surreal'. This was, Ernst claimed, the third eye where the inward looking eye meets the outer eye surveying the world of the real. Ernst made great play of this third reality, as he saw it, and it explains why, when he spoke (or wrote) of himself, he deliberately referred to himself in the third person.

SURREALISM

DEFINITION – AUTOMATISM 1924–9

In December 1924, André Breton, in the first issue of the journal *La Révolution surréaliste* (it ran through twelve issues in the years 1924–9), presented the Surrealist manifesto to which members of the movement were to adhere and conform. There is a strange sense of contradiction in the use of a dictionary-type definition for Surrealism. It aped modular scientific rationalism in using a definition, while at the same time it claimed to be opposed to reason:

> *Surrealism*, n. Psychic automatism in its pure state, by which one proposes to express —verbally, by means of the written word, or in any other manner – the actual functioning of thought. Dictated by thought, in the absence of any control by reason, exempt from any aesthetic or moral concern.[8]

Surrealism's own hidden pre-history was to be incorporated from the very beginning, and the seeking out of heroes or forbears 'surreal before the word' was an important concern now sometimes forgotten when the subject is addressed. Among the hero-precursors was the infamous Comte de Lautréamont (Isidore Ducasse),whose strange novel, *The Songs of Maldoror* (1869) became a canonical text to the Surrealists. The juxtaposition of a sewing machine and an umbrella on a dissecting table first appeared in the writings of Lautréamont – its macabre *frisson* delighted all Surrealists. Later, a sewing machine would be wrapped by Man Ray and called *The Enigma of Isidore Ducasse* (1922), and just as readily served as a subject for Oscar Dominguez in his painting called *Umbrella and Sewing Machine* (1943), over twenty years later. Lautréamont's ubiquitous umbrella was to make frequent appearances as a *leit motiv* running through surreal art.

The litany of heroes was extended as the result of research and investigation by the artists and poets within the movement over the next twenty years. Writers like Lewis Carroll, Edgar Allan Poe, William Blake, and the Romantic-Gothic tradition were incorporated wholesale. Increasingly with time given over to the nightmarish, the fantastic, and the macabre, others were added. Northern and Italian Renaissance artists, like Hieronymus Bosch, Pieter Bruegel the Elder, Lucas Cranach, Piero di Cosimo, and Giuseppe Arcimboldo found their way into the Surrealist pantheon of the past. Symbolist artists like Böcklin, Beardsley, and Hodler were also included, sometimes for their *œuvre* as a whole, more often for specific works thought to contain surreal content. This idea of unearthing a pre-history of forgotten precursors fitted in well with the archaeological metaphors derived from psychoanalysis. Freud used notions of the mind as if it were arranged in strata, casting himself in the role of an archaeologist sifting through psychical layers of repression, so as to unearth and expose the hidden neurosis. There was a paradox at the heart of this desire for a history *avant le mot*, since it implied a sense of determinism, as if the present was a result of the past, something the Surrealists associated with nineteenth-century ways of thinking. Certainly, Surrealist references to Hegel were contradictory to their disavowal of nineteenth-century determinism. However, history was integral to their position as pseudo-Marxists, and this makes a connection to Hegel plausible. The idea of 'revolution' itself was inevitably tied to the idea that there was an existent history against which one might revolt.

Psychical automatism, the key definition of Surrealism used by André Breton between 1924 and 1929, also had a history, and though Breton particularly disliked the philosopher-psychologist Pierre Janet, Janet's book *L'Automatisme psychologique* (Psychological Automatism, 1889), was not unknown to him. Breton's dislike of Janet

73. André Masson, *The Blood of the Birds*, 1925/6, Musée National d'Art Moderne Centre Georges Pompidou, Paris.

treatise on *Surrealism and Painting*, serialized in the journal *La Révolution surréaliste* from 1926. Ernst's works were driven more often by manipulated chance under the control of his conscious mind. Only his works of *frottage* (a rubbing technique) and later *grattage* (a scraping technique), could be argued as automatic productions, and in these works there were a considerable number of manipulations made after the first chance effects generated by the *frottage* rubbings (Ernst, 1982). This notion of chance finds, or for that matter the love of the anamorphic principle (visible forms that appear in other things when seen from another point of view), was not a new addition to artistic means. The ink-blot was used as a logo or motif on the headed paper of the Surrealists from 1929. Blots were also used and developed by Hermann Rorschach in his psychological testing from 1919. Alfred Binet (d. 1911), the early French child psychologist may also have used them in his intelligence testing of schoolchildren somewhat earlier. The intended suggestion here is not that Surrealists appropriated these means but were re-connecting to 'neglected associations' mentioned in their manifesto.

Several other Surrealist artists were successful in their pursuit of automatic techniques. André Masson's sand paintings of 1926/7, are a case in point. He used glue and sand spread across a canvas surface, and then dripped painted across in a series of gestures (a 'drip' technique that was mastered and systematized twenty years later by Jackson Pollock). This gave the effect to Masson's painted works of not just gesturalism, but of a sort of parallel to automatic drawing. An example of this technique is found in *The Blood of the Birds* (1926?; Plate 73) where other chance materials like a bird's feathers have been added. Masson's works carried poetic and fantastic references in their titles like that of *The Battle of Fishes*, a title also found earlier in the work of Max Ernst.

Miró's dream paintings of 1925/6 reflected Surrealist notions of the automatic cited in the manifesto, though as we now know the automatic aspects of the works emerged from original drawings that were transposed onto preprepared canvases. In *Stars in Snails' Sexes* (1925; Plate 74) and other works Miró juxtaposed poetic texts creating a sort of title, fluidly transcribed by brush onto the work. This doubling of the sense or poetic parallelism appealed to the Surrealists' love of the marvellous and of distant realities. The use of poetry in Miró's work was, however, very different

was due to his perceived philosophical elitism, and to the fact that Pierre Janet consigned 'automatism' to lower levels – mental disagregations – of the human unconscious. The 'theory of automatism' had first been observed in the nineteenth century within the context of clinical psychiatry (or, alienism as it was then called) among the writings of the mentally insane (called 'aliénés'), precisely the group that Surrealists thought to have greater rather than lower levels of creative insight. An important text for André Breton and Paul Eluard in the 1920s, was brought by Max Ernst from Germany as a gift for Eluard, it was called *Bildnerei der Geisteskranken* and was first published in 1922.[9] The book contained illustrations of drawings and other works as well as textual information on the art of the insane, with a special attention given over to ten artists who the writer called 'schizophrenic masters'. The psychiatrist Hans Prinzhorn (who had previously trained as an art historian) showed that the works of the insane were as rich and various as cultural art – or so the Surrealists chose to interpret it.

The complexity of how to apply 'automatism' was the main issue of artistic and literary production in the years 1924–9. Max Ernst was quite frankly not good at producing automatic art forms, even after Breton wrote and published his

74. Joan Miró, *Stars in Snails' Sexes*, 1925, oil on canvas, 129.5 x 97 cm., Kunstsammlung Nordhrein-Westfalen, Düsseldorf.

75. Yves Tanguy, *The Dark Garden*, 1928, oil on canvas, 91.4 x 71.1 cm. Kunstsammlung Nordrhein-Westfalen, Düsseldorf.

from the ruptured sense of the text found in Dada subversions of word and image.

The rather limited options allowed by automatism were mitigated after the publication of Breton's *Surrealism and Painting*, and oneirology was extended as a source for Surrealist imagery. From 1927 Yves Tanguy became 'the most surreal of us all', a soubriquet Breton lavished on several of the Surrealist painters in turn in the 1920s. Tanguy's biomorphic and imaginary landscapes, presaging in many ways the later spectral landscapes of Salvador Dali, were dream-like imaginings of landscapes of the mind, though like many Surrealist works they followed the old and conventional use of perspective and the horizon. This is clearly evident in Tanguy's painting called *The Dark Garden* (1928; Plate 75).

Automatism was the means and the marvellous the end in the second half of the 1920s, but this does not of itself make for a full understanding of the history of the scope of Surrealism in this period. The most problematic and contentious issue was Surrealism and politics. There were a series of ruptures that began with the so-called 'Naville Crisis' in 1926. Surrealist politics were an enormously diffuse and complicated subject, as much shaped by Breton and his personality as by a secure commitment to ideology. Pierre Naville, the poet and early member of the movement, raised the issue of Surrealism *vis-à-vis* Marxism and Communism. The 1920s, as the decade following the Russian Revolution, was the great age of conflict, debate, and interpretation concerning the assumed eventual triumph of Marxism. And, as Surrealism claimed itself to be a revolutionary and political movement its position remained to be argued out and fully established. At the centre of the debate was whether Surrealism was a psychological revolution, through which the nature and structure of human thinking would be changed,

desire + reality.

or must the materialist revolution take precedence, as Naville argued in line with Marxist historical materialism. In what may seem today an obsolete question, they asked whether to concentrate on material changes (i.e., who controls the means of production), or whether Surrealism must first establish its new ways of thinking in order to fulfil this materialist Communist project. Breton and many other Surrealists around him had a problematic relationship with the French Communist Party (sometimes being members and at other times not), yet the Surrealists were racked by these issues which led to expulsions in the years between 1926 and the early 1930s, and eventually to the departure of leading figures from Surrealism. Aragon left in the wake of the Kharkov Conference and the debacle surrounding the poem *Front rouge*.[10] The debate was complex and personality led, not least by Breton, who was motivated by a desire to keep control over what he had defined as the true nature of Surrealism. Political issues and the expressive limitations of automatism and oneirology were among the reasons which lead Breton to write the *Second Manifesto of Surrealism* of 1928/30 (Breton, 1972).

In the 1930s André Breton increasingly dominated the movement, shaping almost every ideological twist and turn. This was particularly true of his opposition to his rival Georges Bataille and the journal *Documents*, which by 1930, had challenged Breton's total control of Surrealism, and presented an alternative, darker view of the condition of the Surrealist nature. At the end of the *Second Surrealist Manifesto*, using Marx as his authority, Breton referred to Georges Bataille as that 'excremental philosopher'. The violent expression used tells us much about Breton's Surrealism. For him imagination was grounded largely in the cerebral experience, while a suggestion of the squalor or 'filth' (Bataille's principle of Surrealism was much more visceral and anthropologically rooted) at the heart of the real world and human consciousness always disturbed him. This was one of the reasons why Breton was so shocked by Dali's painting *The Lugubrious Game* (1929), which touched on Freudian ideas and on coprophilia, literally 'shit eating'. Modern ideas on abject art descend from Georges Bataille and not the pristine and relatively tidy imagination of Breton's strain of Surrealism. By the late 1920s there were many different burgeoning threads within Surrealism and the *Second Manifesto* was intended to counter them.

Re-definition
Freud and Sade 1929–35

The years 1929–30 saw a decisive shift in thinking about what constituted Surrealism. An extended understanding of Freud and increasingly the Marquis de Sade influenced André Breton and the movement. Both Breton and Bataille championed the Marquis de Sade though with very different interpretations of his life and intentions. In the *Second Manifesto of Surrealism*, Breton speaks of the Marquis and 'the impeccable integrity of Sade's life and thought, and the heroic need that was his to create an order of things which was not as it were dependent upon everything that had come before him.' It was not the desire to emulate the Marquis de Sade or the deviance found in his novels that Breton intended to praise, but rather the sense of simultaneity between Sade's unconscious desire and conscious actions. This impressed the Surrealists and it gave him a pre-eminent position as the precursor of modern psychology – the most extreme fusion of desire and reality. While this sounds a fanciful reading, the effect was an important impulse to the Surrealists whose works in the early 1930s took on increasingly a concern with sexuality and the hidden nature of desire in all its forms. Through the 1930s and 1940s Surrealist artists were to devote time to designing series of illustrations for republished eighteenth- and nineteenth-century editions of Sade, perhaps most notable among these were the drawings of Hans Bellmer and the Czech woman artist Toyen.

Salvador Dali only joined Surrealism in 1929, at the same time as the filmmaker Luis Buñuel, and it was due in large part to the shock created, and the eventual banning, of the films *Un Chien andalou* and *L'Age d'or*. The Belgian Surrealists René Magritte, Camille Goemans, and Paul and Gala Eluard had first met the Catalan artist at Cadaques in 1928, and in 1929 Dali had his first one-man exhibition connected to Surrealism at Goemans' Gallery in Paris. The impact on Breton of Dali's painting *The Lugubrious Game* (sometimes called *Dismal Sport*), shown at this time, has already been mentioned. Its explicit sexuality and coprophagous nature, with the limp candle of Freudian impotence at the foot of the stairs, as well as the garish colours used gave it an hallucinatory effect.

The theme of unconscious sexual desires and broadly Freudian readings of them became uppermost (there was a series of letters between Breton

and Freud in the early 1930s), and the 'paranoia critical method' was explained by Salvador Dali in a lecture given in 1933. Dali's method, such as it was, was of an intentional derangement and literally the farming of delusions. Dali entered an irrational unconscious state for the purposes of a 'delirium of interpretation', thus avoiding the one-way door of psychosis in the process – today we know that such a thing is not possible and it only seemed so at the time. The images he achieved were then executed in the meticulous academic painting style for which Dali is well known. How seriously we can take the supposed windows onto the unconscious is neither here nor there, the fact is that these works, like his other works *The Invisible Man* (1929/33), *William Tell* (1930), and *The Enigma of William Tell* (1933), are at best little more than personal insights into Dali's own unconscious needs and hidden desires. For while in Dali's paintings the use of anamorphism (images hidden under the appearance of other things) was greatly extended, the images generated were often little more than illustrations to the text of Freudian understandings of the workings of the unconscious. In this they shared a visual kinship with paintings by the Belgian Surrealist artist Paul Delvaux, though they are far less literal in their actual transcription and more sophisticated in their content.

The subject of Surrealism and Women has warranted extended histories in its own right.[11] From the inception of the movement Surrealists had cast women into the role of 'muse', and played with old clichés that women were the more intuitive gender and closer to nature. Breton's important novel, *Nadja*, published in 1928, proved exemplary in expressing the polarity and extremes to which the inspiration of the muse was stretched to conform with male Surrealists' needs and assumptions. Today, many of these ideas read like no more than a form of outrageous chauvinism, and have been the subject of wide-ranging feminist critiques. The Surrealist male projections of what they imagined constituted female actions and women's desires were incorporated into Surrealism from the beginning. In the first issue of *La Révolution surréaliste* the young murderess Germaine Burton had been shown surrounded by photographs of the Surrealists – including one of Sigmund Freud. In 1928, they celebrated the fiftieth anniversary of hysteria, thought in the nineteenth century to be a purely female disorder, and something that had been investigated under hypnotic trance by the psychiatrist Jean-Martin

Charcot at the Salpêtrière Hospital in Paris (Freud had briefly studied with Charcot at Paris in 1885). Rather theatrical performances with hysterical women had been publicly presented by Charcot and were fashionable events in the mid-1880s, until the whole idea was disproved and debunked by Hippolyte Bernheim (head of psychiatry at Nancy), when they were shown to be nothing other than the consequences of trained suggestion. Yet, typically, perhaps, the Surrealists turned this anniversary into a great celebration of the 'otherness' of woman, used for the purposes of their personal inspiration, intuition, and insight. Something that even Simone de Beauvoir the postwar feminist writer acceded to in 1949, in her book *The Second Sex*, when she also inferred or constructed woman as 'other'. In 1929 a photographic reproduction of a Magritte painting, called *I Did Not See the [Woman] Hidden in the Forest*, appeared in the last issue of *La Révolution surréaliste*, and showed snapshot photographs of the group with eyes closed (blindness again) feigning hypnotic or trance-like states surrounding and framing the image. In 1933, a photo-collage by Salvador Dali appeared in *Minotaure* (no. 3/4) called *The Phenomenon of Ecstasy*. This showed a series of women and sculptures of women, on this occasion the women in their own hypnotized or trance state. It purported to be Dali's and male Surrealists' insight into what they considered female ecstasy – what possible understanding Dali could have had on the actual nature of female ecstasy remains open to serious question.

Yet, perhaps, the most significant and complex view of male desire and 'woman as object' was presented by the Belgian René Magritte. Magritte and the Surrealists in Brussels had not been interested in Breton's definition of automatism as the guiding principle of Surrealism before 1929. Breton had rejected the idea of *mystère*, or mystery, which fascinated Magritte, and it has been a constant error to include him in with the Parisian group – even though he frequently visited Paris throughout the 1920s and 1930s. However, by 1933/4, Breton and Magritte came much closer together and Breton's famous text *Qu'est-ce que le Surréalisme?* (What is Surrealism?), was first delivered as a lecture in Brussels. In his painting *The Rape* (*Le Viol*), 1934 (which was the cover illustration for the book *Qu'est-ce que le Surréalisme?*) (Plate 76), Magritte directly transposed the implied aspects of male desire, the breast and the vagina, to the face of a female bust portrait. While today it all seems rather literal, at the time it cre-

76. René Magritte, *Le Viol* (The Rape), 1934, oil on canvas, Menil collection, Houston.

77. Leonora Carrington, *Portrait of Max Ernst*, c. 1939, oil on canvas, 50.2 x 26.7 cm., the Young Mallin Archive Collection, New York.

ated a shocking effect, pointing explicitly to the woman as an object of male desire on the one hand, and revealing what some have called the 'hidden visible' or that which follows psychically from the thing seen – that which we read or infer from the object seen. Where there are beautiful women a 'hidden visible' of their gender is apparent, where there is an envelope we must suppose there to be a letter, where there are such things as shoes we must suppose there are feet to fill the shoes – these implied invisibles are the 'hidden visible'. This issue points also to the rather complicated semiotic word games at work in the paintings of Magritte. Whether Magritte intended *The Rape* as a proto-feminist observation would seem extremely unlikely but it aptly portrayed the condition of woman as object. This was to be something that the increasing number of women involved in the Surrealist movement generally resented. Artists like Leonor Fini, Leonora Carrington, and Toyen, inverted many of these ideas in their own work. In her paintings Leonor Fini turned young men into beautiful objects, sitting at her feet or led around on leashes, as 'toyboys' of female desire. Leonora Carrington in her *Portrait of Max Ernst* (1939), shows him as less the womaniser and masculine figure (which his biography seems to suggest), but rather as a haunted fragile figure in the frozen wastes (Plate 77). The Czech woman artist Toyen later illustrated the Marquis de Sade's works showing the rapacious animality of female desire to be greater than that of a man.[12]

While it is clear that the imposition of 'muse' was often resented by women in the movement, it remains important to register that the most stereotypical role of women almost never appears to be used by the male Surrealists, namely that of

78. Salvador Dali, *Retrospective Bust of a Woman*, 1933, painted porcelain, height 49 cm., Museum of Modern Art, New York.

woman as mother. When it does appear it was in the work of the American artist Dorothea Tanning, who lived with Max Ernst in the United States during the Second World War years and after in France. In works like *Maternity* (1946), Tanning problematizes the whole event of motherhood, as does the Mexican artist Frida Kahlo (not strictly speaking a Surrealist) whose works showed birthing as a horrific experience. In a painting called *My Birth* (1932) she gives birth to herself, with her own adult head forcing its way out of the womb through the vagina into the world. Woman as earth, as nature and chthonic (underworld and demonic) principle, was to be extremely important to all Surrealist art throughout the 1930s and well beyond.

The third major innovation in the early 1930s was that of the development and extension of the Surrealist object, in which Dali, Magritte and Giacometti played a major part (Giacometti had joined the Surrealists in the late 1920s). The earliest members like Joan Miró and André Masson, while still remaining attached, were making their own successful careers and gradually drifting free of direct Surrealist influences in the 1930s. Picasso, who had also played his part in the early period of Surrealism, was by the early 1930s less interested and had gone his own way. Breton's need for Picasso's fame and symbolic support in

the early period of the movement lessened – Picasso was never a keen group participant.

The Lautréamont principle of the 'bringing together of distant realities' and the *objet trouvé* became increasingly important in the Surrealists' pursuit of the marvellous. They often wandered through the flea markets of Paris, and were delighted when they found strange objects whose use was unknown to them. The utility of an object was of no importance, and if it was explained they often threw it away. The assemblage of disparate materials or objects into stranger objects was practised not merely by the artists in the movement but by Breton himself, and many other members of the group. Dali was particularly adept at Surrealist objects, and his were considered three-dimensional manifestations of the unconscious content of his paintings. In *Retrospective Bust of a Woman* (1933; Plate 78), we find the porcelain bust of a woman, with a large 'baguette' or loaf on her head, surmounted by an ink-stand depicting Millet's *Angelus* – the theme of Millet's *Angelus* was an obsession for Salvador Dali in the early 1930s, going back in origin to a classroom print of the image he recalled from childhood. As with all Surrealist objects, the main intention, regardless of the biographical content found in so many of them, was not merely to produce puzzlement but the *frisson* of the marvellous. To be surreal was to profess openness to the potentials of what happened when the imagination fused with life. André Breton and the other Surrealists argued that the life they lived and their propensities shaped an understanding of the marvellous, the place where desires and reality were fused as one. Breton described these experiences using terms such as 'convulsive beauty' in his book *L'Amour fou* (Mad Love, 1937), and as the 'waking dream' in *Les Vases communicants* (The Communicating Vessels, 1932).[13]

POLITICS AND THE INTERNATIONALIZATION OF SURREALISM 1935–40

By the mid-1930s, following further political ruptures, the departure of Louis Aragon to a clear cut Stalinist position and active membership of the *Parti communiste*, serious political debates and realignments of Surrealism led to attempts to internationalize the movement. This was further cemented by Breton's visit to Leon Trotsky, who was in exile in Mexico in 1937. The founding and the declaration of an *International Federation of*

Independent Revolutionary Artists followed from the meeting in 1938.

The political complexion of Surrealism in the second half of the 1930s was all but totally shaped – noticeably for the first time against a background of systematically documented horrors – by the slaughter and genocides of the Spanish Civil War. Yet André Breton still avoided any form of alignment with Stalinism for a number of reasons. The first of these was that Surrealism was against the principle of one-nation communism advocated by the Soviet leader. This was at odds with the international aspects of the Surrealists, who, to the extent that they had theorized a position, believed that Surrealism carried universal applications; an alignment with the Trotskyite position on international communism helped to retain some credibility for the movement. Another reason concerned the psychical or the material form that revolutionary creative activity should take. Under the Stalinist Soviet regime Socialist Realism had been imposed as the official art of Communism: this utilitarian and work-related art was almost totally opposed to notions of the imagination and the unconscious. And when it was mentioned at all, Surrealism was dismissed increasingly as marginal and irrelevant. Stalin's singular support for the Popular Front Government in Spain against the Fascists made the position of the Surrealists particularly difficult, given their own alignment with the Free Forces.

Against this background the International Exhibitions of Surrealist Art began, taking the Surrealist message to Mexico, to Prague where a Czech group was founded, to Copenhagen where a similar international group of young Danes were involved, and to London. A Surrealist map of the world was produced in 1929, in which the different countries were shown not in relation to their actual size or land mass, but by the Surreal content of their indigenous peoples and culture. Mexico was massive, the United States non-existent except for Alaska, Canada also huge, due to strong North America Native cultures which expressed the imaginary and magical propensities of their peoples. Britain was barely the size of a pin-head when set next to the Celtic and mythical imagination of Ireland. No doubt the British empirical mind was thought largely antithetical to a Surrealist imagination, though this changed when the British Surrealist movement was founded at an International Exhibition held at the New Burlington Galleries in London, on 11 June

1936. Led by Roland Penrose and E.L.T. Mesens the group lasted three years, up to the outbreak of the Second World War.[14]

By far the most important of the International Exhibitions was that held in Paris in 1938. This proved to be the last coming together of the original artist participants in the movement. The profile of Breton's Paris-based Surrealist group had changed substantially by the second half of the 1930s. By 1938, Eluard had left or had been expelled, ostensibly because he had written for the Communist Party paper *Commune*. Max Ernst was hardly involved; although still a maker of highly provocative forms of Surrealist art, he was living in Saint-Martin d'Ardeche in the South of France with Leonora Carrington and was semi-detached from the group. A new generation of mostly young international artists took their place in the Paris group, these included the Chilean artist Roberto Echaurran Matta, Jacques Hérold, Victor Brauner, Kurt Seligman, Wolfgang Paalen, Oscar Dominguez, and Wilfredo Lam, the Cuban artist and a close friend of Picasso. In 1938 the German Hans Bellmer arrived in Paris joining the group and began to produce the extraordinary *poupées* (dolls), dealing with the fragmentation and disposition of the female body. In many respects, however, Bellmer's dismemberment and erotic reassemblies of female dolls were closer to Bataille than Breton, and by this late date a sort of rapprochement had taken the place of the conflicts between the two men common to the earlier part of the 1930s.

The Paris International Surrealist Exhibition was the fourth in the series, and took place at the Beaux-Arts Gallery, opening on 17 January 1938. The dominant theme of the exhibition was of the manikin or doll, a long time interest of the Surrealists, with a whole series of precursors like De Chirico, who had earlier been championed for the oneiric or dream qualities in his metaphysical school paintings (1911–22). Another inspiration may have been the series of photographs of disjointed manikins taken in the couture Pavilion at the Paris Universal Exhibition held a year earlier, from which the Surrealist group had been deliberately excluded by Leon Blum's Popular Front Socialist government.

The significance of this International Surrealist exhibition was that it was in the form of total installation (a precursor in many respects to installation art today), in which the manikins were dressed by the artists to reveal what they

79. Man Ray, *Mannequin*, photograph from the International Surrealist Exhibition of 1938, in Paris.

thought to be hidden desires and fantasies. The room was kept dark, coal sacks were hung from the ceiling and placed on the ground, the lighting came from burning braziers. A handtorch was required to enter the exhibition and the works shown had to be seen by torchlight and the fire-light of the braziers. The installation included many Surrealist paintings and objects, and the visual experience was of a hidden and secretive nature. The sense of being blind and the reliance on the torch to show the way picked up on the now familiar theme redolent throughout the whole history of Surrealism – they have eyes but cannot see (Plate 79).[15] Perhaps, more than any

other international exhibition this Surrealist event reflected the idea of 'convulsive beauty' which Breton had expressed in *L'Amour fou* published the year before, in 1937.

The exhibition was the last involvement of Dali in Surrealism, for he was expelled from the group shortly afterwards. Dali's increasing fascination with megalomania and dictators, and the ambivalence of his position over the Spanish Civil War made him intolerable to many other members of the group. Also, his love of money, self-aggrandizement, and success later earned him the anagrammatic nickname 'Avida Dollars'.

80. Jacqueline Lamba, *As. 1941*, original drawing for the
Tarot de Marseilles, 1941.

SURREALIST DISPERSAL AT MARSEILLES 1940–41

With the outbreak of the Second World War the Surrealist group became fragmented and scattered across France. In the phoney war period 1939/40, the Germans in the group, Ernst and Bellmer, were temporarily interned at a camp called Les Milles, near Aix-en-Provence. Both artists drew and recorded their experiences of the camp at this time. With the Fall of Paris to the German Army in 1940, the group gravitated South in fear of the consequences that might befall them, in view of the Nazi hatred of Surrealist literature and art which they had already proscribed as degenerate. They were living in the Vichy Government administered part of France – though how long they would remain at liberty was not clear – for the wartime regime under Marshal Pétain had its own neo-Fascist agenda in the South culminating in Pétain's triumphal entry into Marseilles in December 1940.

At Marseilles in the years 1940/41, there was the last flowering of pre-war joint expression.[16]

This took the form most notably of a pack of Tarot cards; each card was executed by an artist or writer of the surviving group (Plate 80). In many ways this idea followed from the earlier experiments with the parlour game of *Exquisite Corpses* (*Cadavre Exquis*), but it was also in keeping with an increased interest in magic, esoterica, and the arcana of the late 1930s. Not only did it engage with ideas of chance, it also referred to a sense of fate and survival which was the pressing issue at the time.

A number of the group left Europe. Yves Tanguy was married to the Surrealist, Kay Sage, who was an American and could freely leave; Max Ernst married Peggy Guggenheim, and they both left for the USA in 1941. Others, like Miró, who left for Catalonia, Giacometti, who was a Swiss, could simply re-patriate themselves to their own countries. Matta, the Chilean, went to America, and Wolfgang Paalen to Mexico, where he joined the Mexican Surrealists and set up his own journal *Dyn*. Others had to take their chances with Varian Fry from the US Consulate in Marseilles, who set up a Commission and made every effort to get out as many members of the Surrealist group as he could. In this way Masson and Breton went to the United States. An open-air exhibition of works (they were literally hung from the trees) by Max Ernst was held at the Château Bel-Air in 1941 with the help of Fry, where works were sold to try and raise monies for the artists. Several others were left to make do as best they could, some declining to leave. Picasso, Brauner, Bellmer, Dominguez, Hérold, and Eluard stayed in France, surviving under difficult and varied circumstances (Cone, 1992). Some, like Brauner and Hérold, even hid out in the South of France and survived the Occupation, still producing their art in arduous circumstances – Brauner produced extraordinary encaustic and wax paintings at this time. Immediately after the war the sense of moral superiority felt by those who stayed was to become an issue.

The years in America are another story, but one that was vital to the understanding of the development of the post-war New York School of Abstract Expressionism. Surrealism continued with exhibitions, and with journals of support, most notably *VIEW* and *VVV*, and artists like Matta (and at some distance Miró) had an influential role in the development of a Surreal Abstraction, known sometimes as Lyrical Surrealism found in the paintings of Arshile

81. Marcel Duchamp, *Please Touch*, 1947, Velvet and foam
rubber cover for deluxe catalogue, *Le Surréalisme en 1947*,
Musée Nationale d'Art Moderne, Paris.

Gorky. It was this link with the French and Surrealist exiles in the USA that gave to post-war American critics like Clement Greenberg many of their intellectual grounds for arguing that the New York School had become the true inheritors of the European modernist tradition in art.

The Failure of 1947

The character of post-war Surrealist activities when the artists and poets returned in 1945–6 was influenced by a number of political factors and also by Breton's lack of awareness of the change of intellectual atmosphere that had taken place because of the Occupation. After the war years of propaganda the new philosophical and theoretical life of Paris was to be shaped by the newer Existentialism and Phenomenology – largely subjective philosophies of the self and the object. Jean-Paul Sartre and Maurice Merleau-Ponty, with the founding of their journal *Les Temps modernes*, represented independent leftist thought in a battle with the Stalinist left of the *Parti communiste française*.[17] The existential rejection of a group or collective-type action associated with the Surrealists left them isolated – out of time and out of place. Equally the sheer age of the Surrealist leaders (they were mostly in their fifties) left them out of step with the period, and several leading artists defected to the newer intellectual cause. Notable among these was Alberto Giacometti who rejected Surrealism in the late 1930s and whose new 'brutalist' sculptures were championed by Jean-Paul Sartre and the Existentialists. The young German artist Wols, who had spent part of the war in hiding at the Provençal fishing village of Cassis, and who before the war might have been expected to gravitate towards Surrealism, became to Sartre 'the existentialist painter *par excellence*'. Indeed, the fracturing of France's intellectual life led to a vast array of styles and stances in the immediate post-war period (Art Informel, Brutalism and Matière, Art Brut, the New Ecole de Paris, and the geometric tendencies of the Salon des Réalités Nouvelles to name a few). It was in this reality, and with the background of the USA funded Marshall Plan, that Paris ceased to be the dominant centre of intellectual life for the visual arts, though this was not immediately apparent at the time. The life of the *flâneur* – the peripatetic poet of life and the streets – was seen as trivial against the background of the terrible events in the concentration camps, and

the nuclear bombs dropped on Hiroshima and Nagasaki. With the experience of holocaust Sartre's observation, 'we have to take violence seriously', took on a powerful resonance, set against a Surrealist proclivity for sexuality, dream and the unconscious. It might even be said that the worst nightmares of the vivid Surrealist imagination had passed to the reality of the Second World War – the so-called 'marvellous' or 'convulsive beauty' had turned into almost unimaginable acts of horror.

The International Exhibition of Surrealist Art that took place at the Galerie Maeght in 1947 was in many ways a final attempt to re-establish Surrealism as still a dominant post-war aesthetic. It was arranged on two floors of the gallery and inadvertently, perhaps, the layout of the exhibition began to historicize the movement from the moment you entered. The lower floor space exhibited several of the Surrealist heroes and precursors, setting the tone of a movement reflecting upon its past. On climbing the stairs to the upper gallery this idea was further developed in book spines and inspirational writers painted in *trompe l'oeil* on the step-riser as you ascended – the whole feel being of the present built on the past. The contemporary Surrealist work on the second floor exposed the dominant themes of the exhibition: voodoo, superstition and magic. Before returning to Paris Breton had passed through Haiti, and had discovered his own *objet trouvé*, the supposed witch-doctor Hector Hippolyte, who he brought back to Paris with him. The late 1930s had already witnessed in Surrealism an increased interest in the occult. The exhibition extended it by getting artists like Lam to construct a series of altars, in his case exposing fetishized breasts and two Kali-like arms waving phallic swords. The orgiastic theme of sexuality and religion, of violence, sacrifice and the occult was not successful. By involving Frederic Kiesler, who was responsible for the installation, it was hoped that the show would achieve the same success as the USA Surrealist exhibition in New York, in which he had also been involved.

The catalogue of the exhibition was designed by Marcel Duchamp, briefly involving himself with the Surrealists at this time. The cover of the small edition catalogue was a 'falsie' breast and the visitor was instructed to 'Please Touch' (the main run had a photograph) (Plate 81). While it seems amusing today, in the context of the hardships and bread shortages of post-war Paris squeezing

false breasts, and questions of hidden sexual desires, sacrifice, occult, of magic and superstition were seen as largely trivializing. The sense of being out-of-step with the age was cruelly exposed by this exhibition and the show was pilloried by the press. Thereafter the group and movement of Surrealism began rapidly to decline in influence, which is not to say that it disappeared, for Surrealist journals like *Neon* (five issues, 1948), *Medium* (four issues, 1953–5) and *Le Surréalisme même* (three issues, 1956–7), as well as Surrealist art production continued unabated. The failure of Surrealism in the post-war years, if 'failure' it was, was, perhaps, no more than the exhaustion of a generation that also appeared to be almost historical by the 1950s. For the Second World War not only swept away Surrealism, but large parts of the world-view from whence it had been formed.

Conclusion

In this cursory account of the history of Dada and Surrealism in Paris, it is evident that there are multiple histories to be told. They read like litanies or vast themes running through the polymorphous and multi-aspectival considerations of an enormous literary movement, of which the visual arts formed only a small part. A few of the themes have barely been touched upon and represent large areas of enquiry in their own right – Surrealism and heroes, Surrealism and religion, Surrealism and women, Surrealism's relationship to Romanticism, Surrealism and psychoanalysis, Surrealism and literature, and so on. The options appear endless, for 'surreality and life' underpins all that can be said about the movement. In this account we have, perhaps, concentrated on André Breton, not because it is believed that he 'was' the total scope of Surrealism, though it might have appeared so at the time. Movements of art and culture are not determined by a single figure, as if reality could ever be expressed alone through the biography and behaviour of one man. Yet it is true that the poet-writer André Breton composed Surrealist manifestos and was the only figure who remained with Surrealism from inception to decline, and he was also equally involved in the attempted revival of Surrealism in the late 1950s. In 1959–60, the last International Surrealist Exhibition on the theme of *Eros* (the erotic), took place at the Cordier Gallery in Paris. Its relative failure was not the death of Surrealism, since most of the issues raised by the Surrealist movement had long before fragmented and were then to be found in many new groupings of art and artists throughout the 1940s and 1950s. An interest in the art of the insane was taken up by Jean Dubuffet and *art brut*, CoBrA (Copenhagen – Brussels – Amsterdam) inherited similar concerns as well as that of child art and the 'primitive' (Karel Appel). An interest in graffiti, pictograms, ideograms, the mythical, are all found in the art of the Danish CoBrA artist, Asger Jorn (Plate 117). And, by the late 1950s, so-called neo-Dada concerns had returned in their own right as movements in Fluxus, Happenings, Performance, and in many other forms. Far from dead, Dada and Surrealism in Paris transformed and made commonplace topics, themes, and subjects that artists have used ever since.

NOTES

1. Cowling, E. and Mundy, J. eds, *On Classic Ground: Picasso, Léger, de Chirico and the New Classicism 1910–20*, ex.cat., Tate Gallery, London, 1990.
2. Willett, J., *The New Sobriety: Art and Politics in the Weimar Period 1917–33*, London (1978) 1987, pp.44–56.
3. Elderfield, J., *Kurt Schwitters*, London, Thames and Hudson, 1985, pp.30–118.
4. Breton, A., 'La Confession dédaigneuse', in *Les Pas perdus*, Paris, Gallimard, [1924], 1979, pp.7–22. Nadeau, M., *The History of Surrealism* (1944), trans. R. Shattuck, London, Jonathan Cape [1968] and Plantin, 1987.
5. Sanouillet, M., *Dada at Paris*, Paris, Jean-Jacques Pauvert, 1965.
6. *André Breton: La Beauté convulsive*, ex.cat., Musée Nationale d'Art Moderne, Paris, Editions du Centre Georges Pompidou, 1991.
7. Breton, op.cit. note 4, 'Lachez tout'.
8. Breton, A., *Manifestos of Surrealism*, trans. R. Seaver and H.R. Lane from *Manifestes du Surréalisme* (Paris, Jean-Jacques Pauvert, 1962) Ann Arbor, University of Michigan Press, 1972, p.26.
9. Prinzhorn, H., *The Artistry of the Mentally Ill*, trans. E. von Brocksdorf, from *Bildnerei der Geisteskranken* (Berlin, Springer Verlag 1922), New York and Berlin, Springer Verlag, 1972.

(Berlin, Springer Verlag 1922), New York and Berlin, Springer Verlag, 1972.

10. Nadeau, M., 'The Aragon Affair', in *The History of Surrealism*, op. cit. note 4, pp.75–82.

11. Chadwick, W., *Women Artists and the Surrealist Movement*, London, 1985, pp.103–40.

12. Op.cit. note 11.

13. Gascoyne, D., *A Short History of Surrealism* (1935), San Francisco, City Lights, reprinted 1987.

14. Robertson, A., Remy, M., Gooding, M. and Friedman, T., *Surrealism in Britain in the Thirties: Angels of Anarchy and Machines for Making Clouds*, ex.cat., Leeds City Art Galleries, 1986.

15. *Paris–Paris 1937–1957*, ex.cat., Musée Nationale d'Art Moderne, Centre Georges Pompidou, pp.72–89.

16. *La Planète Affolée: Surréalisme, dispersion et influences 1938–47*, ex.cat., Centre de la Vieille Charité, Musées de Marseilles; Paris, Flammarion, 1986.

17. *Aftermath: France 1945–54 New Images of Man*, ex. cat., Barbican Art Gallery, London, 1982. Francis Morris, *Paris Post War: Art and Existentialism 1945–55*, ex.cat., Tate Gallery, London, 1993.

REFERENCES

ARAGON, L., *Paysan de Paris*, 1926, trans. S. Watson Taylor, *Paris Peasant*, London, Jonathan Cape, 1971

BRETON, A., *Manifestos of Surrealism*, Ann Arbor, University of Michigan Press, 1972

CHADWICK, W., *Women Artists and the Surrealist Movement*, London, Thames and Hudson, 1985

CONE, M.C., *Artists under Vichy: A Case of Prejudice and Persecution*, Princeton University Press, 1992

ERNST, M., *Histoire Naturelle*, Paris, 1926, trans. R. Penrose, *Histoire Naturelle: Leaves never grow on trees*, London, Arts Council of Great Britain, 1982

GORDON, M. ed., *Dada and Performance*, New York, PAJ Publications, 1987

QUINN, J. *et al.*, *Max Ernst*, Barcelona, Ediciones Poligrafa, 1984

WALDBERG, P., *Surrealism*, London, Thames and Hudson, 1965

JACKSON POLLOCK & ABSTRACT EXPRESSIONISM

PAUL WOOD

APPROACHING POLLOCK

Jackson Pollock's *Summertime*, of 1948 (Plate 82), is an unusual painting in more ways than one. An obviously unorthodox feature is its shape: very wide in proportion to its height. This gives it a frieze-like quality more often associated with murals than with easel paintings. Presented with a title like *Summertime*, many people might expect to see a landscape. This might be just a landscape, perhaps with green grass, or flowers, or a blue sky; or it might consist of images of people in a landscape performing 'summery' activities, lying down in the grass, or on a beach, or playing. One could imagine an Impressionist painting with a title like *Summertime*. But Pollock's *Summertime* contains neither people, nor landscape, nor does it make use of warm bright colours. It is made instead, mostly, out of a skein of lines of varying thicknesses which extend evenly across the whole width of the painting. In addition there are some dispersed coloured planes in yellow, blue and red; plus some dabs of paint which appear to have been squeezed straight out of the tube. It does not really 'look like' anything at all, at least nothing to do with summer.

If anyone looks closer they will notice something else. The lines were not put on the canvas with a brush. You cannot get that kind of looping line with oil paint on a brush. So how were they created? The answer is that they were poured or dripped. And if you want to drip paint onto a surface, that surface cannot be vertical. So *Summertime* was not painted on an easel. When Jackson Pollock started to work on it, his canvas must have been lying flat on the floor.

Far from being an inviting depiction of familiar leisure pursuits on a warm summer's day then, Pollock's *Summertime* is an abstract painting, and a strange one at that: not much in the way of forms and colours; an unusual overall shape; and it was made in an unorthodox way. Pollock is conventionally regarded as the leading figure of the Abstract Expressionists, a group of painters active in New York after the Second World War. Others included Barnett Newman, Mark Rothko and Clyfford Still, though there were many more. For a time Abstract Expressionism became the dominant international art movement of the period, and so influenced virtually the whole output of subsequent modern art, either positively or as something to avoid. We will look at *Summertime* again below, but, what I want to do here is to discuss Pollock's work more generally: the resources it was made from, and some of the controversies which have surrounded it.

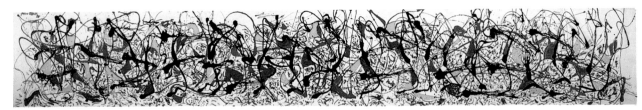

82. Jackson Pollock, *Summertime no. 9A*, 1948, oil, enamel and house-paint on canvas, 85 x 500 cm. Tate Gallery, London

All works of art mean something. They are the products of purposive human activity. To call something made by a human being 'meaningless' is often an expression of the viewer or listener's frustration with what may be an unfamiliar or uncongenial image or sound or statement, rather than a significant description of the image or sound or statement itself. (To that extent, the disposition to call unfamiliar things 'meaningless' is often a mark of conservatism and idleness, rather than openness or curiosity.) In the case of paintings in the western tradition the dominant way they have produced their meanings is through images – illusions – which look like real things in the world. But it is important to realise that even in the case of figurative paintings, this is not the end of the matter. How those images are organized – how they are composed, coloured, drawn, how big or small they are, how brightly or darkly they are lit – will contribute to the mood or feeling of the work: that is, to its pictorial meaning. In the case of an abstract painting, where there is no figurative resemblance to objects in the world, the best starting point for inquiry is therefore not the blunt question 'What does it mean?', but the related questions, 'Out of what has it been made?' and 'How might those forms colours, line etc. be seen as conveying meaning?' There is a fundamental point about attitude at stake here. We should not be asking 'How can I squeeze this (unfamiliar) thing into my pre-existing categories?' but rather, 'Is it possible that this unfamiliar thing is challenging me to revise my ideas?'

Jackson Pollock was born in 1912. His career as an artist is often divided into four phases. An early period in the 1930s involved an expressive form of social realism with images of American pioneers or scenes of manual work (Plate 83). Then there emerged in the early 1940s a type of painting still expressive in form but with imagery derived not from American society, but from the unconscious or from myth (Plate 84). Gradually the surfaces of these paintings became more homogenous or 'all-over' as the figures became less easily separable from the grounds (Plate 86). By about 1948 this resulted in the large dripped and poured abstract paintings for which Pollock is best known, and of which *Summertime* is an example. Another work from this period, which indicates the range of effects Pollock was able to achieve with what is basically a simple technique, is *Out of the Web*, 1949 (Plate 85). Then, in a fourth phase, from about 1950 onwards, often working with only black, poured paint, Pollock began to reintroduce more explicit figures into his skein of lines. The years from *c.* 1953 to his death in 1956 tend to be seen as unresolved, mixing more conventional figuration with all-over abstraction.[1]

Summertime comes from the keynote period of Pollock's career, that of his all-over drip paintings, from *c.*1947 to 1950. It is the only one of these paintings in a public collection in Britain. To see a representative sample of them you have to visit one of the major American galleries such as the Museum of Modern Art or the Metropolitan in

83. Jackson Pollock, *Miners*, *c.*1934–8, lithograph, 29 x 39 cm. Smithsonian Institution, Washington DC

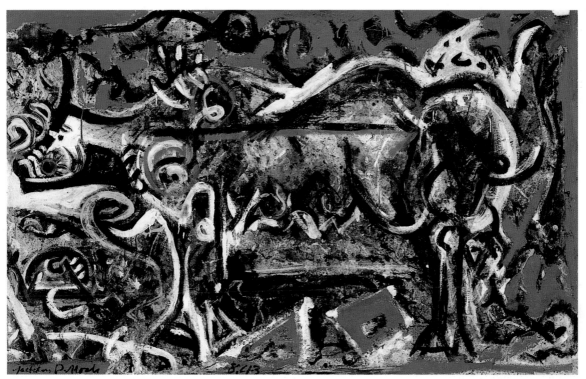

84. Jackson Pollock, *The She Wolf*, 1943, oil, gouache and plaster on canvas, 107 x 170 cm. Museum of Modern Art, New York, purchase.

New York, or the National Gallery in Washington, or a selection of the larger modern art museums in France and Germany. Otherwise you will only see them illustrated in books. Illustrations, usually no more than a few inches across, can only offer an approximate reference point for paintings, and sometimes a misleading one – in particular they tend to diminish the sense of the painting as a

85. Jackson Pollock, *Out of the Web, (Number 7 1949)*, oil and enamel paint on masonite, cut out, 122 x 244 cm. Staatsgalerie, Stuttgart.

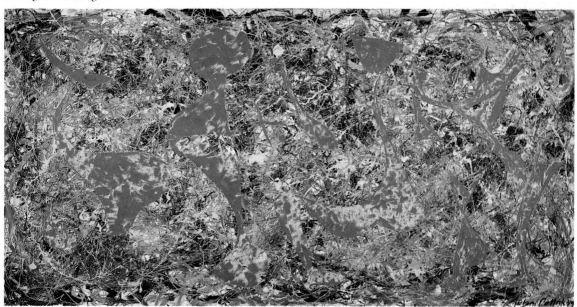

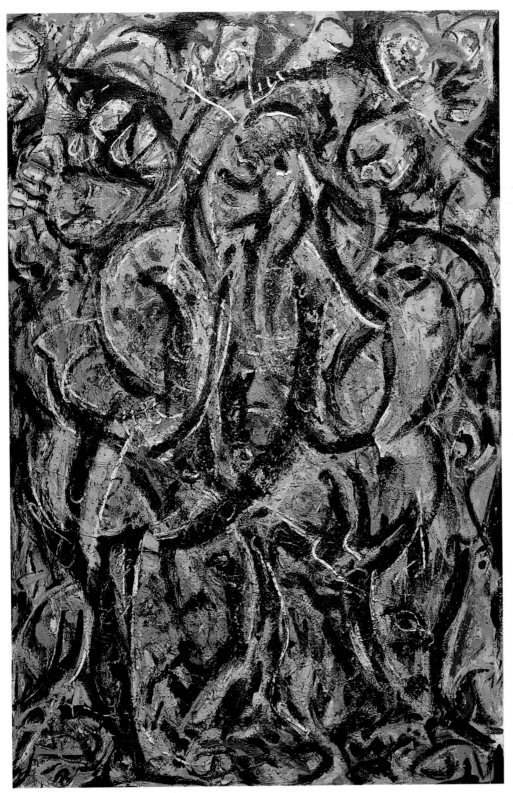

86. Jackson Pollock, *Gothic*, 1944, oil on canvas,
215 x 142 cm. Museum of Modern Art, New York.
Bequest of Lee Krasner.

made thing. Pollock's work suffers particularly. The prevalence of illustrations is an important factor in the view of his paintings as scribbles, or as resembling an unravelled ball of string, or simply a disordered, drunken mess. In general abstract art suffers more from colour reproduction than do conventionally illusionistic pictures. This is particularly true of paintings such as those of the Abstract Expressionists where the effect depends on the spectator looking concentratedly at that particular surface with those particular dimensions, and considering the consequences of its spatial, linear and colouristic character. Of course, actually seeing such a painting in a gallery carries no guarantee that you will think it anything other than an even bigger mess than it looked in the book. To perceive an order in such paintings, or to attribute a purpose to their production requires a kind of effort and commitment that the wider culture does much to dissuade. It is one of the tasks of the present text to assist such a perception, though success cannot of course be guaranteed.

What is at issue here is not a matter of art appreciation. Liking a painting, or not, can be a trivial matter. We have already seen (in Chapter One), how one of the principal functions of art in our culture is as a form of leisure activity (which, it should be underlined, is not how artists like Pollock or Clyfford Still saw it).[2] A mixture of aspiration and curiosity gets people into art galleries. Once there, a relatively open-ended sense of adventure may interact with a more closed attitude of knowing what one likes. This is difficult territory. When major institutions such as the Tate Gallery, London, and other national galleries sanction both a version of art as spirituality and a version of art as commodity (selling Rothko posters or Pollock fabrics in the shops which are now an established part of such museums (Plate 30)), then some highly complex economic and psychological transactions are taking place.

What are you buying when you purchase, say, a poster of Van Gogh's *Sunflowers*? Are you charitably acquiring an image by a poor man on the verge of mental illness that your own gallery-going nineteenth-century equivalent would have thought an incompetent daub? Or are you investing in an image of integrity, sensitivity and misunderstood intensity of feeling – that is, the story told in numerous films and books of Van Gogh's life? Or do you just happen to like the bright colours as a potential piece of interior decor? Or are you ironically selecting one of the

great clichés of modern art for your upcoming seminar on the culture industry? It could be any of these (but, importantly, it could not be all of them). In the face of such questions, which invite consideration not only of one's own motives, but the requirements of an extensive apparatus which needs to sell the posters, cards and T-shirts it produces, then the whole notion of individual likes (or dislikes) begins to look less solid than one might initially assume.

That said, whatever else it does, appreciation or liking concerns a painting's appearance, its effect – visual, emotional, or cognitive – on the person looking at it. These effects are hard to determine not least because they so obviously involve the state of mind of the viewer, as well as other variables. A text like the present one promises more if it uses a different approach. I intend to talk less about the visual or aesthetic effects of Pollock's painting than to investigate its causes. We shall, as it were, look behind the painting and try to see why it is as it is. This of course is not as simple as it seems, and is furthermore, only half the story.

Much recent art history has been concerned with the reception of Pollock's work, and that of Abstract Expressionism in general. We are now, arguably, in the third phase of such accounts. Initially, in the 1950s and 1960s the main argument was between an existentialist account of Abstract Expressionism which linked it to contemporary themes of individualism and alienation (associated with the critic Harold Rosenberg), and a formalist account which separated it from the wider culture and purported to study its solely visual effects (associated with the critic Clement Greenberg). Subsequently, in the 1970s and 1980s various social historians of art including Eva Cockroft, Annette Cox and Serge Guilbaut produced explanations which interpreted the success of Abstract Expressionism as being bound up with Greenberg's de-politicization of it. This was held to have made it a serviceable propaganda weapon for the American state in the context of the ideological struggles of the Cold War, in particular the assertion of values of individual freedom. More recently, in the 1990s, those claims have been re-examined by historians such as Michael Leja, T.J. Clark and Fred Orton.[3] With the barrenness of partisan defences of formalism and social history alike increasingly in evidence, Clark wrote that 'There is a feeling in the air that the study of Abstract Expressionism has reached an impasse.'

What he proposed was an open ended attempt to re-address the issue of this work's complexity and difficulty in the context of the post-war American culture it was a part of. The aim of the present text is more modest than this. For the most part, we shall be concerned to investigate the cluster of conditions and interests out of which a work like *Summertime* emerged.

POLLOCK'S PRECONDITIONS

We must be selective here. The possible range of such factors is enormous: economic, political, psychological and technical reasons vie for consideration. We have to try and deploy criteria of relevance. Does it matter to our explanation of *Summertime* what Pollock had for breakfast the day he started work on it? Possibly not. Does it matter that in 1948 nuclear weapons had recently been developed and that the Cold War was getting under way? It probably does, one senses, but quite how is hard to say. Does it matter that after the Second World War American art critics as well as painters were beginning to talk of the exhaustion of the European avant-garde, and to look for signs of its successor in America: an American avant-garde culture on a par with an American economy dominating an 'American century'? Once again, intuitively yes; but just how does that relate to the specific paintings Pollock, Rothko and others actually made? All such questions of relevance are difficult to resolve, and any particular resolution will always be provisional.

Here I intend to focus on the artistic elements in the constellation of factors which bore upon Pollock's work, and to let other elements fill out rather than dominate the explanation of these artistic conditions. What follows is *a* narrative of Pollock, not the only one. I want to propose three key elements, to be looked at in turn. First the influence of the preceding European avant-garde. Second the influence of a technically conservative American art form of the inter-war years, Regionalism. Third, the cluster of debates around ideas of a socialist, or at least a public art, which circulated in the Depression years of the 1930s.

THE AVANT-GARDE I: EXPRESSION

One of the turning points of art was the development of the idea of artistic expression in the last quarter of the nineteenth century and the first decade of the twentieth. Expression is a concept which has been subject to controversy in contem-porary art-historical debates, but without doubt, valid or not, the idea of artistic expression was historically a powerful component in avant-garde artists' sense of what it was they were doing.

The centre of gravity shifted from a conception of art as depicting or representing an objective external world, natural or social, to a concept of art as expressing the artist's subjective or emotional responses to an experience of the world. The corollary of this was that the burden of expression was carried by the artistic means of the painting, its colours, forms and lines, more than by any sense of what it might be that those colours, forms and lines were depicting. Thus a relatively feature-less landscape might be invested with great expressive force if it was painted in harsh clashing colours, in apparently jagged and impulsive brushstrokes. Or an unexceptional city street might be made to seem claustrophobic if the picture space was compressed and the angles of the buildings exaggerated (Plate 43).

Certain important features of these works can be noted. Often the colours of objects in them have ceased to be the colours such things have in the world. Likewise the forms, which frequently become simplified, or exaggerated, or flattened. The space in the pictures is no longer a Renaissance pictorial space based on perspective. And whereas in traditional paintings the figures – often people – were easy to distinguish from the backgrounds, now the grounds often seem to receive as much attention as the figures. This results in a more overall visual effect, which in turn means it is less easy to read the paintings in terms of part-to-part sequential narratives. Non-naturalistic colours, distorted forms, a shallower picture space and a more 'all-over' composition meant that paintings increasingly became, instead of secondary replicas of objects in the world – trees, say, or houses, or people – primary entities themselves: organized surfaces which it was believed had the power to express meanings and emotions to spectators who were responsive to them, having themselves been freed from the old expectations of accurate imitation and story-telling.

A painting which would be widely accepted as a paradigm of early expressionism, even though debate might continue as to what it is actually expressing, is Picasso's *Demoiselles d'Avignon* of 1907 (Plate 3). At one level a picture of five prostitutes in a brothel in Barcelona, *Les Demoiselles* is an undoubtedly complex and powerful painting,

at over eight feet square bearing down on the spectator with meanings which are still in dispute. Whatever it is however, it is scarcely an image of ease and plenitude. Currents of fear, sexuality, power and alienation can be seen to run through it, and they are produced by the formal and spatial distortions and the harsh colours.

Some of these ideas are philosophically and politically quite problematic and have come under increasing criticism as the period of the avant-garde has receded into history. But be that as it may, some notion of the expressive properties of colour and form underlies virtually the whole of avant-garde artistic production in the period under review. Certainly the work of artists as eminent as Gauguin, Cézanne, Van Gogh, Matisse and Picasso makes no sense otherwise. Without such an idea the distortion of form, colour and space which characterizes avant-garde art is inexplicable, or explicable only as incompetence on the part of artists who could not paint accurately. With such an idea, of course, the artist is in effect liberated to produce arrangements of colours and forms of whatever kind he or she finds appropriate to what it is they feel they are trying to express.

THE AVANT-GARDE II: ABSTRACTION

It is a relatively short step from expression to abstraction: from the idea that the shapes and colours in a painting may take precedence over visual fidelity to the objects those shapes and colours represent, to entertaining the idea that maybe the painting can do without such props entirely. In which case the whole weight of expressive meaning would have to be borne by the colours and forms alone, interacting in their own space – the space of the picture. The virtue of such a step is that the resulting expression would be concentrated and intensified, freed from the demands of narrative or imitation. Of course, much of art's traditional interest would thereby be lost.

The sense of skilful imitation on the part of the artist, or an engaging story which the picture tells, all evaporate. The compensation, to use a term which frequently cropped up in avant-garde debates, is that what was left would have been 'purified'. This means that a range of factors which are often deemed to have been literary – such as the story – have been boiled away. What is left is seen as a purified, and specifically visual effect. This is the kernel of the theory of Modernism in art.

Historically however, it was one thing to desire a pure art of intensified expression, but quite another actually to produce it. In the western, post-Renaissance tradition, art has enjoyed the power to address the great themes of human experience on a par with literature, drama and music. To state the matter in extreme form, Rembrandt stands alongside Shakespeare and Beethoven. A self portrait, in such hands, is the equal of a tragedy or a symphony. Yet if painting was to be purified of its references to recognizable people doing recognizable things in a recognizable world, how could such an engagement be sustained? Might not such an art degenerate to the condition of mere decoration?

Abstract art had to find a way of continuing to relate to a world of human experiences and emotions without depicting human beings having those experiences and emotions. This is the principal reason for the popularity of analogies between abstract art and music. For music is both abstract and meaningful. Something about the particular ordering of sounds, contrasts of harmony and discord, loudness and softness, produces emotional responses in people who can hear. This is not quite a matter of the possession of ears: it is a mixture of having the perceptual capacity and also knowing what to listen *for*. Likewise with abstract art.

The problem facing abstract art was that it risked losing the work's character as art and producing something indistinguishable from wallpaper or curtain material: basically a flat pattern, more or less pleasing to the eye. For there is a distinction to be made between art and design, even though both involve at some level the manipulation of visual elements. In essence, one might say, design seeks to embellish or to enhance the business of living, while art offers the possibility of imaginative, critical reflection upon lived experience. However close in appearance an abstract painting might come to a piece of design, they remain in this sense categorically distinct.

Patterns are flat, paintings are not. Or rather their surfaces are, literally, flat, but they characteristically produce illusions of space in which the actions they represent take place. In the western post-Renaissance tradition that space is perspectival space, in which illusions of human bodies and other objects are disposed. Their interaction has an effect on the imagination of the spectator, who is drawn into the action and potentially experiences the ethical drama being played out. Something changes in the case of an art which

(handwritten) ⟶ items found in life – art enlarge experiences at life.

functions more according to the precepts of expressive meaning. The most immediately noticeable result in avant-garde art was a decreased emphasis on the depiction of fully modelled figures and an increased integration of the surface. The traditional discrimination between figure and ground, on which imaginative entry into the pictorial drama depended, became harder to make as the pictorial space became shallower. As pictorial narrative decreased, or rather, as the space in which such narrative dramas could be acted out shrank, greater imaginative effort came to be required of the spectator. It was not so easy to slip into the pictorial drama, when the fact that it was a picture, rather than a drama, was so insistently being made. And at the same time, the spectator had to make a more conscious commitment to playing the game: to looking at the pictorial forms as if they were figures interacting in pictorial space and not as if they were merely pleasing surface decoration. To see a painting such as Kandinsky's *Cossacks* (Plate 4) as just an array of bright colours and spontaneous lines is in fact not to see it. Or more precisely, it is to see it as a pattern and not as a painting, where this latter term opens out onto the western tradition of high art, rather than onto the tradition of craft and design.

Abstract art was historically difficult to achieve, and it required more effort of its spectators than traditional figurative art. Nonetheless despite the pitfalls, not to mention the downright eccentricity of some of the solutions, the idea of an abstract art remained a challenge in the early years of the twentieth century. The prospect it held out, of a new kind of art somehow appropriate to new forms of modern experience, outweighed the difficulties.

In the event the technical breakthrough which enabled the substantial development of an abstract art was provided by a form of art which was not itself abstract: Cubism. Cubist paintings looked strange – because they abstracted from actual visual appearance, and did so systematically. But they were never completely abstract in a full-blown sense. They remained rooted in the genres of portraiture and, in particular, of still life. Braque's *Clarinet and Bottle of Rum on a Mantlepiece* (Plate 87) still contains fragmented hints of the objects in the studio on which it is based: the musical instrument placed horizontally just above centre. The vertical shape of the bottle is harder to discern, but a part of the label RHU (rhum: rum) gives a clue. In the bottom right the scroll holding up the mantlepiece is quite clearly depicted, as is

87. Georges Braque, *Clarinet and Bottle of Rum on a Mantlepiece*, 1911, oil on canvas, 81 x 60 cm. Tate Gallery, London

the decorative motif on the firescreen at bottom centre. There are hints of another instrument, possibly a violin, and what appear to be several pieces of rolled-up paper. The clue to these is given by the word VALSE (waltz) – presumably they are sheets of music.

Cubism broke up traditional pictorial space. It broke up continuous surfaces and contiguous space into short overlapping planes. The effect of these technical changes was to make the painting more unified than hitherto. Areas of figure and ground, which in the example of a person standing in a traditional landscape would be easy to distinguish, were much more closely entangled. A bit of space between a chair and a wall, or an indeterminate area between a sheaf of papers and some bric-à-brac on a mantlepiece might turn out to have as much significance in the painting as the objects that would normally take precedence. In fact Braque is wryly self-conscious of this play with different conventions of representation. Towards the top right, a nail tacked into the wall is illusionistically depicted with a cast shadow: a

88. Piet Mondrian,
*Composition No. 10
(Pier and Ocean)*, 1915,
oil on canvas, 85 x 108
cm. Rijksmuseum
Kröller Muller, Otterlo.

fugitive token from the world of orthodox representation which the rest of the painting explodes. The painting becomes a meditation on the business of representation itself, rather than on the particular qualities of the objects comprising the still life. The particularity at stake becomes the particularity of the painting, rather than the particularity of this clarinet, or this bottle.

The implications of this are still, and probably always will be, subject to argument and dispute. For some, either of a conservative disposition, or possessed of the desire for an art of wide social relevance and accessibility, Cubism marked the point of degeneration of Western art, its slippage into incomprehensibility and elitism. For others however, including the majority of the European avant-garde, it marked the threshold of a truly modern art, and continued to provide the principal technical foundation of such art for the next quarter of a century or more. Certainly, for those with an eye to the possibility of an abstract art, the technical development of Cubism offered an indication of how one might paint abstractly, even though neither Picasso nor Braque themselves ever showed any interest in producing wholly abstract work.

By the time of the First World War Piet Mondrian had pushed the process of Cubist-inspired abstracting from conventional motifs,

frequently landscapes, about as far as it could go (Plate 88). Around 1915 he reversed the process, perhaps having gained confidence from finding out that a picture could be made of so little yet still continue to retain its identity as a work of art. Instead of abstracting from naturalistic motifs, he took the step of building up a painting from a vocabulary of new, wholly abstract shapes, namely coloured rectangles (Plate 66). This step was accompanied by the elaboration of a complex theory which Mondrian called Neo-Plasticism.

The result was an art of resolute abstraction which annulled all reference to naturalistic effects. Once again however it must be stressed that the result was not intended as decoration, and certainly not as a repeatable pattern. For Mondrian each work was a unique resolution of the tensions in play in the painting: tensions of scale, colour, weight, area. In a traditional painting, a vertical human figure at one side may be balanced by a tree at the other (even though the tree may be in the distance and the figure in the foreground); or someone may be painted wearing a red jacket to pull that bit of the picture forward (because of the brightness of red in contrast to, say, the green of surrounding trees). In one of Mondrian's abstract paintings these relations become the sole focus of the work: the relative weight of a large yellow square and a small red one; the space created by

the advancing and retreating effects of different colours, blue and red for example, the balance of the asymmetric black grid, complicated by the equally asymmetric planes of colour. The work of painting for Mondrian was, in effect, the tuning of these different elements: not unlike harmonizing a series of notes in music to produce a chord which, when played, sounds fuller and deeper than any of the individual notes out of which it is made.

Each painting thus represented a model of harmony and resolution. It is possible to see this harmony as just that. Or it is possible to see it as a kind of utopian template for the world outside. Although he was an idealist, Mondrian was not a fool, and it is unlikely that he really believed the modern social world could ever achieve in practice the harmony of one of his austere paintings. Nonetheless, the art could, if viewed properly, function as a kind of model. The contingent, historical, messy human world could never match it, but those living such a life could potentially be inspired, or calmed, or otherwise helped by the image of 'plastic' resolution.

The exploration of the possibilities afforded by the abstract art which he achieved by 1920 occupied Mondrian without pause, first in Paris then in exile from Nazism in London and New York, until his death in 1944. However simple the paintings might have appeared to the casual glance, for Mondrian they literally provided enough work to last a lifetime.

Jackson Pollock's paintings do not look much like Mondrian's. The rectangular grid is replaced by a skein of lines. The picture space never has the rigorous orderliness of one of Mondrian's paintings. And crucially, most of Pollock's paintings – and those of Newman, Rothko and Still – are much larger than the characteristic works of the European avant-garde. Nonetheless, were it not for the example of a wholly abstract art built up out of abstract elements owing nothing to the demands of depiction and imitation, such as had been achieved by Mondrian and others in the inter-war European avant-garde, it is unlikely that Pollock and other American artists of his generation would have been able to push abstraction in the direction they did. For Pollock to transform abstraction presupposed that there existed an established and relatively secure form of abstract art from which to go on, differently. That had not been the case for artists of Mondrian's generation. They established the possibility, and they were enabled to do so by the technical innovations of Cubism.

THE AVANT-GARDE III: THE UNCONSCIOUS

The third avant-garde element on which Pollock drew came not from expressionism nor from the tradition of cubism and abstract art. It is associated with the other main strand of the inter-war European avant-garde, Surrealism. Surrealism placed great emphasis on the unconscious. The idea that there was more to art than could be explained by rational or scientific calculation had been an important feature of the avant-garde, with roots going back to Romanticism at the end of the eighteenth century. Notions of insight, intuition, vision and instinct had been given particular prominence by the French avant-garde of the late nineteenth century, and had contributed to the interest in the idea of an expressive art discussed above. But in the twentieth century the concept of the unconscious had assumed an altogether new and greater significance as a result of the work of Freud, and subsequently of other psychoanalysts such as Jung.

Surrealists set out to exploit Freud's insights, to work upon the new understanding of the unconscious, particularly as a site of repressed fears concerning sexuality. Their intention was to disturb the polite veneer of middle-class society. Surrealism, in origin at least, was not the stuff of clever advertisements aimed at inducing people to buy more of the commodities churned out by consumer capitalism. It was explicitly intended to help radical communism destroy the social order of the bourgeoisie. It opened a second front, so to speak, against bourgeois society, by not offering a direct attack on its political and economic institutions but by trying to disrupt and disturb the soft targets of morality, the family and social convention in general. In the words of Surrealism's founder, André Breton, painting was a 'lamentable expedient in the service of the Revolution'.

The technique developed by Breton and the other Surrealists to tap into the unconscious was named psychic automatism. Surrealism began in literature, and so it was automatic writing that was first developed, in texts such as Breton and Soupault's *Magnetic Fields*. It was writing as stream of consciousness, propelled by free association, and not subjected to the normal controls of the conscious mind.

Somewhat later a visual version was developed. Thus the first Surrealist art did not take the form of dream imagery, with which it tends to be associated today through the work of artists like Dali and Magritte. It consisted of automatic draw-

89. Max Ernst, *The Horde*, 1927, oil on canvas, 46 x 55 cm.
Stedelijk Museum, Amsterdam.

90. Pablo Picasso, *Guernica*, 1937, oil on canvas, 349 x
777 cm. Museo Reina Sofia, Madrid.

ing, where the artist allowed the pen or pencil to wander over the paper, unconstrained by the demands of normal composition. If images began to suggest themselves, these were seen as having welled up from the unconscious. Subsequently the artist may then draw out or heighten such unconscious imagery, or they may be left in suggestive, half emerged form. Another technique for the automatic production of images was developed particularly by Max Ernst. A canvas or piece of paper was placed over textured surfaces such as wood, or skeins of string and then rubbed over with crayons or paint to produce unexpected images, for example struggling figures, or dense forests, or forbidding walled cities. This technique was called *frottage* (Plate 89).

Each of these three avant-garde developments was an important antecedent for Pollock: the idea of expressive form, the automatic technique for releasing unconscious images, and the idea of abstraction itself. One artist above all seemed to epitomise the avant-garde for Pollock, namely Picasso. *Les Demoiselles d'Avignon* was nothing if not expressive. A few years later, along with Braque, Picasso developed Cubism, the paradigmatic modern art movement of the first half of the twentieth century. In the inter-war period, although never a member of the Surrealist group, he did become closely identified with it: his work was included in Surrealist exhibitions, and illustrated and discussed in Surrealist journals. Towards the end of the 1930s Picasso painted an exceptional work, the wall-sized portable mural *Guernica*, which can be seen to embody all three of these elements, and which had a profound influence on Pollock (Plate 90).

The avant-garde legacy, complex though it was, constituted only one element in the artistic constellation at work upon Pollock. The European avant-garde's preoccupation with technical radicalism, under the aegis of concepts of expression and abstraction, made problematic its accessibility to a wider audience unversed in the specialized concerns of art.

This question of art's relation to a wide public became important in the 1930s: a decade which saw not only the rise of fascism in Germany and Italy, and the conflict between fascism and socialism in the Spanish Civil War, but also the emergence of an international capitalist economic crisis. And whereas the political crisis was largely felt in Europe, the economic one dominated American life too.

THE AMERICAN SCENE

In America in the 1920s and 1930s isolationism was a powerful factor. In contrast to the period after the Second World War when the United States aspired to global domination, after intervention in the First World War the Americans retreated from international entanglements. In the field of art this took the form of widespread rejection of European styles. Distortion and fragmentation had become the immediately noticeable characteristics of avant-garde art. Those who rejected the consequences of this usually did so for one of two reasons. On the one hand was the idea that art needed to continue to be able to address a mass audience. On the other was the desire to maintain the standards of the past, which it was felt the avant-garde had eroded.

These responses are not the same: one tends to invite a politics of the left, the other a more conservative alignment. But to say that these two responses lead in different directions does not mean they can be unfailingly distinguished. Ultimately this is to do with the differences between thinking and painting. Thus, it was possible to reject the avant-garde for a variety of philosophical or political reasons; as we have seen, a potentially conservative desire to maintain the standards of the past, or a prospectively socialist desire to have art relate to broad masses of people. But when it comes to making paintings which reject the avant-garde, the field of options is not so open. You could reject the avant-garde for any number of reasons, but to make a painting which rejected the avant-garde led only in one direction. Avant-garde paintings, as we have seen, were marked by technical characteristics of distortion and spatial flattening associated with expression and abstraction. If you rejected painting with such characteristics, essentially you were left with only one course of action: to reinstate the kind of spatially consistent pictures the avant-garde had abandoned; that is, to produce fully modelled figures in a coherent pictorial space using naturalistic colour and 'accurate' drawing. Political reasons notwithstanding, a rejection of the avant-garde pointed the artist back to the skills and techniques of the academic tradition. This led to the irony that politically committed left-wing paintings, and traditionally motivated academic paintings looked more like each other than either resembled the products of the avant-garde. In terms of the artistic styles they valued, if nothing else, political right and political left had more in

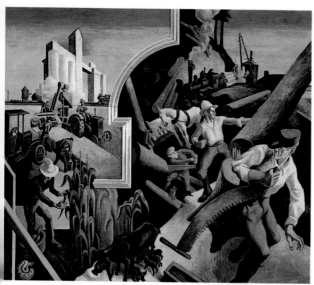

91. Thomas Hart Benton, Mural from The New School of Social Research, New York, *Agriculture and Lumbering*, 1930-1, egg tempera and distemper on linen mounted on panels, 231 x 265 cm. collection the Equitable Life Assurance Society of the US.

common with each other than with the putatively independent art of modernism. The consequences of this have been far-reaching.

In an American context the rejection of things European often carried with it a concern about the degenerate characteristics of urban civilization in general. By contrast, virtue was located in the countryside – and there was a lot of that in America. Hence the reaffirmation of tried and tested artistic techniques often accompanied a desire to propagandize the virtues of the American heartland. What this came down to was painting pictures of rural life, often in a deliberately unvarnished or quasi-primitive style which was held to equate to the homespun values of that life itself (Plate 91). The movement was known as Regionalism, and one of its leading exponents was Thomas Hart Benton.

Although Jackson Pollock's mature work shares very little in terms of appearance with Regionalist art, for much of the 1930s Benton was Pollock's teacher and mentor. Pollock moved to New York in the 1930s, but he was a Westerner, born in Wyoming and raised in Arizona, very much an American. Unlike many Abstract Expressionists, such as Rothko, Newman, Gottlieb, Kline, De Kooning and others, Pollock had no roots in Jewish culture in particular or European culture more generally. Pollock's cowboy image has been much exaggerated, but his early experi-

ence was of the west. He became a painter, and he came into contact with European ideas, but he had also seen the Grand Canyon, witnessed Indian ceremonies, and travelled rough across America. Regionalism tended to be not merely a technically but also a politically conservative formation, certainly in Benton's case. However, it did have something the avant-garde manifestly did not – a potentially wide popular appeal. Regionalism addressed public and national themes, and was capable of doing so on a large scale.

A PUBLIC ART

There was another side to American art which was anything but politically conservative, and which came to the fore in the Depression years of the 1930s. Class politics were much more prominent at that time than after the Second World War, when the left was marginalized. John Reed Clubs, named after the journalist who had taken part in the Russian Revolution, were formed in several cities as a focus for left wing art and literature.

Periodicals such as *New Masses* and *Art Front* debated issues of social realism. Many radical artists were members of the Communist Party, including some who were subsequently involved in Abstract Expressionism. And from the mid-1930s onwards the Popular Front drew artists and intellectuals into common activity against racism and fascism. In addition to the orthodox Communist Party there was also a flourishing Trotskyist subculture in New York, oriented around the magazine *Partisan Review* and in part sustained by the relative proximity of Trotsky himself, by then in exile in Mexico. These circles included subsequently important intellectuals such as Clement Greenberg, Harold Rosenberg and Meyer Shapiro. Above all there was the Federal Art Project. As part of Roosevelt's New Deal artists were paid by the state to produce art. This was unprecedented, and it allowed many American artists whose practice would otherwise undoubtedly have foundered, to survive the Depression. The Project also allowed a glimpse of a social role for art other than as a form of bourgeois leisure. Such a role, indeed such a society, never materialized. The Depression passed, and, not unconnectedly, the Second World War started. The vision of a public art receded. But it remained in the background, one of the tantalising elements in the antecedents of the large-scale paintings Pollock came to produce in the later 1940s.

Whereas Regionalism emphasized rural themes, social realism was focused on urban life and labour. But these different subjects were often treated in similar styles. In the nature of the case, depictions of boxing matches, bars, unemployment demonstrations and so on tended to employ the same pictorial conventions as depictions of farming the prairie or picking cotton. These were precisely the conventions which avant-gardism had undermined: recognizable people in coherent pictorial space performing actions to which it was easy to attach narrative explanations.

Not all socially engaged art was quite so technically orthodox however. Of particular importance for Pollock was the work of the three Mexican muralists, José Clemente Orozco, David Siqueiros (in whose experimental workshop Pollock studied for a time in 1936), and Diego Rivera, who were all active in the United States during the period (Plate 92). The first two employed a degree of expressive distortion in their heroic figures, while Rivera drew on an idiosyncratically spectacularized version of pre-Columbian sources, such as Aztec sculpture. Earlier, Rivera had been a Cubist in Paris at the time of the First World War. It is a measure of the social problems faced by the avant-garde during the inter-war years that when, under the twin stimuli of the Mexican and Russian revolutions, Rivera felt compelled to produce art with an explicit public dimension, he simultaneously renounced Cubism. For Rivera, the need to turn his art into a weapon of the revolution meant that he had to abandon the experiments of the avant-garde.

POLLOCK'S WORK

What faced Pollock in America, then, was very different from the legacy of Europe. The European avant-garde's technical radicalism had originally been rooted in a desire to measure up to modernity. The nineteenth century offered a range of urban experiences which were new in human history, and to produce an art which matched that experience it was not enough simply to depict new objects (such as steam engines) using traditional means rooted in the Renaissance; the techniques of art had to be modernized too. But the paradox was that, as the avant-garde developed, the technical radicalism which had started as an attempt to get modernity more convincingly into the art ended by largely excluding the possibility of depicting the modern world. Cubism and abstract art

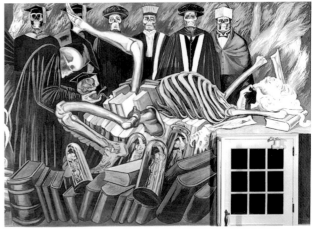

92. José Orozco, *The Epic of American Civilization: Gods of the Modern World*, 1933-4, fresco commissioned by the Trustees of Dartmouth College.

related to modernity in such an indirect way that it was easy to feel that the interests of modern art had become remote from the most pressing issues of the modern social world. In America however Pollock was also faced by more orthodox forms of art, variously inspired by conservative or radical social ideologies, which continued to address just such wider public concerns. Much avant-garde art, abstract in form or rooted in desires for self-expression, gravitated to the private sphere. If there was subject matter at all, it tended to involve figures in interiors, in the garden, or in the artist's own studio. It tended to evoke basically personal responses, and to function as a kind of visual lyric poetry requiring sustained and solitary contemplation. Yet for many, perhaps the majority, the 1930s represented a time of intense public struggle, when the fate of masses of people hung in the balance. The problem for the avant-garde was that an art which seemed to ignore all that courted irrelevance.

It is this polarization of the demands of the avant-garde and the demands of a socially conscious art which makes Picasso's *Guernica* crucial (Plate 90). The painting, or rather a painting, was commissioned from Picasso by the Spanish Republican government in 1937 to be installed in its pavilion at the World Fair in Paris. The Spanish Civil War was then in progress, and it was while Picasso was searching for a way to fulfil his commission that the German Condor Legion, fighting on the side of General Franco's fascists, bombed the Basque capital city, Guernica. This was the first instance of the large scale aerial bombardment of a civilian population, uniquely barbaric

by the standards of its time (though these were to be quickly eclipsed in the ensuing full-scale European conflict after 1939). The destruction of Guernica provided the starting point for Picasso's mural.

The painting does not however depict the bombing of Guernica. It seems to mobilize a range of private or semi-private images of violence and destruction, of possibly unconscious significance to Picasso, such as bulls, horses and a broken statue, and distribute them on a monumental scale across a shallow Cubist space. In a reversal of one of the expressionist devices of accompanying distorted forms with heightened colour, *Guernica's* formal distortions are instead reduced to a blue-grey monochrome. It remains something of an open question whether, by treating his theme in this way, Picasso renders an historical conflict with ascertainable causes and responsibilities personal and idiosyncratic, or whether he elevates the contingent tragedy to a universal plane of human suffering. The painting was intensely debated in these terms at the time, wherever it was shown, in mainland Europe, Britain, or America, as it travelled around in support of the Republican cause. For Jackson Pollock, *Guernica* seems to have represented a unique synthesis: evidence that a technically radical avant-garde art, could, given the right ambition and scale of vision, break through from the domain of the private picture, to address major themes animating the culture as a whole; and could do so moreover with the universal force of the unconscious rather than the superficial journalism which always seemed to lie in wait for a merely depictive realism.

In this complex range of influences technical and ideological factors interact, and quite often contradict one another, to make new art. Social responsibility, self expression, originality, art as a weapon in the wider struggle for emancipation, art as a utopian model, all claimed the attention of Pollock's generation. This mixture of radicalism and conservatism, of Depression-induced poverty and War-induced prosperity, of attraction to the sheer adventurousness of the avant-garde mixed with aversion to a largely compromised European culture, all added up to a highly contradictory situation for Pollock and his colleagues. Pollock himself betrays these tensions in an interview he gave in 1950 when he asserts both that most modern painters 'work from within' and that modern art is 'nothing more than the expression of contemporary aims of the age that we're living in'.

In the 1940s Pollock produced a body of work which drew on all these influences yet appeared entirely novel. The paintings' innovative qualities are largely technical. When Pollock produced a work such as *Miners* in the 1930s (Plate 83), it is easy to see that he is marrying socially relevant subject matter with the expressive devices pioneered in the avant-garde. Such work was not uncommon in the period, and indeed continues today.

For a variety of reasons, partly to do with the artistic impact of Surrealism, partly out of a determination not to get conscripted into the propaganda machine of 'total war', Pollock and others such as Rothko abandoned social subject matter in the early 1940s in favour of subjects drawn from myth. Myth was seen as offering something at once more personal and universal than the journalistic entrapments of contemporary imagery. Mythical subjects, represented through an avant-gardist's expressive technique, appeared in paintings such as *She Wolf* of 1943 (Plate 84). At the same time other artists in New York such as Rothko, Newman, Gottlieb and Gorky worked on similar themes in a broadly similar manner.

As the 1940s went on Pollock seems to have emphasized the gestural technical features of his painting at the expense of picking out the identifiable image – the wolf, the woman, the table, the horse, or whatever. The result was that the impressions of recognizable things, such as an eye, or a limb, or a head became subsumed into an all-over configuration of marks. More emphatically than in previous painting the expressive weight shifted from the depicted image to the character of the painted surface as a whole (Plate 86).

By about 1946 or 1947 the resulting paintings often had an encrusted, congested feel to them. Clement Greenberg in an essay on 'The Present Prospects of American Painting and Sculpture' referred to Pollock's 'thick', 'emphatic' surfaces, and appeared to feel that the 'exasperation' and 'stridency' this betokened narrowed his art; though he also discerned in Pollock's work of this time his potential to be a major artist – a judgement which was, to put it mildly, controversial.[4] Although not particularly successful in commercial terms, and certainly not wealthy, Pollock at this juncture had accrued the status of a leading figure in the New York avant-garde. He had weathered the storms of the Depression and the War, and had also accumulated a body of work

with a history and an identity of its own. This position had a material effect on his subsequent development.

It seems that Pollock was trying to loosen-up his paintings as well as to make the process of mark-making still more direct, less mediated by the conventions of brush work and expressive paint application. At this time some money from his dealer enabled him to move out of New York to a place near the sea, on Long Island, where he eventually converted a barn into a larger studio. He began to experiment both with applying paint with his fingers in some small canvases done in the original small studio (a spare bedroom), and also by pouring household-type paint onto a canvas lying on the floor in the new larger studio. He had used dripped and poured paint before, but this now became his principal, and characteristic, method of paint application. The technique seemed to free him from the constraints imposed by the movement of elbow and wrist, and permitted him to make more expansive gestures using the whole of his arm and upper body. It also allowed him to walk around the canvas, working on it from all four sides.

It was this procedure, which by 1948 he had learned to control and develop, that resulted in paintings such as *Summertime* (Plate 82). Most were big, though relatively few had the freize-like dimensions of *Summertime* itself. Some were quite open; some densely worked and re-worked. By 1950 some were extremely large: eight or nine feet high and sixteen feet wide. Others remained smaller but employed variations on the technique. Thus *Out of the Web* of 1949 (Plate 85) was painted not on canvas but on masonite, a cheap form of building material like hardboard. Pollock produced his web of lines, but it seems that on this occasion it lost its rhythm and became too dense – a mess, as in fact must have happened occasionally, given the technique. This time however Pollock was able to recover it by the extreme device of taking a knife and continuing to make the sweeping gestures he made with his brush or stick. This allowed him to cut out, or scrape off, areas of paint, leaving the impression of reddish forms behind the web of lines, on the edge of coalescing into identifiable figures.

In the case of *Summertime* there were also distinctly identifiable stages to the work. First a skein of grey lines was poured over the canvas on the floor, using cheap household paint. Then another skein of lines, this time in black, was laid down over the first one. These black lines were however regulated differently. Pollock has obviously slowed his gesture down to produce the thicker f-like shapes at regular intervals across the sixteen feet of the canvas. After this he must have lifted the canvas off the floor and attached it to the wall. He then took more orthodox oil paint and a brush and filled in small planes all of approximately the same size in the primary colours red, yellow and blue, again at regular intervals across the surface. Finally some other colours, brown and green and some blue and purple squiggles were added, either with his fingers or straight from the tube. Instead of being applied evenly across the surface these marks congregated in what had by now become the bottom half of the picture.

Something like a connotation of landscape had emerged, with earth colours (green and brown) at the bottom, and the appearance of space at the top; just as the poured black marks also seemed to connote figures in motion – a rhythmic, dance-like motion perhaps not unlike that with which Pollock himself produced the marks as he moved around the canvas dripping and pouring the paint. Pollock did not set out to depict a summer scene. He set out to produce a long narrow abstract painting at the limits of what could be cohered in the one pictorial form. But the expressive implications of what he ended up with may have suggested the title *Summertime*. By the same token, we do not know what he intended when he laid down his sheet of masonite, but he arrived at a sense of figures either struggling into identity or receding into undifferentiated flux. Such connotations notwithstanding, we should not forget that many of Pollock's titles were conferred by visitors to the studio and that he himself for the most part restricted the identification of the paintings to numbers: in the case of *Summertime*, *Number 9A* (1948); in the case of *Out of the Web*, *Number 7* (1949).

It remains difficult to say what we are left with in works such as these of Pollock's artistic maturity. Many accounts have been offered. These include: formal configurations appealing to eyesight alone; traces of anxiety at the onset of the nuclear age; a sense of both achieved aesthetic unity and its irrevocable loss, in a tension which is only just held together; traces of hedonistic physical joy; metaphysical meditations on being; an attempt to cope with urban life; an elevation of the process of making over the finished product. These are only some, and it has to be said that some are

→ ambiguity –
Brings out own concerns.

more fanciful than others. But whatever sense one may make of these paintings, there is no doubt that Pollock's work proved immensely generative for the American avant-garde in the years after the Second World War. His status is perhaps parallelled only by the earlier impact of Cubism after the First World War. His contemporary Willem de Kooning acknowledged that Pollock 'broke the ice' for his generation. In a very different context, in 1970, when the Modernist artistic culture which Pollock's work had stimulated was coming under fundamental criticism and beginning to fragment into a range of Post-Modernist subcultures, Philip Leider, the editor of the highly influential art magazine, *Artforum*, wrote that Pollock's was the last work of whose value everyone with a serious interest in the arts was convinced.

MODERNISM AND HISTORY

We have now sketched in some of the main elements in that cluster of conditions out of which Pollock's mature work developed, and a brief description of some of that work itself. It is less easy to say how those antecedents get into that work. How are the complex engagements with art's public role, with the unconscious, with the alienating effects of modernity, transmuted into a web of lines? It is as well to be clear what is being asked by such a question. For what cannot be produced is a sort of checklist: 'this type of line signifies A', 'this type of splodge indicates B', 'at this point Pollock is telling us C', and so on. The paintings are not like that. The futility of such an approach can be shown by setting a mature work by Pollock alongside one by Rothko (Plate 93). They appear wholly dissimilar, one a skein of lines, the other soft-edged planes of colour. Pollock and Rothko were very different, the one a westerner, the other a Jewish immigrant. But Rothko's adolescence was spent in the west, in Oregon. And both experienced in New York during the 1930s the poverty of life in the Depression, the government's Federal Art Project, the proximity of left wing politics, the presence of European avant-gardists in exile, and so on. Yet that shared experience produces wholly dissimilar works of art.

Or does it? The point, much like our point about determining the relevance of conditions, depends where you set the parameters. In both Pollock and Rothko's work of the mid to late 1930s social themes and expressive distortions are

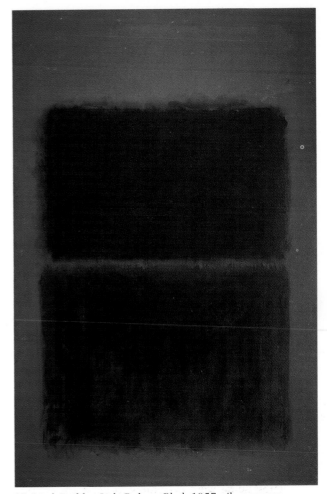

93. Mark Rothko, *Light Red over Black*, 1957, oil on canvas, 232.7 x 152.7 cm. Tate Gallery, London.

both in evidence, though their paintings are not at all similar. In their art of the early 1940s distinct though their works are, it is once again possible to detect a certain level of common concern in archetypal images, in notions of the primitive, in the unconscious. And even when one sets together their work of the late 40s, the one all linear and gestural, the other all fields of colour, one only has to set them against preceding art for similarities to emerge. Thus both have expunged the social references of Regionalism and social realism, and their Surrealist-indebted excursions into myth. And relative to what has gone before in the avant-garde, say in Cubism or in Mondrian's abstraction, both share an entirely new sense of scale. These are pictures that a human being – the artist – can move around in, instead of reaching into; and which by

the same token another human being – the spectator – can encounter as if occupying their own space, a bit like another person, rather than looking into them as if into a window or a box. For all the manifest differences, there is much these works share, compared with other art. And that goes for intention and effect, too. It is commonplace to see Pollock's work as all violent flailing and Rothko's as all serenity and consoling spiritual calm. Yet Rothko himself said: 'I would like to say to those who think of my pictures as serene ... that I have imprisoned the most utter violence in every inch of their surface.'[5] While Clement Greenberg said of Pollock's painting that, 'like all great art, it gets quiet in the end.'

These are difficult questions, then. And the answers it is possible to give are not likely to satisfy a questioner who wants a readily consumable response. Perhaps the simplest way of putting it is to say that one can, to a degree, enumerate influences from the series of conditions bearing upon Pollock's work from the mid 1930s to the mid 1940s, and that thereafter one cannot; and that is the point: that Pollock has made of that constellation something of his own. The closest analogy might be that between a chemical mixture and a compound. A mixture is still separable out into its constituent elements; a compound is not. One simply cannot draw direct lines of cause and effect from such a complex constellation of influences to an achieved and individual artistic style.

In addition to these considerations, it is necessary to acknowledge that many of the terms being employed here to write about Pollock's work have a history of their own. Many of these terms are treated as compromised by those newer art histories which have tried to establish a critical distance from the Modernist tradition which itself valorized the products of the avant-garde. 'Expression' is a term we have already mentioned. 'Style' is another which, in contemporary art-historical jargon, has been 'opened up to scrutiny'. No term has been more ruthlessly scrutinised than 'originality'. For all its persistence as a value in the wider culture, in academic debate 'originality' is routinely dismissed as a 'modernist myth'.[6] It is now a kind of commonplace that nothing is new, everything is made out of materials to hand, no integral individual can ever express completely original statements, and so on. This may well be the case. But away from the carpeted domain of art-historical niceties, the urge not to repeat, not to have one's utterance circumscribed by cliché

and convention, has formed a guiding principle of modern art; even as each new form has itself contributed to new conventions and prescriptions for going on.

It was not easy for the Impressionists to challenge Academic convention. Neither was it easy for the artists who developed Cubism to transform what had started to become a series of Post-Impressionist avant-garde conventions. The ultimate historical status of Abstract Expressionism remains contested. There is no doubt that the work of Pollock and others was immensely generative for subsequent Modernism. But we now live in a period one of whose governing self images is that the present is Post-Modernist. In film and television, music and architecture no less than art, Modernism is widely perceived as an historical phenomenon.

We have to decide, among other things, whether Pollock's work considered as a whole represents a useful resource, or not. Is such abstract art elitist, and – paradoxically – the new academicism of an international business culture? Did Abstract Expressionism become the creature of American capitalism: in its degenerate manifestations, at least, the decoration of corporate boardrooms the world over; and as such complicit in the workings of the dominant culture? Does any cultural practice alert to the conditions of the late twentieth century therefore have to avoid what artists like Pollock did, to reject their whole sense of what art was about? Or on the other hand could it be argued that any cultural practice in the present that would establish a distance from the engulfing conventions of mass culture cannot afford to ignore Pollock's example, not least its resistance to the cultural conventions of its own day? It is worth reminding ourselves that whatever became of Modernism as a culture, with its museums and magazines, its prizes and impresarios, the stance of Pollock and others like him represented an intransigent commitment against most of what passed for polite culture.

So whether Abstract Expressionism represents the cul-de-sac of a new academicism, or whether its rigour offers a lesson for any critical work even now, is an unresolved question. But it is worth remembering that only a superficial approach to art will dismiss Pollock's work as trivial while itself lacking the intellectual and historical tools out of which an understanding might be constructed. Most of us can 'see' the world, or think we can. Yet even that takes time: it is the process we call

'growing up'. But if it takes time, and experience, to learn to see normality, how much more effort will it take to 'see' things which challenge our habits of looking themselves? In the end abstract art, far from being easy, turns out to be very difficult to understand.

There are two sides to this. One concerns the fact that a lot of relatively specialized historical information has to be amassed in order to flesh out an understanding of the conditions under which such art was produced, and was believed by its authors to be a sensible and coherent project to undertake. The other side is rather different. It does not concern the amassing of historical fact. It concerns rather something like the development of an attitude, or perhaps better, an aptitude for exercising the imagination: an attitude at once trusting that there is something worthwhile going on yet also sceptical of the mystification which abounds in talk of art.

Beyond their display as more – or less – attractive objects of leisure time pursuit, what can paintings such as those of Pollock or Rothko do for us? A common charge against abstraction in art is that it generalizes, deflects attention away from the concrete historical here and now into a misty realm of feelings and emotions, subjective and risking indulgence. Certainly, works like Pollock's do not depict our world, neither do they model a utopia, as Mondrian's arguably do. What they can perhaps be seen to do, however, is to turn the trick around. They put the focus of particularity not on a painted image, a fiction after all, but on the actual transaction between painting and spectator. What is at issue is your imagination, your perspicacity, your attention. The painting offers its particular construction of relationships: of figure and ground, of individuation, of being and becoming, of the emergence of identity, or its loss. The result may be a form of imaginative meditation on self-consciousness. That is what the painting can 'give', but it can only 'give' it in a committed transaction; as Rothko put it, a form of consummation.

Gaining purchase on the possibility of such effects is a matter of experience and conversation. Texts such as the present one can only be a part of this conversation, and a relatively primitive part at that. They may offer some rudimentary building blocks for understanding; any stimulus to the imagination must be accounted a bonus. Understanding art is less an achieved state than a process, and the work it requires is both extensive and intensive, cumulative and self-critical. As Rainer Maria Rilke said of Cézanne, he could not see anything until suddenly he found that Cézanne had given him the right eyes.[7] It is uncertain whether, in order to 'see' ourselves at the end of the twentieth century, we need to be able to 'see' Abstract Expressionism, or indeed modern art as a whole. This essay proceeds from the assumption that it may help.

NOTES

1. There is an extensive literature on Pollock. Modernist treatments include Rubin, W., 'Jackson Pollock and the Modern Tradition', *Artforum*, February, March, April, May 1967, pp.14–22, 28–37, 18–31 and 28–33 respectively. A sophisticated discussion of Pollock's 'all-over' period can be found in Fried, M., *Three American Painters*, exh. cat., Fogg Art Museum, Harvard University, 1965. There is an extensive essay by the social historian T.J. Clark, titled 'Jackson Pollock's Abstraction' in Guilbaut, S., ed., *Reconstructing Modernism*, Cambridge, Mass., and London, MIT Press, 1990, pp.172–243. A recent monograph is Landau, E.G., *Jackson Pollock*, London, Thames and Hudson, 1989. The recent biography *Jackson Pollock. An American Saga*, New York, 1989, by Steven Naifeh and Gregory White Smith offers a heavily psychological reading of Pollock's career, written in an often sensationalist style, but is factually exhaustive.

2. Still, C., 'Letter to Gordon Smith', 1959, in Harrison, C. and Wood, P. eds, *Art in Theory 1900–1990*, Oxford, Blackwells, 1992, pp.584–6.

3. In addition to the works on Pollock cited in note 1, relevant material includes: Rosenberg, H., 'The American Action Painters', 1952, in his *The Tradition of the New*, London, Thames and Hudson, 1962; Guilbaut, S., *How New York Stole the Idea of Modern Art. Abstract Expressionism, Freedom and the Cold War*, Chicago University Press, 1983; Leja, M., *Reframing Abstract Expressionism. Subjectivity and Painting in the 1940s*, New Haven and London, Yale University Press, 1993.

4. Greenberg, C., 'The Present Prospects of American Painting and Sculpture' (1947), in O'Brian, J. ed., *Clement Greenberg. The Collected Essays and Criticism*, vol. 2, *Arrogant Purpose*, Chicago University Press, 1986, pp.160–70.

5. Breslin, J.E., *Mark Rothko. A Biography*, Chicago University Press, 1993; and Greenberg, C., *Jackson Pollock*, television interview with T.J. Clark, BBC/Open University, 1983.

6. Krauss, R., *The Originality of the Avant Garde and Other Modernist Myths*, MIT Press, Cambridge and London, 1985.

7. Rilke, R.M., *Letters on Cézanne* (1907), ed. C. Rilke, trans. J. Agee, Jonathan Cape, London, 1988.

MODERNITY & TRADITION: WARHOL & ANDRE

DAVID BATCHELOR

INTRODUCTION

Is it the business of art to represent the contemporary world in which the artist lives? Or should art rise above the everyday and reflect on more general, abstract or spiritual matters? Do we have to make a choice between the two possibilities? Are these irreconcilable alternatives?

The injunction to depict the here-and-now has been made many times by many artists during the modern period. Courbet is said to have said: 'I cannot paint an angel because I have never seen one' – a straightforward enough remark on the face of it. But, as Courbet was very well aware, the implications for painting in the mid-nineteenth century were quite fundamental. The statement amounts to a denial or a denunciation of the most highly valued subjects of academic art: namely, all religious, mythological and history painting.

Since Courbet's time, the idea that art should focus on the everyday, the contemporary, the here-and-now has been articulated in many different ways and identified with many different causes, many of them not obviously compatible with one another. And today it remains one of the most keenly fought over issues in modern art. The relationship of art with its modernity has been a persistent question for artists, critics, historians, and so forth, but it has not been, nor is it now, simply a given of art. On the contrary, if modernity is defined in part by its transitory nature, by its one constant of continual change, it follows that art will also have constantly to change and re-invent its relationship with the world in which it is made. As Brecht wrote in the 1930s: 'Reality changes. In order to represent it modes of representation must also change.'[1]

Charles Baudelaire's essay 'The Painter of Modern Life' (1863)[2] is probably the first and certainly one of the most vivid and eloquent examinations of the relationship between art and modernity. His essay involves far more than a simple assertion of the importance of depicting modern life in painting. There are at least three interlocking themes in the text. First, there is Baudelaire's stress on the iconography of everyday life – 'from costume and coiffure down to gesture, glance and smile' – which the painter should observe and record. But for Baudelaire modernity was more than a shopping list of contemporary fashions and types of behaviour. It was also a mode of experience, a subjective response to modernity's outer form. In depicting the contemporary world, the painter of modern life would have to attend both to its particulars and details but also to its mood, to the experience of 'the fugitive, the ephemeral, the contingent'. The difficulty here of course is that a mood, unlike a top-hat,

94. Andy Warhol, *210 Coca-Cola Bottles*, 1962, silkscreen ink on synthetic polymer paint on canvas, 208 x 267 cm., courtesy Thomas Ammann Fine Art, Zurich.

95. Andy Warhol, *Marilyn Monroe (diptych)*, 1962, silkscreen ink on synthetic polymer paint on canvas, 208 x 145 cm., private collection.

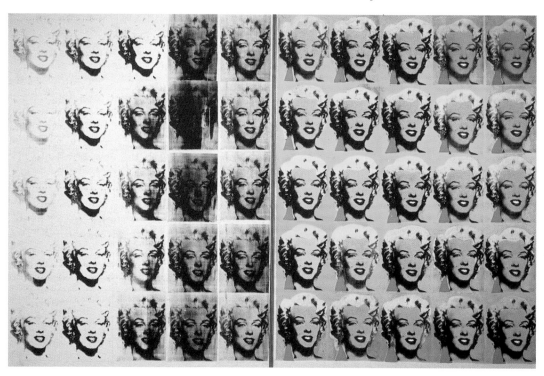

does not have an identifiable form and colour which may be depicted in a picture. Rather, mood has to be evoked in the form, structure, composition and colour of the painting.

But these two combined elements of modernity – its outer shape and the inner experience – were for Baudelaire only 'the half of art', which had to be integrated with its other half, 'the eternal and the immutable'. This other half we might call artistic tradition, that vast (and itself changing) catalogue of historical works in relation to which artists, critics and historians judge their own efforts. More particularly, there was for Baudelaire the recognition that certain works of art, while 'clothed in their own modernity', nevertheless remained vivid far beyond their own time and place. If an artist were to ignore this area of experience, his or her art would be merely superficial or illustrative; if he or she were to dismiss modernity, the results would never be more than academic. Modernity, for Baudelaire, had to be 'distilled' into art.

In order to consider how two artists working in North America during the 1960s and 70s developed the relationship between art and modernity in painting and sculpture, one can take the three markers of the Baudelairean painter of modern life and use them as a framework for examining the work of Andy Warhol (1928-87) and Carl Andre (b.1935). To summarize, these markers are the choice of modern iconography, the means by which modern experience is represented, and the relationship of the modern to the traditional in art.

ANDY WARHOL

What is the appropriate subject matter of modern life painting? To put it another way, what items, objects or events most concisely embody the experience of modernity? Clearly how one answers this question will depend on how one experiences the modern world. An unemployed homeless teenager, for example, might not come up with precisely the same response as, say, a government minister. The most public, conscious, symbols of a state's or a nation's achievements may not turn out to be, and perhaps cannot turn out to be, the most appropriate expressions of its modernity. Since Baudelaire and Manet identified the prostitute as a kind of unconscious emblem of the modernity of Haussmann's Paris, artists have often sought out the more oblique, tenuous and

96. Andy Warhol, *Green Disaster Ten Times*, 1963, silkscreen ink on synthetic polymer paint on canvas, 267 x 201 cm., Museum für Moderne Kunst, Frankfurt.

contingent products of their society in order to reflect on its particular character.

Andy Warhol's inventory of modern America is now so familiar that it is easy to forget the extent to which Warhol selected rather than merely reflected these emblems of modernity. Best known are his images of the Coca-Cola bottle (Plate 94), the Campbell's soup can, Marilyn Monroe (Plate 95) and Elvis Presley. What do these subjects have in common with each other and with Warhol's other favoured images such as the dollar bill, the Statue of Liberty, Jackie Kennedy, the electric chair, car crashes (Plate 96), wanted criminals and race riots? Some belong to that realm of official national symbols whereas others are icons of a developing youth culture; there are some unique monuments, and some ubiquitous disposable consumer packages; there are celebrities (of differing kinds) and crowds; the famous and the infamous and the anonymous; the living and the dead; an object which symbolizes the nation's highest aspirations and one which symbolizes its most

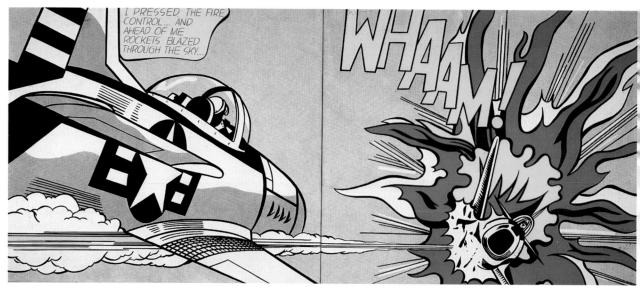

97. Roy Lichtenstein, *Whaam!*, 1963, acrylic on canvas,
173 x 406 cm., Tate Gallery, London.

emphatic form of retribution. Warhol's subject matter seems to span American culture from the great and the good to the bad and the ugly. Is there anything which unifies the diversity of his referents besides their very American-ness?

In order properly to answer this question it becomes impossible to separate what Warhol depicts from the way he portrays it. Look at Warhol's large *210 Coca-Cola Bottles* and his *Marilyn Diptych*. In each work the same image is repeated across the entire canvas surface. In the case of the Coca-Cola bottles this could be something we might expect to see in racks at a supermarket. But what is at stake in reproducing a portrait one hundred times? A portrait is by definition something significantly unique: an individual.

Warhol is evidently not dealing with a one-to-one encounter between artist and sitter. Rather his starting point is not perhaps Monroe the person at all so much as her public image, an image which by definition is infinitely reproducible. Warhol is depicting not so much a person as a product. In this sense Marilyn Monroe has a lot in common with Coca-Cola: both are carefully contrived commodities packaged for global consumption. And most of Warhol's other subjects share something of this. In the universe of the image, there is no need to differentiate between humans and tin cans, heroes and villains, celebrities and carnage. They are all equivalent.

The sense of the mass production of the image is intensified by aspects of Warhol's technique other than serial repetition. We can see even in reproduction that there are slight variations among the hundred faces in the *Marilyn Diptych* and among the *210 Coca-Cola Bottles*. This is achieved in two principal ways. First, by 1962 Warhol had begun to use a screen printing technique in his pictures which allowed a monochrome photographic image to be repeated at will across the canvas. By altering the quantity of ink on the screen the image would come out either darker or paler – to the point of obliterating the image in either direction. The right panel of the *Marilyn Diptych* was left at this stage. Second, by masking off various areas of the image on the screen, Warhol was then able to lay down five different colours on and around the faces in the left panel. Several of these are not registered particularly accurately, which also produces small but significant variations. We might expect these variations, which serve to make each of the Marilyns technically unique, to distract from the mechanical implications of the work. In fact something like the opposite happens. The apparently careless quantification of images does far more to amplify than negate the mass produced and impersonal mood of the image, as does the use of sharp, hard, colour which treats all areas as equal flat islands, irrespective of whether it coincides with face, lips, eyelids, dress or background.

98. Jasper Johns, *White Flag*, 1955, encaustic and collage on canvas, 200 x 307 cm., collection of the artist, courtesy of the Leo Castelli Gallery, New York.

99. Robert Rauschenberg, *Canyon*, 1959, combine painting: mixed media on canvas with objects, 207 x 178 x 61 cm., Sonnabend collection, New York.

Warhol was not alone among artists during the early 1960s either to work with commercially produced images or to employ quasi-mechanical means. His contemporary Roy Lichtenstein had begun independently to exploit pre-existing imagery and a crude colour printing technique made up of Ben-Day dots in his huge blow-ups of sections from popular strip-cartoons (Plate 97). A few years earlier two other New York-based artists, Jasper Johns and Robert Rauschenberg, had begun to employ every-day imagery and objects in paintings otherwise reminiscent of the scale or gestural techniques of abstract expressionism (Plates 98, 99).

How should we interpret Warhol's representations of his modernity? The world he shows is one of the mass production and mass consumption of images, one where there is even a kind of regulated democracy: all images are rendered equivalent. Warhol's studio, incidentally, was called the 'Factory'; he had many assistants who would have made part or perhaps all of a work: he did not just observe so much as participate in the process of mass production of images. But is there a moral in

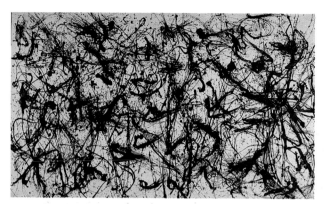

100. Jackson Pollock, *No. 32*, 1950, Kunstsammlung Nordrhein-Westfalen, Düsseldorf.

this? Is Warhol criticizing this world of the image? Or is he celebrating it? How might we make a decision, and on what basis?

I think there might be an alternative, which is to suspend the question of morality altogether. The world of intense, bright surfaces which Warhol presents may precipitate feelings of delight or dismay or neither or both. For some (from the Left and from the Right), Warhol's is a debased art in a debased world; for others it is an invitation to look at all aspects of the world, serious or superficial, without the distorting lens of prejudice. Warhol himself was careful never to discuss his work in such terms saying instead: 'If you want to know all about Andy Warhol, just look at the surfaces of my paintings and films and me, and there I am. There's nothing behind it.'[3] The feelings we experience are at least as likely to be our own projections about this world as something produced by the artist. It is important to try not to confuse our sense of the rights and wrongs of this world with the artist's. One of the things which is perhaps engaging about Warhol's work is that it seems, so to speak, to have enough room within it to allow for quite divergent responses.

However we might choose to judge Warhol's work, it does seem quite intensely immersed in modernity, both in his choice of subject matter and in his modern production techniques. How then, if at all, does Warhol engage tradition?

In 1962 a photographic image of a film star's face taken from a publicity still would have been a far from orthodox starting point for a large-scale painting. The re-introduction of contemporary subject matter into ambitious modern painting in the work of Warhol and Lichtenstein, Johns,

Rauschenberg and others has been represented as a critical response to the high-flown metaphysics associated with Abstract Expressionism. And if we focus on the imagery of Warhol's work in relation to the fluid abstract webs of a Pollock (Plate 100) they do appear quite dramatically different. But if we look at other aspects of Warhol's canvases – in particular the size and structure of his compositions – such apparent differences are at least qualified.

The precedent for large-scale modern painting had only been set by the likes of Pollock, Newman, Rothko, Still, De Kooning and others in the late forties and early fifties. Previously, modern European art from the Impressionists through the Cubists to the Surrealists had been typically small scale, informal and oriented towards the 'private'. Warhol clearly draws on the more assertive and 'public' scale of the earlier American work. Here at least it seems more that Warhol is trying more to continue than to criticize an aspect of Abstract Expressionism. Furthermore, Warhol's signature compositional device of serial repetition – giving equal emphasis to all areas of the canvas so that there is no overall figure/ground or centre/margin distinction – also represents more a development of than a departure from the compositional precedents set by the previous generation of painters. Pollock's compositions could be described in almost exactly the same general terms as Warhol's – allover, balanced, contained, flat.

In more general terms it has also been suggested that Warhol's work displays connections with artistic tradition rather than a break with it, in that most of his chosen subjects correspond to the categories or genres of traditional art. Certainly the still-life (Coca-Cola bottles, Campbell's soup cans) and portraiture (Marilyn, Elvis, Kennedy, mug-shots, etc.) represent a large proportion of his *œuvre*. Following this convention of classification, it has also been argued that some other of Warhol's subjects, particularly those culled from news agency stills of car and plane crashes, suicides and riots, correspond to the high academic genre of history painting.

Warhol did not necessarily have in mind the academic classification of subjects when he set about making his work. Rather it is a way of looking at his work which helps to show something of the complexity of the relationship between modernity and tradition in art. It is too much of a simplification to say that art which addresses the here-and-now must do so at the expense of tradi-

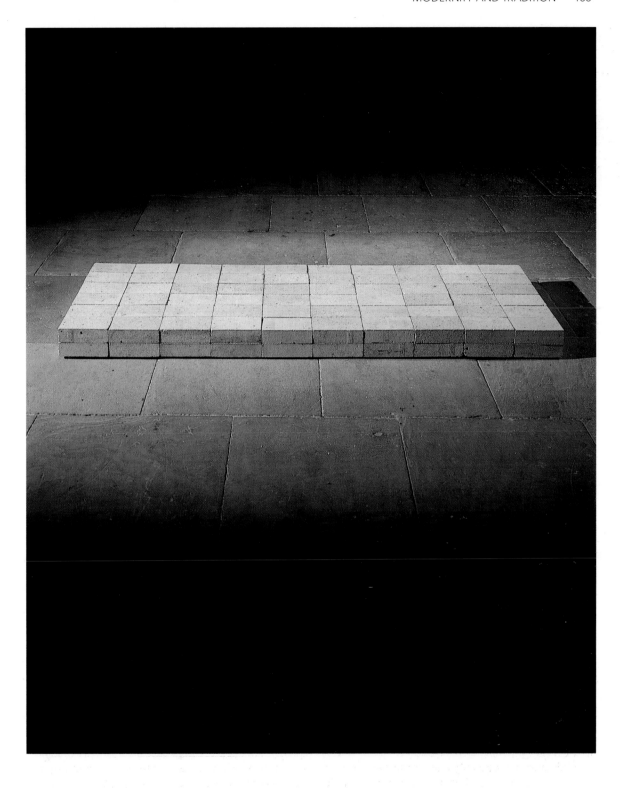

101. Carl Andre, *Equivalent VIII*, 1966, firebricks, 12 x 229
x 68 cm., Tate Gallery, London.

102. Pablo Picasso, *Guitar*, c.1912–13, sheet metal and wire, Museum of Modern Art, New York. Gift of the artist.

103. Vladimir Tatlin, *Corner Relief*, 1913/14, reconstruction by Martyn Chalk, 1979, Annely Juda Fine Art, London.

104. Julio González, *Maternity*,1934, welded steel on stone base, 1305 x 410 x 235 cm., Tate Gallery, London.

tion and the past. It is more that art re-invents tradition in novel ways and thereby continues tradition by departing from it. Brecht again: 'Nothing comes from nothing; the new comes from the old, but that is why it is new.'[4]

CARL ANDRE

The kind of discussion built around Warhol's paintings could be applied to some rather different, albeit contemporary, work: the sculpture of Carl Andre.

Andre is best known in this country for a huge controversy, conducted by the popular press in 1976, over the purchase of one of his works by the Tate Gallery, London. The work, *Equivalent VIII* (Plate 101), was originally made in 1966, and bought by the Tate in 1972, apparently for around £4,000. Consisting of a rectangular arrangement of 120 firebricks, *Equivalent VIII* was, as far as the Tate was concerned, a good example of American Minimalist art. As far as the press was concerned, this was a good example of the emperor's new clothes: 'the bricks' (as the work came to be known) were just that, bricks. Not sculpture. Not art. Better seen in a builders' merchants than in a museum. And cheaper, too.

There seems to be a kind of common-sense justification for the scepticism, or cynicism, voiced by the press. At the same time there might be good

reason to be sceptical of common-sense justifications in general, and of those voiced by the press in particular. Whatever one's thoughts on such issues, the furore does nonetheless point to a real gulf between the public's (i.e. the press's) expectations of art, and the interests of those inside the art-world.

We will come back to this question later. For the moment we should concentrate on the work in question. Is it possible to see *Equivalent VIII* as art? Or as sculpture? Can we talk of a rectangle of 120 fire bricks as having subject matter? Or of being engaged with modernity? Or of being a part of artistic tradition? What are the differences between Andre's work and Warhol's? Are there any similarities?

Andre's work does not depict anything. But then nor does Mondrian's, Rothko's or Pollock's mature work. Nonetheless, all these artists were insistent that their work was concerned with the representation of modern experience. In 1952, for example, Rothko commented: 'I always painted realistically. My present paintings are realistic'.[5] Illustration has never been the principal means by which art has sought to convey experience; rather, as we have discussed, the subjective experience of the world has to be conveyed by more abstract means – through the entire form of the painting. In the case of Warhol it is through the techniques such as repetition and its implications

105. David Smith, *Untitled*, painted steel, Tate Gallery, London.

106. Dan Flavin, '*Monument*' *for V.I. Tatlin*, 1966–9, fluorescent lights and fittings, Tate Gallery, London.

107. Don Judd, *Untitled*, 1980, steel with inset blue perspex panels, ten units, each 230 x 1016 x 788. Tate Gallery, London.

that some sense of modernity is established, not by his choice of imagery alone. If we were to imagine somehow blocking out the specific imagery of, say his *Marilyn Diptych*, what would there be left to look at? Two rectangles, each containing a regular grid of fifty smaller identical rectangles. Warhol's basic compositional structure is in fact remarkably close to Andre's ... which in turn makes Andre's relatively like Pollock's.

But of course Andre's work is not painting. It is three-dimensional, floor-based, literal. The elements from which it is made (Andre called them 'particles'), are standard, mass-produced, readily available products which the artist acquired from a brickyard. Warhol's basic unit on the other hand is ... what? A commercially available, mass-produced product which the artist acquired from a publicity still, before having it mechanically transferred onto a canvas. Warhol takes a pre-given image as the starting point of his work; Andre takes a pre-given object.

Unlike an image, an object has a given material form. Many sculptors during the twentieth century have sought to develop an engagement with (or at least an acknowledgement of) the here-and-now through exploring modern materials and methods of fabrication. Carving in marble, modelling in clay, casting in bronze – the traditional methods and materials of sculpture – had increasingly been put aside by artists for material such as

timber, metal, glass and plastic. Following a precedent set by Picasso in a remarkable group of experimental sculptures from 1913–14, (Plate 102) many artists began to assemble works by bolting, welding or even tying them together. In much the same way as painters had earlier abandoned the illusionism and finish of academic painting, so sculptors began to distance themselves from the solid, monolithic and illusionistic sculpture of the nineteenth century. In a work by Picasso, Tatlin or González, (Plates 103, 104) whether abstract or figurative, the materials are clearly displayed as what they are, usually in an open, non-monolithic composition. By the 1950s, the American sculptor David Smith was producing linear, semi-totemic, semi-'primitive' forms by welding together modern industrial steel 'I' beams (Plate 105), a rough equivalent, perhaps, of some of Pollock's totemic paintings.

In all these sculptors' work there is a move away from using one material (say, stone) to create the illusion of another (say, flesh). In the same general way as painters had earlier begun to display more and more openly the materials they were using, so sculptors in the second decade of the twentieth century began to declare openly the materials from which their work was made. And as the techniques and materials of illusionistic, monolithic, sculpture were abandoned, so sculptors found the way clear to experiment with new

108. Sol LeWitt, *Two Open Modular Cubes/Half Off*, 1975, baked enamel on aluminium,Tate Gallery, London.

109. Carl Andre, *Magnesium Square*, 1969, 345 x 345 cm., Tate Gallery, London.

110. Anthony Caro, *Early One Morning*, 1962, painted steel and aluminium, 290 x 620 x 333 cm., Tate Gallery, London.

and intrinsically modern materials and techniques. And thus the sculptor's choice of materials and techniques becomes not a given of the work, but a part of its subject.

Andre's work needs to be seen within this line of development. The materials he employs are part of the subject of his sculptures. ('Their subject is matter' he once said).[6] Be it brick, metal or timber, Andre's materials are always industrial in origin, and in pre-formed standard shapes, either rectangular or square. Unlike earlier generations of sculptors, however, Andre made a decision not to alter the basic forms he acquired by cutting into or adding anything onto them: 'I do not cut or mould the particles of my sculptures. Rather, I use the particles of my sculptures to cut into space'.[7] Nor does he join the elements together in any way which is not self-supporting – in other words he does not weld, glue or bolt them together. Thus it could be argued he carries the anti-illusionistic aesthetic of modern sculpture a stage further than earlier artists by eliminating any gravity-defying effects, or, as he put it by refusing 'to impose properties on materials'.[8]

Once again, we should note that Andre like Warhol was not working in an artistic vacuum. By the mid-1960s, a number of other sculptors of about the same age, among them Dan Flavin, Donald Judd, and Sol LeWitt (Plates 106–8) had also begun to experiment with modular units, regular grid compositions, and standard industrial materials. LeWitt described his aim to develop a 'hard industrial look' in his work, and to negate an expressive, ornamental or craft-like appearance.

Both he and Judd began to have work fabricated in workshops by trained metal workers from diagrams supplied by the artist. Whereas Warhol simulated a factory environment, many of these three-dimensional works were literally assembled in factories.

Andre could have chosen to arrange the elements of *Equivalent VIII* in a more dramatic or baroque fashion by varying the relationships between the elements and adjusting the overall shape and height of the work. It would in a sense have been easier – that is, more conventional – to make an artful arrangement of these industrial materials. That he selected a direct, clear and apparently artless composition is significant, and most of his work from the mid-1960s is similar in composition: square or rectangular or linear, and flat. His *Magnesium Plate Square* (1969; Plate 109) is a square unit made of one hundred and forty-four squares of magnesium. The sculpture is less than a centimetre high. It was not Andre's aim to transform his materials into a semblance of something else, that would be illusionism. For Andre, any 'imposition of properties' was a kind of illusion or conceit. Even the fully abstract welded steel sculptures of the contemporary English sculptor Anthony Caro were seen in roughly these terms by some Minimalist sculptors. The unique, one-off, almost floating asymmetric balance of works such as Caro's *Early One Morning* (1964; Plate 110), came to look (to Don Judd at least) craft-like, anthropomorphic, and redundant.

The aversion of Andre and his contemporaries to the kinds of sculptural composition typified by Caro's work was expressed in their use of square, rectangular and linear arrangements of similar or identical basic elements. But there was also an important positive value in this use of composition and materials. Andre's work might be described in roughly the terms in which the composer John Cage characterized Warhol's: 'Andy has fought by repetition to show us that there is no repetition really, that everything we look at is worthy of our attention.' He added 'That has been a major direction for the twentieth century, it seems to me.'[9] As in Warhol's work, repetition in Andre's is always modulated by the variations and blemishes inherent in the materials; he would never polish metal to a uniform finish, for example.

Cage's injunction – to look at everything without judgement, even the most ephemeral stuff of our everyday lives – is perhaps as impossible as it seems simple. It is not something we can just choose to do so much as something we might aspire to do: to step outside our interests and prejudices; to look at things not in terms of how we might use them, but in terms of what they are. Cage is suggesting that we use our imagination when looking in order to see beyond the merely habitual and functional. To see *Equivalent VIII* as 'a pile of bricks' is, in Cage's terms, to fail to look imaginatively. It is perhaps no great wonder that the British press has consistently failed on this count.

Andre's subject is matter, not bricks, and the way that matter occupies space. But the implications of this suggest something of a departure from the theme of the here-and-now. To (try to) look at something beyond the terms of its immediate use value is also to detach that something from its present. Andre has often noted the importance for him of seeing Stonehenge on a visit to England when a child, and his sculpture has sometimes been compared with primitive stone circles. It is a connection which clearly interests Andre. He has commented that his type of work 'went out of fashion 3,000 years ago',[10] and that 'All art is either Palaeolithic or Neolithic: either the urge to smear soot and grease on cave walls or pile stone on stone'.[11] The suggestion is that, for Andre, art is a deeply traditional activity, a response to some basic human drive, irrespective of age, race, culture, gender or class. It is an indication of an essential sameness within the human species underlying the contingencies and variations which mark us off into different times and cultures. (We are after all not that different, biologically, from humans of a few thousand years ago.) The specifics of his particular modernity are in an Andre sculpture as much as they are in a Bronze Age burial mound, but this exists in relation to and not in contradiction of its traditional character.

Arguments which emphasize the continuity of human activity between different ages and cultures were more popular in artistic and oppositional circles during the 1960s and 1970s than they were during the 1980s and early 90s. In as much as it is possible to generalize, we could say there is a greater tendency these days to look at art for evidence of cultural specificity and difference. Andre's more transcendental talk is a bit tricky. The problem is not that it is necessarily untrue, so much that it is all a bit vague. It is quite easy to take an example of late twentieth-century industrial production and a relic from an ancient

culture, and find some similarities between them. That does not make those similarities profound. Nor though can we safely assume that profound connections do not exist. The point may be that the opposition between the themes of continuity and difference is a false one: all art probably draws in some measure on deep and not necessarily conscious traditions (Baudelaire's 'eternal and immutable'), and at the same time responds to the transitoriness of its modernity (the 'ephemeral, the fugitive, the contingent'). It is not a matter of whether art ought to do one or the other, but of how the relationship between the two is embodied and negotiated in the work.

We have, in theory at least, established some ways in which Andre's work engages with his modernity, some ways in which it engages with the materials and techniques of modern sculpture, and some ways in which it engages with an idea of tradition. We have, then, tackled the first two questions I asked at the beginning of this chapter, questions about the subject of Andre's work. Have we also answered the second two? Can something which might conceivably be found in exactly the same form in, say, a brickyard, be sculpture? Can it be art? There are no craft skills in Andre's work. His materials are bought or found and arranged on the floor. Just about anyone could put together a 'Carl Andre' in their back yard or bedroom and it would not cost much to make. So what is it that makes Andre's a work of art and their's a joke?

There are several ways of discussing these questions, most of which involve contextualizing Andre's work in some form. One answer would be that Andre did his work at a time when this kind of sculpture had not been previously imagined, whereas now it has become a familiar 'look' of modern art. It requires a certain amount of effort, concentration and skill (though not necessarily craft skill) to make art which remains within the boundaries of technique and taste set by the conventions of a culture. It takes imagination and courage to make art which extends, revises, or re-invents those conventions. The risks are greater; it may be that you succeed in changing the way people look at art (result: great artist); it may also be that you fail (result: sad fool). The real test is whether other artists become convinced of your work and begin to employ the new vocabulary. It worked for Manet. It worked for Warhol. It also worked for Andre. Andre and his contemporaries convinced a generation of other artists that sculpture could do without certain things (e.g. certain

kinds of 'balanced' and gravity-defying compositions) and could include other things (e.g. the modular grid composition) – and still be sculpture.

To arrange 120 bricks in the context of sculpture is a different kind of imaginative activity than doing the same in a brickyard. One effect of Andre's work is to highlight, or to invite the viewer to inquire into, the relationship between art and non-art. To render those boundaries uncertain may not be the denial of art but a condition of art, of all the arts, in the modern period. For most of this century there have been forms of art which have to a greater or lesser degree incorporated non-art materials – be it Cubist collage, Duchamp's 'readymades', Dada collage, or the Surrealist 'found object'. If Andre's work makes the viewer more conscious of his or her surroundings, of the conditions under which spectatorship takes place in art, and of the relationship between the intrinsic value of a work of art and its exchange value, then this might be seen as another form of anti-illusionism in his work. That is to say, this might be seen as part of the value of the work, not as a complaint against it.

The literal cost of 120 fire bricks is not that much, certainly much less than the price paid by the Tate Gallery for *Equivalent VIII*. But the intrinsic value of any work of art will tend to be a lot less than its market value. The *Mona Lisa* would certainly have cost less in terms of materials than those used by Andre, but it is regarded as priceless. If we do not baulk at this form of hyper-inflation, it is probably because we allow some other factor to make up the difference. That factor of course is Leonardo's work, his skill. But the whole of modern art shows that 'skill' is not a fixed value. The skills of the academy were jettisoned by Manet and others because they proved unsuitable for dealing with the changing world around them. They were not modern skills. As we have suggested before, the demand the modern world makes on modern artists is that their vocabulary, their techniques, their skills be permanently in a state of revision. They are not able to assume, simply because 'x' was a valuable resource for art yesterday, that it will remain so today.

Insofar as artists have had to re-invent art in order to continue art, it follows that the audience of art will have to re-invent the skills required for viewing it. As spectators, we can not assume that the baggage of hopes, expectations and preferences we brought with us yesterday will necessarily be of use today. But at the same time it

is practically very difficult, faced with only one or two examples of a new kind of art, to sense what might be appropriate to viewing it. A useful context for any new art is an adequate range of that art and sympathetic viewing conditions – two things which are often very hard to find.

Andre's sculpture needs to be seen in the context of modern sculpture but also in the context of Andre's other sculpture. As the title suggests, *Equivalent VIII* was one (in fact the last) of a series of closely related works exhibited together in a commercial gallery in New York in 1966 (Plate 111). Each work consists of the same quantity of bricks stacked two deep and arranged in grids of either 3 x 20, 4 x 15, 5 x 12, or 6 x 10, and aligned along either their short or long sides. Hence the equivalence: each work has the same mass and volume but a different form. The original exhibition clearly gave the viewer something more to go on and think about than when we see one of the series in isolation. If we then look at *Cuts*, a related work by Andre from the following year (Plate 112), which is a kind of negative version of the *Equivalents*, it becomes somewhat more evident what Andre meant when he talked of using his sculpture 'to cut into space'. An installation shot of his 1979 retrospective exhibition at the Whitechapel Gallery, London, shows more fully the range of material, scales, and compositional devices he employed over a decade and a half (Plate 113). (*Equivalent VIII* is on the far left of the picture, *Equivalent VI* is on the far right; the earliest sculpture is the carved *Last Ladder*, from 1959 in the top right corner; the latest is *The Way North, East, South, West (Uncarved Blocks)*, of 1975, in the foreground.) Viewed within this wider range of his work it is possible to see how Andre employs some reasonably traditional themes and relationships in his work: figure and ground, volume and space, horizontal and vertical, proportion, composition, and so on.

It is quite difficult to approach Andre's work (and Warhol's) without some additional information and contextualization. Certainly it requires a degree of openness, thought and reflection on the part of the viewer, as does all art. But the work can still seem difficult and exclusive. It has often been called elitist. 'Elitism' is a highly charged term, and it is important to be careful when using it. 'Difficult' and 'elitist' are quite different things. The term 'elite' denotes a privileged group, access to which is gained by some 'absolute' physical or mental attribute. Modern art might better be defined as a relatively specialized activity, the dif-

111. Carl Andre, installation shot of *Equivalent I – VIII*, Tibor de Nagy Gallery, 1966, photograph of exhibited works, *The Observer*, 22 February 1976.

112. Carl Andre, *Cuts*, 1967, concrete blocks, 1748 unit rectangle (38 x 46 array with 8 voids of 30 units), overall dimensions 893 x 1509 x 9 cm., each unit 9 x 19 x 40 cm., installation view in the National Gallery of Canada, 31 July – 4 November 1979, private collection.

113. Carl Andre, installation view, Whitechapel Gallery, London, 1979.

ference being that a specialization may be acquired by anyone prepared to devote the time and energy to learning the norms, concepts and language that makes up the activity. The point here is that our modernity is characterized by very high levels of specialization in all activities – in science, law, technology, sport, education, economics, politics, you-name-it. And if specializa-tion is one of the principal characteristics of the modern world, should not we expect art to repre-sent this? This is not so much a moral question as a practical one. It is not a question of whether art should or should not represent this feature of our lives; insofar as art participates in a meaningful way in the modern world is it not bound to become specialized?

NOTES

1. Brecht, B., 'Popularity and Realism', reprinted in Frascina, F. and Harrison, C. eds, *Modern Art and Modernism*, London, Harper and Row, 1982, pp.227–31

2. Reprinted in op.cit. note 1, pp.23–8.

3. Berg, G., 'Andy: My True Story', *Los Angeles Free Press*, 17 March 1967, quoted in Buchloh, B., 'Andy Warhol's One-Dimensional Art: 1956–66', in *Andy Warhol: a retrospective*, ex.cat., Haywood Gallery, London, 1989.

4. Op.cit. note 1, p.229.

5. Bresslin, J.E.B., *Mark Rothko: a Biography* (interview with William Seitz, Jan. 1952), Chicago and London, University of Chicago Press, 1993, p.330.

6. Batchelor, D. '3000 Years: Carl Andre interviewed by David Batchelor', *Artscribe*, 76, Summer 1989, pp.62–3.

7. Art.cit. note 6, p.62.

8. *Carl Andre*, Whitechapel Gallery ex.cat., London, 1978, p.11.

9. McShine, K., *Andy Warhol: a retrospective*, Hayward Gallery ex. cat., London, 1989, p.13.

10. Art.cit. note 6, p.62.

11. Art.cit. note 6, p.63.

CHAPTER NINE

VISUAL CULTURES OF OPPOSITION

JONATHAN HARRIS

Introduction

A number of kinds of art produced in the period
between the late 1960s and the mid 1980s offered
fundamental challenges to the then predominant
account of the character and role of modern art in
the twentieth century. Before the late 60s modern
art had been understood to have developed histori-
cally in the period between, for example, Picasso's
and Braque's Cubism (1907–16) and the success
of the Abstract Expressionists, working in the
United States during the 1950s. Modern Art,
according to this account, was a term which
should only be used in relation to a very small
number of artists held to be worthy of serious
attention (and said, therefore, to belong to the
canon of Greats), whose work was claimed to
belong to the 'art-for-art's-sake' tradition originat-
ing with the work of Edouard Manet and the
Impressionists active in France during the 1860s,
1870s and 1880s.

The art-for-art's-sake tradition held that art
was essentially a practice not concerned with the
world – with, for example, social life, politics or
ideas – but rather a form of self-referential enquiry
centred on the media and techniques of art-mak-
ing. Paintings might refer to things in the world,
depicting people, places and events, but the claim
was that these references were largely incidental
or secondary to the act of examining the material

and technical characteristics and potential of a
specific medium, such as oil painting. This ten-
dency towards self-reference was claimed to
increase during the late nineteenth century and
into the twentieth century. It became closely asso-
ciated with the development of abstract art, such
as that of Wassily Kandinsky, Piet Mondrian and,
in the post-World War Two period, the American
Abstract Expressionists.

This predominant account, by the late 1960s,
could be found articulated in a number of diverse,
but inter-connected and important, institutional
locations. These included, for instance, the collec-
tions and exhibitions of galleries and museums,
such as those of the Museum of Modern Art in
New York. The account, in its essentials, also
could be found in an array of standard text books
and catalogue essays produced by art historians,
including Alfred H. Barr's texts *Cubism and
Abstract Art* (1936) and his introduction to *The
New American Painting* (1958) – both based on
shows organized by the Museum of Modern Art.
Critical studies of modern art, such as Clement
Greenberg's essay 'Modernist Painting' (1961)
presented the argument in systematic and appar-
ently rigorous form. In another context, the
curriculae and bibliographies of courses in modern
art history and art practice taught in colleges and
universities across Western Europe and North

America specifically acted to reproduce the criteria and value judgements of this art-for-art's-sake tradition by recruiting new practitioners, critics and scholars committed to the predominant account.

Texts and publications of all kinds were active in the structuring and shaping of this particular culture and may be included within the broad sense of 'institution'. Journals such as *Artforum*, published in the USA since 1962, also may be said to have had an important role in maintaining the prevalence of art-for-art's-sake accounts of modern art, allowing increasingly influential younger critics, such as Michael Fried and Rosalind Krauss, to expound their defences and elaborations of this tradition. Fried and Krauss, both US university-trained art critics and intellectuals, began to produce texts during the 1960s heavily indebted to the values of the art-for-art's-sake tradition. They also attempted to identify contemporary American artists whom they believed continued this tradition in the wake of the Abstract Expressionists. By 1966 or 1967, and despite the market success of the Pop artists explicitly concerned in their work with contemporary society and social issues (such as Andy Warhol or Roy Lichtenstein), the art-for-art's-sake position remained extremely powerful, both in terms of an account of which artists were claimed to be important – the canon of the Moderns – and in terms of why their art was said to have made lasting achievements.

The success of figurative Pop art had confounded and annoyed proponents of the art-for-art's-sake tradition, who believed their criteria and evaluations of quality in art were essentially bound up with the development and critical claim of abstract art. For in this development lay the most important facets of their argument – about the nature of art and the nature of social reality – both given theoretical articulation during the 1960s. Those critics and historians (along with some artists) defending this account of the Moderns – whom I shall call, from now on, the Modernists – believed that a line of continuity linked the Cubists to the Abstract Expressionists (through intermediates, including Henri Matisse, Joan Miró and André Masson), in that this tradition of making modern art was understood as a practice of quasi-scientific investigation. Painting was conceived as a specific form-bound medium of expression necessarily consisting of marks made on a flat surface, in a space of two dimensions bound by a frame. These artists, according to the

Modernist critics and historians, had conclusively rejected illusionistic and narrative concerns in art (along with the usually conservative social role of academic artists in nineteenth-century society) and were embarked on a novel kind of material, technical and cognitive exploration of their practice.

This notion of Modernism may be contrasted with a much broader sense used to identify a wider range of artists, groupings and idioms of expression in art, present since the late nineteenth century. Although many modern artists in this general sense adopted the visual languages of, for example, cubist painting (that is, the use of faceted planes and multi-point perspective), these languages were often mobilized for clear social and political purposes – for instance in the work of the Italian Futurists or the Dada artists, such as Georg Grosz. The term Avant-Garde, often used synonymously with modernism, has an aggressive, military connotation which appealed to those artists – such as Gustave Courbet in the 1840s and 1850s – and critics, who saw art as radical in both technical and social terms.

However, while art-for-art's-sake Modernists believed that serious art was no longer concerned with the depiction of the world, Michael Fried, a critic highly influenced by Greenberg, added a twist to this claim a few years later by arguing that the realities of modern society increasingly made illusionistic or representational art impossible (Fried 1965).

What kinds of realities might Fried have had in mind? On Saturday 21 October 1967 90,000 people attended a demonstration at the Pentagon in Washington against the US involvement in the Vietnam War. It had been the seventh such national event and indicated the arrival of the American 'New Left' as a major (and potentially violently disruptive) force in contemporary US society. By the end of the following year 30,500 US troops had been killed in Vietnam since 1962, but over half of them had died between 1967 and 1968. Over half a million US soldiers were on active service in south-east Asia, many thousands of them poor African-Americans who had joined the armed forces supposedly as a route out of poverty and racism in the United States. The US government was spending thirty billion dollars per year on the maintenance of the war in Vietnam, while at home, during 1967, eighty people had died in civil rights demonstrations against poverty and racism in more than 100 cities. In 1968 the

114. Kenneth Noland, *Magus*, 1967, acrylic on canvas,
225 x 686 cm. collection Mr and Mrs David Mirvish,
Toronto.

liberal Democrat presidential hopeful Robert Kennedy and Martin Luther King jr, the leader of the campaign for African-American civil rights, were both assassinated.

By the beginning of 1969 the Students for a Democratic Society numbered 60–100,000 (in 1966 membership had been only 8,000). Rebellion and rioting spread to almost every university campus in the country between April 1968 and 1970. At Kent State University on 4 May 1970 the Ohio National Guard shot and killed four student demonstrators, and wounded nine others. Some civil-rights groups, such as the Weathermen, the Revolutionary Youth Movement and the Black Panthers began campaigns of organized violence against selected state, military and corporate capitalist targets. At the Washington demonstration against US intervention in Vietnam an African-American protester had carried a banner saying 'No Vietnamese ever called me a Nigger'.

These frightening and dislocating events in American society in the 1960s might be the sorts of realities which Fried considered active in undermining the role of art to represent social life. In those circumstances it is understandable that Modernist critics, if they were relatively politically conservative, wanted to sustain contemporary abstract art such as that produced by Frank Stella or Kenneth Noland (Plate 114). They wished to preserve an account of the nature and purpose of modern art not perturbed by the actual politics and struggles of day-to-day life for most people (the working class, ethnic minorities, women) in the US of the late 1960s.

Over the twentieth century as a whole, in fact, the same kinds of features had importantly shaped and characterized modern history: violent revolutions and repressions, social fragmentation, gross inequalities of wealth within capitalist societies and between advanced western societies and their colonial possessions, and the emergence of new forms of political struggles and identities. Within this broader history of social conflicts and transformations a cluster of art critics and historians responsible for adumbrating the Modernist position (including Roger Fry and Clive Bell, writing in England before the First World War), chose to defend and celebrate art and artists whose work they believed was unconnected and uninterested in the representation of these historic forces and struggles. Matisse, emblematically, had said that his art was made for 'the tired businessman', who was not concerned, it can be assumed, with the fate of revolutionary socialist organizations, critiques of patriarchy or the rights of minorities.

Greenberg, writing in essays such as 'Avant-garde and Kitsch' (1939), 'Towards a Newer Laocoön' (1940), and the later 'Modernist Painting', developed the preferences (and exclusions) of Fry and Bell into much more scholarly and systematic arguments, subsequently extended in Fried's texts *Three American Painters* and his essay 'Art and Objecthood' (1967), published in the magazine *Artforum*. Although Greenberg had professed socialist beliefs during the Depression of the 1930s, and his earlier essays had hinted at links between aesthetic (modernist) and political radicalism, by the mid-1960s the critical doctrine often identified as 'Greenbergian Modernism' was coming under attack from other historians and critics (such as Lawrence Alloway, a supporter of Pop Art, and Lucy Lippard, a feminist writer) as well as other artists who were attempting to construct practices no longer constrained by the precepts of what they considered by then an out-

115. Leon Golub, *Vietnam II*, 1973, acrylic on linen, 305 x 1219 cm.

right reactionary Modernism. The following four case-studies examine what may be called 'oppositional visual cultures', which were intended both to negate principles of the Modernist or art-for-art's-sake tradition and to offer new visualizations of contemporary social and political struggle.

How might a painter, using relatively traditional means of representation, attempt to construct such an oppositional practice? What might the paintings of such an artist look like?

LEON GOLUB

Consider Leon Golub's painting *Vietnam II* (Plate 115) from 1973. This is a large painting in acrylics on linen, over three metres wide and twelve metres long, and in this respect it uses conventions of scale and types of materials present in some Abstract Expressionist paintings produced by, for instance, Jackson Pollock or Barnett Newman, in the early 1950s, and celebrated by Modernists as major achievements in twentieth-century art. But Golub's painting depicts a scene of violent conflict between a group of three US soldiers, on the far left of the canvas, moving through the illusory space of the painting in front of an armoured vehicle, towards, on the far right of the canvas, eight Vietnamese civilians (six adults, a child and a baby in arms), in front of the remains of a hut, who recoil (physically and emotionally) from the attack of the soldiers. The middle section of the canvas, however, remains empty of figurative detail, with no convincing depiction of three dimensional space.

The picture, then, depicts schematically a scene of conflict, with enough visual information provided for the viewer to identify the two groups of figures and to understand the meaning of their inter-relation, but the painting refuses to allow the viewer to see only the scene depicted, and simultaneously draws attention to the artifice of the representation: picture and painting are thus held in a dialectical tension – we see both the scene and the physical materials out of which the scene is made.

Now consider Golub's later painting *Mercenaries IV* (1980; Plate 116), which similarly depicts two groups of figures in front of an undefined, abstracted red space or background. This is also a large painting, three metres wide by nearly six metres long. Golub, in response to a question, explained the painting in the following way:

> In *Mercenaries IV* this black merc on the left is taunting the white guy. They're not actually at war with each other, they're members of the same outfit, but it's one of those hostile moments when they turn on each other ... There's a raunchy restlessness between these guys, irritable tensions. The events, the protagonists, have to be tensed in respect to each other as well as in respect to us. The mercs are inserted into our space and we're inserted into their space. It's like trying to break down the barriers between depicted and actual space, the space of the event ...
>
> Leon Golub (1982) p.4

Golub, we may gather from this account, was interested in attempting to picture something of the psychological realities of conflict, rather than simply producing a highly illusionistic image of war. This is as true of *Vietnam II* as it is of *Mercenaries IV*, the latter painting being one in a series concerned with the activities of soldiers of fortune in central America, who were often financed by the USA (openly or covertly).

Golub, a generation younger than that of the Abstract Expressionists (he was roughly the same

116. Leon Golub, *Mercenaries IV*, 1980, acrylic on canvas,
305 x 584 cm.

age as the artists Sam Francis, Roy Lichtenstein and Robert Rauschenberg), had moved from Chicago to New York in the 1950s. By the 1960s he was attempting to construct a painting practice informed by some formal aspects of Abstract Expressionism, but in other, major respects, quite divergent from the conventions of this art (that is, abstract, lacking narrative or clear figurative content). He was also very hostile to the Greenbergian critical principle of art about art. In the mid-1950s Golub had launched an attack on the Abstract Expressionists for harping on metaphysical and transcendental themes, rather than dealing with contemporary social issues (Golub, 1955). However, Golub took from Abstract Expressionism the idea that large format paintings could represent a kind of modern history painting (in the tradition traceable back to Gustave Courbet), but he was concerned that his work should exhibit technical and social radicalism. Like Pop artists in the 1960s Golub mobilized photographs and other illustrative sources – there is almost a cartoonish quality to his pictures, utilizing schematic and brash design – but these sources were then worked up, transformed within his paintings, which maintain a double life as both depiction of event and articulated surface.

In this respect Golub's paintings have been produced in the light of the stipulations made by Modernist critics on the need to preserve the sense of the painting as material artefact, but he has not been shy of mixing the metaphors of literal and depicted depth in his pictures. Space, in Golub's paintings, is both illusory (the battle ground) and real (the space on the canvas); events are similarly depicted (violence and suffering) and actual (the incidents of paint and line on the canvas). Golub is anxious that the viewer sees the paintings as narratives, with socially-symbolic meanings and ethical implications – to do with US intervention in Vietnam, and with the dynamics of male emotional and physical violence. But he also wants his paintings to be recognized as materially fabricated, pictorial constructions of space and events, in which figures (both pictorial and symbolic) act and interact.

Golub's work in the 1970s, then, represented one response to the social and political events dominating US society since the early 1960s, and was informed by a critique of militarism and imperialism, as well as by an emergent pro-feminist analysis of the mentalities of male violence and manipulation. A broader dissection of US corporate capitalist power in the world certainly was

implied by these themes, although Golub's chosen means of analysis – painting – was arguably, by the late 1960s, a relatively conservative option. His work was still situated within the conventional art world contexts of bourgeois taste and corporate Modernist museum culture, exemplified by the Museum of Modern Art, New York.

A much more fundamental and wide-ranging critique of western political and cultural power (capitalist and state socialist) informed the activities of a grouping active on the other side of the Atlantic. They were concerned, as their own chosen name suggests, with the predicament – the situation – of modern society.

THE SITUATIONISTS

The European group of artists and writers known as the Situationists, active in many countries around the world during the 1950s, 1960s, and early 1970s strove to make central this question of the place in which work was produced, displayed, or debated. In this respect they launched a radicalism of enquiry and activism far in advance of Golub's paintings, although they were concerned with some similar themes: the structure of modern capitalist society, sources of western European authoritarianism and eastern European totalitarianism, and the suppression of aesthetic, social and sexual freedoms. The Situationist groupings that emerged, organized events, published books and journals, disintegrated and reformed over a period of years between 1957 and 1972 (when the Situationist International dissolved itself) did include artists, but the movement was not specifically or simply concerned with the arts (visual or otherwise).

Being based in Europe, those involved had what was a common antipathy to the imperialising influence of US popular and high culture (such as Abstract Expressionism). This was being exported to European countries as evidence of the wealth of US capitalism and the health of its artistic producers in intended contrast to Soviet Communist socialist-realist culture and society (through such agencies as the Museum of Modern Art, which brought tours of American abstract painting to Europe during the 1950s). The Situationists' chief theorist, Guy Debord, wrote a treatise for the group – *The Society of the Spectacle* (1967) – which, in some ways expressed the same distrust of, and hostility to, popular culture as that

117. Asger Jorn, *Dream scene*, 1959

found in the key texts of US Modernism, such as in Greenberg's early essay 'Avant-garde and Kitsch'. As an opposition to commodity culture the Situationists advocated what they called the 'supersession of art' and the transformation of all artistic practices in the name of cultural and social revolution. This was to replace the maintenance and entrenchment of a supposedly pure, quasi-scientific form of artistic practice held to be autonomous of that contaminated spectacular society (advanced capitalist culture).

Although some members of the Situationist International, such as the Danish painter Asger Jorn, did use relatively traditional materials – in his case painting over and obliterating parts of popular prints of idealized landscape paintings, such as *Dream scene* (1959; Plate 117), many others involved rejected such conventional materials altogether. Jorn's so-called modified paintings arguably had a similar thematic purpose: to enact, symbolically, a negation and transformation of a reality thought to be degraded, false and empty of authentic meaning and value. The Situationists did find value in some kinds of popular culture. Like the Surrealists of the 1920s, they were committed to the explosive and critical power of humour (not a quality particularly salient in US Modernism) and the activities of la dérive or 'the drift' – a chaotic walk or journey through the modern city – exemplified this 'serious playfulness'.

Theorized as a component of what was called psychogeography – a kind of reorganization of mental universes, the drift was intended as a practical negation of the rationality and instrumentality of capitalist commodity society in the 1960s. This was articulated by the Lettrists – a group which prefigured some of the ideas of the Situationists:

> The concept of drift is indissolubly linked with the 'reconnaissance of the effects of a psychogeographic nature' and the affirmation of a constructive-playful behaviour.
>
> *Lèvres nues* (Naked Lips)

The spaces of the modern city, according to Debord, had to be recovered from their role in the organization of spectacular society, and reconceived within a new 'beauty of situation'. New experimental cities were conceived, with buildings given glass ceilings to allow views of the stars and rain, and mobile houses designed to be able to turn towards the sun. Constant Niewenhuis (known simply as Constant), a Dutch Situationist, exhibited spatial constructions intended as models for novel architectural structures.

The concept of *détournement*, like the drift, was central to Situationist activities and could take place within a number of different practices and contexts. *Détournement* translates as 'to divert' and it involved the appropriation of elements from one aesthetic or social configuration (or context of meaning), which would then be reorganized in another situation in order to produce new meanings. Drawing on Dada and Surrealist traditions, *détournement* could occur in the production of, for example, paintings, writings, architecture and music. The Italian Giuseppe Pino-Galizio's so-called 'industrial paintings', supported by the Situationists as anti-paintings, consisted of huge rolls of canvas pressed and hand painted with oils and resin. Sold by the metre they were regarded as 'detourning' the usual operation of values in the art market – dominated by Modernist notions of aesthetic quality. Parts of Pino-Galizio's paintings would be pinned to a gallery wall while models might also wear other parts or walk up and down on the canvas.

The Situationists offered an understanding of culture (including art) not as a set of discrete objects or histories, but as a way of life inseparable from the social and political orders of advanced capitalism, and in this respect they prefigured the development of forms of radical cultural theory in the 1970s associated particularly with the Welsh literary critic and novelist Raymond Williams, leader of the radical wing of British Cultural Studies. In response to a US-dominated purist, art-for-art's-sake Modernism powerfully influential in Europe during the 1960s, the Situationists proposed and disseminated an international, way-of-life conception of culture hostile both to critical elitism and to what they saw as the corrupting influences of modern consumer capitalist society. In this respect the Situationists opposed the Cold War that had divided the world into two antagonistic power blocs, and in which the United States represented itself as guardian of economic, political and cultural freedom, premised on the superiority of the capitalist system and US representative democracy.

The growing cultural pessimism of some key members of the group, including Debord himself, however, perhaps helped to drive the group to its own destruction in the early 1970s. Its nihilistic, negative side, characterized by Debord's morbid pronouncements on the complete 'massification' of society and the apparent destruction of all critical culture, eventually helped to suffocate the creative, poetic and playful – and lyrical – facets of Situationist culture.

How did women artists in the early 1970s – radicalized by new and resurgent forms of feminist politics – address the question of gender and politics in modern culture? How might their concerns echo or differ from those of the (usually male) Situationists?

FEMINIST ART IN THE EARLY 1970S

By the late 1960s in the US and western Europe new feminist social and political organizations had emerged, sometimes working in alliance with, or as a part of, the 'new left' discussed above, and sometimes separately, even committed to what became known as separatist politics. Campaigns for equal rights and pay for women, along with the call for free abortion on demand and adequate child care facilities, became linked to emergent gay and lesbian political struggles. Feminists quickly became involved with the politics of the visual image, both in relation to art and wider popular culture, and by 1970 groups and alliances of women working as artists, critics and historians had sprung up on both sides of the Atlantic Ocean.

118. Judy Chicago, *The Dinner Party*, 1979

In New York, for instance, an *ad hoc* Committee of Women Artists was formed in 1970 to protest at the marginal five per cent of women exhibited in the annual survey exhibition of art held at the Whitney Museum of American Art. Women in the Arts was a group founded to show work only by women. It organized the exhibition 'Women Choose Women' at the New York Cultural Center in 1973. In England the first Women's Liberation Art Group exhibition was held in 1971 at the Woodstock Gallery in London. The following year women organized the National Women's Liberation Conference.

In terms of artistic practice during the early 1970s feminist artists continued to use traditional media such as painting and sculpture – but they also mobilized forms of display and other activities far removed from mainstream, orthodox modernist forms and materials. This included extensive use of popular cultural resources – photography and graphic design – and also the organization of a wide range of events and installations. These activities drew partly on conventions and objectives developed within early, relatively neglected avant-garde history – for instance, the events organized by Dadaists and Surrealists before the Second World War – and partly on the performance art experiments organized by John Cage and Robert Rauschenberg at Black Mountain College during the 1950s.

Despite the extensive variety and differences in materials and forms feminist artists had at least one common objective: to raise consciousness about the history and status of women within societies they identified as patriarchal (that is, dominated systematically by men's power and values). Feminist artists Judy Chicago and Miriam Schapiro believed that women should celebrate and represent women's sexual difference from men and so the theme of vaginal iconology (representation and study of the meaning and value of women's genitalia) became an important element of feminist art in the 1970s. Women's genitals could be represented literally or metaphorically (through the image of a flower, for instance) and in this way Chicago and others made art that both attested to women's sexual difference from men and alluded to the life-giving purpose of the vagina, made analogous to many forms of flora in the natural world.

Chicago's *The Rejection Quintet: Female Rejection Drawing* (1974) pictures a vagina-like opening through the metaphor of flower petals, depicted in an abstract style. Chicago was concerned to represent that which was usually not spoken of or celebrated in patriarchal culture, and she drew on Freud's argument that men unconsciously saw the vagina – perceived as an absence or lack – as a metaphor for their own possible castration and subsequent loss of power. At the same time Chicago linked women's sexual identity to their achievements as artists and writers, achievements which had similarly been denied or denigrated by men. Chicago's *The Dinner Party* (1979; Plate 118) consisted of a real table set with places for dozens of women cultural producers (artists, writers, philosophers) – such as Virginia Woolf – represented, in this case, by an image of fertile growth symbolizing creativity and openness. By the mid 1980s Chicago's work was often criticized by younger feminists as essentialist (that is, reducing women to a biological condition) and attacked for portraying the vagina as a site simply for procreation rather than as an organ for women's own sexual pleasure.

In the early 1970s the Canadian feminist artist Colette Whiten began making casts of men, but she did so through a process which became a significant event in itself. Whiten constructed elaborate machines within which willing men (usually her friends) would be held in place while a cast of their body position could be made. With the assistance of women helpers this whole process of installing the man, taking the cast, and releasing the man became an effective performance piece, involving both ritual elements and the subsequent production of testimonies from those involved. Whiten's practice involved literally and symbolically restricting men and, through this performance, alluding to the constraints women face in patriarchal society. The man would be depilated (have his body hair removed) and vaselined, in order to protect the skin from the plaster. While in the machine holding him the man would be dependent on women helpers for water and sympathy. Whiten's performances contained an erotic charge (possibly for both man and women involved, as symbolic relations of domination and subordination were invoked) but they also linked this issue of sexual pleasure to a wider set of questions relating to social power in society.

Unlike Chicago's drawings and paintings, then, Whiten's events incorporated women and men into her critical practice as a feminist artist. This may tell us something about the nature of Whiten's feminist politics (possibly that she was not then a separatist), and it certainly tells us about her views on the place of the art object within her feminist art practice. For Whiten it appears that the art object (the cast) was, in many ways, simply the residue of a more important social process – the casting event or performance. Whiten was probably aware of debates at the time about whether or not women could represent men's bodies in a way which made them look as passive or vulnerable as the way women's bodies had traditionally been depicted within the genre of the female nude. Many Feminists believed it was not possible to produce representations of men which did not maintain or reinforce male power. Whiten's practice simultaneously reduces the significance of the art work (the cast of the male body) and turns the process of the making of the cast itself into a critique of power and domination.

Lynda Benglis explored further this issue of sexual and social power in a full-colour advertisement she placed in the journal *Artforum* in November 1974. This showed her naked, except for a pair of opaque sunglasses and a giant vibrator which she held in front of her vulva. She had originally intended the photograph to appear in an article about her work featured in the journal but the editors had refused to print the image. The photograph paid for as an advertisement, however, was accepted. Benglis's previous work had been concerned with erotic themes (both in video

pieces and the construction of poured-foam sculptures) and the *Artforum* photograph drew together a number of important artistic, social and sexual issues.

Whatever the aesthetic radicalism of the journal, and it had been associated closely with Modernist theory and art in the 1960s, the editors found this graphic depiction of sexuality, and the implication of transexuality – the blurring of sexual identities and practices – embarrassing and unacceptable. Some of the editors wrote a letter to the journal condemning the photograph as 'an object of extreme vulgarity ... brutalizing ourselves and ... our readers' (Lippard, 1976, p.104). Feminists such as the critic Lucy Lippard concluded from this that the photograph indicated that despite the gains women had made – in general and in the art world in particular – 'there are still some things women may not do' (Lippard, 1976, p.127). It has also been argued convincingly that the editors were particularly upset by this photograph because it was by Lynda Benglis and of Lynda Benglis and that it therefore subverted the usual subject-object relation of male viewer and women viewed (Bracker, 1995).

Benglis's photograph importantly appeared printed in a publication, rather than in an exhibition in a gallery. This suggests the urgency she felt both to reach a wide audience and to use modern forms of mechanical reproduction. By the early 1970s many artists – feminists and otherwise – had taken a decision to leave behind the traditional media of painting and sculpture, which they saw as vehicles of conservative art-for-art's-sake Modernism.

How might the emergent technologies of visual representation have been taken up by artists – some preferring to describe themselves as 'cultural producers', which they thought was not an elitist term – in the context of the radicalized politics of both US and western European societies?

Nam June Paik

By the mid-1960s television in the USA had eclipsed film as the dominant form of popular visual culture. The earliest video cameras were also becoming available at that time. The Korean artist Nam June Paik, based in America, closely associated with the European avant-garde group Fluxus in West Germany during the 1950s, became one of the first artists to use video and television as both subject and object of his practice. Fluxus had experimented widely in the use of innovative materials and the organization of performance events, explicitly confounding the Greenbergian Modernist doctrines of the purity of medium (that is, painting understood as an integral and self-sufficient practice) and the supposed autonomy of the aesthetic from social and political life.

Paik's interest in television and video concerned not just an exploration of the potential of these forms as means of production of visual (and audio) representations, but also the implications of the social organization of these forms, through

119. Nam June Paik, *TV Garden*, 1982

corporate capitalist institutions. Paik's piece *Magnet I* (1965), consisted of a large magnet placed on and around a television monitor which, when moved, creating interference registered on the screen as a series of abstract patterns. Further pieces using microphones and closed circuit cameras explored the relations between viewers and the television set, at the level of both actual and symbolic interference. These works were intended symbolically to counter the perception of television as simply a passive medium inducing passivity in the viewer.

By the late 1960s television had begun to influence popular perceptions of major social issues – such as the civil rights campaigns in the US and the war in Vietnam – and in this sense Paik's use of video and television raised questions about the possible subversive capacity of electronic technologies. And, as with the work of feminist performance artists and the activities of the Situationists, Paik's use of novel means to address issues of power and the social order constituted a practical rejection of the priorities of mainstream Modernist art.

Paik's later *TV Garden* (1982; Plate 119) explored the place of television as part of the now naturalized habitat of human society. This raised questions about the function and value of electronic culture, dominated by capitalist corporate institutions, in putatively democratic societies such as the USA. Paik's piece was bought by the Whitney Museum of American Art in New York and much of his earlier work has been collected by the Museum Moderner Kunst in Vienna. This raises the question, relevant to all the work discussed in this chapter, about the capacity of establishment institutions, such as museums, but also journals and academic courses, to assimilate and neutralize apparently radical challenges to mainstream art. Golub's paintings, the Situationists' activities, feminist art and Paik's electronic pieces may be seen as diverse, practical and theoretical 'visual cultures of opposition' to conservative Modernism. Despite the critical power of these works (and the ideas and values propelling them) however, the institutions which enable and control their display and interpretation still, on the whole, restrict and reduce the 'charge' the work was intended to have.

These institutions, on the whole (certainly at national level), are controlled and funded by groups and forces in society opposed to the kinds of fundamental social changes these artists implicitly or explicitly call for in their art. Their power depends on things remaining the way they are. The point was made by radicals in the USA in the late 1960s that some senior directors of the Museum of Modern Art in New York had long been involved directly in US government administrations. The Rockefeller family, for instance, helped found and support the museum, with Nelson Rockefeller a member of the board of trustees since 1932. In 1969 the Guerrilla Art Action Group called for the resignation of the Rockefellers from the museum's board because of their interests in companies such as Standard Oil and Chase Manhattan Bank. It was alleged that these, and other Rockefeller companies, were connected to the production of napalm, to chemical and biological weapons research, and to armaments, some of which were linked to the Pentagon. How convenient it was for them, then, to find Modernist theory and criticism, institutionalized at the Museum of Modern Art, defending the autonomy of the aesthetic and claiming that artists should avoid the political issues then dominating American (and world) society.

On the other hand it is impossible for institutions totally to dominate the way work is seen and understood. This has always been the case. Many of the Abstract Expressionists celebrated by Modernist critics as artists whose work transcended social reality and achieved aesthetic autonomy were themselves mordantly hostile to capitalism and state authoritarianism during the 1950s. Their ideas and work were, in this sense, as appropriated and manipulated as the work of Paik and other radicals may have been over the last twenty five years. One thing is fairly certain, though: by rejecting the conventions of abstract painting used by Pollock, Newman, Mark Rothko and others in the early 1950s and by embracing many different kinds of figurative representation – including the live arts of performance and installation – the visual cultures of opposition made it harder for conservative institutional forces to assimilate or disarm their work. The spaces for that opposition are still open.

REFERENCES

I would like to thank Francis Frascina and Alan Schechner for information used in this essay.

BARR, A.H., *Cubism and Abstract Art*, New York, Museum of Modern Art, 1936

BARR, A.H., *The New American Painting*, New York, Museum of Modern Art, 1958

BELL, C., *Art*, London, Chatto and Windus, 1931

BRACKER, A., 'A Critical History of the International Art Journal *Artforum*', Ph.D. dissertation, Leeds University, 1995

DEBORD, G., *The Society of the Spectacle*, Detroit, Black and Red, 1970

FRASCINA, F., and HARRIS, J. eds, *Art in Modern Culture: An Anthology of Critical Texts*, Oxford, Phaidon, 1992

FRASCINA, F., HARRIS, J., HARRISON, C., and WOOD, P., *Modernism in Dispute: Art since the Forties*, New Haven and London, Yale University Press, 1993

FRIED, M., *Three American Painters: Kenneth Noland, Jules Olitski, Frank Stella*, Cambridge, Harvard University Press, 1965

FRIED, M., 'Art and Objecthood', *Artforum*, vol. 5, no.10, 1967

FRY, R., *Vision and Design*, London, Chatto and Windus, 1920

GOLUB, L., 'A Critique of Abstract Expressionism', *The Art Journal*, vol. 14, no.2, 1955

Leon Golub, Mercenaries and Interrogations, ex.cat., London, ICA, 1982

GREENBERG, C., 'Avant-garde and Kitsch', *Partisan Review*, vol.vi, no.5, 1939, reprinted in Harrison and Wood, op. cit., 1992

GREENBERG, C., 'Towards a Newer Laocoön', *Partisan Review*, vol.vii, no.4, 1940

GREENBERG, C., 'Modernist Painting', *Arts Yearbook*, no.4, 1961, reprinted in Frascina and Harrison, op. cit., 1982.

Les Lèvres nues (complete collection) 1954–8, Paris, Plasma, no date

JAMESON, F., *Postmodernism, or the Cultural Logic of Late Capitalism*, London, Verso, 1991

LIPPARD, L., 'The Pains and Pleasures of Rebirth: women's Body Art', *Art in America*, May-June 1976

SHIFTING PRACTICES:

NEW TRENDS IN REPRESENTATION SINCE THE 1970S

FIONNA BARBER

POST-MODERNISM AND DIVERSITY

Two pieces, one of which consists largely of a collection of second-hand dresses while the other mainly involves a large black and white photograph which deliberately refers to – and quotes from – an American figurative painting dating from 1940, are the focus of this chapter. In discussing Annette Messager's *Histoire des Robes* (1991) and Victor Burgin's *Office at Night No.6* (1985–6) we clearly need to draw on different critical skills to those required by Modernism, given that this has tended to emphasize an increasing specialization both of means of representation and the demands made of viewers in their response. Both of these works by Messager and Burgin certainly do make demands of spectators, but in different ways. Both, in fact, can be seen as part of the major cultural shift which has become increasingly visible since the 1970s, and which is known as Post-Modernism. This requires some explanation before moving on to a closer look at the implications raised by these two works.

Differences between Modernism and Post-Modernism might be investigated through an examination of the ways in which they deal with distinctions between 'high' and 'low' culture. (By this I mean the distinction between forms of repre-sentation such as painting and sculpture, on the one hand, and film, photography, newspapers or advertising – mass media – on the other.) A *papier collé* still life by Picasso, such as *La Suze* (1912; Plate 120) clearly involves elements derived from mass culture in its prominent use of cuttings from newspapers. Yet these are taken out of their original context and combined with other pieces of pasted paper, gouache and charcoal. The written content of the newspaper cuttings can be seen as highly relevant to Picasso's original interests, but within the terms of Modernist criticism it can also be seen as subordinate to overall formal and aesthetic concerns as part of the overall composition. By comparison a work by a Post-Modernist practitioner such as Cindy Sherman could be seen to engage with mass culture in a very different way. *Untitled Film Still No.21* (1978; Plate 121) is firstly a photograph depicting a female figure frozen in action in what appears to be an instant plucked from a narrative. This invites speculation, not merely because of her troubled expression: the framing of the figure against large buildings and the camera angle (looking upwards) also evoke a scenario from a Hitchcock film or a 1950s 'B' movie. Both of these are forms of mass culture appealing to a popular audience, as distinct from

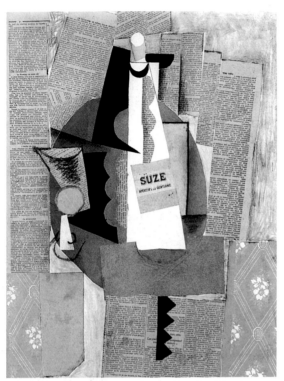

120. Pablo Picasso, *La Suze* (Glass and Bottle of Suze),
1912, Washington University Gallery of Art, St Louis
University purchase, Kende Sale Fund, 1946.

the more restricted number of viewers for whom
Picasso's collages would have been readily accessi-
ble. Indeed it has often been claimed that
Post-Modernism has succeeded in breaking down
barriers between high and low culture by giving
more importance to aspects which have previous-
ly seemed marginal, and in this sense it is impor-
tant to re-emphasize that this piece, by one of the
major Post-Modernist practitioners, is actually a
black and white photograph.

This shift away from high art towards previ-
ously marginalized forms of representation, which
can include material derived from advertising (as
in the work of Barbara Kruger) or subway graffiti
(Jean-Michel Basquiat or Keith Haring), is often
seen as a process of decentring, moving away from
painting as a basis of institutional power within
the visual arts. Yet another major characteristic of
Sherman's work is that it does not involve an
actual film still, or even an image dating from the
1950s; rather it has been made in the late 1970s
with the intention of deliberately suggesting an
earlier moment. This is an attitude to the past very
different from that associated with Modernist ways
of thinking, in which previous forms of representa-
tion are continually superseded as a form of artis-

tic progress. Post-Modernism, on the other hand,
often explicitly involves a degree of recycling or
even plundering the past, reinvesting it with
meaning in a new context. As a result we cannot
trust what we see to mean what we think it does;
Sherman's reconstructions can be said to open up
a distance from the original meaning of images
such as movie stills. And although this is an argu-
ment to which I will return in looking at the work
of Victor Burgin, this method of picture making
serves a similar function in Sherman's photograph
– that of introducing speculation about the mean-
ing of subject matter.

Untitled Film Still No.21 is part of an extensive
series of photographs, which tend to feature a
female figure in a range of scenarios and which,
like this image, evoke speculations not only about
the drama of the situation, but about the identity
of the woman involved. This speculation is fuelled
further when we learn that, despite the huge
diversity of images, in each case the female figure
is Sherman herself. As a result it can be argued
that the real subject of these photographs is not
what appears to be depicted, but the notion of
female identity as something which is fluid and
unstable, rather than fixed or readily definable.
This is another sign of the shifts which have
occurred within Post-Modernism, which goes
beyond the notion of a break with Modernism
which is purely aesthetic. For many artists – not
just women, but gay or black artists also – the
shift towards previously marginalized forms of
representation has provided a language for the
exploration of their own identities as culturally
marginal.

Cindy Sherman is a photographer who lives
and works in New York. However it would be mis-
leading to think that Post-Modernism is purely an
American phenomenon, even if it came to domi-
nate art practice in New York during the early
1980s. Similar ideas were taken up by two practi-
tioners working in Britain and Europe over the
same period, although there are crucial differences
between them. Victor Burgin, although a British
photographer, has lived in the United States since
the mid-80s. Yet his work is important for us to
examine here for a variety of reasons as it engages
with the radical, decentring processes of
Post-Modernism in a particularly effective way,
both through the means of representation (pho-
tography) and his particular choice of subject mat-
ter. His critique of both the social relations of capi-
talism and the operation of gender roles also
demonstrates a clear engagement with aspects of

121. Cindy Sherman, *Untitled Film Still #21*, 1978.

the important developments within British cultural theory during the 1970s. In fact through his exhibited work, published essays and role as a college lecturer, while still resident in Britain, Burgin's position has had a major impact on the development of different forms of cultural practice.

Annette Messager's work by comparison is less theoretically oriented, engaging with its key themes on very different terms. Despite being active (and exhibiting throughout Europe) since the early 70s, her work has until recently continued to occupy the traditional marginal status of women artists. However her installations and collections are becoming increasingly well known, partly because they embody many of the concerns increasingly addressed by a range of women artists, both in attitudes to subject matter and the working methods employed.

In the work of Susan Hiller it is the retrieval of different forms of marginal experience which

becomes of prime importance. A piece entitled *Monument* (1980–81) consisted of an assemblage of photographs of memorial plaques to forgotten individuals found in a London park. Viewers sat on a park bench listening to a soundtrack through headphones which discussed questions of memory and representation; that the spectator faces away from the photographs serves only to reinforce the anonymity of those commemorated. Other works by Hiller invoke a sense of marginal experience through the materials from which they are made: a series of paintings dating from the mid-Eighties (such as *Extra Terrestrial*, 1986) use heavy black Ripolin enamel paint to block out areas of the surface which is itself the type of wallpaper usually found in a child's bedroom. And although much of Hiller's work does not concern itself explicitly with the construction of female identity it is also important to note that her concern with aspects of marginality is one which is

122. Sutapa Biswas, *Synapse I and II*, 1992, diptych, black
and white photographs, collection the artist.

consistently informed by an awareness of a 'femi-
nine speaking position' as silenced and repressed
within a patriarchal culture.

For other practitioners, such as Sutapa Biswas,
photography is employed as a means of exploring
different aspects of both race and gender within
the formation of marginal cultural identities.
Biswas's installation *Synapse* (1992; Plate 122)
raises questions of exile, displacement and location
as negotiated through memory; superimposed on
photographs of her own body are images from a
visit to India in 1987. In Messager's case however
this concern with the marginal is one which is
fundamentally rooted in a history of radical
European art practices. And although Messager's
work engages with a similar critique of female
subjectivity and identity, its incorporation of
Post-Modernist tendencies is also far removed
from the base within mass culture which charac-
terizes the work of Cindy Sherman and many New
York-based artists.

VICTOR BURGIN: OFFICE AT NIGHT NO.6

Like the five others in this series, this is a work
which raises questions not just about its obvious
subject matter – the relationships between men
and women within office employment necessary
to the workings of capitalism – but about the ways
in which images are produced, and the business of
looking itself. All the components of *Office at Night*
follow a standard format, consisting of large,
mural-sized triptychs which combine the media of

photography and painting (Plate 123). The main
feature is a black and white photograph of a
female figure within a setting reminiscent of an
office interior; on the left is a monochrome painted
panel, and finally a kind of pictogram, or schemat-
ic depiction of an object such as a camera or an
open door, outlined in black on a white back-
ground. This last part of the triptych helps to draw
attention to the importance of the notion of stan-
dardization within this project as a whole; in the
black and white photographs, for example, the
woman also wears a standard 1980s business suit
while carrying out various activities typical of
office work, such as filing papers or reading
reports. We might expect that an artwork con-
cerned with what might be seen as the tedium and
monotony of office life might itself have little to
sustain the viewer's interest. Yet I would argue
that, on the contrary, Burgin's *Office at Night*
works rather differently. Although the series *seems*
to be based around some of the key features of
everyday work processes, it also represents them
in a particular way – one that makes visible their
underpinnings within accepted notions of gender
and power within the viewer's expectations, while
also saying something about the ways in which
images themselves are constructed.

The main photograph in panel No.6 depicts a
woman sitting at an office desk, front lit, and
examining a piece of paper. Behind her a rectangle
of light frames another seated figure which seems
to echo her pose, yet there are some crucial differ-
ences. This figure is male, and his clothes, as far as
we can make out, appear old-fashioned in compar-

123. Victor Burgin, *Office at Night #6*, 1985.

124. Edward Hopper, *Office at Night*, 1940, oil on canvas, Walker Art Center, Minneapolis.

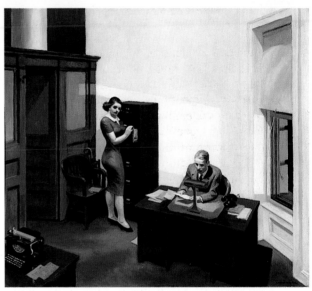

ison with the smart 1980s business suit and bobbed hair of the woman in the foreground. The difficulty in actually discerning distinct features within this part of the image, meanwhile, could suggest that we are looking at something which has been made rather differently from the crisp contrasts of the photograph which surrounds it. In fact it is a fragment of a painting by the American artist Edward Hopper, also entitled *Office at Night* (Plate 123) and dating from 1940. Parts of this earlier work also appear in the first panel of Burgin's series and in each case they have been rephotographed as a transparency and projected onto a screen behind the female figure. In itself, this process of recycling images can be seen as typical of an attitude to the past which characterizes Post-Modernist practices of picture making. But it still does not explain why Hopper's painting should be relevant to a practitioner working in the 1980s.

BURGIN, HOPPER, AND THE PROBLEM OF MEANING

Hopper's painting depicts two figures, a man seated at a desk to the right of the composition and a woman standing at a filing cabinet at the other side of the room, turning towards the desk while her right hand rests on an open drawer. Unlike Burgin's version the difference in their clothing is quite significant – he wears a business suit while she is wearing a very tight blue dress with a white collar. Both this and her pose emphasize the contours of the body; her weight rests on the back leg and her head is turned towards the desk as she looks at a piece of paper resting on the edge. The whole scenario is full of erotic tension; the impending movement will take her into his realm, where some kind of encounter could take place. In a manner similar to Burgin's sixth panel, his first image only uses part of Hopper's original painting, isolating the figure of the woman as a projected image behind the posed model (Plate 125). This use of a transparency helps to draw attention to

125. Victor Burgin, *Office at Night #1*, 1985.

the ways in which both the photograph and painting are made. In Hopper's painting a patch of artificial light falls obliquely on the back wall, both emphasizing the space between the two figures and delineating the space the woman is about to occupy. Here it clearly has a dramatic function, yet it is similar also to the shape delineated by the edge of the projected transparency in Burgin's version, thus making clear that both are parts of the image which are deliberately constructed, rather than being either natural or arbitrary.

Why would Victor Burgin have chosen this painting by Edward Hopper as a catalyst for his series? One possible explanation lies within the interpretation of Post-Modernism itself. Like Modernism, Post-Modernism can be utilized for ends which may be either politically conservative or radical; the invocation of the past, as Burgin himself has argued, can be used either to reinforce the *status quo* through the sense of an unbroken

and timeless tradition, or as a means of showing up the inconsistencies and contradictions within the present order of things:

> We may 'return to the past' in order to demonstrate that it is never simply past; rather it is the locus of meanings which are lived by, and struggled over in the present.
>
> (Burgin, 1984, p.45)

Clearly it is with this latter interpretation that Burgin identifies his own practice, rather than with the former. And this sense of a 'locus of meanings' which may be given new validity at a later moment, also helps to explain the relevance of certain features of Hopper's painting to a practitioner in the mid-80s.

One important aspect of the painting is its sense of 'constructedness', which operates on different levels. As with the use of different forms of representation in the photographic panel, a sense

126. Victor Burgin, *Possession*, 1974,
photolithographic print, 124 x 84 cm. Arts Council
Collection

of unreality is set up by a shifting perspective which also disrupts the viewer's ability to look at the painting in an unproblematic manner. The office walls are not parallel while the floor slopes to one side beneath the weight of the man's desk to the right; the resulting difficulty in assessing the spatial relationship between the two figures contributes to the degree of tension suggested between them. Indeed it could also be said that the ability of Hopper's paintings to hold the imagination of viewers is due to a tendency to position the spectator in a certain way. Although he or she may appear to be merely an unseen observer of an enacted tableau, this is a role which is far from passive; the meaning of the image is dependent on the viewer's ability to read it in terms of their own fantasies and speculations about the situation portrayed. This active role of the spectator is one implied in the art historian Robert Hobbs's discussion of Hopper's work, where

> the assumed viewer is analogous to a camera in a film (... enabling) Hopper to be intimate and distant, to show glimpses of people's everyday lives without invading their privacy ... The observer then becomes an actor, the painting a script, and the play a reading of the script by the actor/viewer.
>
> (Hobbs, 1987, p.20)

To read Hopper's work in this way, however, also has particular implications for the study of Burgin's series *Office at Night.* To suggest that both viewer and camera can actively intervene within the construction of the meaning of images is to assume a position similar to that found in Burgin's work since the mid-Seventies, although it is also one which has become modified over this period. By comparison with the *Office at Night* series, works such as *Possession* (1976) – a series of posters displayed in the streets of Newcastle-upon-Tyne directly confronted the viewer through a combination of text and photographic image derived from advertising. Yet – in a position derived from Brecht – Burgin has always argued that the means of representation itself needs to be considered in terms of how appropriate it is for opening up new meanings. To this end his work of the 1970s has tended to involve the juxtaposition of text and image, not as a means of reinforcing each other, as in advertising, but as a means of triggering a response in the viewer through the contradiction between what is seen and what is read. It is also important to be aware that Burgin

has not been the only recent practitioner to work in such an interventionist manner. This is a strategy which, in its use by a number of other artists including Barbara Kruger and Hans Haacke, has contributed to the development of radical tendencies within Post-Modernist practice. That it is also a position derived from the writings of radical Modernist theorists, such as Brecht or Benjamin, should perhaps lead us to question whether the supposed break between Modernism and Post-Modernism is perhaps not as clear-cut as might have been assumed.

PHOTOGRAPHY, GENDER AND POWER

Burgin's concern in his series, then, is not merely to rework Hopper as a kind of pastiche; the earlier painting should be seen as a catalyst or trigger for the further development of already well-established concerns within his own practice. Some of these concerns are pre-empted by the subject matter of Hopper's painting, insofar as it engages with the work processes normal to capitalism, and with the relations between men and women. Both of these have been significant issues within Burgin's practice from an early stage. The male and female figures in Hopper's *Office at Night* can be seen as representative of the generation which came to maturity in the 1930s, during a time of massive unemployment. Many of them eventually found work as a consequence of a shift in US economic policies towards the supply of arms to European nations involved in the fight against fascism. This took place in 1940, the year in which the first *Office at Night* was also produced. Consequently Hopper's painting could be seen on one level as depicting the alienating and dehumanising effects of capitalist work processes; it is significant that, throughout his work, depicted figures are more easily recognizable as types rather than as specific individuals. Indeed, much of Hopper's work can be viewed as an investigation of the effects on individuals of the processes of modernization taking place within American society. One key area of these was the break-up of existing social relations in the modern city, and their replacement with the routine of the capitalist workplace. However, Burgin's observations about Hopper's painting indicate that there are other readings which may be derived from the image, and which correspond to theoretical and practical concerns which became increasingly significant from the mid-Seventies onwards:

Office at Night may be read as an expression of the general political problem of the organization of Desire within the Law, and in terms of the particular problem of the organization of sexuality within capitalism – the organization of sexuality for capitalism.

(Burgin, 1986, p.18)

For Burgin, then, Hopper's painting is also underpinned by the sexual relations of capitalism, which involve both female subordination and sexual availability as repressed and contained within the workplace.

In order to consider how this might have informed Burgin's intention to engage with similar issues in the 1980s we need to look more closely at the relationship between the female and male figures in *Office at Night No.6*, and to consider how they correspond to the operation of power relationships between men and women within an office environment. In some ways the female figure appears to be more real – she sits in the foreground, in what could be seen as a believable part of the space which the viewer occupies, outside the frame. This is also a more public area than the space of the male figure behind. Slightly above and to the left, he appears to be sitting behind her. The implication is that he is her boss, and the distance between them makes the power relationship seem more credible. Her smart and conventionally attractive appearance could even imply that she was a receptionist, with the role not only of regulating access to corporate power through her interactions with the public, but of conveying a particular kind of company image through her own person. Yet we can only speculate on the precise nature of her role; what is significant here is that authority appears to reside with the male figure in the background, corresponding to the normal division of power within business practice. Burgin is drawing here on the viewer's expectations based on prior knowledge and assumptions that work at a level of which we may not even be aware – that male dominance is the norm within our culture, and relations between men and women within capitalism will thus be determined by patriarchy. But it is the way in which Burgin does this which is significant. The obvious shift here from posed photograph to projected transparency can make us aware that both are actually constructed forms of representation, yet it can also draw attention to what is being represented. Rather than taking for granted the subordinate role of women within office work (and more gener-

ally, within capitalism) this process encourages us to become more fully conscious of it. Our assumptions, then, should be challenged on two levels – firstly in terms of the realism we expect of photography, and secondly in terms of our ideas about gender and the lack of equality between men and women.

ISSUES OF REPRESENTATION

These are issues which (among others) began to emerge in Burgin's work of the 1970s, much of which was also concerned with the social relations of capitalism, and the role of women within this. Another photowork from 1976, for example, *St Laurent Demands A Whole New Lifestyle*, focuses on an Asian woman factory worker as a means of drawing attention to the invisible exploitation of both race and gender within the fashion industry. Once again meanings are opened up for the work through the contradiction between image and text, which reads like copy for the fashion pages of an upmarket women's magazine. The addition of a written component is notably absent from *Office at Night No.6*, however. Instead it is replaced by the small pictograms or 'Isotypes' in the left hand panel.

The Isotype (International System of Typographical Pictorial Education) was first developed in Vienna by the philosopher Otto Neurath during the 1920s with the intention of finding a clearly comprehensible international visual language for everyday use. The success of Neurath's pictograms can be measured by their locations, where they have become commonly accepted features of modernity. There are however various implications of Burgin's use of Isotypes within this piece. Although the disassembled camera at the left of *Office at Night No.6* functions at one level by drawing attention to the means of representation in identifying the process of photography itself, this is also an image which lacks any individuality. It has instead been reduced to a 'type' suggestive of the standardization of commodities within capitalist mass production and also, by implication, the standardization of the roles of women and men within the social relations of capitalism – the kind of theme which the main panel of *Office at Night No. 6* is concerned with. What is more, Burgin's intention to replace verbal with visual language is clearly not as utopian as Neurath's project – his early comments on the piece as a work in progress, for example, single out the diffi-

127. Chris Killip, *Rosie and Rocker Returning Home, Lynemouth*, 1983

culty of designing an Isotype which just says 'person' rather than 'man' or 'woman' (Burgin, 1986, p.188). This degree of anti-idealism is something which can clearly be linked to Burgin's awareness of the problematic relationship to Modernism for contemporary practitioners. His use of the Isotype also calls into question the tendency towards universalism in Neurath's pictograms which is characteristic of Modernist thinking; in applying the same language within his work of the 1980's, an awareness of potential pitfalls suggests a degree of distance from the project of Modernism itself. What is at issue here is once again not an outright rejection of Modernism but a critical engagement with its language, as one of the possibilities available within Post-Modernism.

REALISM AND POST-MODERNISM

The role of the woman in the foreground of *Office at Night No.6* is made more believable by the use of black and white photography. As a form of representation this has acquired strong connotations of authenticity and truth. In Burgin's photowork, however, its status is problematised by its combination with other types of visual code: the Isotype, or reference to a figurative painting. It would be useful, finally, to compare this work with another photograph which not only conveys a very different notion of work, but also uses very different strategies to do this. The photographer Chris Killip worked closely with a community in Lynemouth, near Newcastle-upon-Tyne in the North East of England during the early 1980s in order to produce a body of images which documented the sea-coal economy in the area. For some years waste coal had been collected from the beach at Lynemouth, where it had been washed up after having been dumped from a colliery at nearby Ellington; the sea-coal collectors were able to make a living by collecting the waste and selling it on to a coal factor. Consequently we might expect

to find a different notion of work being conveyed at a time during the 1980s when the dominant image of the workplace was one of the consolidation of business interests. Indeed the result is very different from the type of representation we might associate with Victor Burgin in that, although it also uses black and white photography, very different strategies are employed to address the viewer and provoke a response.

One image in particular provides a useful comparison, in that it highlights the involvement of women within the sea-coal industry. *Rosie and Rocker Returning Home, Lynemouth* (1983), depicts an elderly woman and a young boy driving a horse and trap along the seashore, a large sack (presumably full of coal) in front of them (Plate 127). The stony beach and breaking waves behind combine to give the setting an air of barrenness, which works to reinforce the apparent signs of poverty; there is a sense that these are people on the edge of society. The woman's lined face and hooded head, in addition to the outmoded form of transport all suggest readings similar to Millet's depictions of the dispossessed French peasantry in the mid-nineteenth century; the image evokes the degree of timelessness which tends to be associated with agricultural or rural work, taking place outside the regulated workspace of industrial capitalism. The framing of the two figures within the landscape helps to suggest this; their heads are lifted above the shoreline, monumentalizing the figures, and making them appear to some degree heroic.

Apart from such precedents as the work of Millet, the depiction of Rosie and Rocker draws on a tradition of documentary photography stretching back to the 1930s, when the ability of such images to prick social consciences was forged particularly powerfully in the work of American photographers such as Dorothea Lange, who recorded the plight of dispossessed farmers in the mid-West during the Depression. There are also more immediate precedents in the work of Bill Brandt who, although American, spent some time working in North East England. Yet despite drawing on these historical precedents Killip's sea-coal photographs have a relevance which is highly contemporary; taken in the early 1980s they provide a powerful reinforcement of the notion of an underclass emerging in Thatcher's Britain, of people dispossessed and marginalized, scraping a living where they can. This is reasserted by the retrospective knowledge that the photographs were made just before the Miners' Strike of 1984–5 which was to have a radical effect on sea-coal collecting, ultimately resulting in the closure of local pits on which the industry depended (Haworth-Booth, pp.16–23). Yet we should be wary of suggesting that Killip's photograph of Rosie and Rocker is somehow more real than Burgin's *Office at Night No.6*, or that it offers a more accurate representation of life in Britain during the 80s. Despite convincing suggestions to the contrary, things are not what they seem in documentary photography.

Although a very different type of photograph, *Rosie and Rocker Returning Home, Lynemouth* is quite typical of the kind of practice which still continues in the 80s and 90s. It tends to predominate in newspaper journalism, where images are required to portray a true and accurate account of events, even though in actuality this will always be selective and partial. Killip's practice relies heavily on the conventions of realism for its effect: but what sort of realism? With Josie Bland's discussion of nineteenth-century painting (Chapter Two) in mind, Killip's practice might appear to be less like Faed's depiction of the deserving poor and more like Courbet's view of the French peasantry, in that Killip's photograph seems to claim to represent the real situation of people belonging to an underclass. Yet it is also less like Courbet and more like Faed in that it depends on an emotional response from the viewer – one which also depends on these two figures being recognized as passive objects of the camera's gaze, with the implication that they are victims rather than being active individuals with complex lives. We can also draw other comparisons with *Office at Night No.6*. Burgin's image evokes an emotional distance, dependent on the recognition of the image as obviously staged rather than appearing to be spontaneous. This is one characteristic which also reinforces the claims to truth implicit in *Rosie and Rocker Returning Home, Lynemouth*. However this is not to imply that Killip's image does not also rely on strategies of representation for its effect: the difference is that, unlike Burgin, these are representational devices which are self-effacing, not getting in the way of the viewer's response. It would seem that even in relation to visual representation in the 1980s we still need to assess the question of realism. In its concern for making visible the means of representation in the process of encouraging a reassessment of its subject matter, Burgin's practice rather than Killip's could be seen as closer to Courbet's Realism.

128. Annette Messager, *Histoire des Robes*, installation shot,
1992, Douglas Hyde Gallery, Dublin.

Post-Modernism, once again can be seen not so
much as a radical break with the past, but as
prompting the need for re-evaluation of both past
and present from a new vantage point.

ANNETTE MESSAGER, 'HISTOIRE DES ROBES', 1990

For many viewers, Annette Messager's *Histoire des
Robes* is not the sort of work they would usually
expect to encounter within the space of the art
gallery (Plate 128). For a start it is not one single
piece, but made up from a large number of differ-
ent elements which reinforce each other, trigger-
ing off different meanings. Like Andre's *Equivalent
VIII* (Plate 101), these are not made from the type
of materials usually found in galleries; yet Andre's
piece can still be read as a single, unified object,
with a fixed number of components. *Histoire des*

Robes is much more fluid by comparison, a collec-
tion or series of different pieces, not all of which
will necessarily be exhibited at the same time, or in
the same order.

Here it is not only the diversity of its compo-
nents, but the associations which the viewer
brings to them, which means that the piece must
be read in quite different ways. Indeed the title
itself helps to trigger off certain expectations:
Histoire des Robes can be translated as 'story of
dresses', with all the associations of narrative and
fantasy as opposed to any concern for realism or
objectivity. Yet in identifying female clothing it is
also clear that these associations themselves are
gendered, implying a narrative which is more
specifically concerned with female experience.

So what, then does Messager's *Histoire des
Robes* consist of? Individually enclosed within dis-
play cases are different dresses – children's frocks,

nightdresses, or ballgowns, for example. Most of these can be fixed horizontally to the wall or laid flat on the floor for the viewer to walk between; others are intended to be hung vertically. These are items of female clothing which as one critic has observed 'map out the various stages of a woman's life, from snowsuit to widow's weeds.' (Adams, p.145) In addition, superimposed on each piece of clothing are small images, often drawings or photographs, and these are either pinned directly onto the fabric or suspended from pieces of string tied to clearly visible safety pins. Attached to one pink evening frock, for example, is a gouache sunset with a small photograph of a crouching female nude, while another display case holds a black dress scattered with numerous black and white photographs of embracing couples; yet another contains a child's frock and a fairy-tale watercolour of a mouse and another animal fighting over a piece of cheese (Plate 129).

How do we explain the particular combination of artefact and imagery in *Histoire des Robes*? What are the type of meanings generated by an artwork of this nature? Is it indeed, within the realms of what can be defined as 'art'? For many viewers this last question might be particularly relevant; a collection of second-hand clothes with pieces of paper attached by string is quite distant from a painting on canvas of a recognizable subject mat-

ter (Plate 130). It is also worth noting that many of the individual pieces in *Histoire des Robes* are enclosed in frames or boxes, identifying them as special kinds of objects – the kind likely to be found within the institutional space of the gallery. There is an important precedent for this, and one which helps to locate Messager's work within a history which is quite specifically European, rather than the type of media-based work which is more closely identified with contemporary female practitioners in the United States, such as Sherman or Kruger. Nevertheless the address to the viewer implied in Messager's work is not one which is confined to a specifically European cultural context; a concern for issues of female identity and marginality is clearly a tendency shared with other Post-Modernist practitioners in the United States and elsewhere.

It is these two aspects of the ways in which Messager's work may be read that are relevant here: firstly, the means of addressing issues of the construction of femininity and marginal identities current within women's art practice since the early 1980s (which were discussed earlier in relation to the work of Susan Hiller and Sutapa Biswas), and secondly the ways in which Messager's position is informed by an engagement with radical tendencies in specifically European art practice.

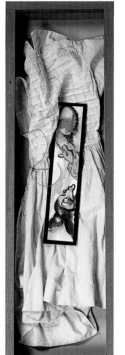

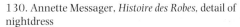

129. Annette Messager, *Histoire des Robes*, pink evening frock.

130. Annette Messager, *Histoire des Robes*, detail of nightdress

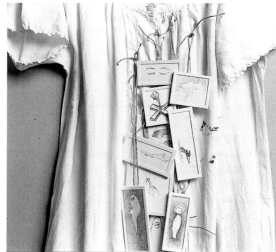

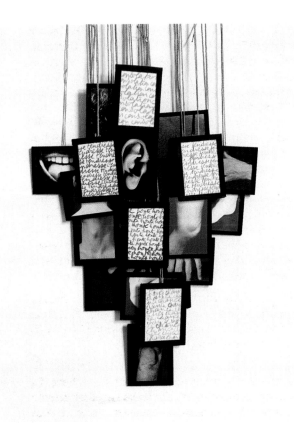

131. Annette Messager, *Mes Voeux*.

The Public, the Private and the
Woman Artist

It might help initially to identify some of the features of Messager's practice prior to *Histoire des Robes*, as a means of establishing the artist's concern with issues of gender. During the early 1970s Annette Messager made a conscious decision to work within her home rather than a separate studio. She divided her activities into two parts which she entitled 'Annette Messager Artiste' and 'Annette Messager Collectioneuse' (Collector). This refers to a process of researching and assembling a large collection of images from newspapers and magazines, many of which found their way into a number of 'albums' also containing Messager's drawings and photographs. These collections have frequently provided the source material for subsequent works, yet despite their appearance of revealing something personal and private to the artist, Messager's practice should alert us to the possibility that this is yet another consciously adopted stance. It is not for nothing that another of Messager's self-designated titles is 'Truqueuse' (Trickster). Despite the decision to locate her prac-

tice within the 'private' domain of the home, the allocation of separate named identities to different aspects of her practice also informs the public construction of her own image as an artist, categorizing the ways in which she has wished to be perceived. An exhibition of 1974, for example, was entitled *Annette Messager Collectioneuse* (Arc 2 – Musée d'Art Moderne de la Ville de Paris) and this insistence on titling can be seen as clearly related to a desire to control aspects of her public identity. Yet a decision to work within the home is also significant in that it foregrounds issues of gender. The domestic sphere is not only a space associated with the private lives of individuals, it is also one which, since the rise of capitalism, has historically become associated with femininity, as opposed to the masculine domain of the 'public'. The studio, meanwhile has connotations of the activities of the artist as a professional. Yet this is an identity which is also fundamentally gendered: artists are usually assumed to be male unless stated otherwise. Ever since the Renaissance this has been a situation which women artists have had to negotiate, if their work is to be taken seriously rather than being regarded as marginal and derivative from that of their male counterparts. For Messager the decision to work in the home was a deliberate strategy, which in conjunction with other aspects of her practice is designed to show up the contradiction between 'woman' and 'artist'.

The choice of materials used in Messager's work is something which also reveals this. These are primarily associated with domesticity: clothing, sewing thread, materials which clearly have less cultural value than oil paint or marble, which in Messager's practice become linked to an awareness of the lives of women as relatively marginal and apparently unimportant, largely taking place outside the public domain. And indeed the use of photography in *Histoire des Robes* can also be identified in similar terms. In looking at the snapshots of lovers there is a suggestion that we are spying on someone else's private mementoes, yet more accurately they appear to be derived from one of Messager's earlier 'collections' entitled *Mes Clichés – Témoins* (1976). (The small photographs of body parts which make up other works such as *Mes Voeux* (My Wishes, 1989; Plate 131) are also similarly intimate.) This is clearly a very different use of photography from the work of Victor Burgin; on the surface, at least, it does not appear to have been intended for public consumption. Nevertheless with an artist who, like Messager,

continually adopts different strategies and poses we should be cautious of making such assumptions – both *Mes Clichés – Témoins* and *Histoire des Robes* have been exhibited (in public space) on different occasions. The public/private distinction also has implications for the ways in which the work is put together. Much of *Histoire des Robes* looks amateurish – crayon drawings on scraps of paper attached with string and safety pins – something which is far removed from what we might expect art on public display to look like. But these methods of construction are also a deliberate strategy, challenging the viewer's preconceptions about finish and professionalism, which of course are heavily laden with associations of gender.

There is, however, a potential problem here. In emphasizing the contradiction between woman and artist in this manner, particularly through an emphasis on an amateur appearance of the work, there is always the danger that it might fail to challenge either category sufficiently. Messager is treading a fine line. One consequence is that both her emphasis on women's experience and the lack of finish to certain parts of the work could easily result in it being seen as evidence of a lack of ability, linked to conventional assumptions about the practice of women artists. By this I mean a tendency to regard women's art as a separate category, where an apparent inability or unwillingness to engage with the terms of the masculine world of the public, professional art is something which tends to reassert value judgements about the work's quality (i.e. seeing it as inferior to art made by men) instead of re-evaluating a gender-based distinction. Yet there are various indications that Messager is merely being playful, setting one category off against another, in effect saying one thing and meaning another, which as I have argued earlier is one of the key characteristics of Post-Modernism.

In this sense her practice since the early 1970s is closer to that of Cindy Sherman (developed later in the decade) than to the type of feminist art which became dominant primarily in the United States at the same time. This could be described as largely confessional, based on a belief that both women's art and women's experience are essentially different to that of men, due to the fact that women are also biologically different. Many feminist artists and critics (such as Lucy Lippard) during the Seventies believed that feminist art should reveal something of this biological difference through its imagery and formal characteristics. In

a major work by Judy Chicago entitled *The Dinner Party* (1975–9; Plate 118), for example, this took the form of an emphasis on 'core' or vaginal imagery as a means of expressing a sense of universal continuity between women across different cultures and historical moments. This view is problematic because it depends on a concept of female identity as fixed and predetermined; and in stressing supposed similarities it has the effect of eradicating any awareness of cultural difference.

Clearly Messager's practice, with its emphasis on the instability of identity, and the desire to play with different categories, is very different. Even work such as *Mes Voeux* which appears to be confessional or autobiographical, supposedly revealing something about the artist herself, is indeed a further pose, as Messager herself has claimed:

'I' is an invented persona just like the others ... I do not talk about myself but at the same time the idea is always there on the fringe. If I say 'I' then I am still playing tricks.

(Messager, p.78)

Yet there is something further at stake here. In addition to questioning the ways in which female identity can be presented, Messager's practice does succeed in offering a radical challenge to conventional notions of the artist based on a belief in an authentic expression of 'true' emotion or identity. That her work is able to do so is due to its engagement with certain tendencies already in existence within European art practice, even if her engagement with them is one which is fundamentally gendered – that reinterprets them from an explicit recognition of her status as a woman artist.

RADICAL ART PRACTICE IN EUROPE AND THE WOMAN ARTIST

Annette Messager's work demonstrates certain characteristics typical of a general shift in art practice since the late 60s, whereby it is the ideas which surround the making of art which become as important – if not more so – than the finished piece itself. Although its lineage can be traced back to the work of Marcel Duchamp, this is a tendency which can be identified with certain strands of radical art in Europe at this time, associated with such figures as Joseph Beuys, Marcel Broodthaers, or the Fluxus Group, all of whose work Messager knew to a greater or lesser degree. In common with many European artists, Messager was profoundly affected by the events in Paris of

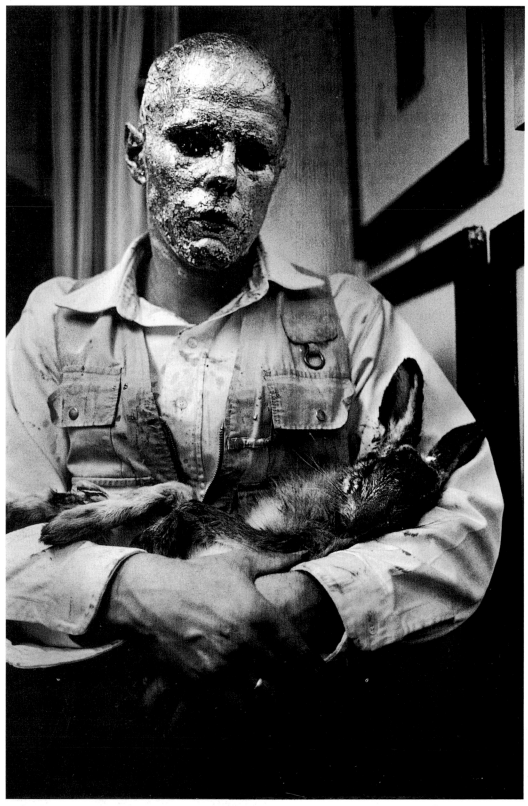

132. Joseph Beuys, *How to Explain Pictures to a Dead Hare*,
1965.

May 1968 when an alliance of workers and students briefly – but spectacularly – managed to challenge the power of the French state. Both the ideas of artists and writers, such as the Situationists, and the graphic work of the Atelier Populaire played an important role within this. A key means of communication proved to be through graffiti and poster bearing slogans often derived from Surrealism: 'Under the street, the beach' or 'Art is dead. Let us create our daily lives', for example (Plant, 1992). The effects of this political crisis were to be particularly profound for many young artists, filmmakers and writers, prompting on one hand the development of highly influential models of cultural theory, and on the other a range of strategies designed to challenge the more normal associations of 'great art'.

One consequence was a concern for issues of the identity of the artist. Prior to the events of May 1968 one artist, who had already been working in this area, was Joseph Beuys, whose practice was to become hugely influential despite – or because of – its contradictory elements. In performance pieces such as *Explaining a Work of Art to a Dead Hare* (Düsseldorf, 1965; Plate 132) he seemed to be proposing quite an esoteric, almost shamanic role for the artist. The piece consisted of Beuys seated, his head covered in gold leaf and cradling a dead hare to which he talked for several hours. On other occasions however his intention was clearly to make art more overtly accessible to a general public; several performance pieces consisted of Beuys engaging directly in dialogue with an often sceptical audience. The significance for any assessment of Messager, however, is that Beuys represents a further example of a practitioner for whom the enactment of identity was of fundamental importance in the work – and as a result of which any sense of the artist's real identity remains unknowable.

Messager's interest in the notion of the collection also has precedents in the work of the Belgian artist, Marcel Broodthaers, who died in 1976. In 1968, in his Brussels apartment, Broodthaers opened the Musée d'Art Moderne, Département des Aigles, Section XIXème Siècle (Museum of Modern Art, Department of Eagles, nineteenth-century section). This initially consisted of packing crates, postcards and inscriptions and the event as a whole, which questioned the role of the museum as a means of representing art, was linked in a statement by Broodthaers to the events of May in Paris during the same year. The point was that the

museum itself remained fictional, existing only as an idea, capable of re-emerging in a new form in a new location. In 1972 another version of Broodthaers's collection, the *Section des Figures*, was exhibited in Düsseldorf . Here, in the form of works loaned by museums, collectors and dealers, the eagle was represented as a 'multifaceted cultural object'; without any systematic order examples of military eagles were placed next to preserved eagles' eggs from natural history collections, for example (Borgemeister, pp.135–54). In much the same way that Messager's practice attempts to destabilise the notion of woman through her own practice, Broodthaers's intention was to challenge the notion of the eagle as a highly overdetermined symbol of cultural power. Messager's interest in the cliché as a signifier of experience in *Histoire des Robes* can also be seen in this way; the snapshots of lovers or painted sunsets function in a similar way as Broodthaers's image of the eagle.

A major part of *Histoire des Robes* involves the assembly of elements which have been made previously. The moment of selection of one piece over another – as opposed to the act of putting paint on canvas – is therefore extremely important (although the attached small paintings and drawings have themselves been made by Messager at some point). This emphasis on selection and assemblage is a practice with a certain provenance

133. Marcel Duchamp, *Fountain*, 1917. Photograph by Alfred Stieglitz, Museum of Modern Art, New York.

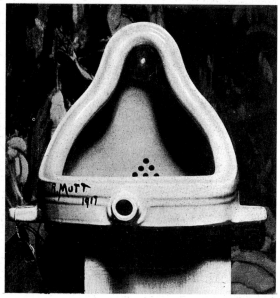

in twentieth-century Modernism, traceable back to the work of Marcel Duchamp and his use of the 'readymade', a manufactured object selected and exhibited as art. Probably the best-known example of this is Duchamp's *Fountain* (1917), an upturned urinal which he submitted for exhibition to the Independent Artists exhibition in New York under the pseudonym R. Mutt (Plate 133). Apart from the disruption of the viewer's expectations of what might be found within the institutional space of the gallery or museum – a theme which was to be developed by Broodthaers – this way of working has important precedents for the work of Annette Messager. Objects such as Duchamp's *Fountain* tend to challenge the notion of skill as a fundamental part of the making of art – and the implication that this is an almost mystical process unique to certain gifted individuals.

Yet there is an important distinction which can be made between Duchamp's practice in the 'readymades' and *Histoire des Robes*. In selecting prefabricated artefacts for transformation into 'art', Duchamp was drawing attention to the relationship between art objects and other sorts of commodities, which can be bought and sold within a market. In the case of *Histoire des Robes*, however, Messager is using pre-existing objects because of their explicit associations with femininity. Clothing is after all an important site of the cultural construction of gender difference. The use of a ballgown in *Histoire des Robes* is a case in point – the nipped-in waist, satin taffeta and net all serve to construct a reading of femininity as glamorous, as a kind of spectacle one might say, very different from the more sober types of clothing which more readily characterize masculinity.

What is more, as recent fashion historians have tended to argue, items of clothing are themselves significant because of the associations which individuals attach to them as signifiers of memory and experience (Wilson, 1985). Everyone can remember the sort of clothes they used to wear when they were fifteen years old, and the ways in which this evokes dreams and aspirations, the desire to be like or different from one's friends. There are perhaps closer similarities between Messager's practice in *Histoire des Robes* and the use of the 'found object' within Surrealism. This functioned through triggering off irrational associations for the viewer, calling up areas of the unconscious usually repressed and marginalized. In Messager's work these are associations with a notion of women's experience as something which is devalued and silenced within a patriarchal culture.

REFERENCES

ADAMS, B., 'Annette Messager at Crousel-Robelin / Bama', *Art in America*, Jan. 1991

BORGEMESTER, R., '*Section des Figures:* The Eagle from the Oligocene to the Present', trans. C. Cullens, in B. Buchloh ed., *Broodthaers – Writings, Interviews, Photographs*, October 1987

BURGIN, V., 'The Absence of Presence: Conceptualism and Postmodernisms', 1984, in *The End of Art Theory: Criticism and Postmodernity*, London, Macmillan, 1986

BURGIN, V., *Between*, Oxford, Basil Blackwell, 1986

HAWORTH-BOOTH, M., 'Chris Killip – Scenes from Another Country', *Aperture* 103, Summer 1986

HOBBS, R., *Edward Hopper*, New York, Abrams, 1987

MESSAGER, A., 'Interview with Robert Storr', in *Annette Messager Faire Parade 1971–95*, Paris, Musée d'Art Moderne de la Ville, 1995

PLANT, S., *The Most Radical Gesture: The Situationist International in a Postmodern Age*, London, Routledge, 1992

WILSON, E., *Adorned in Dreams, Fashion and Modernity*, London, Virago, 1985

GLOSSARY

The following are broad definitions of terms or phrases contained within this book. However, some of the terms have a narrower application and, in those cases, are defined in the specific sense of their usage in particular chapters.

ABSTRACT Unlike 'figurative' art, 'abstract' art does not represent things from the visible, three-dimensional world around us (or for that matter, from our imagination). Examples of abstract art movements contained within this book include DE STIJL, ABSTRACT EXPRESSIONISM and CONSTRUCTIVISM. There are, however, movements in art which are, strictly speaking, figurative but, nonetheless border on abstraction; for example, CUBIST painters do indeed represent the physical world but use methods which 'abstract' the objects they depict.

ABSTRACT EXPRESSIONISM The stylistic label given to painters working mainly in New York in the 1940s and 1950s. Abstract Expressionism may be broadly divided into two sub-groups; the 'Action painters' typified by Jackson Pollock's use of large, paint spattered canvases and the 'Colourfield painters' typified by Mark Rothko's large, colour blocks on canvas.

ACADEMIES OF ART/ACADEMIC ART Academies of art were first formed in Europe in the sixteenth century to institutionalize training for students in the fine arts. Academies had a virtual monopoly on artistic activities, including provision for exhibitions, competition prizes and public and private patronage. Moreover, their institutional apparatus upheld CLASSICAL models of painting and sculpture throughout the eighteenth and nineteenth centuries. The authority of the Academies was challenged by artists working in a less orthodox idiom in the second half of the nineteenth century. See also ART GUILD, IMPRESSIONISM.

AESTHETIC Imported from philosophy, the aesthetic is concerned with principles of taste and beauty in art. Like HUMANISM, it is a term which makes claims to universalism. For instance, the aesthetic (as a criteria for judging art) implies that 'beauty' (in itself a loaded concept) resides in the art object and that 'taste' is the viewer's capacity for appreciating the beautiful. More recent scholarship insists that the context in which the art object was produced and is subsequently viewed (including the class, race or gender of the viewer) invariably impinges upon our aesthetic appreciation of the object. So nowadays, it is possible to talk of a 'lesbian aesthetic' or a 'black aesthetic'.

ANARCHIST Anarchists are political activists who advocate that all forms of governmental authority be abolished. In place of the current political systems, anarchists believe that individuals or groups of individuals should control their own lives by means of mutual co-operation.

ART GUILD Before ACADEMIES assumed responsibility for training fine artists, art guilds were the main organizations for training artists and craftsmen and women alike. Under an apprenticeship system an 'artist' joined the workshop of a particular guild for around six years in order to learn the skills of the trade. Interestingly, the BAUHAUS based its workshop system of training on the structure of the old art guilds.

AUTHENTICITY Literally meaning genuine or valid, authenticity, in terms of a criteria for art, changes under the aegis of MODERNISM. From the IMPRESSIONISTS onward this book shows how artists increasingly sought their 'authenticity' outside the ACADEMIES. For instance, by looking to the PRIMITIVE for a model of 'expression'. Thus authenticity here is the validation of new ideas or new means of representation in the visual arts.

AUTOMATISM DADA and SURREALIST artists, in particular, made an AESTHETIC virtue out of automatic painting (automatism). These artists believed that the physical outcome of a work of art may be left to 'chance'. That is to say, that the conscious, premeditated act of making, say, a painting could be surrendered to the fortunes of unconscious or spontaneous processes. Each artist had different methods for invoking 'chance', so examples of 'automatic painting' vary from the improvisations of Jean Arp, to Paul Klee's *Taking a Line for a Walk* and the FROTTAGE of Max Ernst.

AUTONOMY Autonomy is often diametrically opposed to 'determinism', in the sense that 'autonomy' implies the freedom of art while 'determinism' sees it as governed by cultural, political and social structures. This book challenges specific claims to 'the autonomy of the AESTHETIC' (the dubious proposition that our AESTHETIC commerce with an art work is wholly independent of political or social conditioning) and demonstrates how 'art-for-art's-sake' is a questionable concept.

AVANT-GARDE The term was first applied to artists in the nineteenth century to indicate those whose work seemed to be at the forefront of new developments in art – as opposed to artists who hitched their artistic fortunes to ACADEMIC conformity – and as such its linguistic fortunes have parallelled MODERNISM (although theorists such as Peter Bürger prefer to see the two as separate). Some critics have argued that with the demise of MODERNISM and the inception of POST MODERNISM, avant-gardes too have disappeared.

BAUHAUS An influential German school of art and design located at Weimar, Dessau and Berlin between 1919 and 1933. Endorsing a loosely CONSTRUCTIVIST approach to art and design, the Bauhaus was closed down by the National Socialists in 1933 although its teachers and its

principles were highly influential in the teaching of art and design after the Second World War.

BLAUE REITER, DER A casual organization of painters based in Munich between 1911 and 1914, its best known members included Wassily Kandinsky and Paul Klee. Der Blaue Reiter (meaning 'the blue rider') was principally an organization of artists who exhibited together but, unlike DIE BRÜCKE, they produced no manifestos and had few stylistic affinities. See also EXPRESSIONISM.

BLOOMSBURY Influential exponents of English MODERNISM whose numbers included the painters Vanessa Bell and Duncan Grant, the art critics Clive Bell and Roger Fry and the writer Lytton Strachey. They took their name from an area of central London where most members were living in 1905. Given the nature of its membership and the scope of its activities, Bloomsbury can also be used as an adjective to describe a particular brand of the English intelligentsia or as a style of DECORATIVE interior design.

BOHEMIANISM Someone with unconventional tastes or who behaves in an unorthodox manner (according to the standards of the day) is a Bohemian. Artists and writers have been formally associated with the term since the nineteenth century when their lifestyles were viewed as outside BOURGEOIS social and moral codes of behaviour.

BOURGEOIS SOCIETY The term 'bourgeois' has come to be synonymous with the term 'middle class'. However, in the first half of the nineteenth century the bourgeoisie was (according to Karl Marx) a revolutionary force responsible for the social upheavals in France. In the second half of the nineteenth century the bourgeoisie themselves became the establishment and their attendant IDEOLOGIES became DOMINANT. This has coloured the view (stemming from Honoré Balzac) of a bourgeois society which is essentially a reactionary force within society – conventional, unadventurous and small-minded, particularly in matters of art.

BRÜCKE, DIE A formal (they produced membership cards and a manifesto) organization of German artists based in Dresden between 1905 and 1913. The artists of die Brücke are usually connected with those of DER BLAUE REITER under the umbrella label German EXPRESSIONISTS. Meaning 'the bridge', die Brücke was the first AVANT-GARDE movement in Germany to react in an organized way to ACADEMICISM and the dominance of French art. Seeking a unique, NATIONAL style, members of the group – Ernst Ludwig Kirchner, Emil Nolde, Karl Schmidt-Rottluff and Erich Heckel – practised unconventional techniques in painting. For instance, they depicted dark and seedy subjects using exaggerated outlines and acid colours.

CANON Coming from the Greek word for ruler or measuring stick, canon was originally used to define biblical books or scriptures that were approved by the Christian church. In its migration to art theory, canon is used to designate those artists who are considered to be of major significance – Picasso, Matisse, say, are central to the canon of art history, whilst Käthe Kollwitz and Norman Lewis are not. The way in which artists come to occupy a place in the canon is the result of a combination of factors – the art market, its literary organs, etc. – although a canon may be revised in the light of subsequent critical ratification.

CAPITALISM MARXISTS define capitalism as an exploitative economic arrangement whereby the BOURGEOISIE own the means of production (factories) while the proletariat (the workers) possess the labour to work in them. More generally, capitalism implies that the means of production are privately controlled and the goods it produces are sold for profit in a market economy. It is in this sense that many MARXIST historians interpret the production of works of art. See also COMMODITY.

CLASSICAL Strictly speaking classical art describes works produced during Greek and Roman antiquity. However, the revival of antique subjects and styles in the art produced during the Renaissance has continued to influence artists working in Europe. Classical art came to be associated with the ACADEMIES of art which taught students to improve upon nature, idealizing the subject of the human figure and landscape according to a set of preconceived ideas about composition –proportion, harmony and colour. Hence the equation between 'classic' and work of the highest order or standard.

COLD WAR Although active hostilities (a 'hot war' involving armed combat) ceased in 1945, the term 'Cold War' was coined in 1947 to describe the threatened hostilities between the United States and the USSR. This was conducted largely through political and economic wrangling and the spreading of propaganda on both sides. The Cold War 'thawed', in theory, after 1963 following an agreement between the two to restrict the testing of nuclear missiles, although the term was still used until 'Glasnost' and 'Perestroika' in the 1980s.

COLLAGE Reputedly dating from 1912, collage is the act of attaching materials to a surface. Braque and Picasso are usually credited with producing the first collages in western high art, by pasting their paintings with newspaper cuttings, chair caning and other materials which, in those days, assaulted ACADEMIC values. Collage was further developed by the artists connected with the DADA movement, in particular by Kurt Schwitters who made an aesthetic statement out of exhibiting 'pure' collages of found and selected ephemera which he dubbed 'merz'.

COLONIALISM Colonialism is a form of IMPERIALISM which describes the political control and subordination of one country by another such as British rule in India or French rule in North Africa. MARXISTS see colonialism as the export of CAPITALISM to lesser developed markets and social, political and economic exploitation of its people and resources. More pertinent to this book is the theory of 'Post-Colonialism' which has emerged particularly since the demise of colonial regimes, giving rise to art and literature which directly responds to the experience of Colonialism from the point of view of indigenous peoples.

COMMODITY MARXIST analyses of culture are largely responsible for defining commodity. Not only is a commodity something that may be sold or bought, but it is something whose value does not necessarily reflect the labour that went into making it. In terms of CULTURAL commodities, then paintings and sculpture have an intrinsic value structure which is based on the peculiar forces of the CAPITALIST art market and other controlling factors.

CONSTRUCTION/CONSTRUCTIVISM The term stems from Vladimir Tatlin's 'corner constructions' of 1914, which were 'sculptures' assembled from various pieces of metal, wood and string, as opposed to being cast, carved or modelled. The term has since come to describe the work of painters, designers and architects in revolutionary Russia usually working in an abstract idiom to an impersonal and common revolutionary agenda. Stalin's policy of SOCIALIST REALISM cut off state support for constructivist artists but the concept was exported to the BAUHAUS by Wassily Kandinsky and Laszlo Moholy-Nagy after 1921.

CUBISM Cubists tended to think of their work as a wholly new means of representation, rather than a style or AESTHETIC. As modern painters, their aim was to represent the physical three-dimensional world in a two-dimensional space without resorting to conventional, ILLUSIONISTIC techniques – summed up by Braque as 'not to try and reconstitute an anecdotal fact but to constitute a pictorial fact'. Together Pablo Picasso and Georges Braque evolved Cubism between 1906 and 1912, consecutively reviewing the functions of perspective, form, colour and even materials to the process of painting and, to a lesser extent, sculpture. See also COLLAGE.

CULTURE The proliferation of the term 'culture' as both prefix and suffix (youth culture, mass-culture, television culture, culture-shock, etc.) means that it is difficult to pin down because its precise meaning may vary from one discipline to the next. In the last century it would have been safe to generalize; to say that culture was the material expression of a society (so the pyramids are the material remains of ancient Egyptian culture). However (and given that there are now academic courses called 'Cultural Studies') nowadays culture is not just a reference to material production in itself but to the range of meanings generated by all manner of human activities.

DADA Dada was the name selected for an iconoclastic art movement with groups in Zurich, New York, Berlin and Hanover between 1916 and 1921. Outraged by the carnage of World War One, Dada responded by challenging existing BOURGEOIS notions of value and taste through performance, soundworks, READYMADES and COLLAGE. Dada, however, is not a style of art, but refers instead to the 'spirit' with which a number of diverse European artists (including Hugo Ball, Marcel Duchamp, John Heartfield and Kurt Schwitters) are associated.

DECORATIVE Sometimes used to distinguish the 'applied' or decorative arts – textiles, ceramics, woodwork or metalwork – from the fine arts – painting, sculpture and printmaking. This division came about once ACADEMIES took control of fine art training, leaving the decorative arts to be taught by the ART GUILDS.

DISCOURSE (DOMINANT) Originally, a discourse was a formal exposition delivered either written or as a speech. However, the meaning and signification of 'discourse' has shifted in recent years. According to Michel Foucault (*The Order of Things: An Archaeology of the Human Sciences*, 1970) discourses are active, they generate 'knowledge' about particular groups, objects or ideas (as well as being specific to that group, hence medical discourse, legal discourse, etc.). A dominant discourse is the product of dominant social and institutional formations, which may be why 'discourse' is sometimes confused with 'ideology'. In terms of this book it is perhaps useful

to think of ideology as a system of beliefs, while distinguishing discourse as the institutionalization or application of ideologies.

EMPATHY THEORY Unlike GESTALT THEORY, which maintains that the emotional content of a work of art is located within the work itself, empathy theory maintains that the viewer projects his or her feelings onto a work of art. For instance, a viewer may become psychologically involved (wittingly or involuntarily) with the work of art depending upon his or her emotional state.

ETHNOGRAPHIC There is a misconception that ethnography is about 'foreign' CULTURES. Strictly speaking, ethnography is the study of societies and their different CULTURES from the 'inside'. Nevertheless, there is a tendency to view the material artefacts of 'ethnic' peoples from the 'outside' – as curiosities. For example, African masks and Aboriginal 'paintings' have traditionally been displayed in cabinets in museums rather than on the walls and pedestals of art galleries. On the other hand, there are problems inherent in labelling ethnographic work 'art' since these pieces did not necessarily fulfil the same function to indigenous peoples as they do when transplanted to western galleries or collections.

EXPRESSIONISM Ostensibly a stylistic designation which, when it was first coined, connected the work of DIE BRÜCKE and DER BLAUE REITER in Germany with those of the French FAUVES and, at the time, the CUBISTS. In a wider sense still, expressionism has come to signify paintings, sculpture, dance, theatre and film which emphasize mood and feeling.

FAUVISM The Fauves were christened in 1905 by the art critic, Louis Vauxcelles, making the derogatory observation that their work was reminiscent of 'wild beasts'. The term has stuck and hence Fauvism is used to label the paintings of Henri Matisse and his immediate followers (André Derain, Raoul Dufy and Maurice Vlaminck) between 1905 and 1911. Characteristically, their work broke several ACADEMIC conventions; for instance, their use of non-descriptive colour (bright red trees and green faces) and simplified outlines of objects (wavy, asymmetrical lines around a window frame) make Fauvism arguably the first modern art movement.

FEDERAL ART PROJECT The Federal Art Project was part of President Roosevelt's New Deal to counter some of the effects of the Depression on the arts. From the mid thirties the American government subsidised a number of artists (it is estimated that 5,500 artists received grants of $95 per month) to renovate and decorate public buildings. Interestingly, the Federal Art Project made no direct stipulations about the type of work produced so both abstract painters and figurative painters were on the payroll.

FEMINISM After thirty years of scholarship, Feminism now has a relatively established position within discourses of art history. Its impact in simple terms has been twofold: first bringing to light the art produced by women which had been hitherto neglected in DOMINANT DISCOURSES of art. Secondly, feminism has overhauled the way in which art historians consider representations of women in art. Feminist 'interventions' in male art history have exposed a system of patriarchal domination which has controlled not only discourses of art but also the institutions of art.

Consequently feminism has become a more rigorously methodological way of interpreting the historic images and is associated with the NEW ART HISTORY.

FIGURE/GROUND 'Figure/ground relations' are pictorial devices to deceive the human eye into thinking that it is looking *into* an image contained within a frame rather than looking *at* a flat, two-dimensional space. This is the result of ILLUSIONISTIC techniques which make figures look as though they are occupying a real three-dimensional space, equivalent to the one that we inhabit.

FORMALISM Formalism is the critical practice of evaluating an art work in terms of its 'formal qualities' (colour, composition, technique, etc.) in isolation from its content (subject matter and socio-historical context). Its key twentieth-century exponents include Clive Bell, Roger Fry and Clement Greenberg. In recent years formalism has been challenged on the grounds that criticism should be more responsive to the contexts and content of a particular art object and the meanings generated by both.

FROTTAGE The French word for 'rubbing', frottage is a way of mark-making which suggests images to the artist. Max Ernst is credited with the first frottage, reputedly made by crayoning paper placed on floorboards, the grain of which transferred onto the paper and was used as a starting point for a series of paintings and drawings. Frottage is sometimes linked to AUTOMATISM in the sense that it is a process in which the conscious, controlling mind is suspended in favour of a more improvisational approach to making images.

FUTURISM A vociferous movement beginning in Italian art and literature which dates from 1909, when its chief protagonist, Filippo Marinetti, launched the first *Futurist Manifesto*. Several other manifestos followed outlining a Futurist programme which not only put the arts to right but advocated a complete overhaul of modern life – endorsing war, riots, speed, cities and unpalatable culinary dishes. The Futurists appropriated existing MODERNIST art practice – POINTILLISM and CUBISM – as well as inventing some techniques of their own – 'dynamism' and 'Cubo-Futurism' – in order to challenge orthodox art in Italy.

GENDER Men and women are born with biological differences which define their sexual function in adult life. Many of the differences between men and women, however, are not present at birth, but are learned in childhood. The purpose of separating the terms 'sex' and 'gender' is that sexual differences are relatively fixed phenomena but gender differences are socially and culturally defined, since each society teaches its population how to behave as men and women.

GENRE PAINTING Paintings of everyday life – particularly domestic activities – and paintings of animals or still life – vases of flowers, arrangements of fruit or meat on a table top – are collectively known as 'genre painting'. In terms of this book it is probably useful to consider 'genre painting' as a counterpart to HISTORY PAINTING, since genre painting was designated as inferior by the ACADEMIES of art because its subjects were not as elevated as the CLASSICAL themes of history painting.

GESTALT Gestalt criticism insists that, as viewers of art, we do not project our emotions onto a work of art (the oppo-

site of EMPATHY THEORY) but those emotions are already there in the work waiting to be 'felt'. Gestalt has another, slightly different, though not unrelated, usage; it is the German word for 'configuration' and, in theory, is the belief that a work of art is perceived as a whole rather than expressed in terms of the sum of its parts. This is most commonly associated with the theory of MINIMALISM.

HEGEMONY In its broadest application, hegemony is the dominance (usually political) of one group or culture over another. But its more precise application (in MARXIST criticism) views hegemonic control as the outcome of a complex socio-economic and political web of relations that exist in any given culture. The pattern of hegemonic control is, according to Marxist interpretation, such that those constructing a DOMINANT IDEOLOGY insinuate that their control is 'natural' and indeed beneficial to the needs of both groups. Thus hegemony may be endorsed from below as one which serves mutual interests.

HISTORY PAINTING Paintings whose content derives from the Bible, CLASSICAL mythology or literature were grouped together under the heading 'history paintings' in the nineteenth century. History painters were nearly always trained by the ACADEMIES and tended to treat their subjects in a grave manner, emphasizing the moral or religious tone of their day. As a result, history painting was generally regarded as a higher form of painting than GENRE PAINTING.

HUMANISM The term has a long and complicated provenance but, briefly, since the Renaissance humanism has come to signal the conviction that the INDIVIDUAL is paramount in shaping his or her own world. Believing that the human spirit is essentially universal and therefore capable of transcending conditions of time and place, humanist thinkers place man at the centre of things. Feminist, lesbian and gay and Post-COLONIAL critics have pointed out that claims to universal humanism are, at the very least, suspect because man in the humanist sense of the word is invariably constructed as white, western, middle-class male. Nor is 'he' really free to determine 'his' own existence, but is, in fact, constrained by conditions of class, race, GENDER and sexual orientation.

ICON An icon is traditionally an image or likeness which describes medieval religious portraits. Icons of saints were believed to be invested with a spiritual presence of the figure depicted. Hence an icon is not only a compelling depiction of a saint, it has come to mean anything regarded as sacred or that embodies great symbolic value.

IDEOLOGY (DOMINANT) Broadly speaking an ideology is a set of values, practices or beliefs which underpin a particular society or group. A dominant ideology is one which a number of people have a vested interest in maintaining. For instance, patriarchy has been (and arguably still is) a dominant ideology in most societies and draws its support by controlling the types of DISCOURSE – cultural, economic, political and social exchange – between those in its grip. Dominant ideologies marginalize conflicting systems of belief or groups counter to their ideas. The term 'other' is often used to describe any peoples, system or set of values dispossessed by a dominant ideology.

ILLUSIONISTIC Put simply, all figurative art is illusionistic since it purports to resemble something we have seen (or fantasize about seeing) and artists have always employed eye-fooling devices to convince the spectator that what they are seeing is 'real'. On the other hand, the links between 'art' and 'illusion' have become more complex in the twentieth century, since modern art frequently employs anti-illusionistic devices which confound the viewer's visual expectations. It is not the remit of the modern artist to make facsimiles of nature or approximate it in any way. On the contrary, MODERNISM has given artists creative licence to explore ABSTRACT patterns and gestures which have more to do with SELF-EXPRESSION than shared VISUAL PERCEPTION.

IMPERIALISM In general terms, Imperialism is the conquest and subsequent rule of land and peoples by a more powerful nation state. The heyday of Imperialism was the late nineteenth century up until the First World War when, for example, powerful European countries ruled over various African territories. Imperialism is interpreted by MARXISTS as an outlet for economic trade and political gain but it is often qualified in terms of NATIONALISM, in the sense that the dominant power is extending its 'civilizing' influence over a 'lesser developed' group. See also COLONIALISM.

IMPRESSIONISM Used to describe the paintings of a group of artists working in France from the 1860s onward. The Impressionists – Edouard Manet, Claude Monet, Pierre-Auguste Renoir, to name but three – are often viewed as proto-MODERNISTS, challenging the authority of the ACADEMIC system and paving the way for an AVANT-GARDE. Impressionism is also a style which describes the looser brushwork, the palette and the contemporary subject matter of these paintings.

INDIVIDUALISM A central tenet of BOURGEOIS ideology is that each person 'owns' his or her destiny. In the 1980s 'Thatcherism' was a political form of individualism whereby each person was supposedly empowered, for instance, to set up their own business. MARXIST and FEMINIST writers argue that individuals' lives are determined by their social relations and that true individualism is a myth. See also SELF-EXPRESSION, HUMANISM.

INSTALLATION A relatively recent term to describe art works which are generally site-specific and often temporary. Usually a commissioned piece of work, an installation occupies a site (sometimes in an established gallery, but theoretically in any agreed spot) and takes its physical dimensions, materials and occasionally its thematic cue from its surroundings.

KITSCH Taken from the German verb meaning 'to make cheap', kitsch has come to mean vulgar, mass-produced imitations of 'objects of high' art and design. Today, the concept of kitsch is problematic since, as the old adage goes, 'one man's kitsch is another man's culture'. Moreover, there has been a tendency in POST-MODERN art and design to use kitsch 'knowingly' in order to parody concepts of good taste.

LIBERAL CULTURE Unlike RADICALISM, liberalism seeks to adapt existing political and social structures to accommodate hitherto excluded groups, rather than to overthrow the system altogether. In terms of this book, a 'liberal culture' is one that is characteristically tolerant of a range of different ideas and beliefs and this is reflected in its endorsement of MODERNISM.

MARXISM Karl Marx did not write specifically about art but his ideas about 'material life' have been adapted by Marxist historians of art particularly in the 1960s. Crudely put, Marxists believe that the economic 'infrastructure' of any society determines its CULTURAL 'superstructure'. So, for example, western art is the product of its economic base and when that base changes, as for example it did during the Industrial Revolution and again since in a technological revolution, then so the art of the period responds. Marxists further believe that those in charge of the economic base of society also control its DOMINANT IDEOLOGIES. To take a recent example, 'Victorian values' are not universal but a product of a ruling class extending their IDEOLOGY to other class groups in order to regulate their lives.

MESOAMERICA Geographically, the 'middle' of America: that is, the region from Mexico to Nicaragua.

MINIMALISM More commonly associated with sculpture and music than with painting, Minimalism is an art movement dating from the 1960s which, characteristically, employed sheet metal, perspex and house bricks to make regular, geometric constructions on a fairly grand scale for art galleries and sculpture parks. Ironically perhaps, even though Minimalism was a deliberate reaction to the INDIVIDUALISTIC qualities of ABSTRACT EXPRESSIONISM, it is often seen as indulgent.

MODERN The dictionary definition of modern is 'of the present or very recent past'. Thus modern is synonymous with 'contemporary'. However, modern can be a confusing term since its present tense connotations are confounded by definitions of MODERNISM. Modern thus has implications beyond the contemporary – it is essentially an urban, post-industrial term. For instance Baudelaire's *Modern Painters* (1863) were those who were actively engaged with subjects of modern city life.

MODERNISM Modernism has a long and varied provenance which describes a period designation, a style and a theoretical stance. Broadly speaking, Modernism can be dated to the 1860s and describes the efforts of artists (as well as architects, designers and poets) to break the codes and conventions of visual production – especially those preserved by ACADEMIES. Typically modernist art is concerned with the 'new' – using unconventional materials, novel means of construction and experimentation with new ways of depicting the subject. Some believe that modernism ended in the 1970s and that, at the time of writing, we are living in a POST-MODERN period.

MODERNITY/MODERNIZATION In his book *All That is Solid Melts into Air; The Experience of Modernity* (1983), Marshall Berman distinguishes between MODERNISM, modernity and modernization. According to Berman, 'modernization' is a process of economic, social and technological advance based on innovations associated with CAPITALISM. Whereas modernity is the condition or state of transformation brought about by CAPITALISM in the nineteenth and twentieth centuries in Europe and North America.

NATIONALISM The imposition of geographical borders is a relatively recent phenomenon which has divided the

globe into nations, some sharing a common language or historical links. Nationalism is the belief that being of the same nation state entails shared identity, beliefs or traits – occasionally implying that these make one's country superior to other nations. Nationalism has been enlisted in support of diverse political beliefs – sometimes, as in the case of Irish Nationalists, to oppose 'foreign' rule, other times, as in the case of the National Socialists in Germany in the 1930s, to rally the country for territorial expansion.

NATURALISM Often used synonymously with REALISM, naturalism, in terms of art, avoids precise and measured usage. Since what constitutes naturalism has changed over the centuries, then it is most useful to think of it as a way of painting rather than having a particular content (unlike REALISM). Consequently the work of the IMPRESSIONIST Claude Monet sits comfortably under the heading 'naturalism' because it is concerned with conveying the appearance of light at a particular time of day in a particular season under particular weather conditions.

NEO-IMPRESSIONISM The collective name given to the group of artists working in the POINTILLIST manner in the 1880s and 1890s, it gets its name from the critic Félix Fénéon in 1886. Its chief practitioners were Georges Seurat and Paul Signac the latter writing a book on Neo-Impressionism in 1898.

NEW ART HISTORY As its name implies, the 'New Art History' is a reaction to an outmoded 'old art history'. It was formally identified in the 1980s when the New Art History was proposed as an 'alternative' (very topical term in the 1980s) history of art. Targeting connoisseurial and FORMALIST as well as certain Marxist art histories, practitioners of the New Art History adopted theoretical models and methodological approaches in order to rigorize the discipline. FEMINISM is often cited as a particular brand of the New Art History.

NEW DEAL A domestic policy delivered by President Franklin D. Roosevelt to rescue the American economy from the effects of the Great Depression in the 1930s. Targeting the elderly and the unemployed, the New Deal regulated state responsibility for social and economic welfare. The New Deal also gave rise to the FEDERAL ART PROJECT which provided, in theory, a financial safety net for artists.

NEW INTERNATIONALISM In our multicultural society, it is no longer appropriate to perpetuate the MODERNIST 'myth' that art is the prerogative of the white, western, male artist, since this no longer (and arguably never did) adequately describes the artist. The 'new internationalism' is the recognition that art is made by, and for, and in response to, many different cultural groups.

ONEIROLOGY A term used by the Surrealists to describe the study of dreams (both in waking and sleeping) and its effects, hallucinations and the disordering of consciousness, confusional states analogous to alcoholic and other forms of intoxication. Oneirology represented the antithesis of logic and reason in the conscious or waking state. SURREALIST artists like Yves Tanguy and Salvador Dali, and others used it extensively from the 1920s.

ORIENTALISM Before the publication of Edward Said's *Orientalism* in 1978 the term simply meant the appropriation of and/or the cultural infatuation with Eastern themes and artistic effects. Said has exposed Orientalism as a peculiarly western DISCOURSE based largely on stereotypes of exotic harems, scantily clad odalisques, eunuchs in turbans and despotic political systems. See also COLONIALISM.

PARADIGM Generally referring to a pattern or model, a paradigm is an art work, a system or standard which one CULTURE deems worthy of imitation (although it has more specialist usage in literary theory). This book contains several examples of 'paradigms'. For example, ACADEMIC art was paradigmatic until the advent of MODERNISM. However, as this book demonstrates, MODERNISM itself became a paradigm; a way of making art which eventually became mainstream – taught in art colleges and represented in art galleries and sold for well-publicized sums of money. It should also be noted that such paradigmatic shifts are difficult since, by its very nature, a paradigm is culturally endorsed.

PHOTOMONTAGE This is a variety of COLLAGE (photo collage) which is much closer to photography itself. It is a wide term which is applied to the superimposition and layering of photographic images.

PICTORIAL SPACE The dimensions of the surface of a painting may be distinguished from what is represented within, in the sense that a picture has its own internal logic of scale and depth. Pictorial space is an ILLUSIONISTIC 'suspension of disbelief' which allows us to look *into* a painting and respond to the information it gives us with varying degrees of success.

PLURALISM A much vaunted aspect of POST-MODERNISM, pluralism is the attitude which maintains (nominally at least) that all points of view, all styles of art, all cultural forms are open and equal. In art since the 1970s this has signalled the acceptance of a variety of artistic enterprises – INSTALLATION, performance art or REALISM – at any one time instead of HEGEMONY of one PARADIGMATIC art form.

POINTILLISM The style and theory of painting in small mosaics of colour used by the NEO-IMPRESSIONISTS. Pioneered by Georges Seurat, Pointillism is the application of small, regular dots of colour to the canvas which is then 'mixed' by the onlooker standing, in theory, at a distance of a third of the width of the canvas.

POLITICS OF REPRESENTATION The relationship between an image and the reality it purports to represent is, according to many contemporary critics, implicitly political. This is because theorists have identified a connection between texts/images and power. For example, representations of women, ethnic minorities or disabled groups are inevitably constructed according to DOMINANT IDEOLOGIES. When traditionally marginalized groups represent themselves, their work often calls into question many of the power relationships that mainstream art embodies.

POPULAR CULTURE Associated with the MODERN period and facilitated by the growth of 'disposable income' among people living in a CAPITALIST society. Forms of popular culture include television and radio, magazines and news-

papers, records and videos. Unlike the 'high' CULTURE of who first outlined their views in the magazine*fine art,* which has traditionally been the preserve of an elite, popular culture is an everyday mass culture.

POST-IMPRESSIONISM Although not coined until 1910–11 by the English art critic and member of the BLOOMSBURY circle, Roger Fry, the term Post-Impressionism is retrospectively applied to a handful of artists whose careers followed hard on the heels of the IMPRESSIONISTS. There is actually little in common between art works by Vincent van Gogh, Paul Cézanne, Paul Gauguin and Henri Toulouse-Lautrec although all appear in anthologies of Post-Impressionism. Perhaps the most helpful thing to say is that, in the most famous periods of their careers, each moved on from IMPRESSIONISM often towards less NATURALISTIC ends.

POST-MODERNISM Post-modernism tends to be defined either as the period after MODERNISM or as a 'condition' whereby established values are rapidly eroded by new technological advances and a general apprehension of what the future will bring. Either way, it is profitable to qualify the term with regard to the visual arts by noting that while Post-Modernism endorses PLURALISM in styles of painting and eclecticism in architecture and fractured narratives in film and literature, it is by no means resolved at the present time. This, in itself, is very Post-Modern; living without fixed laws and standards, seeing institutional authority and its DOMINANT DISCOURSE dissolved by (contradictory and complementary) FEMINIST, post-COLONIAL and other theoretically denominational thinkers.

PRIMITIVISM Once a pejorative term which labelled anything that was foreign or went before western CLASSICISM, primitivism gained currency in the first half of the twentieth century as a way of describing non-European cultural artefacts; such as Oceanic, pre-Columbian, African or Aboriginal carvings and textiles. Because 'primitive' objects were highly collectable in the early years of the twentieth century, the term also came to describe the work of western artists who copied the effects and incorporated the designs of non-European artefacts in their own art. The term is more problematic today since implicit in our understanding of the primitive is the cultural supremacy of the West which has made exchanges between western artists and tribal 'artists' one way appropriation and the relationship unequal.

PSYCHOANALYTIC THEORY OF ART Taking their cue from Sigmund Freud, a number of art historians believe that art may be analysed as a direct consequence of the human psyche. In order to understand the creative output of an individual artist, one needs to examine the influences upon his or her mental life —not simply what 'happened' to the artist but what is held back or repressed. By extension, a psychoanalytical approach to interpreting art is one which applies biographical detail in order to 'reveal' the unconscious mind of the artist. See also SURREALISM, AUTOMATISM, FROTTAGE.

PURISM The architect Le Courbusier and the painter Amédée Ozenfant pioneered purism in the years after 1915. Essentially a revolt against the 'excess' of late CUBISM, which they felt had become gratuitously decorative, Purism, as its name implies, denoted a much more sober and uniform approach to art and design.

RADICALISM Unlike, LIBERALISM, radicalism proposes extreme solutions to existing social, economic and political problems. Usually associated with the far left in politics, in art, radicalism may be any challenge to the establishment. This book shows how AVANT-GARDE groups 'radically' challenged the authority of the ACADEMIES after the 1860s and the term 'technical radicalism' is employed to describe the changing appearance of the SURFACE of the paintings they produced.

READY-MADES The first conscious ready-mades in art were exhibited by Marcel Duchamp after 1913. Typically these consisted of bottle racks, shovels and infamously, a urinal bearing the artist's bogus signature. The significance of these ready-mades in the history of MODERNISM is that they dispensed altogether with the notion of fine art that is skill-based and also that they stretched the viewer's capacity for AESTHETIC appreciation. Although it must be said that Duchamp, himself, always maintained that he was 'indifferent' to the selection of ready-made objects; they were 'intended' to be playful 'interventions' in the serious environment of the First World War. See also DADA.

REALISM Realism in art is beleaguered with problems since art is not 'real'. It is a term commonly confused with NATURALISM – in which artists depict subjects which are 'true to life' or use technical means which closely approximate the way things 'really' appear. Realism, too, is inextricable from the concept of resemblance to actual life although different cultures have different expectations of 'reality'. As a movement in the history of western art, then the distinguishing features of Realism are that it tends to draw its subject matter from day-to-day events, lived by ordinary people.

REGIONALISM The Regionalists were North American painters – including Thomas Hart Benson and Grant Wood – who were working in the 1930s and 1940s. They all produced figurative work which took its subjects from everyday imagery – landscapes of the mid-West and domestic interiors. ABSTRACT EXPRESSIONISM is sometimes presented in literature on the subject as a reaction to this branch of American art.

ROMANTICS/ROMANTICISM Romanticism is a late eighteenth- and early nineteenth-century movement in art and literature. According to the literature, Romanticism is more emotional and passionate than the understated, intellectualized depiction of CLASSICAL subjects. Storm-tossed landscapes and violent human encounters are the stock-in-trade of the Romantic artist.

SELF EXPRESSION The idea that the production of art is driven by the deep felt need of one artist to communicate something very personal from within, is part of the currency of western MODERNISM. It has some diluted precedence in INDIVIDUALISM and HUMANISM, but, in general terms, the art produced under the aegis of ACADEMICISM was not represented in its day as the expression of an individual. The concept of 'self expression' is really a MODERN phenomenon which underlines the unique status of the artist as someone with an extraordinary ability to represent feelings or ideas through art. See also SUBJECTIVITY.

SITUATIONISM The Situationists were an ANARCHIC but politically unaffiliated group of artists and intellectuals,

Internationale Situationniste in 1958. Situationism is not easy to define since it refers to a programme of 'constructing situations' rather than to a style of extant art works. What the Situationists actually advocated was a 'revolution of everyday life' which extended to all forms of intellectual activity. It was, therefore, the spirit in which they 'agitated', rather than the actual art they made, which was significant. The Situationists were, for instance, responsible for much of the graffiti and many of the slogans that featured in the Paris riots of 1968.

SOCIAL REALISM Social Realism is the portrayal of socially concerned subjects in art and literature. Usually Social Realists adopt a NATURALISTIC style or at least a figurative approach to painting. Unlike the CONSTRUCTIVISTS or the painters of DE STIJL, who used an ABSTRACT language to convey meaning, Social Realists tend to literally paint the message, perhaps as part of a narrative or a scene of everyday life.

SOCIALIST REALISM Gained currency in the 1930s in Revolutionary Russia as the official doctrine governing the production of art works. Stalin decreed that artists (seeking official state patronage) should make art which celebrated the State so painters represented working people going about their labour in the fields and factories of the new Russia. Moreover, and as the name implies, Socialist Realism favoured NATURALISM over CONSTRUCTIVISM since Stalin believed that a natural style was a more effective means of mass-communication. Other Communist countries – in the Far East and Latin America – also adopted a policy of Socialist Realism.

STIJL, DE Taking its name from a periodical published between 1917 and 1931, de Stijl was an informal association of painters, designers and architects in Holland. Meaning 'the style' it advocated a sober and impersonal AESTHETIC based on geometrical shapes and primary colours. Its best known paintings are the blue, red and yellow grids of Piet Mondrian and its best known architecture is the cubic design of Gerrit Rietveld's Schröder House. Their pursuit of anonymous and regular forms reportedly reflects a socialist agenda for art and life.

SUBJECTIVITY In this book subjectivity is a condition of MODERNISM, since the subjective mode is involved, coloured by personal feelings, and therefore places the onus on the self in the production and consumption of visual art.

SUPREMATISM Patented by the Russian artist Kasimir Malevich in 1915, Suprematism was a short-lived ABSTRACT art movement. Characterized by paintings of geometrical, coloured shapes, it is invariably linked to broader Russian CONSTRUCTIVISM, since both were ABSTRACT art movements.

SURFACE First the support on which paint or any other media is laid is the 'surface' of a work of art. In terms of this book, the surface is, in itself, an index of MODERNISM. To illustrate the point: the surface of a 'successful' early nineteenth-century ACADEMIC painting was relatively smooth and built up by layers of precise brushwork. MODERNISM, however, is often measured according to the 'technical RADICALISM' of its surface; that is to say that the increasingly 'unstructured' and comparatively 'free' approach of, say, ABSTRACT EXPRESSIONISM, is a marker in the 'progress' of MODERNISM.

SURREALISM French Surrealism formally dates from 1924 when the first Surrealist Manifesto was published. Growing, in part, out of DADA, Surrealism developed into a more self-conscious 'art movement' – with a leader, André Breton, and a shared set of aims and principles. Surrealism is also a wider movement in western art which is still practised today. Given the nature and scope of Surrealism it is only possible to generalize that, as a visual art movement, Surrealism typically confounds the viewer by juxtaposing objects that are not normally associated, or by reconfiguring the subject in a visually irrational manner. See also AUTOMATISM.

VISUAL PERCEPTION In general, an awareness and interpretation of our visual surroundings may be termed perception. Theories of visual perception have altered significantly in the twentieth century. At one time it was assumed that everyone saw everything in roughly the same way, irrespective of conditional factors. Rudolf Arnheim's *Art and Visual Perception* (first published in 1954) has established perception itself as a subject for analysis; laying down criteria for how and why we perceive the visual field as we do. See also ILLUSIONISTIC, PICTORIAL SPACE, PSYCHOANALYSIS.

INDEX

Page references including illustrations are shown in *italic*

THE AUTHORS

FIONNA BARBER

Fionna Barber is Senior Lecturer in the History of Art at Manchester Metropolitan University. She has written on issues of gender and location in relation to comporary art practice.

DAVID BATCHELOR

David Batchelor is an artist and writer on modern and contemporary art. He is Tutor in Critical Studies at the Royal College of Art

JOSIE BLAND

After gaining a degree in Fine Art, Josie Bland spent many years teaching art to secondary pupils. Subsequently she obtained a Masters Degree in the History of Art, and now teaches the History and Theory of Art at Cleveland College of Art and Design in Middlesbrough. In addition, she is a course tutor for the Open University's Modern Art Course, A316.

MARK GISBOURNE

Mark Gisbourne is an art historian and critic, a graduate of the Courtauld Institute of Art, where he is currently completing his PhD. He teaches art and theory and is the MA supervisor at the Slade School of Fine Art, and of an MA course of Post-War and Contemporary Art at Sotheby's Institute. He is UK President of the International Association of Art Critics, and has published on modern and contemporary art, particularly in those areas related to art and madness. His published works include *Gonn Mosny: Breathing and Painting* [Stuttgart, 1989], as well as essays for several major international exhibitions at the Grand Palais [*L'âme au corps* 1993/94], *Los Angeles County Museum* [*Parallel Visions: The Modern Artist and the Outsider*, 1992/93], and *The Artist Outsider* [Smithsonian Press, 1994]. He regularly writes contemporary art criticism in London.

JONATHAN HARRIS

Jonathan Harris is Lecturer in Art History and Critical Theory at Keele University. His most recent book is *Federal Art and National Culture: The Politics of Identity in New Deal America* (Cambridge University Press, 1995). Harris coedited, with Francis Frascina, *Art in Modern Culture* (Phaidon and the Open University, 1992). He is now working on a history of the American Artists' Congress Against Racism and Fascism.

PAM MEECHAM

Pam Meecham is a Lecturer in Art and Design Education at Liverpool John Moores University. She is also an occasional Lecturer and Teacher at the Tate Gallery, Liverpool, and an Open University Summer School Tutor for A315 and A316 courses.

PAUL OVERY

Paul Overy teaches in the School of History & Theory of Visual Culture at Middlesex University. His publications have included books on Kandinsky, De Stijl and the Rietveld Schröder House (co-author). He has curated exhibitions of Rietveld Furniture and the Schröder House and of the work of the Bauhaus artist and designer Josef Albers for the South Bank Centre, London, and is currently completing a book on International Modernism in art, architecture and design.

JULIE SHELDON

Julie Sheldon is a lecturer in the History of Art at Liverpool John Moores University. She has worked with the Tate Gallery Liverpool to produce *Venus Re-Defined: Resource Pack for Teachers* and contributed to their CD ROM *Investigating Twentieth Century Art*.

PAUL WOOD

Paul Wood is a Lecturer in Art History at the Open University. Co-editor (with Charles Harrison) of the anthology 'Art in Theory 1900–1990'.

PHOTO ACKNOWLEDGEMENTS & COPYRIGHT INFORMATION